Essential
Graphic Design

Solutions

ROBIN LANDA

5TH
EDITION

Essential
Graphic Design

Solutions

ROBIN LANDA

5TH EDITION

WADSWORTH
CENGAGE Learning·

AUSTRALIA • BRAZIL • JAPAN • KOREA • MEXICO • SINGAPORE • SPAIN • UNITED KINGDOM • UNITED STATES

WADSWORTH
CENGAGE Learning·

Essential Graphic Design Solutions,
Fifth Edition
Robin Landa

Publisher: Clark Baxter

Development Editor: Ashley Bargende

Editorial Assistant: Marsha Kaplan

Associate Media Editor: Chad Kirchner

Brand Manager: Lydia LeStar

Market Development Manager: Joshua Adams

Senior Content Project Manager: Lianne Ames

Senior Art Director: Cate Rickard Barr

Manufacturing Planner: Sandee Milewski

Senior Rights Acquisition Specialist: Mandy Groszko

Production Service: Lachina Publishing Services

Text and Cover Designer: Chen Design

Compositor: Lachina Publishing Services

© 2014 Robin Landa

For product information and technology assistance, contact us at
Cengage Learning Customer & Sales Support, 1-800-354-9706

For permission to use material from this text or product, submit all requests online at **cengage.com/permissions.** Further permissions questions can be emailed to **permissionrequest@cengage.com.**

Library of Congress Control Number: 2012944051

Essential Graphic Design Solutions:

ISBN-13: 978-1-285-08522-7

ISBN-10: 1-285-08522-1

Wadsworth
20 Channel Center Street
Boston, MA 02210
USA

Cengage Learning is a leading provider of customized learning solutions with office locations around the globe, including Singapore, the United Kingdom, Australia, Mexico, Brazil and Japan. Locate your local office at **international.cengage.com/region**

Cengage Learning products are represented in Canada by Nelson Education, Ltd.

For your course and learning solutions, visit **www.cengage.com.**

Purchase any of our products at your local college store or at our preferred online store **www.cengagebrain.com.**

Instructors: Please visit **login.cengage.com** and log in to access instructor-specific resources.

Printed on 30% recycled paper

Printed in the United States of America
4 5 6 7 8 9 10 21 20 19 18 17

BRIEF CONTENTS

CONTENTS

PART I: FUNDAMENTALS OF GRAPHIC DESIGN

Ch. 04/// THE DESIGN PROCESS

Ch. 05/// CREATIVITY AND CONCEPT GENERATION

Ch. 06/// VISUALIZATION AND COLOR

Ch. 07/// COMPOSITION

Ch. 08/// PROPORTIONAL SYSTEMS AND THE GRID

Preface

INTENDED AUDIENCE

Essential Graphic Design Solutions is the most comprehensive reference on graphic design fundamentals for print and screen media. Principles of design and how they apply to the various graphic design formats and disciplines are explained and illustrated with professional work and diagrams. This text serves as a solid foundation for graphic design, typographic design, and advertising design higher education. It can be used as a reference throughout a student's studies. The online pedagogical resources provide a wealth of valuable tools for any educator.

ORGANIZATION

To view contemporary graphic design in perspective, the text begins with a historical timeline. Start there or use the timeline as a reference throughout the course of study.

Essential Graphic Design Solutions provides a very substantial graphic design foundation, full of visual references and vital information about the formal elements, design principles, typography, the graphic design process, concept generation, creative thinking, visualization, and composition.

Chapter 1, the introduction, examines the visual communication profession, familiarizing the reader with the design disciplines and major areas of specialization in graphic design as well as with ethics.

Chapter 2 comprehensively covers the elements and principles of two-dimensional design, serving as a primer, refresher, or reference.

Chapter 3 is a book on typography within a book. It is the most comprehensive study of typography for print and screen to be found in any general graphic design text.

Chapter 4 offers a guide to the graphic design process, explaining the steps of orientation, analysis, conception, design development, and implementation.

Chapter 5 is a thorough examination of creativity and concept development, covering the tools that stimulate creative thinking, the role of conceptual thinking, and generating design concepts.

Chapter 6 is a study of visualization and color, including drawing for designers, a primer on the fundamentals of designing with color, and graphic interpretation—from the creation, selection, and manipulation of visuals to the basics of designing icons. Imagery, image appropriation, and intellectual property are covered. This chapter also offers various points of view on visualization including the conventional canon.

Chapter 7 brings all the basics covered in the other chapters together when readers learn the fundamental principles of composition and the role of type/image arrangements and relationships. This chapter contains unique points of view on composition with type and images as well as traditional principles, including gestalt.

Chapter 8 further examines composition with a focus on mathematical ratios and proportional systems and the grid.

At the end of the book you will find Beyond the Essentials, which is additional information on composition basics, as well as a design checklist and a series of projects for poster and book cover design to foster learning basic principles and acquiring skills. Also at the end of the book are the Glossary to help with terminology, a Selected Bibliography to encourage further reading, and two extensive Indexes—one regarding all subject matter and another referencing all the agencies, clients, creative professionals, and studios mentioned in this book.

Chapter 16 is online, with links to resources including video advice from many top designers. It describes putting together a portfolio, résumé, and the job search.

Additional material and resources (including many exercises and projects) appear online. This material is noted throughout the book by an icon 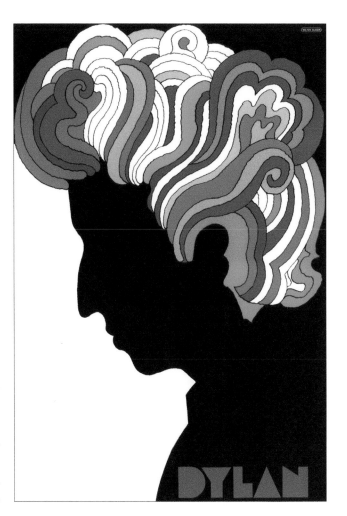.

(*Essential Graphic Design Solutions* is a briefer version of the comprehensive *Graphic Design Solutions*, 5th edition. Part II, an *indepth examination of major graphic design and advertising formats*, appears only in *Graphic Design Solutions*, 5th edition.)

The chapters in *Essential Graphic Design Solutions* provide substantial background and theoretical and applied information, including exercises and projects (with many more in the online companion resource). Sidebars with suggestions, tips, and important design considerations are plentiful. Each chapter includes a selection of Case Studies, Interviews with professional designers and art directors, Showcases of designers's work with commentary by the designers themselves, and Essays by professional designers.

This book covers an enormous amount of ground, allowing for at least three scenarios:

01. Instructors choose content areas and utilize the book in the order that suits their goals.

02. Instructors may assign this book for use in several courses (there is plenty of information to carry over for several courses or semesters).

03. This book is a keeper—most students and designers use this book as a *reference and resource* owing to the abundance of information, historical timeline, comprehensive type chapter, great examples by venerated designers, and creativity and concept generation techniques.

POSTER (ENCLOSED IN A BOB DYLAN RECORD ALBUM): *DYLAN*, 1967

• Milton Glaser

LOOKING AT THE ILLUSTRATIONS

Unlike a design periodical which showcases the most current work, the illustrations in this book were chosen as classic examples that would endure. The illustrations also were chosen to represent different approaches and schools of thought. Every illustration in this book is an excellent example of effective and creative work.

Anyone can learn an enormous amount by analyzing graphic design solutions. Whether you dissect the work of peers, examine the examples of work in this text, or analyze professional work, students will enhance their learning by asking *how* and *why* others did what they did. The examples provided in this text are just that—examples. There are innumerable solutions to any design project. Any visual communication is measured by the degree of success demonstrated in problem solving, communicating, applying visual skills, and creativity within project constraints.

NEW TO THIS EDITION

- The entire text has been expanded and updated to reflect screen media.

- Throughout *Essential Graphic Design Solutions* are new illustrations providing a visual resource of outstanding historical, modern, and contemporary design as well as new diagrams illustrating design principles.

- The timeline is completely rewritten and now includes the major fine arts movements for each decade.

- Chapter 1 is an up-to-date look at the profession with a new Case Study from Winfield & Co. and a new Interview with graphic artist Laura Alejo.

- Chapter 3 includes new content on web type basics, new type diagrams, and new information on typeface pairings.

- Chapter 4 provides a more in-depth, updated look at the graphic design process.

- Chapter 5 has new content on keeping sketchbooks, creative journaling, and creative prompts to improve conceptual and creative thinking.

- Chapter 6 has new content on the basics of designing icons, drawing for designers and graphic interpretation, and the basics of designing with color, as well as new Case Studies from Tangent Graphics and Heads of State.

- Chapter 7 has new content on the importance of grouping, more on composition and the role of type/image arrangements and relationships, and includes a new Showcase of Jennifer Sterling's work.

- Chapter 8 has new content covering the rule of thirds, and more about grids and modularity; it includes a new Case Study from IDEO and a new Interview with Rick Webb, cofounder of The Barbarian Group.

- Chapter 16 (online) contains new information on designing one's own visual identity and updated information on creating a portfolio and the job search.

Also in this new edition:

- More on creativity

- New content on drawing and journaling

- New information on designing with color
- More on concept development
- Many new diagrams
- Preliminary sketches of designers' works
- Alternative solutions to the printed piece
- More information on the grid, including diagrams
- New contemporary illustrations
- Revised tips and sidebars
- Revised Composition Checklist

RESOURCES FOR INSTRUCTORS

The *Instructor Companion Site* hosts PowerPoint® slides designed for use with lectures, an instructor's manual, reflective chapter questions for students, and additional content.

WebTutor™ with ebook on WebCT® and Blackboard® offers a full array of online study tools that are text specific, including learning objectives, glossary flashcards, exercises and projects.

RESOURCES FOR INSTRUCTORS AND STUDENTS

Art Studio is an application that supports instructor and peer review of assignments submitted online with gradebook tracking. Projects can be uploaded to this site rather than sent through e-mail. Students can see and interactively comment on the work of others.

CourseMate delivers chapter-based exercises and projects, topics related to building a portfolio, the interview and career search process, and an innovative video series, Designers Speak, offering video interviews with working designers about how they entered the field of design. The multimedia ebook links to relevant materials in the CourseMate site.

DEDICATION

For my darling daughter Hayley.

Robin Landa
2013

About the Author

Robin Landa

© Kean University Art Direction: Joey
Moran Photography: Jerry Casciano

Robin Landa holds the title of Distinguished Professor in the Robert Busch School of Design at Kean University. She is included among the teachers that the Carnegie Foundation for the Advancement of Teaching calls the "great teachers of our time." Most recently, Landa was a finalist in the *Wall Street Journal*'s Creative Leaders competition.

Robin has won many awards for design, writing, teaching, and creative leadership, including the National Society of Arts and Letters, The National League of Pen Women, New Jersey Authors Award, Creativity, Graphic Design USA, Art Directors Club of New Jersey, The Presidential Excellence Award in Scholarship from Kean University, Kean University Presidential Challenge Grant, and the Rowan University Award for Contribution to Design Education.

She is the author of fourteen published books about graphic design, branding, advertising, and creativity, including *Take a Line for a Walk: A Creativity Journal* (Wadsworth), *Essential Graphic Design Solutions* (Wadsworth), *Advertising by Design*™ (Wiley), *Designing Brand Experiences* (Cengage Learning), and *BYOB: Build Your Own Brand* (HOW Books). Her books have been translated into Chinese and Spanish.

Coauthoring with her colleague Professor Rose Gonnella, she wrote *Visual Workout Creativity Workbook* (Cengage Learning) and coauthored *2D: Visual Basics for Designers* (Cengage Learning) with Gonnella and award-winning designer Steven Brower. Known for her expertise in creativity, Landa penned *Thinking Creatively* (HOW Books) and coauthored *Creative Jolt* and *Creative Jolt Inspirations* (North Light Books) with Rose Gonnella and Denise M. Anderson. Robin's article on ethics in design, "No Exit for Designers," was featured in *Print* magazine's European Design Annual/Cold Eye column; other articles have been featured in *HOW* magazine, *Step Inside Design*, *Critique*, and *Icograda*. Robin's Amazon Shorts—"Advertising: 11 Insights from Creative Directors" and "Branding: 10 Truths Behind Successful Brands"—both reached the number one spot on the Shorts best-seller list. Modern Dog Design Co. illustrated Robin's first children's book, *The Dream Box*.

Robin has lectured across the country at the *HOW* International Design Conferences, Graphic Artists Guild conferences, College Art Association, Thinking Creatively conferences, Art Directors Club of New Jersey, and the One Club Education Summit. She has been interviewed on radio, television, in print, and the web on the subjects of design, creativity, and art.

In addition, working with Mike Sickinger at lava dome creative (http://www .lavadomecreative.com/), Robin is a brand strategist, designer, copywriter, and brand storyteller. She is the creative director of her own firm, robinlanda.com. Robin has worked closely with marketing executives and their companies and organizations to develop brand strategy, enhance corporate creativity through seminars, and develop brand stories. With the keen ability to connect the seeming unconnected, Robin uses her research and writing to support her professional practice.

Acknowledgments

Without the brilliantly creative graphic design and advertising solutions that inhabit these pages, my book would be an entirely different study. Humbly and gratefully, I thank all the creative professionals who granted permission to include their work and words in this fifth edition of *Essential Graphic Design Solutions*. Great thanks to the clients, companies, and organizations that granted permission and to all the generous people whose help was so valuable.

For the new features in this edition, my thanks to Laura Alejo; Heads of State; IDEO; Vijay Matthews, Winfield & Co.; Jennifer Sterling; Tangent Graphics; and Rick Webb.

I am indebted to Professor Martin Holloway, Robert Busch School of Design at Kean University, for his keen insights into designing with type, to Bob Buel for his help with new diagrams, and to Nicole Velez for her assessment of the contents.

Thank you to the following professors for their thoughtful reviews:

Tricia Farwell, Middle Tennessee State University; Rebecca Stewart, Tyler Junior College; Larry Simpson, University of South Alabama; Cassandra Chavez, Westwood College Online; Scott Franson, Brigham Young University–Idaho; Michael Levin, Spencerian College; Nathan Pieratt, Westwood College Online; Sergei Itomlenskis, Bradford School; and Carl Rossini, The Art Institute of Dallas.

At Kean University, I was highly fortunate to have had support for this research from Dr. Dawood Farahi, President; Dr. Jeffrey H. Toney, Vice-President for Academic Affairs; Dr. Kristie Reilly, Vice President of Institutional Advancement; Dr. George Z. Arasimowicz, Dean of the College of Visual and Performing Arts; Prof. Holly Logue, former Acting Dean of the College of Visual and Performing Arts; Prof. Rose Gonnella, Executive Director of the Robert Busch School of Design; Prof. Alan Robbins, Robert Busch School of Design; Dr. Susan Gannon, Acting Director of the Office of Research and Sponsored Programs; and the Release Time for Research committee; and from my wonderfully talented students.

My sincere thanks to the Wadsworth dream team: Clark Baxter, Publisher; Cate Rickard Barr, Senior Art Director; Lianne Ames, Senior Content Project Manager; Sharon Adams Poore; and Marsha Kaplan, Editorial Assistant; and to Chen Design Associates and Christopher Black of Lachina Publishing Services. A special acknowledgment to Ashley Bargende, my Development Editor at Wadsworth, for her terrific insights, guidance, and permission to include her beautiful works of art.

Loving thanks to my friends—Denise Anderson, Jill Bellinson, the Benten/Itkin family, Alice Drueding, and Rose Gonnella. For their unwavering support and patience, a huge thank you to my husband, Dr. Harry Gruenspan, and our daughter Hayley.

Graphic Design Timeline Introduction

THE STUDY OF GRAPHIC DESIGN and art history helps us better understand how we arrived at the present and came to be as we are. Peter N. Stearns, Professor of History at George Mason University, says: "The past causes the present, and so the future."[1]

A comprehensive study of graphic design history is a requirement for any aspiring designer or anyone interested in understanding images. *Meggs's History of Graphic Design* by Philip B. Meggs and Alston W. Purvis is standard reading. *Graphic Style: From Victorian to Digital* by Steven Heller and Seymour Chwast and *Graphic Design Time Line: A Century of Design Milestones* by Steven Heller and Elinor Pettit offer time line format support. A full study of fine art history and modern art is critical, too. *Gardner's Art Through the Ages* is a comprehensive study.

Any serious study also includes design theory, criticism, understanding images, persuasion, world history, and related topics. As with anything temporal, graphic design and advertising are artifacts of their time—of the economy, politics, the arts, philosophy, culture, and society. Graphic design is always affected by small and large human events and factors, such as war, culture, subcultures, cultural unrest, economic turbulence, music, media, and more. Graphic design and advertising, in turn, affect culture, music, media, and us.

1. Peter N. Stearns. "Why Study History?" American Historical Association, July 11, 2008. http://www.historians.org/pubs/free/WhyStudyHistory.htm

Essay

Graphic Design Timeline Steven Brower

STEVEN BROWER

Now in his own design studio, most recently Steven Brower was the creative director for Print magazine. He has been an art director for The New York Times, The Nation magazine, and Citadel Press. He is the recipient of numerous national and international awards, and his work is in the permanent collection of the Cooper-Hewitt National Design Museum, Smithsonian Institute. Most recently, Brower had a solo exhibit, "Eye, Brower," at the Art Institute of California, Inland Empire. He is the Director of the MFA Program for Working Professionals at Marywood University in Scranton, Pennsylvania.

The history of design, like any history, is completely malleable. With no hard start date, we have to make choices. Should we begin with the cave paintings of Lascaux, Chinese movable type, the Trajan column, or Gutenberg? Our history is the history of human communication, so where to begin?

For our purposes, we begin in the modern era, in the late nineteenth century. The advent of improved travel to Asia brought sailors onto the streets of Paris and London, weighted down with Japanese prints in their knapsacks. The influence of these Japanese artists on their European counterparts was profound. An organic sense of form based on nature, refined ornamental borders, and elegant composition became the rage. Combined with refined printing processes, *art nouveau* was indeed the new art.

This style spread quickly to the arts and crafts movement in England, Jugendstil (youth style) in Germany, and Glasgow style with versions in Belgium and the United States. The basic elements were reinvented by each culture, which added their own twist. In Austria, it was taken a step further with the Vienna Succession, a group dedicated to creating a new visual language.

In the early 1900s, the shot heard 'round the world was fired in Germany. Lucian Bernhard was fifteen years old when he visited the Munich Flaspalast Exhibition of Interior Design. He was so moved by the forms and colors he had witnessed that he returned to his parents's house while his father was away on a business trip and painted every wall and piece of furniture in these bold new colors. When his father returned, he was so outraged that Lucian left home, permanently.

Stranded in Berlin, he entered a contest sponsored by Priester Match to create a poster advertising their wares. He painted a composition that included matches on a tablecloth, along with an ashtray containing a lit cigar and dancing girls in the background. Dissatisfied, he painted out the dancing girls. Feeling it was still not working, he deleted the ashtray. The tablecloth was next to go. There remained the singular word "Priester" and two matches, on a brown background, along with a discrete signature. The birth of the object poster was born, prefiguring the Ludwig Mies van der Rohe "less is more" philosophy.

Soon the Russian Revolution was under way, resulting in an extraordinary (albeit short-lived) amount of creative freedom for artists such as El Lissitzky, Rodchenko, and Malevich. The *futurists's* experimentation with typography in Italy resulted in an influence that would outlast their movement, halted by World War I.

After the war, *De Stijl* in the Netherlands and the *Bauhaus* in Germany would further refine the clean *modernist* aesthetic. Artists such as A. M. Cassandre in France would synthesize entire art movements such as *cubism, surrealism, and art deco.*

With the advent of World War II, many of these artists would be forced to emigrate to the United States. Their influence was profound. Just as Japan had influenced the Europeans fifty years earlier, thus America was impacted by Europe. Lester Beall was one of the first American designers whose work showed strong evidence of this inspiration. Paul Rand's and Alvin Lustig's designs, in part, explored the amorphous forms of European painters Paul Klee and Joan Miró.

In 1954, a group of Cooper Union graduates banded together to form Push Pin Studios. Well versed in design and illustration history, they drew upon existing forms, such as art nouveau and art deco, to create new ones. By combining illustration and design seamlessly, they ushered in a new era in contrast to the stark modernist movement that had gone before. Their reexamination of the art nouveau style moved west in the late 1960s, combined with the cultural and musical changes at the time, and reappeared in the form of psychedelic posters by the likes of Rick Griffin and Victor Moscoso.

In the mid-1970s and early 1980s, the retro approach reached its zenith. The European type styling of Louis Fili, Jennifer Morla, Carin Goldberg, and the *constructivist* type design of Neville Brody revisited and reinvigorated existing forms.

In 1984, Apple Computers released the first Macintosh, and the relationship between technology and design moved forward yet another step. Designers such as April Greiman and later David Carson took up the call. A myriad of new typefaces were displayed in *Emigre* magazine. Design, typesetting, and production were fused for the first time. In reaction, hand-lettered typography was suddenly manifest.

Today, we are still reeling from the effects of the personal computer. Designers, perhaps more than ever before, can be the complete masters of their domain, responsible for every aspect of what winds up on the page or digital display. The timeline continues. Where are we headed? Only the future will tell.

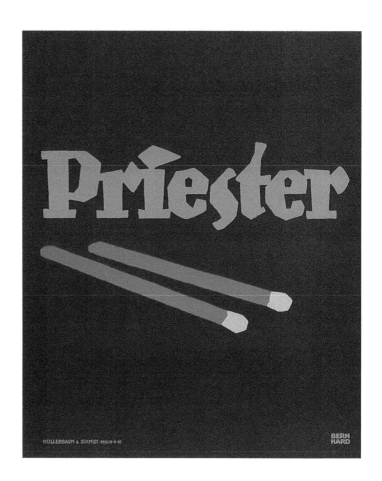

PRIESTER MATCH

DEUTSCHES PLAKAT MUSEUM IM MUSEUM

- *Folkwang, Essen (Fotografie: Jens Nober)*
- *Lucian Bermhard (Emil Kahn, 1883–1972)*
- *Priester [Hölzer]*
- *Deutschland (Deutsches Reich), 1915*
- *Hollerbaum & Schmidt, Berlin*
- *Farblithografie*
- *59.5 × 48.5 cm*
- *DPM 1128*

Historical Image Timeline

1890s–PRESENT

This brief historical overview of visual communication in the twentieth century is in no way meant to substitute for a full study. This offering does not include, as any full history would, the influences of current events, social climate and issues, inventions, politics, music, and art on visual communication. For example, the social and political climate of World War II had a profound influence on European and American artists's and designers's lives and work.

The goal of this brief timeline is to put the information in this book into a broader context. As Steven Brower asks: Should we begin with the human and animal representations and signs in the cave of Lascaux some 16,000 years ago? Does the history of visual communication begin in the eleventh century with the invention of movable type by a man named Bi Sheng in China? Or does graphic design begin with its roots in Johannes Gutenberg's method of printing with movable type in the mid-fifteenth century? Did graphic design begin with graphics that identified? Instructed? Promoted? Did graphic design begin with the combination of words and images in the first poster? For our purposes, we begin in the modern era, in late nineteenth-century Europe.

Industrialization and mechanization transformed life in nineteenth century Europe and America. During the late Victorian period in England, the arts and crafts movement emerged. In response to industrialized mechanization, its proponents advocated the viewpoint of designer as craftsman. The flowing organiclike forms of the art noveau movement were evident in design, art, and architecture. European art was deeply affected by an influx of Japanese prints. In turn, European movements influenced American artists and designers.

In France, advanced by Jules Chéret, color lithography allowed for great color and nuance in poster reproduction. Advances in lithography helped give rise to the poster as a fresh and upcoming visual communication vehicle. Artist Toulouse-Lautrec embraced the poster. Companies hired art nouveau artists, such as Alphonse Mucha, to create posters to advertise their products. In England, Sir John Millais's painting *Bubbles* was used in a poster advertising Pears Soap. Many people objected to this use of fine art for commercial purposes, of borrowing cachet from "high art" for the Pears Soap brand.

1870s–1890s/ Arts and crafts movement

1887/ Sir John Millais's painting *Bubbles* used in a poster advertising Pears Soap

1890/ Art nouveau movement begins

1891/ *La Goulue*, Toulouse-Lautrec's first poster

1893/ Coca-Cola is registered as a trademark

1895/ The Beggarstaffs, a pseudonym for William Nicholson and James Pryde, use an original collage influenced by Japanese art for a poster to promote *Don Quixote* at The Lyceum Theatre, London

1895–1897/ Ethel Reed, American graphic designer and illustrator, created works for literary presses of Lamson, Wolfe and Co. and Copeland & Day

1895–1904/ William H. Bradley designed posters and covers and wrote articles for *The Chap-Book*

1897/ Vienna Secession is formed

1898/ Advertising agency N. W. Ayer created the slogan, "Lest you forget, we say it yet, Uneeda Biscuit," to launch the first prepackaged biscuit, Uneeda, produced by the National Biscuit Co. (today, a company called Nabisco)

Innovative fine art movements challenge conventions affecting all the visual arts. In 1905, artists from the *Die Brücke* (The Bridge) in Dresden contributed to the development of *expressionism*. Leading proponents included Ernst Ludwig Kirchner and Emil Nolde. In 1907, the graphic design of architect/designer Peter Behrens exemplified the relationship between design and industry. Behrens sought a modern visual language to express the age of mass production. Principles of grid composition were taught in Germany, and we saw the birth of *pictorial modernism*.

In France, the cubist style of major artists Pablo Picasso (born in Spain) and Georges Braque affected all the visual arts then and for decades to come. From 1909 to 1910, the Italian futurists wrote manifestos and influenced many visual artists.

1890s

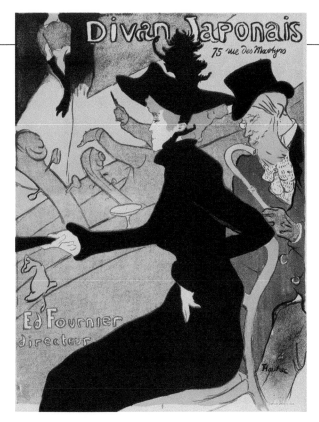

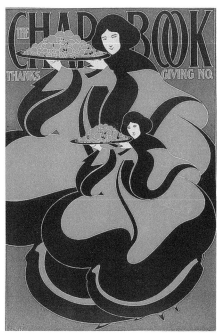

POSTER: HENRI DE TOULOUSE-LAUTREC (1864–1901), DIVAN JAPONAIS (JAPANESE SETTEE), 1893

- *Lithograph, Printed in Color, Composition:* 31⅝" × 23 ⅞". Abby Aldrich Rockefeller Fund (97.1949)
- *Collection:* The Museum of Modern Art, New York, NY, U.S.A.
- *Digital Image © The Museum of Modern Art/Licensed by Scala/Art Resource, NY*

"Although primarily a painter (and printmaker), French artist Toulouse-Lautrec's embrace of the poster would drive the medium into popularity. He created a total of thirty-two posters. The Japanese influence is applied to Parisian nightlife."

—Steven Brower

LITERARY PERIODICAL: WILLIAM H. BRADLEY (1868–1962), PUBLISHED BY STONE & KIMBALL (CHICAGO), *THE CHAP-BOOK* (THANKSGIVING), 1895

- *Color Lithograph, 528 × 352 mm.*
- *The Baltimore Museum of Art:* Gift of Alfred and Dana Himmelrich, Baltimore (BMA 1993.89).

Bradley, influenced by the art nouveau style, introduced an American audience to a new vocabulary of forms.

In 1911, *avant-garde* artists formed *Der Blaue Reiter* (Blue Rider) in Munich, with Russian artist Wassily Kandinsky as a leading member. Kandinsky is credited with the first nonobjective painting and was a great influence on modern art. In 1916, the *Dada* movement began in Zurich, flourishing in France, Switzerland, and Germany. In reaction to World War I, Dadaists advocated chance and irrationality, forever changing fine art.

In 1919, Walter Gropius founded the Weimar Bauhaus in Germany. This highly influential design school, whose philosophy laid the foundation for much of modern thinking about architecture and design, attempted to bridge art and industry—the machine age—with an emphasis on rationality. Students at the Bauhaus school studied with luminaries, including Wassily Kandinsky, Paul Klee, Lyonel Feininger, and Johannes Itten, among others.

1901–1905/ Picasso's Blue period
1905/ Lucian Bernhard designs the Priester Match poster
1905/ Salon d'Automne, Paris, is an important French art exhibit
1907/ Peter Behrens designs (what is considered the first) corporate identity for A.E.G., a German corporation
1907/ Pablo Picasso paints *Les Demoiselles d'Avignon*
1909/ Filippo Tommaso Marinetti publishes "The Foundation and Manifesto of Futurism"
1910–1914/ *Die Brücke* (The Bridge) flourishes in Berlin
1910/ Kandinsky and *Der Blaue Reiter* (The Blue Rider)
c. 1910–1913/ Analytical cubism
1912/ Ludwig Hohlwein's poster for the Munich Zoo

1900s–1920s

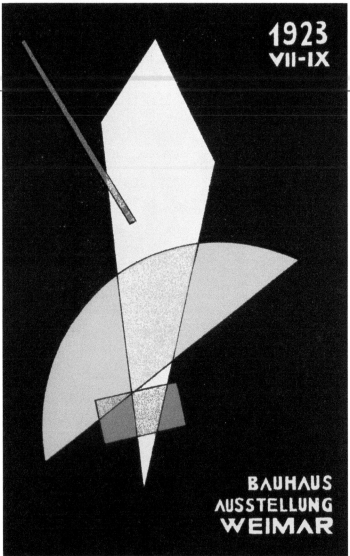

POSTER FOR THE BAUHAUS AUSSTELLUNG WEIMAR MANIFESTO BY LÁSZLÓ MOHOLY-NAGY

• *Alinari Archives/Corbis*

László Moholy-Nagy joined the Bauhaus from 1923–1928.

1913/ Synthetic cubism

1913/ Xiling Society of Seal Carving and Calligraphy founded, Hangzhou, China, with Wu Changshi as its first president

1914/ American Institute of Graphic Arts (AIGA), professional organization for design, founded

1916/ Dada movement founded

1916/ First animated film is made in Japan

1919/ Russian artist El Lissitzky coins the term *Proun*—an abbreviation for the Russian "Project for the Affirmation of the New Art"

1919–1933/ Bauhaus founded in Weimar in 1919 under the direction of architect Walter Gropius

FILM POSTER: HEINZ SCHULZ-NEUDAMM (TWENTIETH CENTURY), *METROPOLIS,* **1926. LITHOGRAPH, PRINTED IN COLOR, 83" × 36 1/2"**

- *Gift of Universum-Film Aktiengesellschaft (80.1961)*
- *The Museum of Modern Art, New York, NY, U.S.A.*
- *Digital Image © The Museum of Modern Art, Licensed by Scala/ Art Resource, NY*

"Art deco meets cubism and the sci-fi film poster is invented."

—Steven Brower

Fine art movements—art deco, cubism, futurism, De Stijl, constructivism, Dadaism, surrealism—greatly affected graphic design and advertising. Influenced by cubism, designers A. M. Cassandre and E. McKnight Kauffer brought their influences through poster design to the greater public.

In an attempt to visually express their dynamic modern age, both artists and designers were highly concerned with the relationship between form and function. In 1921, a group of Russian artists led by constructivists Vladimir Tatlin and Alexander Rodchenko rejected art for art's sake to pursue the duty of artist as citizen. They viewed visual communication, industrial design, and the applied arts as media that could best serve their society. In 1924, surrealism, with the publication of the *Manifesto of Surrealism* by critic and poet André Breton, became an intellectual force.

1922–1924/ The discovery and excavation of the tomb of Tutankhamen
1921/ Artist Alexander Rodchenko became an exponent of productivism
1922/ Aleksei Gan's *Konstruktivizm*, brochure on constructivist ideology
1922/ E. McKnight Kauffer's poster for the London Underground
1922/ Piet Mondrian's *Tableau 2*

1923/ Charles Dawson opens his studio in Chicago
1923–1933/ Vladimir and Georgii Stenberg produce film posters in a Russian avant-garde framework
1924/ El Lissitzky's photomontage, *The Constructor*, promoting his belief of "artist as engineer"
1924/ André Breton's *Manifesto of Surrealism*
1924/ Charles Coiner joins N. W. Ayer's art department
1925/ Industrial and graphic designer Herbert Bayer becomes director of printing and advertising at the Bauhaus
1926/ Bauhaus relocates to Dessau, the Bauhaus school building designed by Walter Gropius
1926/ Fritz Lang's film *Metropolis*
1926/ Ofuji Noburo, Japanese filmmaker, creates animated movies using cutout silhouettes
1927/ Paul Renner designs Futura typeface
1927/ A. M. Cassandre's railway poster
1928/ Jan Tschichold advocates new ideas about typography in his book *Die Neue Typographie*
1929/ Dr. Mehemed Fehmy Agha comes to the United States to become art director for Condé Nast

POSTER: CASSANDRE (ADOLPHE MOURON, 1901–1968)

• *Etoile Du Nord 1927 Ref 200007*

• *© Mouron. Cassandre. Lic. Cassandre-Lcm 28–10–09. www.cassandre.fr*

"Cassandre was a founding partner of a Parisian advertising agency, the Alliance Graphique. The work produced by Cassandre and the Alliance Graphique established a French urbane modern visual vocabulary utilizing Cassandre's typeface design. The romanticism of travel was about the journey, not the arrival."

—Steven Brower

At the end of the 1920s, the modern movement hit the United States. By the 1930s, designers were pioneering visual ideas in the United States, including Lester Beall, William Golden, Alvin Lustig, Paul Rand, and Bradbury Thompson. Lester Beall's posters for America's Rural Electrification Administration have his distinctive imprint and yet are influenced by European modernism. A seminal American designer, Paul Rand, started his distinguished career in 1935 as the art director of *Esquire* and *Apparel Arts* magazines. Rand also designed covers for *Direction*, a cultural journal, from 1938 until 1945. His influence holds to this day. Although Rand was greatly affected by the European avant-garde, he established his own indelible point of view.

The 1930s was a tragic and turbulent time for artists and designers in Europe. Many fled the Nazis and immigrated to the United States, including esteemed Bauhaus members Mies van der Rohe, Josef Albers, László Moholy-Nagy, and Walter Gropius. Their subsequent presence in the United States would have a profound influence on design, architecture, and art. There was an influx of talent to the United States from abroad, including Mehemed Fehmy Agha (born in the Ukraine, immi-

grated in 1929), Alexey Brodovitch (Russian-born, immigrated in 1930), Will Burtin (German-born, immigrated in 1938), Leo Lionni (Dutch-born, immigrated in 1939), Herbert Matter (Swiss-born, moved to New York in 1936), Ladislav Sutnar (Czech-born, traveled to United States in 1939 and stayed), and a woman designer—Cipe Pineles (born in Austria). Boldly testing the limits of contemporary editorial design and experimental page composition, these designers created masterpieces.

1930/ 237 of John Heartfield's photomontages were printed in *Arbeiter Illustrierte Zeitung* (AIZ) (renamed *Volks Illustriete* in 1936) between 1930 and 1938
1934/ Herbert Matter designs Swiss travel posters
1934/ Alexey Brodovitch is art director at *Harper's Bazaar*
1935/ Works Progress Administration (WPA) hires designers to work for the project
1937/ Lester Beall designs Rural Electrification Administration posters
1937/ Picasso's *Guernica* painting about the devastation of the Spanish Civil War
1939/ Bradbury Thompson designs first Westvaco *Inspirations for Printers*
1939/ Leo Lionni becomes art director at N. W. Ayer
1939/ Alex Steinweiss, art director at Columbia Records, invents the illustrated album cover
1930s–early 1940s/ Cipe Pineles becomes the first autonomous woman art director of a mass-market publication, *Glamour* magazine

1930s

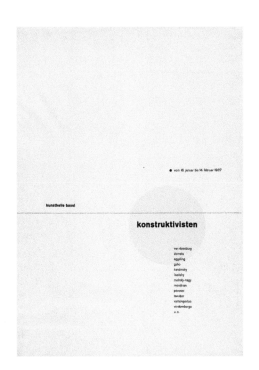

POSTER: JAN TSCHICHOLD, KONSTRUKTIVISTEN (CONSTRUCTIVISTS), 1937

- *Poster:* The Museum of Modern Art, New York, NY. Abby Aldrich Rockefeller Fund, Jan Tschichold Collection, The Museum of Modern Art, New York, NY.
- *Digital Image © The Museum of Modern Art/Licensed by Scala/Art Resource, NY*

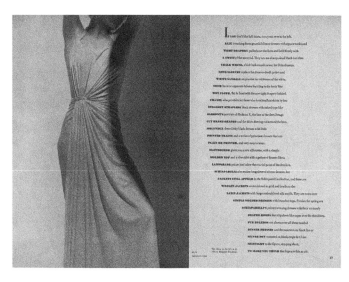

MAGAZINE SPREAD: *HARPER'S BAZAAR*, MARCH 15, 1938

- *Art Director:* Alexey Brodovitch
- *Photographer:* Hoyingen-Huene, Courtesy of *Harper's Bazaar*, New York, NY
- *Photograph Courtesy of the Walker Art Center, Minneapolis, MN*
- *Hearst Communications, Inc*

"Form follows form."
—Steven Brower

In 1939, World War II began. Many artists and designers were called into active duty. Others, including Ben Shahn, E. McKnight Kauffer, Joseph Binder, and Abram Games, created posters to disseminate information, support the war effort, lift morale, and create anti-Nazi vehicles. In England, the British Ministry of Information recruited available preeminent designers to this cause. Many designers were embracing surrealism, using photomontage and bold typography to create stirring war posters, such as German graphic artist John Heartfield, whose strong antiwar work satirized the Nazi Party. What would eventually become the Advertising Council, a public service advertising organization, began in 1942 as the War Advertising Council, organized to help prepare voluntary advertising campaigns for wartime efforts.

In the United States during the 1940s and 1950s, *abstract expressionism* was the primary artistic movement (overshadowing any representational art), with leading artists such as Jackson Pollock, Willem de Kooning, Franz Kline, and Mark Rothko. In the post–World War II years, New York City became the art capital of the world.

1940s/ Paul Rand designs *Directions* covers
1940/ Robert Savon Pious designs event poster for the Chicago Coliseum
1941/ Walter Landor established Walter Landor & Associates in San Francisco
1945–1952/ Alvin Lustig designs the New Classics series by *New Directions*
1945/ LeRoy Winbush founds Winbush Associates (later, Winbush Design)
1946/ Lou Dorfsman joins CBS
1947/ Armin Hofmann begins teaching at the Basel School of Design
1947/ In Italy, Giovanni Pintori is hired by Olivetti
1949/ Doyle Dane Bernbach opens
1949/ Cipe Pineles's cover for *Seventeen*
1949/ Hermann Zapf designs Palatino typeface

1940s

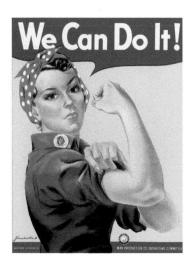

ADVERTISEMENT: WOMEN IN WAR JOBS—ROSIE THE RIVETER, 1942–1945

- *Sponsors:* Office of War Information, War Manpower Commission

- *Volunteer Agency:* J. Walter Thompson

"This powerful symbol recruited two million women into the workforce to support the war economy. The underlying theme was that the social change required to bring women into the workforce was a patriotic responsibility for women and employers. Those ads made a tremendous change in the relationship between women and the workplace. Employment outside of the home became socially acceptable and even desirable."

—The Advertising Council

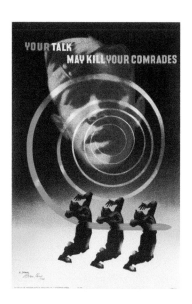

POSTER: ABRAM GAMES, YOUR TALK MAY KILL YOUR COMRADES, 1942

- © *Estate of Abram Games*

Abstract expressionism flourished in New York. The International Typographic style, or Swiss design, played a pivotal role in design with an emphasis on clear communication and grid construction, with Max Bill and Ernst Keller as major proponents. In 1959, the movement became a unified international one, disseminating ideas in *New Graphic Design*, whose editors included Josef Müller-Brockmann and Hans Neuburg.

In America, seminal designers such as Paul Rand, William Golden, George Tscherny, Ivan Chermayeff, Tom Geismar, Otto Storch, and Henry Wolf created watershed work. Saul Bass's movie titles and film promotions set new standards for motion graphics.

Doyle Dane Bernbach (DDB) began a creative revolution in advertising, with art directors such as Bob Gage, Bill Taupin, and Helmut Krone. Bill Bernbach teamed art directors and copywriters to generate creative advertising ideas.

Visual identity became gospel at corporations with in-house designers such as William Golden and Lou Dorfsman at CBS and Giovanni Pintori at Olivetti. Corporations began to rely on graphic designers to create visual identities that would differentiate them within a competitive marketplace, such as Paul Rand who created visual identities for IBM and Westinghouse.

1950/ Jackson Pollack's *Autumn Rhythm*
1950/ William Golden designs the CBS symbol
1951/ Roy Kuhlman designs Grove Press paperback covers
1952/ Rudy de Harak opens his New York studio
1953/ James K. Fogleman defines "corporate identity"
1954/ Adrian Frutiger creates a family of twenty-one sans serif fonts named Univers
1954/ Push Pin Studios is formed
1955/ Saul Bass designs the first comprehensive design program unifying film and print for the *Man with the Golden Arm*
1957/ Ivan Chermayeff and Thomas Geismar open their studio in New York
1950s/ Henryk Tomaszewski creates CYRK posters

1950s

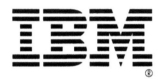

LOGO: IBM, 1956
- *Designer:* Paul Rand
- *Client:* IBM Corporation

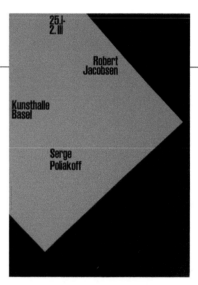

EXHIBITION POSTER: ARMIN HOFMANN, ROBERT JACOBSEN, AND SERGE POLIAKOFF, 1958
- *Collection:* The Museum of Modern Art, New York, NY, Gift of the Designer.
- *Digital Image © The Museum of Modern Art, Licensed by Scala/Art Resource, NY*

ADVERTISEMENT: "UGLY"
- *Doyle Dane Bernbach, New York*
- *Client:* Volkswagen
This gutsy ad winks at its audience.

Representational art made a comeback with the *pop art* movement—a movement drawing upon imagery from popular culture—with leading artists Andy Warhol, Roy Lichtenstein, and Robert Indiana. The pop movement (influenced by graphic design) challenged the conventions of modernist thinking. *Op art* artists used optical effects to evoke physiological responses, with proponents including Bridget Reilly and Victor Vasarely. In 1969, a group exhibit of *conceptual art* opened, and the conceptualism movement started to have great influence.

Corporate identity design grew in importance with work by Lester Beall for International Paper Company and design firms such as Chermayeff & Geismar creating programs for Mobil and the Chase Manhattan Bank, Saul Bass for AT&T and Continental Airlines, and Massimo Vignelli and the Unimark office for Knoll.

Redefining American graphic design and illustration were Push Pin Studios (founding members Seymour Chwast, Milton Glaser, Reynold Ruffins, and Edward Sorel), Saul Bass, and Herb Lubalin. Push Pin Studios in New York and the Haight-Ashbury poster designers in San Francisco, such as Wes Wilson and Victor Moscoso, rocked modernism's structural boat. Wolfgang Weingart was at the forefront of those challenging modernism's core. George Lois's covers for *Esquire* magazine raised the design bar as well as everyone's eyebrows.

In advertising, Doyle Dane Bernbach (DDB) continued to be the force behind creative advertising. Employed at DDB were some of the most creative art directors and copywriters of the twentieth century, such as Bob Gage, Helmut Krone, George Lois, Mary Wells Lawrence, Phyllis K. Robinson, and Julian Koenig. Lois, Koenig, and Wells Lawrence left DDB to open their own ad agencies.

1950s–1960s

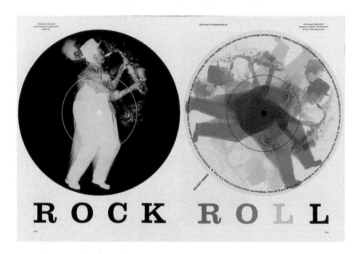

INTERIOR SPREAD: *WESTVACO INSPIRATIONS 210*, 1958
- *Designer:* Bradbury Thompson
- *Copyright by Westvaco Corporation, New York*

Process printing plates were not employed, as just one halftone plate was printed in three-process inks and on three different angles to avoid a moiré pattern (an undesirable pattern produced when two or more dot patterns overlay one another in printing).

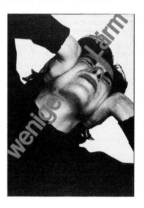

POSTER: JOSEF MÜLLER-BROCKMANN (1914–1996). WENIGER LÄRM (LESS NOISE), 1960
- *Offset Lithograph, Printed In Color, 50¼ × 35½ ft. Acquired by Exchange (513.1983).*
- *The Museum of Modern Art, New York, NY, U.S.A.*
- *Digital Image © The Museum of Modern Art/Licensed by Scala/Art Resource, NY*

Müller-Brockmann was a leading designer in the International Typographic Style.

1960/ John Berg becomes art director at CBS records

1960/ Lester Beall designs International Paper logo

1961/ Alan Fletcher, Colin Forbes, and Bob Gill cofound Fletcher/Forbes/Gill (a forerunner of Pentagram)

1961/ Edouard Hoffman and Max Miedinger design Helvetica typeface

1962/ Andy Warhol's *Campbell's Soup Cans*, thirty-two canvases

1962/ Herb Lubalin designs *Eros* magazine

1962/ Ally & Gargano advertising agency opens

1963/ The International Council of Graphic Design Associations (Icograda) founded

1963/ "The Pepsi Generation" ad

1964/ Pablo Ferro designs main title sequence for *Dr. Strangelove or: How I Learned to Stop Worrying and Love the Bomb*

1964/ First Things First manifesto signed by twenty-two signatories

1965/ Massimo Vignelli is cofounder and design director of Unimark International Corporation

1965/ Tadanori Yokoo's poster in the Persona group's 1965 joint exhibition

1967/ Chiat/Day advertising agency opens

1967/ Graphic Artists Guild (GAG) founded

1967/ Shigeo Fukuda creates posters for Montreal's Expo '67

1968/ Herb Lubalin designs *Avante Garde* magazine

1969/ George Lois's composited *Esquire* cover of Andy Warhol drowning in an oversized can of Campbell's soup

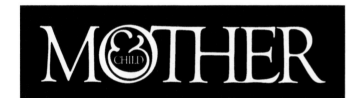

LOGO: MOTHER AND CHILD, 1967

- *Designer:* Herb Lubalin, The Design Collection at The Herb Lubalin Study Center, The Cooper Union, New York

- *Courtesy of the Lubalin Family*

This is a quintessential example of Lubalin's thinking: finding the solution inside the problem.

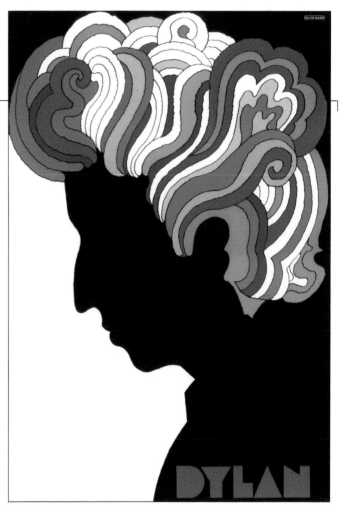

POSTER (ENCLOSED IN A BOB DYLAN RECORD ALBUM): *DYLAN*, **1967**

- *Milton Glaser*

"Islamic art meets Marcel Duchamp at the dawn of the psychedelic era."

—Steven Brower

Some view the 1970s as the end of modernism and the beginning of *postmodernism*. In 1971, critic Robert Pincus-Witten used the term *postminimalism* to describe the contemporary work of Richard Serra and Eva Hesse. During the late 1970s, the Earthworks movement has proponents such as Walter De Maria. At the end of the decade, the *appropriation art* movement, especially Barbara Kruger, influenced all the visual arts.

Some designers saw the modernist style as corporate and reacted with alternative creative thinking. The typography of designers such as Wolfgang Weingart, April Greiman, Willi Kunz, and Dan Friedman lead the postmodernist way in graphic design. The subversive posters emanating from the French design collective Grapus created an independent design point of view. In California, April Greiman was experimenting with type, hybrid imagery, and mixing media to create a whole new visual vocabulary. There was a growing response to the perceived "objectivity" of modernism, with highly individual aesthetics growing around the world.

1970/ Grapus Studio, a French design collective, is formed by Pierre Bernard, François Miehe, and Gérard Paris-Clavel

1970/ Raymond Loewy designs the U.S. Mail eagle symbol

1970/ Shigeo Fukuda designs graphics for Expo '70

1971/ Massimo Vignelli and Lella Vignelli establish Vignelli Associates

1971/ Saul Bass designs the United Way logo

1971/ Tom Burrell and Emmett McBain open Burrell McBain Advertising, Chicago

1971/ Archie Boston founds Archie Boston Graphic Design

1972/ Pentagram opens in London

1973/ *Graphic Artists Guild Handbook* first published

1974/ Paula Scher designs covers for CBS records

1974/ First set of Passenger/Pedestrian Symbols was published, produced through collaboration between the AIGA and the U.S. Department of Transportation

1975/ Milton Glaser designs the I LOVE NY symbol

1975/ The One Club for Art & Copy, organization for the recognition and promotion of excellence in advertising, founded

1978/ Louise Fili becomes art director of Pantheon Books

1978/ Pentagram opens their New York office

1979/ M&Co founded by Tibor Kalman with Carol Bokuniewicz and Liz Trovato

1970s

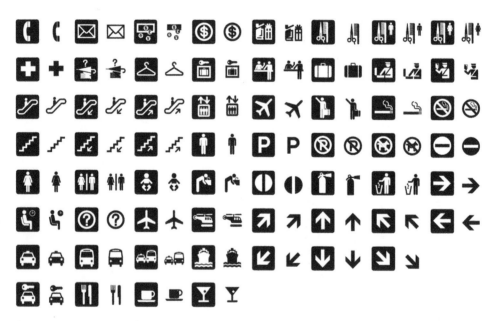

SYMBOL SIGNS: AIGA, 1974 (FIRST SET OF THIRTY-FOUR; 16 MORE SYMBOLS WERE ADDED IN 1979)

- *A Complete Set of Fifty Passenger/Pedestrian Symbols Developed by AIGA*
- *AIGA Signs and Symbols Committee Members:* Thomas Geismar, Seymour Chwast, Rudolph De Harak, John Lees, Massimo Vignelli
- *Production Designers:* Roger Cook, Don Shanosky; Page, Arbitrio and Resen, Ltd.
- *Project Coordinators:* Don Moyer, Karen Moyer, Mark Ackley, Juanita Dugdale

In 1973, the U.S. Department of Transportation (DOT) commissioned the American Institute of Graphic Arts (AIGA), which formed a committee of five outstanding designers, to create a set of passenger and pedestrian symbol/signs for use in DOT public spaces. The final set of symbol/signs was designed and created by Cook and Shanosky Associates.

In 1980, a group of *neo-expressionist* artists including Julian Schnabel, David Salle, and Eric Fischl exhibited in New York. Barbara Kruger's art, considered part of the "pictures generation," continues to influence many. IBM and Apple launch desktop computers. During the late 1980s, British art enters an exciting phase with the era of the Young British Artists (YBAs).

In 1984, Apple introduced the Macintosh computer, which provided graphic designers with the most significant tool since the pencil. New technology enabled designers to generate type without a typesetter, more easily manipulate imagery (as opposed to using handcrafted photomontage), imitate visual effects such as airbrushing, easily make changes, and substitute hand-lettered and hand-drawn comps with digitally produced typography and images.

Termed the postmodern (or late modernist) period, the 1980s and 1990s were an eclectic time as artists and designers experimented with new technology. The political and social climate of the 1980s pro-vided a fertile environment for many, including provocative designers such as Tibor Kalman, founder of M&Co.

In California, Rudy VanderLans (trained in the Netherlands) and Zuzana Licko (born in Czechoslovakia) collaborated to create experimental typography in *Emigre*. David Carson designed *Beach Culture* magazine, and his typographic methodology would eventually divide designers into camp divisions about typographic design. In England, Neville Brody was challenging conventions with his own typeface designs and his art direction for *Face* magazine.

George Lois's ad campaign concept "I want my MTV" transformed entertainment. Chiat/Day created one of the great moments in TV advertising with its "1984" spot for Apple's Macintosh. Thanks to new technology, advertising agencies outside the hub cities (New York, Chicago, Los Angeles) became homes to creative advertising, including Minneapolis and Dallas.

1980s

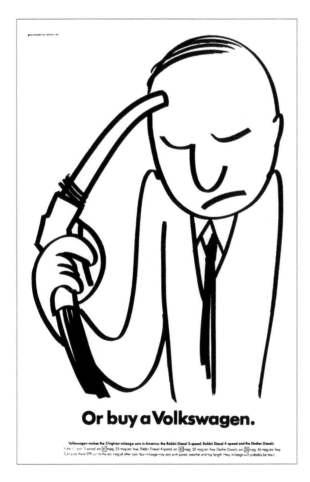

PRINT ADVERTISEMENT: OR BUY A VOLKSWAGEN, 1980

- *Doyle Dane Bernbach, New York*
- *Art Director/Artist:* Charles Piccirillo
- *Writer:* Robert Levenson
- *Client:* Volkswagen

1980/ IBM launches the personal computer (PC)

1981/ MTV logo

1981/ Ikko Tanaka's poster for the dance troupe Nihon Buyo

1982/ George Lois's "I want my MTV"

1983/ R/Greenberg Associates film title sequence for *The Dead Zone*

1983/ *Meggs's History of Graphic Design* is published

1984/ Apple's Macintosh TV spot "1984" by Chiat/Day Agency, directed by Ridley Scott

1984/ *Rolling Stone* "Perception/Reality" campaign by Fallon McElligott and Rice, Minneapolis, MN

1985/ Bartle Bogle Hegarty (BBH), London, revitalizes the Levi's® brand

1986/ Neville Brody designs Typeface Six for *Face* magazine

1986/ Chip Kidd starts in the art department at Alfred A. Knopf

1987/ Fred Woodward becomes art director of *Rolling Stone* magazine

1987/ Gail Anderson becomes deputy art director of *Rolling Stone* magazine

1987/ Shigeo Fukuda is the first Japanese designer inducted into the Art Directors Hall of Fame in the United States

1988/ David Carson designs *Beach Culture* magazine

1988/ Young British Artists exhibition *Freeze* organized in London by Damien Hirst

1989/ The Hoefler Type Foundry opens, now Hoefler & Frere-Jones

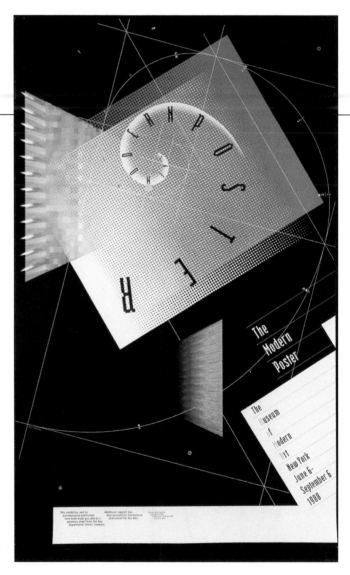

EXHIBITION POSTER: THE MODERN POSTER, 1988

- *Designer:* April Greiman, Los Angeles, CA
- *Client:* The Museum of Modern Art, NY

A West Coast American designer, Greiman (who studied in Basel), was one of the first designers to utilize the Macintosh computer.

The fine art of the 1990s was eclectic and varied, from painter Christopher Wool adapting his paintings to a billboard series to *installation art* and immersive video installations by Doug Aitken to the influential photography of Cindy Sherman to Japanese artist Takashi Murakami's wide-ranging body of work, which bridged fine art, design, animation, fashion, and popular culture. The 1990s saw the worldwide spread of anime and manga.

In 1990, Adobe released its Photoshop digital imaging software. The web became a home to every brand and corporation worldwide. Designers worked closely with technology professionals. As the century came to a close, new technology deeply affected all the visual arts.

Design received new respect in museums. There were hot debates on the topics of consumerism, typographic design form/function, and issues of sustainability. Besides creating design for clients, some designers were tackling social and political issues with independently conceived and produced works. Corporations continued to count on

branding to distinguish their brands internationally. Irony became a truly pervasive postmodern approach. No longer belonging to the arts, postmodernism was co-opted by major brands seeking to align themselves with hipsters and to be perceived as trendsetters.

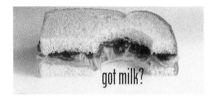

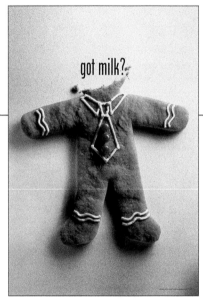

1990s

MAGAZINE SPREAD: *EMIGRE* **NO. 19, "STARTING FROM ZERO," 1991**

• *Designer/Publisher:* Rudy VanderLans
• *Typeface Designer:* Barry Deck

"Ever since I started conducting my own interviews, I have been intrigued with the idea of how to re-create the actual atmosphere or mood of a conversation. Usually, as a graphic designer, you receive a generic-looking, typewritten transcript, written by someone else, that you lay out and give shape to. Before I start the layout of an interview, I have spent hours transcribing the tape, listening to the nuances of the conversation, the excitement in someone's voice, etc. Much of the expressive/illustrative type solutions that I use in *Emigre* are a direct result of trying to somehow visualize the experience of having a conversation with someone. Although this approach is not always successful (some readers are put off by the often 'complex-looking' texts), when it does work, and the reader gets engaged in deciphering and decoding the typographic nuances, the interview inevitably becomes more memorable."

—Rudy VanderLans, *Emigre*

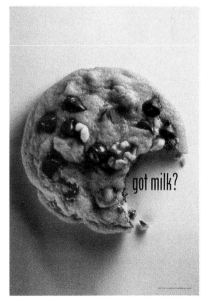

ADVERTISING CAMPAIGN: "GOT MILK?" 1993

• *Goodby, Silverstein & Partners,* San Francisco
• *Client:* California Fluid Milk Processor Advisory Board

1990/ Tibor Kalman becomes editor-in-chief of a Benetton magazine, *Colors*

1990/ Fabien Baron redesigns *Interview* magazine

1991/ Paula Scher joins Pentagram, New York

1991/ Carlos Segura founds Segura Inc. in Chicago

1993/ David Carson designs *Ray Gun* magazine

1993/ Sagmeister Inc. founded by Stefan Sagmeister in New York

1994/ "Got Milk?" ad campaign by Goodby, Silverstein & Partners, San Francisco, for the California Fluid Milk Processor Advisory Board

1995/ Razorfish web design studio is founded

1996/ "Mixing Messages: Graphic Design in Contemporary Culture" at the Cooper-Hewitt National Design Museum

1996/ Takashi Murakami founds the Hiropan factory in Tokyo, which evolves into Kaikai Kiki Co., a large-scale art production and management corporation

1997/ Saki Mafundikwa opens the Zimbabwe Institute of Vigital Arts (ZIVA)

1997/ Hayao Miyazaki writes and directs *Princess Mononoke*

1998/ *PC Magazine* reports Google™ as the search engine of choice

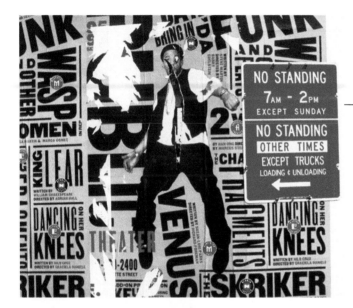

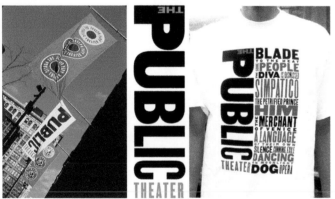

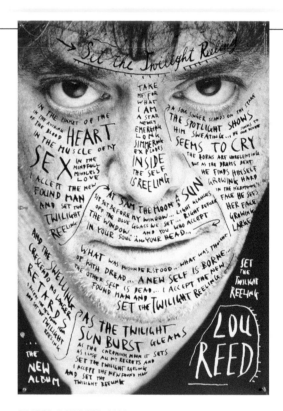

VISUAL IDENTITY: PUBLIC THEATER, 1994–1996

- *Pentagram, New York*
- *Designer:* Paula Scher

Starting out by designing album covers at CBS records, Scher moved onward and upward to become a highly esteemed designer and partner at Pentagram, whose work is revered and often imitated. In her book, *Make It Bigger*, Scher describes her brilliant career and talks about working with clients and her design philosophy. The energy of the city is reflected in the graphics for the theater.

POSTER: LOU REED, 1996

- *Sagmeister Inc., New York*
- *Art Director/Designer:* Stefan Sagmeister
- *Photography:* Timothy Greenfield Sanders
- *Client:* Warner Bros. Records, Inc.

"I went to a show in Soho given by Middle Eastern artist Shirin Neshat. She used Arabic type written on her hands and feet. It was very personal. When I came back, I read Lou's lyrics for 'Trade In,' a very special song about his need to change."

—Stefan Sagmeister

Technology and new platforms continue to reshape graphic design and advertising. From print to desktop web to mobile web to animated books and magazines on tablets to social media, design does matter. Whether it is to disseminate information to the public, create useful or amusing apps, design better election ballots or posters to "Get Out the Vote," create public service campaigns to raise awareness, aid education, or create entertaining commercial messages and websites that we share, creative professionals constantly shape our visual culture, entertain us, and inform us. The pages of this book are filled with outstanding examples of contemporary graphic design and advertising.

2000–Present

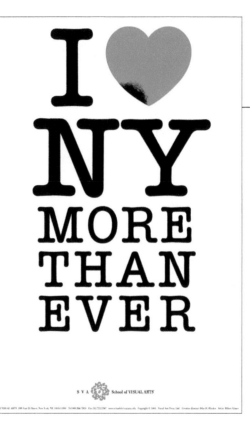

POSTER: I LOVE NY MORE THAN EVER, 2001

- *Credit:* Milton Glaser
- *Client:* School of Visual Arts (SVA)

This poster is a poignant post-9/11 commentary with Glaser altering his own logo design for New York State.

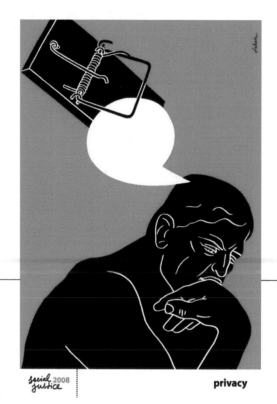

POSTER: PRIVACY FROM THE SOCIAL JUSTICE SERIES 2008

- *Poster Portfolio Series*
- *Luba Lukova Studio, New York*
- *Designer/Illustrator:* Luba Lukova

Lukova's distinctive style and design concepts are thought provoking.

THE L!BRARY INITIATIVE MURAL, 2010

- *Alfalfa Studio, New York*
- *Architect:* Richard H. Lewis
- *Art Director/Designer:* Rafael Esquer
- *Design Assistants:* Jessica Covi, Daeil Kim, Wes Kull, Nikhil Mitter, Minal Nairi
- *Children's Workshop Assistants:* Laura Anderson Barbata, Nikhil Mitter, Jenny Tran
- *Commissioned by Michael Bierut, Pentagram*

"The L!brary Initiative enlisted leading designers, architects, illustrators, and photographers to transform every school library within New York City's public school system into inspiring places for learning. Esquer was invited to design a seven-foot-high multipanel mural along three-quarters of the library interior at Public School 195–197 in the Bronx.

"Esquer's twin goals for his mural were to represent the library as a sanctuary for language and the entire world of ideas and to give the students a sense of library ownership. To meet both goals, Esquer gathered thirty students from Grades 1 through 6 for a workshop to generate content for the mural. Armed with reams of paper, poster paint, and artist's brushes, he asked students to have fun painting answers to dozens of questions about words. For example, the questionnaire asked, 'Imagine you could eat words. Which one would taste really good?' Esquer collected nearly 1,000 painted words and incorporated them prominently into his child's universe mural. Superimposed on silhouettes arranged in thematic groups, the children's words give voice and attitude to this visual universe, bouncing playfully from home life to nature, from foods to media and books, and from animals to people and professions."

—Alfalfa Studio

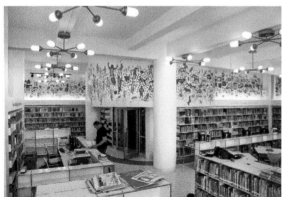

1 INTRODUCTION: THE GRAPHIC DESIGN PROFESSION

We don't have to go to a museum or gallery to see graphic design—it surrounds us. Everything from a website to a poster to a mobile advertisement is visual communication—ideas, messages, and information conveyed through visual form aimed at a mass audience. Graphic design and advertising are both communication design disciplines and are integral parts of contemporary popular visual culture.

Since communication design plays a key role in the appearance of almost all print, film, and screen-based media, graphic designers and advertising art directors are the primary makers of the visual artifacts of our environment and popular culture. Imagine a world with no provocative posters. Imagine cities without wayfinding or signage systems. And imagine the chaos of a newspaper or website that wasn't designed by a professional graphic designer. That would be a world without graphic design.

WHAT IS GRAPHIC DESIGN?

Graphic design is a form of visual communication used to convey a message or information to an audience. It is a visual representation of an idea relying on the creation, selection, and organization of visual elements. "Design is the intermediary between information and understanding," explains Richard Grefé, executive director, AIGA (http://www.aiga.org).

OBJECTIVES

01 DEFINE GRAPHIC DESIGN

02 BECOME FAMILIAR WITH THE MAJOR GRAPHIC DESIGN DISCIPLINES

03 LEARN ABOUT WORKING IN THE FIELDS OF GRAPHIC DESIGN AND ADVERTISING

04 BE INTRODUCED TO ETHICS IN GRAPHIC DESIGN

A graphic design solution can persuade, inform, identify, motivate, enhance, organize, brand, rouse, locate, engage, and carry or convey many levels of meaning. A design solution can be so effective that it influences behavior: You may choose a particular brand because you are attracted to the design of its package, or you may donate blood after viewing a public service advertisement. "Graphic design is the language that creates belief in an object, idea, message," states Brockett Horne, professor and co-chair, Maryland Institute College of Art, Baltimore.

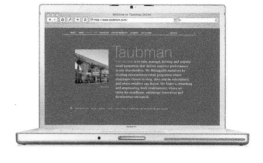

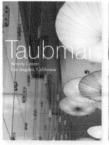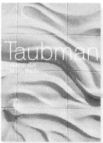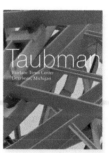

Fig. **1-1** /// BRANDING: TAUBMAN

CARBONE SMOLAN AGENCY, NEW YORK

- *Creative Director:* Ken Carbone
- *Designers:* Anna Crider, Channing Ross, Amy Wang
- *Project Manager:* Rachel Crawford

"Taubman, one of the nation's top retail mall developers with a growing international presence, looked to Carbone Smolan Agency to update its 50-year-old logo and identity. Appealing to Taubman's fashion-forward clientele, CSA's new designs include a refined logotype, fresh color palette and bold approach to imagery."

—*CSA Carbone Smolan Agency*

GRAPHIC DESIGN DISCIPLINES

Designers solve a wide range of visual communication problems working with a variety of clients—from a nonprofit organization attempting to reach families in need, to a brand promoting a new product, to a corporation that wants to go green, to a revitalized city's transportation secretary who needs a wayfinding system. Graphic design is categorized into disciples and formats. Some formats, such as posters and websites, cross disciplines.

The broad categories of disciplines are:

Branding and **identity design** involve the creation of a systematic visual and verbal program intended to establish a consistent visual appearance and personality—a coordinated overarching identity—for a brand or group (group refers to both commercial entities and nonprofit organizations). Identity design formats include logos, business card, letterhead, visual identity program, signage, environmental design, package design, websites, mobile web, as well as other formats across media. Some other primary *branding* projects include brand naming, brand conception, brand strategy, brand revitalization (see Figure 1-1), rebranding, brand launch, digital branding, global branding, and political branding.

Corporate communication design involves any communication design formats used to communicate *internally* with employees, create materials for a sales force or other employees, as well as formats used by a corporation or organization to communicate *externally* with the public, other businesses, and

stockholders. Emphasis is on maintaining a consistent corporate voice throughout any and all applications. Corporate communication formats include annual reports, brochures, sales kits, marketing collateral, corporate publications, business-to-business materials and applications, corporate websites and intranet, and new product offerings materials.

Editorial design involves the design of editorial content for print or screen; it is also called *publication design*. The editorial designer makes content accessible, interprets content to improve communication, enhances the reader's experience, creates visual interest, and establishes a voice, character, and structure for a publication. Editorial design formats across media include book design, magazine design, newspaper design, newsletters, and booklets; on screen, in addition they include vlogs, mologs, and blogs.

Fig. **1-2** /// T-MOBILE NBA ALL-STAR WEEK EXHIBIT

HORNALL ANDERSON, SEATTLE

- *Art Directors:* James Tee, Mark Popich
- *Designers:* Thad Donat, Andrew Well, Jon Graeff, Ethan Keller, Javas Lehn, Kalani Gregoire, Brenna Pierce
- *Producers:* Rachel Lancaster, Peg Johnson, Judy Dixon, Chris Nielson, Ryan Hickner, Jordan Lee
- *Client:* T-Mobile

Environmental design can be promotion, information, or identity design in constructed or natural environments and defining and marking interior and exterior commercial, educational, cultural, residential, and natural environments. For Figure 1-2, Hornall Anderson comments:

"As the Official Wireless Telecommunications partner of the NBA, T-Mobile approached us to help them create a splash at the All-Star weekend and launch their latest T-Mobile Sidekick, a Dwyane Wade Limited Edition—on which we consulted with him.

"The overall focus of the weekend was to position T-Mobile in the hearts and minds of the NBA fans as their preferred mobile communications provider. In support of this strategy, we designed opportunities for fans to connect with the spirit of the game on multiple levels.

"At Jam Session, the focus of the fan experience, was a total Sidekick brand immersion. Based on the concept of stepping inside the mind of Dwyane Wade, our booth gave fans an interactive three-dimensional experience, allowing a peek inside his world, both on and off the court. Elements of the Limited Edition Sidekick design, such as crisp white and tan leather, transformed the space into a representation of Wade's personal style."

Experimental and/or *self-initiated design* covers a range of projects from designers's self-initiated projects to collaborations with dancers, fine artists, musicians, and writers. For example, "Orphan One," in Figure 1-3, "is an ongoing side project for Tangent. Typically we set each other a design brief on a common theme, and aim to develop new techniques and consider unusual materials in our solutions. The goal is to explore new territory as designers, developing experimental visual styles and ways of working that reach beyond traditional methods."

Illustration is a handmade unique image that accompanies or complements printed, digital, or spoken text. It clarifies, enhances, illuminates, or demonstrates the message of the text. Professional illustrators work in a variety of media and most often have uniquely identifiable styles. The AIGA notes, "Each illustrator brings a different perspective, vision and idea to play that, when married with great design, becomes an original art form." Some graphic designers are also illustrators.

Information design is a "highly specialized area of design that involves making large amounts of complex information clear and accessible to audiences of one to several hundred thousand" (definition by the AIGA). Whether it is an exhibition, chart, website, pictogram, subway map, instruction booklet, or a poster illustrating the Heimlich maneuver, the graphic designer's task is to clearly communicate, make information easily accessible, and clarify and enrich any type of information (from data to listings) for the user's understanding. Information design includes form design (Figure 1-4), charts, graphs, pictograms, symbol signs, icons, sign systems, widgets, and informational or instructional digital and print formats such as websites, apps, brochures, and posters.

Fig. **1-3** /// ORPHAN ONE: A SELF-INITIATED PROJECT BY TANGENT GRAPHIC

WWW.TANGENTGRAPHIC.CO.UK

"The approach we take to Orphan One projects can often later inform our client work."

—*Tangent Graphic*

Fig. **1-4** /// NEW YORK STATE VOTER REGISTRATION FORM

OXIDE DESIGN CO., OMAHA, NE

- **Designers:** Drew Davies, Joe Sparano, Adam Torpin

"There's nothing aesthetic or gimmicky about form design—it's exclusively centered around creating the easiest experience for the user. For the design of this form, we threw out the previous layout and started over with a clean slate. Our process involved determining how a user goes about completing the form, and then facilitating that activity. The primary objective is to maximize the number of users that fill out the form completely and accurately, without confusion or trepidation."

—*Oxide Design Co.*

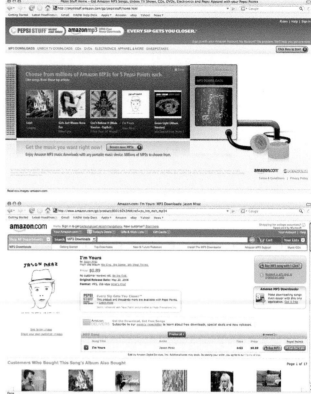

Fig. **1-5** /// **AMAZON PEPSI WEBSITE**

HORNALL ANDERSON, SEATTLE

- *Designer:* Hans Krebs
- *Developers:* Trevor Hartman, Adrien Lo, Matt Frickelton
- *Producers:* Erica Goldsmith, Halli Thiel

"What happens when two global heavyweights team up in a joint promotion of their products? Hornall Anderson discovered this firsthand when we were engaged in a collaborative cobranding project with Amazon, the world's largest online consumer retail destination, and PepsiCo, the world's number-two carbonated soft-drink maker, to develop a website supporting their cobranded Pepsi Stuff campaign. In addition to this being an interesting fifty-fifty branding challenge, the project also required a high level of integration with Amazon's development team and delivery of the site in a short time frame.

"We created a website that offers visitors a multi-dimensional, sensory experience and captivates users without inundating them with information. The experience gives consumers a clear, simple way to shop for digital and physical goods. Branded cues direct user behavior that is supported by key messages and succinct content, which allows for a truly immersive experience relying heavily on key visual elements to communicate the brand and inventive navigation for keeping the user engaged at every level. Amazon was able to integrate our work seamlessly into their online infrastructure, and the ensuing design was welcomed by both sides. The program has had several thousand participants, with the sales metrics exceeding all expectations."

—*Hornall Anderson*

Interactive or **experience design** is graphic design and advertising for screen-based media, including web, mobile, tablet, kiosks, digital public screens, or DVDs, in which the user interacts with the design. Whether for commerce (Figure 1-5), education, government, nonprofit, or any kind of website or platform or app, interactive media are primary experiences for today's person who consumes much of his or her time on screen. Interactive design formats include websites, platforms, widgets, social media, video and image sharing media, installations, public screens, blogs, vlogs, games and other entertainment, and mobile apps.

Motion graphics is screen-based communication design moving (sequentially) in duration, including film title design, TV graphics design, feature film and video openers, feature film end titling (Figure 1-6), e-mail videos, mobile motion graphics, motion for video-sharing platforms, and promotional motion presentations for any screen.

Package design involves the complete strategic planning and design of the form, structure, and appearance of a product's package, which functions as casing, promotes a brand, presents information, and becomes a brand experience. Package design includes structural packaging, packaging and visual identity systems, packaging graphics, new brand development, and self-promotion. Formats range from consumer packaged goods (Figure 1-7) to audio packaging to shopping bags and more.

Fig. **1-6** /// **PARAISO TRAVEL**

HUSH, NEW YORK

- *Animation Director:* HUSH
- *Creative Directors:* Manny Bernardez, Erik Karasyk, David Schwarz
- *Postproduction Supervisor:* J. M. Logan
- *Designers:* Manny Bernardez, Erik Karasyk, David Schwarz
- *Animators:* Emmett Dzeiza, Erik Karasyk, David Schwarz, Manny Bernardez
- *Photography:* Emmett Dzeiza
- *Photo Retoucher:* Robbie Johnstone
- *Production Company:* Paraiso Pictures
- *Director:* Simon Brand
- *Executive Producers:* Jonathan Sanger, Ed Elbert, Sarah Black, Jorge Perez, Santiago Diaz, Alex Pereira, Juan Rendon, Isaac Lee

"For the feature film *Paraiso Travel*, HUSH worked intimately with Colombian director, Simon Brand, to create memorable end titling that keeps viewers entertained and in their seats until the last credit rolls. At the film's thematic core is love, travel, exploration, heartache and the distorted realities of the 'American Dream' for many newcomers looking to make their way in New York City. HUSH's concept revolves around several main characters and their distinct personalities at the most critical moments in the film. The highly stylized animated collages seamlessly transition one character to the next. Each character's representational journey parallels that of the film—both physically and emotionally."

—*HUSH*

Fig. **1-7** /// **COOKIE TREAT PACKAGING FOR OLIVE GREEN DOG**

MODERN DOG DESIGN CO., SEATTLE

- © *Modern Dog Design Co.*
- *Client:* Olive™

"Modern Dog has worked on everything from website design to direct mail to packaging for Austin based Olive™, makers of 'Green Goods for Modern Dogs.' These are organic, handmade, all natural Cookie Treats (no wheat, corn or soy—no artificial colors, no artificial flavors and no preservatives of any kind). We named the products, did all the copy writing and of course designed them as well. Scrummy for your best friend's Tummy."

—*Modern Dog Design Co.*

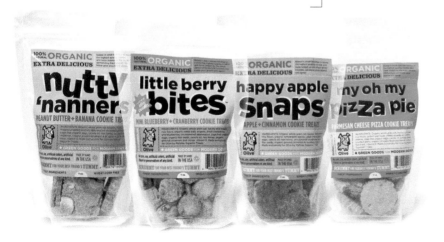

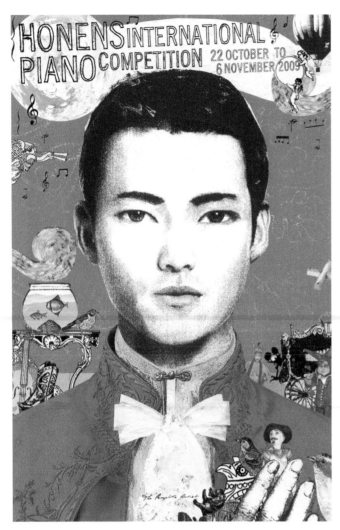
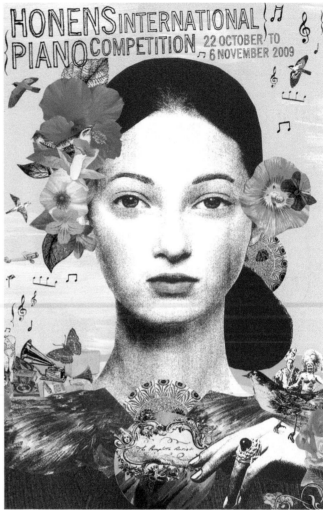

Fig. **1-8** /// **HONENS POSTERS**

WAX, CALGARY, ALBERTA

- *Client:* Honens International Piano Competition
- *Creative Director/Designer:* Monique Gamache
- *Writer:* Trent Burton
- *Illustrator:* Tara Hardy

"Honens is Canada's leading presenter of music for piano. The main communication challenge was to raise the awareness of the triennial Honens International Piano Competition—one of the world's great music competitions. The Competition is subtitled 'The Search for the Complete Artist.'"

—*Jonathan Herman, Art Director/Designer, WAX*

Promotional design and **advertising** involve generating and creating specific visual and verbal messages constructed to inform, persuade, promote, provoke, or motivate people on behalf of a brand or group. Promotional design and advertising encompass a very wide range of formats across media. A project might be a single book cover or poster, or it may be a book cover or poster series (Figure 1-8), an integrated media campaign, including television commercials, outdoor advertising, unconventional formats, mobile media, social media, e-mail, direct mail, videos, websites, apps, platforms, and more.

Fig. **1-9** /// TYPOGRAPHY:
MIKE PERRY

• *Client:* Urban Outfitters

Typographic design is a highly specialized area of graphic design focusing on the creation and design of letterforms, typefaces, and type treatments (Figure 1-9). Some type designers own digital type foundries, which are firms that design, license, publish, and dispense fonts. Other typographers specialize in handmade type and typefaces. **Lettering** is the drawing of letterforms by hand (as opposed to type generated on a computer). Typographic design includes custom and proprietary font design for digital type foundries, hand lettering, handmade type, and custom typography.

MEDIA

We see graphic design across media—print (printed matter in the form of books, magazines, newspapers, brochures, booklets, posters, covers, corporate communication, signage, outdoor billboards, business cards, etc.), screen-based (desktop web, mobile web, social media, tablet, public screens, installations, motion, etc.), and environments (commercial, educational, government, museums, public spaces, etc.). You can read a magazine in the conventional print format or online. You can hold a printed business card in hand or view it as an e-mail attachment. You see advertising as television commercials, commercial trailers run in movie theaters, mobile ads, print advertisements in magazines and newspapers, unconventional formats such as chalk writing on a sidewalk, and motion-activated graphics projected on pavement. There are online ads in the form of websites, marketing that goes viral, web films and videos, banners, social media, and webisodes.

WORKING IN THE FIELDS OF GRAPHIC DESIGN AND ADVERTISING

The main places of employment for a communication design professional are design studios, branding firms, publishers, digital/interactive agencies, advertising agencies, integrated communication firms, marketing companies, and companies, corporations, institutions, governments, schools, and organizations with in-house design departments.

Many experienced designers are self-employed. For a novice, it is advisable to work for someone else to gain design experience and learn all the aspects of running a small business—for example, working with printers and other vendors, billing, and recruiting clients—before going out on one's own. It is highly beneficial to secure an internship or part-time employment in the design field while still in school. Attend the meetings of local art directors's clubs and professional design organizations, such as the AIGA (American Institute of Graphic Arts) and art directors clubs around the world. Read design blogs, such as the AIGA "Design Envy" designed by Winfield & Co. (see Case Study: Website: AGIA Design Envy on page 14 of this chapter). Find a professional design organization or chapter of a national organization in your community. The purpose of these organizations is to advance design as a profession, educate, help set professional standards, set agendas, and promote excellence. Attend as many professional conferences and lectures as possible.

You may begin to notice that you enjoy some areas of graphic design more than other areas. Which work attracts your interest? Which designers do you admire? Noticing which you like may help you decide on the direction of your design career.

COLLABORATION

Whether the client is a local business owner, a large corporation, or a nonprofit organization, the graphic designer's role is to provide solutions to communication design problems. From developing strategy through design implementation, graphic designers often work in partnership with others. More than ever before, graphic design is collaborative. From working closely with their clients to collaborating with web developers, graphic designers team up with a variety of other experts, such as creative directors, design directors, associate creative directors, production experts, photographers, illustrators, copywriters, art directors, interactive designers, motion experts, and type and hand-lettering specialists. They also work with architects, film directors, producers, casting directors, actors, musicians, models, music houses, tech professionals, psychologists, social anthropologists, market researchers, and printers and their sales representatives. When working on television commercials, advertising art directors and creative directors collaborate with directors, location scouts, and postproduction experts. They may also be involved in casting talent (actors, models, spokespeople, celebrities) and suggesting locations as well as selecting music. When working on products, exhibition design, interior graphics, or branded environments, graphic designers might collaborate with industrial designers, engineers, architects (as in Figure 1-10), or interior designers.

Collaboration might begin at the outset when different firms work together to solve a communication design problem. For example, from the start of a large project, a branding firm and an advertising agency might work together. Or a design studio might collaborate with an interactive studio. At other times, the lead design studio or agency may hire freelancers. When a design concept is selected, graphic designers and art directors might select and hire illustrators and photographers.

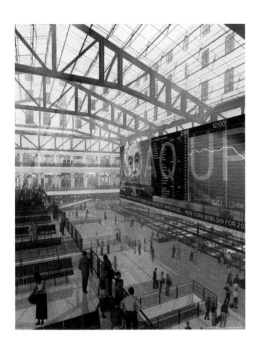

Fig. **1-10** /// MEDIA WALL FOR RENOVATION OF PENN STATION, NEW YORK

PENTAGRAM, NEW YORK

"Part of a comprehensive interior graphics program, this 200-foot-long prototype media wall will inhabit the main concourse at New York's busiest train station. The architectural redevelopment was led by project architects at Skidmore Owings Merrill LLP."

—*Pentagram*

WHY DESIGN MATTERS

As designer Paula Scher wisely said, "Design matters."

Most people know that graphic designers create solutions for brands and corporations. Communication design helps drive the economy, provide information to the public, and promote competition (which can result in the research and development of goods and services). There is another side of graphic design that is less well known but vital to society: designers use their expertise to inform people about important social and political issues and promote good causes. For example, Gilda's Club is a special place where the focus is on living with cancer. But to keep itself financially healthy, the not-for-profit Gilda's Club must consistently reach out to its many benefactors for funding and tell its story to the community at large. Brainforest designed "The Thread That Joins a Community," inspired by a hallmark of Gilda's Club—the Living Quilt (Figure 1-11). "These stories of various individuals touched by cancer were sewn together graphically with humanity and a life-affirming voice," comments Brainforest.

Fig. **1-11** /// GILDA'S CLUB CHICAGO ANNUAL REPORT

BRAINFOREST, INC., CHICAGO

- *Art Director:* Nils Bunde
- *Designers:* Drew Larson, Jonathan Amen
- *Copywriters:* Marion Morgan, Christa Velbel
- *Photographers:* Karl Schlei, Mark Joseph
- *Client:* Gilda's Club, Chicago

ETHICS IN GRAPHIC DESIGN

Each designer is responsible for practicing in ethical ways. Any design problem can be solved in a great number of ways, and each solution has different economic and social benefits and consequences.

Graphic designers respond to social need with projects. Many in the global design community are actively voicing the need for entirely ethical practice and for limiting consumer work. The First Things First manifesto (originally written in 1964 and updated in 2000) is a call for designers to use problem-solving skills in pursuit of projects that would improve society. There are urgent concerns worldwide that would greatly benefit from the expert skills of designers, what the twenty-two original undersigned members of the manifesto would consider "cultural interventions." These include educational tools, health tools, information design, public service advertising campaigns—any design project that moves away from consumerism and toward a socially useful benefit.

Advertising matters, too. It drives the economy in a free market system and provides information and choices to the public. Ethical advertising is critical to competitive enterprise and to bringing better products and services to people. Globally, public service advertising campaigns have helped an enormous number of people. The Ad Council has endeavored to improve the lives of Americans since first creating the category of public service advertising in 1942. In 1983, the Ad Council launched one of its most successful campaigns, featuring the tagline "Friends Don't Let Friends Drive Drunk." The campaign has evolved and continues to motivate Americans to intervene to stop a friend from driving drunk.

"A recent poll revealed that 68 percent of Americans have acted to stop someone from driving drunk after being exposed to the advertising. I think that shows the impact of the strategy and the creative ability to motivate change in attitudes and behavior," says Peggy Conlon, Ad Council CEO, about this campaign.[1]

Though the Friends Don't Let Friends Drive Drunk campaign was very successful, "it did not change the behavior of many potential impaired drivers. Many thought the messages to be targeted at overtly drunk drivers, and not them. When decision time came, they would consider themselves merely 'buzzed' and get behind the wheel," according to the Ad Council (adcouncil.org). New PSAs were created to address this and to motivate people to stop driving buzzed (Figure 1–12).

In the early days of advertising, there were no government regulations or watchdog groups. Concerned citizens united and government agencies formed to protect consumers from unethical manufacturers and fraudulent advertising claims. With or without watchdog groups or government regulations, every creative professional must assume responsibility for ethical practice.

Communication design professionals are among the leading architects of mass communication and its artifacts, creating images that reflect, help delineate, and describe contemporary society. With that function comes responsibility. Professional organizations such as the AIGA are very helpful in creating a foundation for ethical practices. For more information, visit http://www.aiga.org.

1. Peggy Conlon, online interview in *Advertising by Design*, 2nd ed., Robin Landa (Hoboken, NJ: Wiley, 2011).

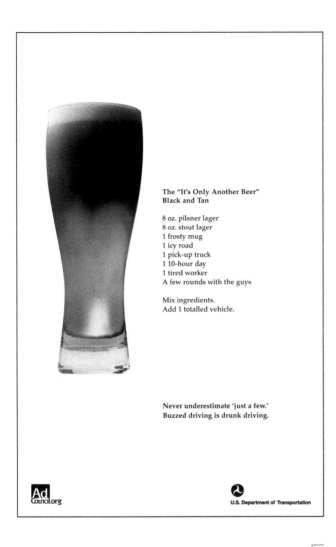

The "It's Only Another Beer"
Black and Tan

8 oz. pilsner lager
8 oz. stout lager
1 frosty mug
1 icy road
1 pick-up truck
1 10-hour day
1 tired worker
A few rounds with the guys

Mix ingredients.
Add 1 totalled vehicle.

Never underestimate 'just a few.'
Buzzed driving is drunk driving.

Ad
Council.org

U.S. Department of Transportation

Fig. **1-12** /// **"BUZZED DRIVING IS DRUNK DRIVING"**

- *Sponsor Organization:* U.S. Department of Transportation/National Highway Traffic Safety Administration
- *Campaign Website:* http://www.stopimpaireddriving.org
- *Volunteer Agency:* Mullen
- *Courtesy of The Ad Council* (http://www.adcouncil.org)

The overall campaign hopes to educate people that consuming even a few drinks can impair driving and that *Buzzed Driving is Drunk Driving.*

DEMANDS OF THE GRAPHIC DESIGN PROFESSION

The graphic design profession demands critical thinking, creative thinking, and creative and technical skills. A broad liberal arts education (anthropology, art and design history, dance, economics, fine art, history, literature, music, philosophy, psychology, sociology, and theater) would best equip a graphic designer to understand the context of design assignments and propose meaningful solutions, as well as to best understand the meaning of images. Both theory and skills are necessary for practice. One must have the ability to solve visual communication problems with a thorough knowledge of design principles, typography, visualization, composition, theories, and the ability to construct meaningful images.

For competencies expected from designers, see the AIGA survey entitled Designer of 2015 Competencies. Go to http://www.aiga.org/content.cfm/designer-of-2015-competencies, or use our link from GDSOnline.

A critical component to becoming more creative is developed through studying great design solutions, such as the ones in this book, so that you can discern the difference between the formulaic and the creative.

Every day, graphic designers have the opportunity to be creative. How many professions can boast about that?

Case Study

Website: AIGA Design Envy Winfield & Co.

The AIGA asked Winfield & Co. to help envision a website that would be a source of inspiration for aspiring and established designers alike.

Dubbed 'Design Envy,' this site would be a daily blog featuring the best in design as chosen by a new curator each week. AIGA, the professional association for design, would select the curator, who would then be encouraged to discover and share envy-inducing examples of design.

Ultimately, the goal of Design Envy is to inspire and inform in equal measures—through strong use of imagery, compelling descriptions about why selections were made, and attributions given to the creative minds behind the work.

It has been the diversity of curators, with their rich variety in submissions, that has made Design Envy a success. Curators, including illustrator and letterer Jessica Hische to up-and-comer designer and AIGA Season 3 Command-X winner Jesse Reed, have provided thought-provoking and conversationally engaging posts. Additionally, viewers can participate in open dialogue within the post, and then rate the submission against four qualities, which include envy-level, concept, execution and social impact. Eventually the highest rated submissions will be included into the AIGA design archives.

Since this was a major outlet for the organization to showcase sources of inspiration, AIGA also commissioned a brief campaign to announce the new site through various web and print outlets. Since no one image could ever capture the diversity of the site, the campaign instead focused on the boldness of the typography, which was custom-designed exclusively for AIGA, to impress upon the viewer the site's impact. Seen in magazines such as *Print*, *HOW*, *Process*, through a postcard mailing, an e-blast, as well as through daily tweets and Facebook postings, the message was successfully delivered, and now the site gets nearly the same number of tweets as the official AIGA website.

At the request of AIGA, the site was built using WordPress, an open-source content management system. What distinguishes this site from many others is how curators post submissions. To prevent any type of any manipulation to the core CMS, a user-facing custom administration interface was designed to allow curators to submit their posts through a straightforward step-by-step interface. Using a secure login, curators would never see the actual management system powering the site, but would instead interface with this simplified submission mini-site. This system allows for a low-percentage of mistakes and questions, because the curator does not have to worry about formatting or styling. The system automatically takes care of the technical issues, and instead, the curator only needs to focus on the content.

—Winfield & Co.

WEBSITE: DESIGN ENVY
HTTP://WWW.DESIGNENVY.ORG/

- *Winfield & Co., New York*
- *http:*//www.winfieldco.com
- *Creative Director:* Vijay Mathews
- *Programmer:* Chris Auyeung
- *Designer:* Vijay Mathews
- *Client:* AIGA

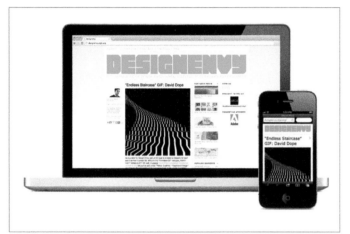

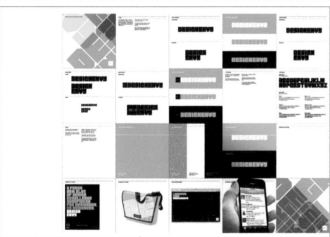

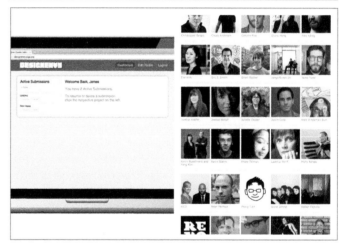

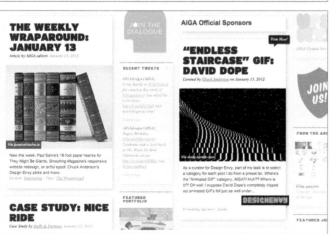

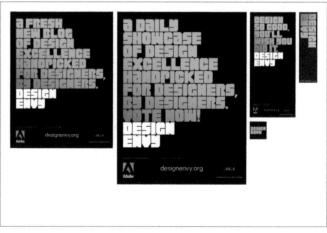

Showcase

Interview Laura Alejo

LAURA ALEJO

DESIGNER,
ILLUSTRATOR, AND
ARTIST, HTTP://WWW
.LAURAALEJO.COM

Laura Alejo is a Spanish graphic artist. During her career, she has developed several personal projects, including *Copyright Magazine*, which evolved into a design studio in Barcelona. At the company, Laura developed a wide range of projects working for MTV Italia, Paramount Comedy, Canal+, and others.

In March 2007, Laura moved to New York where she currently resides. She worked as art director of HUSH for four years where she developed projects for clients like Nike, Sony Ericsson, Nokia, and the Discovery Channel and where Laura led design and illustration projects across media and platforms.

Today, Laura works as a freelance graphic artist for clients all over the world.

Laura has exhibited her work in galleries in Brooklyn, New York, Barcelona, and Madrid, has been featured in multiple international publications, and has served as a panelist in various visual arts festivals around the world.

Q: If you were going to teach a speed workshop about designing for the mobile screen, what five things would you stress?

A: First, a design classic: functionality. As any design task, our number one goal is to communicate, so we have to consider the new constraints and rules for typefaces to use, sizes, color, etc.

Second, don't be confused by the medium. What are you trying to communicate? Don't forget what the message to communicate is and how you want it delivered. Design for a mobile screen has to have a well-defined structure, to be intuitive and easy to use. Plan the work you are doing and consider the different options you have.

Third, the user! On design for mobile, tablets, etc., interaction is the hero. A classic static design is not enough; we need to guide the user through a story that is not even linear. Here is the main difference with designing for print or motion—we can have multiple levels of information and interaction. So ask yourself, how does design help with hierarchy, color palettes, icons? Put yourself in the user's shoes to find the way.

Fourth, everything goes. The mobile screen is a perfect place to bring together different specialties: graphic design, illustration, photography, motion, video, music. . . . Have fun!

Fifth, teamwork. This is still a very young area in design and, as never before, is intimately attached to programming. Imagine the options; don't stop based on the limits that you have already seen; ask, collaborate, team up with developers. Be curious.

Q: *You collaborate with a creative team on many design projects. Who comprises your team and how does that creative process work?*

A: Any design project starts with a brief from the client. Designers usually don't have a direct relationship with the client, so you have a producer. The producer and the creative director meet with the clients to complete the briefing, ask questions, suggest ideas, talk about schedule and budget. Back in the studio, the creative director, the producer, and the art director have a creative meeting where they not only talk about options of how to attack the project but also who the talent is that needs to be involved, according to skill set and budget.

The team then is formed and exponentially, depending on how big the project is, has a creative/design team: designer/illustrator, storyboard artist, and a production team: 2D animator/compositor, 3D person, editor, and a sound designer. The designer starts with style boards to define the style of the piece and other elements involved: characters, type, backgrounds, etc. He or she works together with a storyboard artist to define the story over time, the different camera angles, transitions, etc. When the story is defined on boards over time, the 2D animator puts together an animatic, where some of the elements start to occupy their place over a timeline and there is some rough animation.

When this stage is approved, the production starts. Under the supervision of the art director, the designer generates all the graphic elements necessary for the animation. The 2D/3D animators and compositor build the piece together. After agreed revisions with the client, the edit is locked up with the music, and color correction can happen. The final piece is ready to deliver.

Q: *What tips can you offer about designing for motion?*

A: What I learned over time and I think is very important about motion is that the focus is the story. We are storytellers, and we have lots of techniques and resources to provoke a reaction from the spectator. So the designer has to learn cinematic tips, transitions, care about sound, and care about the script.

Also from a production standpoint, the designer needs to be realistic. Making clever design decisions will prevent craziness later on in the project. When making a design, we have to worry not only from a communication and stylistic point of view, but also how it is going to be animated, what are the resources that we have, and how we build our files. It is very important to be systematic, organized, and think

about economy in design. A designer is generating the first pieces in a puzzle constructed by a team of people, and it's super important to define design systems, libraries of assets, color palettes, etc., as all the elements are going to be shared.

Q: You design for print, screen, and 3D (package design). Please explain the ways you think differently about each.

A: The design process is pretty much the same. You have to communicate something for a certain public with certain restrictions or requests. The only aspects that I think about differently are the ones related to production. There are very different ways to tackle a design if it's going to the printer: decide on colors, paper, format, preparation . . . or if it's going to the screen: timeline factor, interactivity, team work with animators, programmers, etc. Or if it's a package: selling point, the market competition, materials, etc., etc.

Q: How did Spain define who you are as a designer? New York?

A: Spain influenced me a lot in the way I see things, combine colors, etc. Barcelona, where I grew up, is a very visually rich city, with incredible architecture and a long graphic tradition. The style of the city is very full and complex and combines a lot of elements and color. The modernism movement is present in every corner and defines a culture of "More Is More."

I can see how I follow that path, too.

After four years living and working in New York City, I can see influences, too, but still, the baggage I carried on with me is very strong.

Q: What advice would you offer someone just starting out in the business?

A: I realized that most of the people starting in the communication design business don't have a clear path to follow, and they can get frustrated in their first years trying to accomplish very defined goals. I would say don't worry that much about that. Enjoy the process and the everyday aspects of any project, work hard, look and ask, and try out different roles inside the profession.

Another very important note for new professionals is to always have a personal project to work on. Either by yourself or with a group, work on ideas, techniques that intrigue you. These projects will end up being your best calling card.

2 GRAPHIC DESIGN: THE BASICS

OBJECTIVES

01 EXAMINE THE FORMAL ELEMENTS OF GRAPHIC DESIGN

02 UNDERSTAND THE PRINCIPLES OF DESIGN

03 COMPREHEND VISUAL HIERARCHY

04 LEARN ABOUT SCALE

FORMAL ELEMENTS

Aspiring designers are people who enjoy the image-making process and, at a minimum, possess a casual knowledge of formal elements and principles—the vocabulary and tools for building visuals. The goal of this chapter is to explore, or perhaps review, the formal elements and basic design principles to know each element's potential and how it can best be utilized for communication and expression.

The formal elements of two-dimensional design are line, shape, color, and texture.

LINE

A **point** or dot is the smallest unit of a line and one that is usually recognized as circular. In a screen-based image, a point is a visible, single pixel of light (with or without hue) that is square rather than circular. In the digital realm of paint software, all elements are composed of pixels.

A **line** is an elongated point, considered the path of a moving point. A line is a mark made by a visualizing tool as it is drawn across a surface. A variety of tools can draw a line—a pencil, a pointed brush, a software tool, a stylus, or any object that can make a mark (a cotton swab dipped in ink, a twig dipped in coffee; see Diagram 2-1). A line is primarily recognized by length rather than width; it is longer than it is wide.

Line plays many roles in composition and communication. Pick up a pencil and draw a line. That line will have direction and quality. Lines can be straight, curving, or angular. They can guide the viewer's eyes in a direction. A line can have a specific quality. It can be delicate or bold, smooth or broken, thick or thin, regular or changing, and so on.

Various categories of line include:

→ Solid line: a mark as it is drawn across a surface

→ Implied line: a noncontinuous line that the viewer perceives as continuous

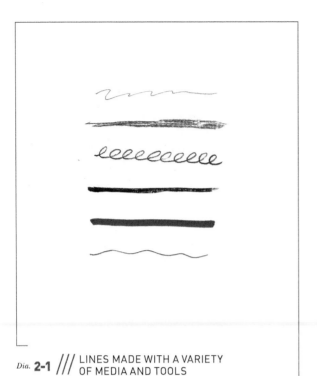

Dia. **2-1** /// LINES MADE WITH A VARIETY OF MEDIA AND TOOLS

- → Edges: the meeting point or boundary line between shapes and tones
- → Line of vision: the movement of one's eye as it scans a composition; also called a *line of movement* or a *directional line*

The basic functions of lines include:

- → Define shapes, edges, forms; create images, letters, and patterns
- → Delineate boundaries and define areas within a composition
- → Assist in visually organizing a composition
- → Assist in creating a line of vision
- → Can establish a linear mode of expression, a *linear style*

When line is the predominant element used to unify a composition or to describe shapes or forms in a design (or painting), the style is termed **linear.**

SHAPE

The general outline of something is a **shape.** A shape also is defined as a closed form or closed path. It is a configured or delineated area on a two-dimensional surface created either partially or entirely by lines (outlines, contours) *or* by color,

Fig. **2-1** /// **GRAPHIC IDENTITY**

HARP AND COMPANY, HANOVER, NH

- • *Designer:* Douglas G. Harp
- • *Client:* Coyote Loco Restaurant and Cantina

"The coyote is a worn-out cliché, it seems, for all things—food, clothing, etc.—to do with the Southwest. But its immediate association with this region is undeniable; our challenge, therefore, was to use this familiar icon, but to somehow give it a different spin. Here, the moon that the coyote is howling at is, in fact, a hot pepper."

—*Douglas G. Harp, President, Harp and Company*

tone, or texture. In Figure 2-1, the yellow pepper, coyote and his eye, stars, as well as the letterforms are all shapes defined by color.

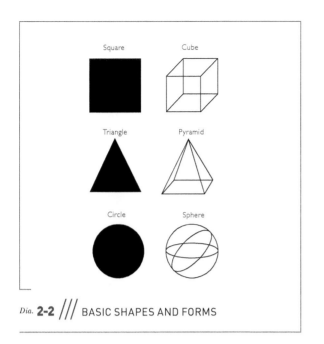

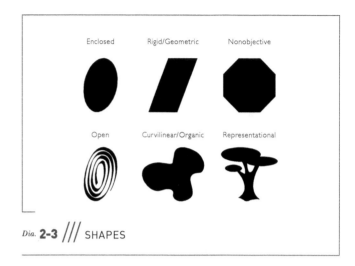

A shape is essentially flat, meaning it is two-dimensional and measurable by height and width. How a shape is drawn gives it a quality. All shapes may essentially be derived from three basic delineations: the square, the triangle, and the circle. Each of these basic shapes has a corresponding volumetric form or solid: the cube, the pyramid, and the sphere (Diagram 2-2).

→ A geometric shape is created with straight edges, measurable angles, or precise curves; it is also called rigid.

→ A curvilinear shape, organic, or biomorphic shape is formed by curves or dominating marked flowing edges, which seems to have a naturalistic feel. It may be drawn precisely or loosely.

→ A rectilinear shape is composed of straight lines or angles.

→ An irregular shape is a combination of straight and curved lines.

→ An accidental shape is the result of a material and/or specific process (a blot or rubbing) or accident (for example, a spill of ink on paper).

→ A **nonobjective** or **nonrepresentational shape** is purely invented and is not derived from anything visually perceived; it does not relate to any object in nature. It does not literally represent a person, place, or thing.

→ An abstract shape refers to a simple or complex rearrangement, alteration, or distortion of the representation of natural appearance used for stylistic distinction and/or communication purposes.

→ A representational shape is recognizable and reminds the viewer of actual objects seen in nature; it is also called a figurative shape (Diagram 2-3).

FIGURE/GROUND

Figure/ground, also called **positive and negative** space, is a basic principle of visual perception and refers to the relationship of shapes, of figure to ground, on a two-dimensional surface. To best understand what is depicted, the mind seeks to separate graphic elements that it perceives as the figures from the ground (or background) elements. In figure/ground relationships, the observer seeks visual cues to distinguish the shapes representing the figures from those that are the ground. The figure or positive shape is a definite shape, immediately discernible as a shape. The shapes or areas created between and among figures are known as the ground or negative shapes or white space. People are attracted to the figure— the image—in a composition. Therefore, to the untrained observer, the ground may appear unoccupied and without shape. However, *a designer must always consider the ground as an integral part of the composition.* Theoretically and even literally, the (back) ground actually takes shape—negative shapes. Considering all positive and negative shapes as active enables you to consider the *whole* space. Both figure (stack and smoke) and ground (blue) are given great consideration in the poster Stop the Plant (Figure 2-2).

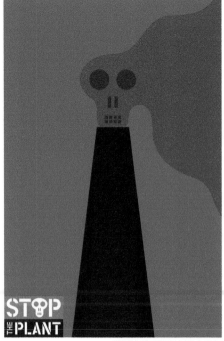

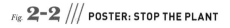

Fig. **2-2** /// POSTER: STOP THE PLANT

- *Art Director/Designer:* Woody Pirtle
- *Client:* Scenic Hudson

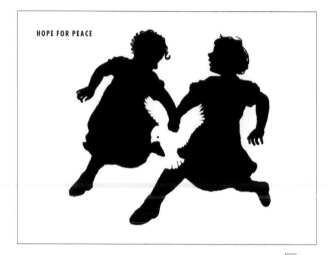

HOPE FOR PEACE

Fig. **2-3** /// POSTER: HOPE FOR PEACE

CALAGRAPHIC DESIGN, PHILADELPHIA, PA

- *Illustrator/Designer/Art Director:* Ronald J. Cala II

Dia. **2-4** /// EQUIVOCAL SPACE

Equivocal space is seen in the yin-yang symbol and in a "checkerboard" composition—the white and black shapes can be seen as either positive or negative shapes.

Figure/Ground Reversal

A traditional example of an equal and interchangeable distribution of figure and ground is the ancient Chinese symbol yin and yang, meaning two principles that oppose one another in their actions (Diagram 2-4). Another example is a simple checkerboard pattern (Diagram 2-4). When shapes are interchangeable, an **equivocal space** or ambiguous figure/ground relationship is created, and you have figure/ground reversal. In Figure 2-3, Ronald J. Cala II creates figure/ground reversal, where the central negative shape is identifiable as a dove.

TYPOGRAPHIC SHAPES

In graphic design, letterforms, numerals, and punctuation marks also are shapes—albeit highly specialized ones that symbolize the sounds of language. And like basic shapes, type can be rectilinear, curvilinear, geometric, or organic. Typographic shapes can be computer generated, as in Hope for Peace (Figure 2-3), or handmade shapes as in *Romeo and Juliet* (Figure 2-4). A letterform, numeral, or punctuation mark is the figure, and the counters or open spaces of type are the ground or negative spaces (see Chapter 3, Typography).

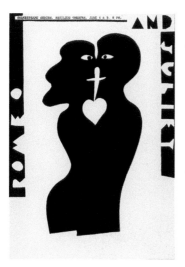

Fig. **2-4** /// POSTER: *ROMEO AND JULIET*

SOMMESE DESIGN, PORT MATILDA, PA

- *Art Director/Designer/Illustrator:* Lanny Sommese
- *Client:* Theatre at Penn State

"The Theatre at Penn State needed a poster for the play, quickly and cheaply. I cut image and headline type out with scissors (low-tech). The concept of the play lent itself to boy/girl with the negative areas between becoming heart and dagger. It also seemed appropriate. At the time, everyone seemed to be doing high-tech, computer-generated stuff. I decided to go low-tech. The simplicity of the image also made it very easy to silkscreen."

—Lanny Sommese

COLOR

Color is a powerful and highly provocative design element. It is a property or description of *light energy*. Only with light do we see color. The colors we see on the surfaces of objects in our environment are perceived and known as reflected light or **reflected color**. When light strikes an object, some of the light is absorbed, whereas the remaining or unabsorbed light is reflected. The reflected light is what we see as color. For instance, a tomato absorbs all but red light; therefore, the red is reflected light. For this reason, reflected color is also known as subtractive color.

Pigments are the natural chemical substances within an object that interact with light to determine the characteristic color that is perceived, as in the bright yellow of bananas, the reds of flowers, and the browns of furs. Naturally occurring or artificially made pigments are added to agents to color such things as paper, ink, and plastic. Naturally or commercially produced pigmented surfaces are seen as reflected light, but the colors on a computer screen are light energy—a wavelength—that we can refer to as *digital color*. For example, when selecting a pure blue color in Adobe Photoshop™ (defined as Blue 255, Red 0, Green 0), the color seen is actually a blue wavelength of light itself. The digital colors seen in screen-based media are also known as **additive colors**—mixtures of light. Mixing light—adding light waves together—creates a variety of colors.

COLOR NOMENCLATURE

We can discuss color more specifically if we divide the element of color into three categories: hue, value, and saturation. **Hue** is the name of a color—that is, red or green, blue or orange. **Value** refers to the level of luminosity—lightness or darkness—of a color—for instance, light blue or dark red. Shade, tone, and tint are different aspects of value. In graphic design projects that require blocks of text, the value of the mass of the type block, paragraph, or column takes on a tonal quality, creating a block of gray tone. **Saturation** is the brightness or dullness of a color—that is, bright red or dull red, bright blue or dull blue. Chroma and intensity are synonyms for saturation. A hue also can be perceived as warm or cool in **temperature**. The temperature refers to whether the color *looks* hot or cold. Color temperature cannot actually be felt. It is perceived. The warm colors are said to be reds, oranges, and yellows, and the cool colors are blues, greens, and violets.

PRIMARY COLORS

To further define color, it helps to understand the role of basic colors called primary colors. When working with light in screen-based media, the three primaries are red, green, and blue (RGB). These primaries are also called the additive primaries because when added together in equal amounts, red, green, and blue create white light (Diagram 2-5).

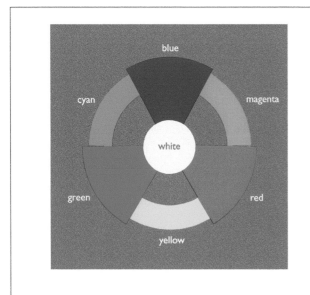

Dia. **2-5** /// ADDITIVE COLOR SYSTEM

The color system of white light is called the additive color system.

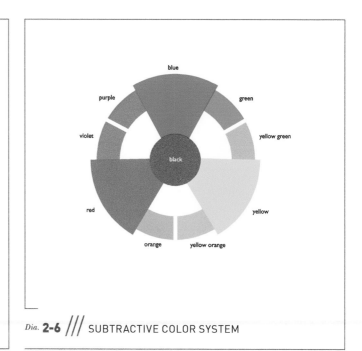

Dia. **2-6** /// SUBTRACTIVE COLOR SYSTEM

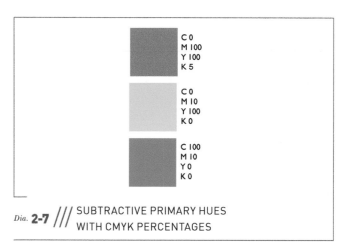

Dia. **2-7** /// SUBTRACTIVE PRIMARY HUES WITH CMYK PERCENTAGES

In offset printing, magenta, yellow, and cyan are the colors of the process inks used for process color reproduction. A fourth color, black, is added to increase contrast.

Using the RGB model,

→ red + green = yellow

→ red + blue = magenta

→ green + blue = cyan

When working with a computer's color palette, you can mix millions of colors. However, it is very difficult, if not impossible, for the human eye to distinguish the millions of tones and values created by the additive primaries on a computer. As mentioned earlier, subtractive color is seen as a reflection from a surface, such as ink on paper. We call this system the subtractive color system because a surface subtracts all light waves except those containing the color that the viewer sees (Diagram 2-6). In paint or pigment such as watercolors, oils, or colored pencils, the subtractive primary colors are red, yellow, and blue. They are called primary colors because they cannot be mixed from other colors, yet other colors can be mixed from them.

→ red + yellow = orange

→ yellow + blue = green

→ red + blue = violet

Orange, green, and violet are the secondary colors. You can mix these colors and get numerous variations.

As seen in Diagram 2-7, in offset printing, the subtractive primary colors are cyan (C), magenta (M), and yellow (Y), *plus black* (K), or CMYK. Most often, black is added to increase contrast. Using all four process colors—cyan, magenta, yellow, and black—to print is called four-color process, which is used to reproduce full-color photographs, art, and illustrations. The viewer perceives full color that is created by dot patterns of cyan, magenta, yellow, and/or black. There are books available that illustrate the various mixtures resulting from mixing two, three, or four process colors.

TECHNICAL CONSIDERATIONS

The dual responsibility of selecting and composing colors for a particular design solution and understanding the technical aspects of color is challenging. Metallic bronze ink may possibly be a good choice for a brochure for a gallery exhibition of bronze sculpture, but in regard to printing, a metallic ink cannot be reduced in saturation or value. It is more expensive than black ink and physically difficult to work with. Metallic ink doesn't always dry quickly (or dry at all on certain papers). Printers (printing company experts) are very helpful in educating designers about the pitfalls of color printing and the nature of ink on paper.

Having a knowledgeable and conscientious printing technician guide a designer through technical color production in print or in screen-based media is essential. However, the student and professional designer should also have a basic awareness of color print production, ink mixtures, and screen "safe" colors—and their problems.

Basic color knowledge should include awareness of the printing primaries of CMYK, the process of layering dots of ink to produce color, and the Pantone® color system of ink selection (Diagram 2-8). The Pantone system is a standardized color matching set of inks used in printing processes. Using a color matching system ensures that the color printed from the digital file is the color intended, though it may look different when viewed on a color monitor. It is always advisable to work closely with a printer to ensure color correctness. It's also advisable to investigate the different printing inks available. There are nontoxic, nonflammable, and nonpolluting inks.

Dia. **2-8** /// SWATCH: PANTONE® MATCHING SYSTEM

Pantone® match color can be specified by the designer for filling a color area using the PMS color number. The printer then matches the color by following the ink formula provided on the swatch. Also, C indicates coated paper and U indicates uncoated paper.

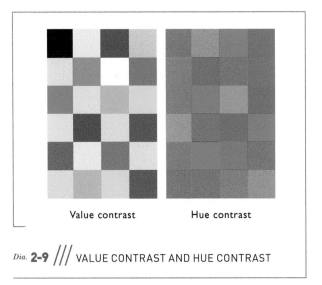

Value contrast Hue contrast

Dia. **2-9** /// VALUE CONTRAST AND HUE CONTRAST

Value contrast creates the greatest differentiation
between the figure and ground, as seen in the grid of
highly contrasting value on the left versus the grid of
similar hue values on the right.

Colors viewed on the web still may be unstable. Therefore, a
palette of the 256 "web-safe" colors has been standardized. The
web-safe colors are listed in Adobe Photoshop™ and Illustra-
tor™ and other web software color selection directories. Web-
safe colors are those that are somewhat consistent and most
reliable when viewed on computer monitors across platforms
(Windows or Apple) and across browser software (Explorer,
Firefox, Safari, Google Chrome, etc.). The browsers and plat-
forms do, however, still display these colors slightly differently.

The myriad of technical aspects regarding color is too expan-
sive to be discussed here. However, technical basics should be
part of a graphic design education. These basics can be found
in specialized courses such as preparing design for printing
(digital pre-press), desktop website and mobile web develop-
ment, as well as in other courses for screen-based media.

There have been many scientific studies of color, with modern
theories by Albert Henry Munsell, Johannes Itten, Josef Albers,
and Faber Birren. Understanding color symbolism relative to
culture, country, region, and demography is crucial. Much of
what you need to know about working with color will come
from experimentation, experience, asking printers questions,
getting color advice before going to print, and observation.
Visit a printer. Attend paper shows. Talk to printers, paper
sales representatives, and professional designers about color
and paper stock (recycled, tree-free), special techniques, the
ink/paper relationship, and varnishes.

VALUE

Value refers to the level of luminosity—lightness or darkness—
of a color, such as light blue or dark red. To adjust the value of
a hue, two neutral colors are employed: pure black and white.

Black and white are colors (pigment), but they are not consid-
ered hues. The two are not found on the visible spectrum and
therefore are considered *achromatic* or *neutral* (without hue).

Black and white have relative value and play an important role
in mixing color. Black is the darkest value and white is the
lightest. Mixed together, black and white make gray. Grays are
the interval neutral colors between black and white. Black and
white are separately mixed into paint and ink colors to make
them darker (shades) or lighter (tints). A black and white mix-
ture will also dilute the intensity of the hue, as noted in the
next section on saturation.

Even if black and white seem to be pure, some level of hue
may still be discernible. A neutral black or white can appear
"warm" (containing red, orange, or yellow) or "cool" (contain-
ing blue or green). A neutral color also will react to and be
affected by its placement in a composition. Placed next to a
hue or among particular hues, the pure neutral color will seem
to take on the hue itself.

In composition, *value contrast* is most useful for purposes of dif-
ferentiating shapes. Note the value contrast of the black type
and white paper of the page of words you are now reading.
The value contrast most clearly differentiates the figure from
the ground. Hue contrasts alone have less impact and therefore
may not be as effective for differentiating between the figure
and ground images or between elements of a single composi-
tion, especially when the hues are close in value (Diagram 2-9).

AMNESTY INTERNATIONAL
CELEBRATES THE 50TH ANNIVERSARY OF THE UNIVERSAL DECLARATION OF HUMAN RIGHTS, 1948–1998

Fig. **2-5** /// **POSTER: UNIVERSAL DECLARATION OF HUMAN RIGHTS, 1948–1998, 50TH ANNIVERSARY**

- *Art Director/Designer:* Woody Pirtle
- *Client:* Amnesty International

COLOR AND GRAPHIC DESIGN

- Color can create a focal point (low saturation color amid a field of highly saturated colors, and vice versa).
- Color can be used symbolically.
- Color can have cultural and emotional associations.
- Color is not universal in its associations and symbolism.
- Color can be associated with a brand personality—for example, Coca-Cola™ red or Tiffany™ blue.
- Color juxtaposition can create the illusion of three-dimensional space.
- Certain colors can enhance or detract from the readability of type, both in print and on screen.
- Ramped color, or a gradation of color, can create the illusion of movement.
- A color should always be selected in relation to the other colors in the piece.
- There are established color schemes, such as monochromatic schemes, analogous colors, complementary colors, split complementary colors, triadic schemes, tetradic schemes, cool palettes, and warm palettes, among others.
- Color palettes can be associated with techniques, historical periods, and art and nature, such as batik colors, art deco, Victorian, retro palettes, ancient Chinese ceramic colors, and earth tones.
- Grays can be warm or cool.
- Context affects color.

Different value relationships produce different effects, both visual and emotional. When a narrow range of values, which is called **low contrast**, is used in a design, it evokes a different emotional response from the viewer than a design with a wide range of values, or **high contrast**. The high contrast—black image and type against a light sky—in the poster for Amnesty International easily captures one's attention (Figure 2-5). (Other types of contrast will be discussed in detail in Chapter 6, Visualization and Color, and Chapter 7, Composition.)

SATURATION

Saturation refers to the brightness or dullness of a color or hue. At its highest level of intensity, a hue is said to be purely saturated. A saturated color has reached its maximum chroma and does not contain a neutralizing color (pure black or white)

or the mixtures of the neutral colors (gray). Mixed with black, white, or especially gray, the fully saturated hue becomes dull in various degrees. The neutral colors dull the intensity or saturation because they dilute the hue. A color mixed with gray is called a *tone* or a reduction of the fully saturated hue.

Color saturation may be selected and adjusted for practical function within a composition. A saturated color will call attention to itself when placed alongside duller tones. A single saturated hue on a black-and-white page or computer screen will grab one's attention because it is most vivid. In a composition, a saturated hue has an advantage of being noticed first when surrounded by hues of lower saturation.

Dia. **2-10** /// TACTILE TEXTURES

Tactile textures can be found in the great variety of paper available for printed designs.

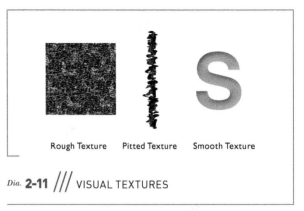

Rough Texture Pitted Texture Smooth Texture

Dia. **2-11** /// VISUAL TEXTURES

Textures are also characteristics of other elements: a square shape filled with a rough texture, a line with a pitted texture, and type with a smooth texture.

TEXTURE

The tactile quality of a surface or the simulation or representation of such a surface quality is a **texture**. In the visual arts, there are two categories of texture: tactile and visual. **Tactile textures** have actual tactile quality and can be physically touched and felt; they are also called **actual textures** (Diagram 2-10). There are several printing techniques that can produce tactile textures on a printed design, including embossing and debossing, stamping, engraving, and letterpress.

Visual textures are illusions of real textures created by hand, scanned from actual textures (such as lace), or photographed (Diagram 2-11). Using skills learned in drawing, painting, photography, and various other image-making media, a designer can create a great variety of textures.

PATTERN

Pattern is a consistent repetition of a single visual unit or element within a given area. In all cases, there must be systematic repetition with obvious directional movement. (An interesting aspect of pattern is that the viewer anticipates a sequence.) If you examine patterns, you will notice that their structures rely on the configuration of three basic building blocks: dots, lines, and grids. In a pattern, any individual small unit, whether a nonobjective (think organic) or representational (think leaf) shape, can be based on the dot. Any moving path is based on lines, also called stripes. Any two intersecting units yield a pattern grid.

If we refer back to the common checkerboard pattern, we see a figure/ground reversal created by an allover pattern; that balanced design is called crystallographic balance. Allover patterns can serve as graphic design solutions in and of themselves.

The patterns in Cedomir Kostovic's poster series are an integral part of the visual message (Figure 2-6). Kostovic explains, "The tag line Open Your Heart—Give Blood is supported visually by images based on combinations of different symbols, which are juxtaposed in unexpected ways. Background images are based on patterns inspired by the rich visual heritage of diverse ethnic groups unique to American culture."

Fig. **2-6** /// OPEN YOUR HEART—
GIVE BLOOD

CEDOMIR KOSTOVIC

- *Poster series designed to promote blood drive by The Community Blood Center of the Ozarks, Springfield, MO, Sappi Ideas That Matter recipient.*

"With project Open Your Heart—Give Blood my intentions were to raise awareness among high school and college students about blood donation."

—*Cedomir Kostovic*

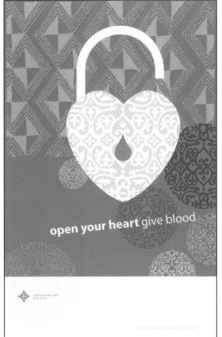
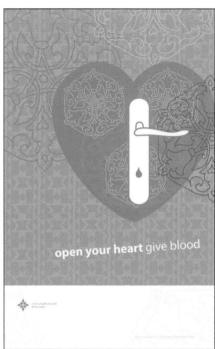

PRINCIPLES OF DESIGN

To compose, you utilize basic design principles. In combination with your knowledge of concept generation, typography, images and visualization, and the formal elements as the form-building vocabulary, you apply the principles of design to every design project.

The basic principles are absolutely interdependent. Balance is about stability and creating equilibrium. Balance helps stabilize a composition. Creating emphasis through organizing a visual hierarchy improves communication. Designing a whole composition in which graphic elements have a discernable visual relationship relies on the principle of unity. Rhythm is a visual pulse and flow from one graphic element to another.

Through practice, a working knowledge of each principle will become second nature—a conditioned consciousness—to you. As you begin, it is necessary to be mindful of the principles.

FORMAT

Before we examine the basic principles, let's understand the role of the format. Format is a term with several related meanings. The **format** is the defined perimeter as well as the field it encloses—the outer edges or boundaries of a design. Also, format refers to the field or substrate (piece of paper, mobile phone screen, outdoor billboard, etc.) for the graphic design project. In addition, designers often use the term *format* to describe the type of project—that is, a poster, a CD cover, a mobile ad, and so on. Graphic designers work with a variety of formats.

THE SHAPE OF A FORMAT

A CD cover is a square shape. A single page of a magazine is a rectangular shape, and a two-page magazine spread has a different rectangular ratio. A brochure can unfold into an extended landscape-shaped rectangle. There are a variety of brochures in different sizes and shapes, and each may open up differently (Diagram 2-12). There are different size mobile screens and computer screens. A tablet has a specific rectangular aspect ratio, screen image width–height ratio (Diagram 2-13).

There are standard sizes for some formats. CD covers, for example, are all the same size. Poster substrates are available in standard sizes; however, you can print a poster in almost any size, too. Sometimes, a format shape and medium are predetermined, and the designer must work within those constraints. In print, almost any size format is available to the designer at varying costs. Shape, paper, size, and special printing techniques can greatly affect cost. Paper is roughly half the cost of any printing job. Size is determined by the needs of the project, function and purpose, appropriateness for the solution, and cost.

SINGLE FORMATS VERSUS MULTIPLE-PAGE FORMATS

Posters, single-page advertisements, outdoor billboards, business cards, letterheads, book covers, any cover, and unanimated web banners and web ad units, among others, are single formats. The composition is confined to a still single page or unit. More often, designers must work with multiple-page formats, such as brochures, the interior design of books, magazines, newspapers, websites, reports, corporate communications, newsletters, catalogs, and more. Corporate, government, and institutional websites can have hundreds of pages. Yet, at any given moment, a website can be one still image (unlike motion graphics)—and look like one still rectangle—viewed on a screen. Any multiple-page format must be addressed as continuous, keeping unity, visual flow, and harmony in mind across the entire format.

4-PAGE　　**6-PAGE ACCORDION**　　**8-PAGE MAP FOLD**　　**16-PAGE BROADSIDE**

Dia. **2-12** /// FOLDING STYLES

No matter what shape or type of format, each component of the composition must respond to the format's boundaries. That page, where you make your first mark, not only has all that white space, but it has edges to which each mark and graphic element should respond. In one of the courses he taught at the Bauhaus (school of design), artist Wassily Kandinsky emphasized the basics of organization of a composition, the function of the center and the *edges*, and the progression from point to line to plane.

BALANCE

Balance is one of the principles that you may grasp more intuitively because you utilize it in your own physical movement. If you practice yoga, martial arts, gymnastics, dance, or sports, you understand that one action balances an opposite and equal action. **Balance** is stability or equilibrium created by an even distribution of visual weight on each side of a central axis as well as by an even distribution of weight among all the elements of the composition. When a design is balanced,

iPad (4:3) or 1.33

iPhone (3:2)

Widescreen display (16:9)

Dia. **2-13** /// ASPECT RATIOS

A large shape is heavier in comparison to a small shape

Black often weighs more than white

Patterns: textures or patterns have heavy visual weight compared to shapes without patterns

Dull tones are lightweight; bright tones are heavy

Cool/cold colors weigh less than warm/hot colors

Dia. **2-14** /// SIZE AND SHAPE OF AN ELEMENT

it tends toward harmony. A balanced composition affects the viewer—communicating stability. The average viewer is averse to imbalance in a composition and reacts negatively to instability. Balance is only one principle of composition and must work in conjunction with the other principles.

INTERRELATED VISUAL FACTORS OF BALANCE

Understanding balance involves the study of several interrelated visual factors: visual weight, position, and arrangement.

In two-dimensional design, weight is not defined as an actual or physical gravitational force but rather as a visual force or as **visual weight.** This visual weight refers to the relative amount of visual attraction, importance, or emphasis the element carries in a composition. Every element in a composition carries energy—an impression of force, strength, or weight.

The size, shape, value, color, and texture of a mark all contribute to an element's visual weight. Where you *position* the mark on the page also affects its visual weight. The same mark positioned at different points on a page—bottom right, bot-

tom left, center, top right, or top left—will appear to change in visual weight because of its position. In visual perception, different areas of the page seem to carry more or less visual weight. Recommended reading about this subject includes studies by gestalt theoreticians as well as books by Rudolf Arnheim, distinguished psychologist, philosopher, and critic, who wrote extensively about visual perception in relation to art and design. There are also many newer studies and experiments by psychologists and social scientists, among others. For strategies on balancing a composition, please see Chapter 7 on composition.

SYMMETRIC VERSUS ASYMMETRIC BALANCE

Symmetry is an equal distribution of visual weights, a mirroring of equivalent elements on either side of a central axis; it is also called reflection symmetry. Imagine a vertical axis dividing the symbol component of the French Leave logo in Figure 2-7 in half. You can see an equal distribution of weight on either side of the vertical axis. Approximate symmetry is very close to outright symmetry. Symmetry and approximate symmetry can communicate harmony and stability.

Asymmetry is an equal distribution of visual weights achieved through weight and counterweight by balancing one element with the weight of a counterpointing element *without mirroring* elements on either side of a central axis (Figure 2-8). To achieve asymmetrical balance, the position, visual weight, size, value, color, shape, and texture of a mark on the page must be considered and weighed against every other mark. Every element and its position contribute to the overall balancing effect in a composition.

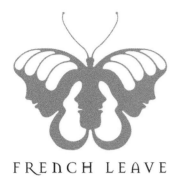

FRENCH LEAVE

Fig. **2-7** /// LOGO

SOMMESE DESIGN, PORT MATILDA, PA

• *Art Directors:* Kristin Sommese, Lanny Sommese
• *Designers:* Kristin Sommese, Lanny Sommese, Ryan Russell
• *Copywriter:* Eddie Lauth
• *Photographers:* Eddie Lauth, Dan Laningan
• *Digital Expert:* Ryan Russell
• *Client:* French Leave

"French Leave is an exclusive resort that is being developed on French Leave beach on the Island of Eleuthera in the Bahamas. The client asked us to create a design approach that was stylish, upbeat and clean, while at the same time capturing the island's calm, quiet grace and unspoiled natural beauty.

"Logo: We felt that the butterfly was the perfect metaphor for the unspoiled natural setting that is Eleuthera and it became the point of departure for our logo. Adding the silhouetted faces to the butterfly's wings was our way to visualize the relationship between French Leave Resort and its pristine surroundings. In order to enhance the stylish, clean, and exclusivity of the resort, the logo was silver foil stamped and embossed in most of its applications."

—*Sommese Design*

Fig. **2-8** /// DESIGN FALL 2004 COVER: "T," *THE NEW YORK TIMES STYLE MAGAZINE*

• *Creative Director:* Janet Froelich/*The New York Times Magazines*
• *Art Director:* David Sebbah
• *Designers:* Janet Froelich, David Sebbah
• *Photographer:* Raymond Meier

The green chair is the focal point in this graphic space, counterbalanced by the magazine title "T."

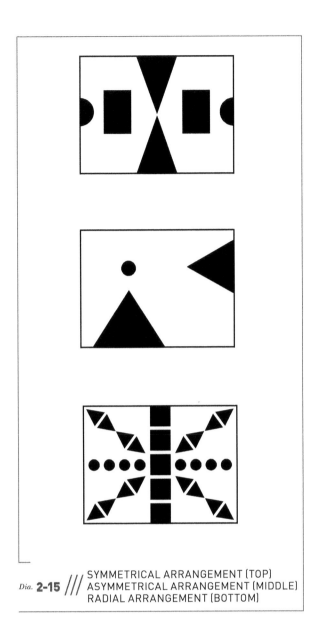

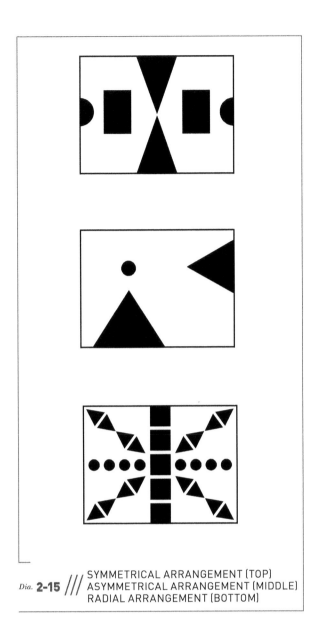

Dia. **2-15** /// SYMMETRICAL ARRANGEMENT (TOP)
ASYMMETRICAL ARRANGEMENT (MIDDLE)
RADIAL ARRANGEMENT (BOTTOM)

Radial balance is symmetry achieved through a combination of horizontally and vertically oriented symmetry (Diagram 2-15). Elements radiate out from a point in the center of the composition.

VISUAL HIERARCHY

One of the primary purposes of graphic design is to communicate information, and visual hierarchy is the primary principle for organizing information. To *guide* the viewer, the designer uses **visual hierarchy**, the arrangement of *all* graphic elements according to emphasis. **Emphasis** is the arrangement of visual elements according to importance, stressing some elements over others, making some superordinate (dominant) elements and subordinating other elements. Basically, the designer determines which graphic elements the viewer will see first, second, third, and so on. This is what creative director John Rea calls the ABCs of emphasis:

A. Where do you want the viewer to look first?

B. Where do you want the viewer to look second?

C. Where do you want the viewer to look third?

The designer must determine what to emphasize and what to de-emphasize.

It is important to remember that if you give emphasis to all elements in a design, you have given it to none of them; you end up with visual chaos. Regardless of the expressive quality or style of the work, visual hierarchy aids communication.

Emphasis is directly related to establishing a point of focus. The **focal point** is the part of a design that is most emphasized or accentuated, as in Figure 2-8, where the green chair is the focal point. Position, size, shape, direction, hue, value, saturation, and texture of a graphic element all contribute to establishing a focal point.

Once past the establishment of a focal point, a designer must *further guide* the viewer, as in Figure 2-9, where first we see the big black lowercase "r," then we read the title, next we see the block of text, then we see the red caption, and so on. As you will recall from the ABCs of emphasis, this rule can be extended to every component part within a composition. (More about creating a focal point through differentiation is in Chapter 7, Composition.)

Fig. **2-9** /// "INSPIRATION: WHERE DOES IT COME FROM?"

- *The New York Times Magazine*
- *Creative Director:* Janet Froelich/ *The New York Times Magazines*
- *Designer:* Janet Froelich
- *Initial letter:* Paul Elliman

Emphasis by Isolation

Isolating a shape focuses attention on it (focused attention equals more visual weight). Please note that a focal point usually carries a good amount of visual weight and must be counterbalanced accordingly with other elements in a composition.

Emphasis by Placement

How the viewer moves visually through a spatial composition is an ongoing topic of study. It has been shown that viewers have preferences for specific regions of a page. Placing a graphic element at a specific position in a composition, such as the foreground, the top-left corner, or the center/middle of a page, attracts most viewers's gaze most easily.

Emphasis Through Scale

The size and scale of shapes or objects play an important role in emphasis and creating the illusion of spatial depth. Used effectively, the size of one shape or object in relation to another—what we call *scale*—can make elements appear to move forward or backward on the page. Large shapes and forms tend to attract more attention. However, a very small object can also attract attention if it is seen in contrast to many larger ones.

WAYS TO ACHIEVE EMPHASIS

To establish a visual hierarchy, decide on the importance of the graphic elements (images and type) of your design. Create a flow of information from the most important graphic element to the least.

There are several means to achieve emphasis (see Diagram 2-16).

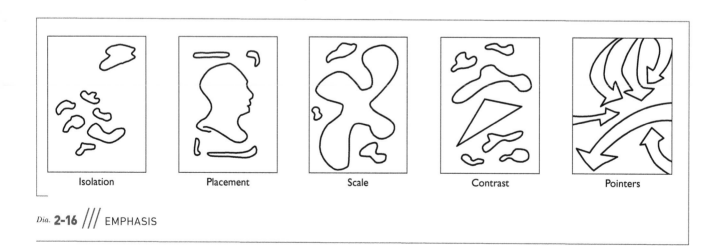

| Isolation | Placement | Scale | Contrast | Pointers |

Dia. **2-16** /// EMPHASIS

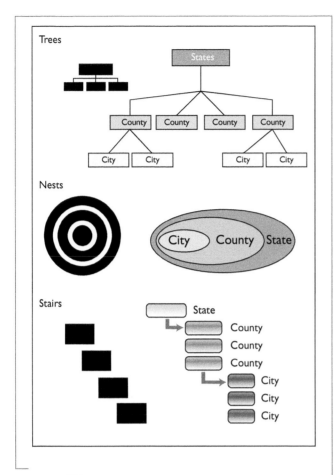

Trees

Nests

Stairs

Dia. **2-17** /// TREES, NESTS, AND STAIRS

Emphasis Through Contrast

Through contrast—light versus dark, smooth versus rough, bright versus dull—you can emphasize some graphic elements over others. For example, a dark shape amid a field of lighter shapes might become a focal point. Contrast also depends on and is aided by size, scale, location, shape, and/or position.

Emphasis Through Direction and Pointers

Elements such as arrows and diagonals use direction to point viewers's eyes to where they should go.

Emphasis Through Diagrammatic Structures

Tree structures. Positioning the main or superordinate element at the top with subordinated elements below it in descending order creates hierarchical relationships. Another

tree structure looks similar to a tree trunk with branches; subordinate elements stem out from the main element carried by lines (Diagram 2-17).

Nest structures. This can be done either through layering (main element is the first layer and other layers move behind it) or through containment (the main element contains the less significant elements). Layering for the purpose of hierarchy is critical to understand in relation to websites and information design.

Stair structures. To illustrate hierarchy, this structure stacks elements, with the main element at the top and subordinate elements descending like stairsteps.

RHYTHM

In music and poetry, most people think of rhythm as the beat—created by a pattern of stress (and unstress). In graphic design, similar to a beat in music, a strong and consistent repetition, a pattern of elements can set up a **rhythm**, which causes the viewer's eyes to move around the page. Timing can be set by the intervals between and among the position of elements on the page. Just as in music, a pattern can be established and then interrupted, slowed, or sped up. Dancers know how important a steady recognizable beat is to the success of moving to the rhythm. Rhythm—a sequence of visual elements at prescribed intervals (think strong dance beat)—across multiple-page formats, such as book design, website design, and magazine design, as well as motion graphics, is critical to developing a coherent visual flow from one page to another. Equally important is incorporating an element of *variance* to punctuate, accent, and create visual interest.

Many factors can contribute to establishing rhythm—color, texture, figure/ground relationships, emphasis, and balance.

REPETITION AND VARIATION

The key to establishing rhythm in design is to understand the difference between repetition and variation. In graphic design, the repetition of rhythm is interposed by variation to create visual interest. In *2D: Basics for Designers*, Steven Brower writes:

"As in music, patterns are established and then broken through. By building expectations, accents can be created that enhance and inform. Once this visual rhythm is achieved through the repetition of pattern, any variation within will break the rhythm, producing the visual equivalent of a pulse or a beat. These can either create a slight pause or bring the entire piece to a halt, depending on the intent of the designer."

Repetition occurs when you repeat one or a few visual elements a number times or with great or total consistency. **Variation** is established by a break or modification in the pattern or by changing elements, such as the color, size, shape, spacing, position, or visual weight. Variation creates visual interest to engage a viewer and adds an element of surprise. However, too much variation will dilute a visual beat.

UNITY

When you look at a website, do you ever wonder how the graphic designer was able to get all the type and images to work together as a cohesive unit? There are many ways to achieve **unity** where all the graphic elements in a design are so interrelated they form a greater whole. When unified, all the graphic elements look as though they belong together.

Viewers best understand and remember a composition that is unified. This relies on *gestalt*, German for "form," which places an emphasis on the perception of forms as organized wholes, primarily concerned with how the mind attempts to impose order on the world, to unify and order perceptions.[1]

From gestalt, we derive certain laws of perceptual organization that govern visual thinking, profoundly affecting how you construct unity in a composition. The mind attempts to create order, make connections, and *to seek a whole* by **grouping**—perceiving visual units by location, orientation, likeness, shape, and color. A fundamental principle is the law of *prägnanz* (German for "precision" or "conciseness")—which means we seek to order our experience as a whole in a regular, simple, coherent manner.

LAWS OF PERCEPTUAL ORGANIZATION

The laws diagrammed in Diagram 2-18 are:

→ *Similarity*: like elements, those that share characteristics, are perceived as belonging together. Elements can share likeness in shape, texture, color, or direction. Dissimilar elements tend to separate from like elements.

→ *Proximity*: elements near each other, in spatial proximity, are perceived as belonging together.

→ *Continuity*: perceived visual paths or connections (actual or implied) among parts. Elements that appear as a continuation of previous elements are perceived as linked, creating an impression of movement.

→ *Closure*: the mind's tendency to connect individual elements to produce a completed form, unit, or pattern.

→ *Common fate*: elements are likely to be perceived as a unit if they move in the same direction.

→ *Continuing line*: lines are always perceived as following the simplest path. If two lines break, the viewer sees the overall movement rather than the break; also called implied line.

1. In 1890, Austrian philosopher Christian von Ehrenfels introduced the term *gestalt* into psychology. In 1912, the gestalt school of psychology gathered momentum from German theorists Max Wertheimer, Wolfgang Köhler, and Kurt Koffka.

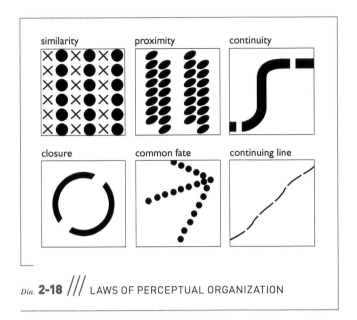

Dia. **2-18** /// LAWS OF PERCEPTUAL ORGANIZATION

Fig. **2-10** /// POSTER: VISUAL METAPHORS

LUBA LUKOVA STUDIO, LONG ISLAND CITY, NY

- *Designer/Illustrator:* Luba Lukova
- *Client:* Contemporary Illustrators Gallery

Look closely at the images comprising the pattern of visual metaphors. Visual metaphors are valuable tools, like their verbal cousins in rhetoric, having the potential to communicate dramatically or poetically, as they do here.

One or more principles may be employed to achieve unity. Here are some of them.

CORRESPONDENCE

When you repeat an element such as color, value, shape, texture, or parallel directions or establish a style, like a linear style, you establish a visual connection or **correspondence** among the elements. Correspondence is the handling of design elements to create similarities of form used to create a family resemblance in one composition. Similarly, if you were designing stationery, you would want to handle the type, shapes, colors, and any graphic elements on the letterhead, envelope, and business card in a similar way to establish a family resemblance among the three pieces.

Unity is one of the primary goals of composition—composing *an integrated whole,* not unrelated component parts. In Figure 2-10, Luba Lukova creates unity through similarity (letterforms and illustrations share common characteristics), corresponding use of red and yellow throughout, as well as through echoing the stepped staircase in the red polygon shape containing the title.

In a series (related yet independent solutions), such as a book series, each cover's composition is unified on its own through its compositional structure, alignment, color, typography, and visualization. Each cover design is also unified as a series

through corresponding (shared) characteristics and through a consistent template (consistent positioning of elements), as in Figure 2-11. Each page of a website must correspond for the visitor to have some sense of location, as in Figure 2-12.

Variety can exist in a unified composition. In Figure 2-13, a promotional poster for the Flaming Lips, although there is a variety of different graphic elements—small silhouetted figures atop the spaceship, the spaceship's legs and ground made from photographic collage elements, black-and-white type versus colored/patterned type—there is a correspondence through the structure of the composition, where the curve of the spaceship strongly echoes the curve of the lips.

Fig. **2-11** /// BOOK COVER SERIES: "THE NEVERSINK
LIBRARY"

- *Design:* Christopher King
- *http://*www.christopherbrianking.com

"The modernist look aims to convey the
emotional essence of these classic books and
their authors using an absolute minimum of
information."

—*Christopher King*

Fig. **2-12** /// WEBSITE AND LOGO: THE DESIGN STUDIO
AT KEAN UNIVERSITY

- *Website Co-Creative Director:* Steven Brower,
 former CD, The Design Studio at Kean University
- *Website Co-Creative Director/ Website Designer:*
 Michael Sickinger, Lava Dome Creative, Bound
 Brook, NJ (Kean alumnus)
- *Logo:* The Design Studio at Kean University
- *Designer:* Steven Brower
- *Client:* Robert Busch School of Design at Kean
 University

The Design Studio is an internship program
in the Robert Busch School of Design at Kean
University, where students provide work to on-
campus clients and the community. In the logo,
Brower finds edges that seem intuitive while
also making good use of interstices.

Fig. **2-13** /// POSTER: FLAMING LIPS

MODERN DOG DESIGN CO., SEATTLE

This is an example of unity with variety.

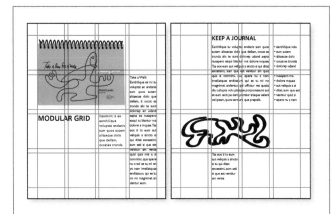

Dia. **2-19** /// A MODULAR GRID

STRUCTURE AND UNITY

Various structural devices can aid in unifying a static page or multiple-page formats. Modular systems, grids, and mathematical devices and alignment can help establish unity.

Viewers will perceive a greater sense of unity in a composition when they see or sense visual connections through the alignment of elements, objects, or edges. Because people seek order, their eyes easily pick up these relationships and make connections among the forms. **Alignment** is the positioning of visual elements relative to one another so that their edges or axes line up. A graphic structure, such as the grid, used to organize the placement of visual elements incorporates guides to set up alignment (Diagram 2-19). Besides type alignment, other elements contribute to unity in a design solution—color, typeface selections, and the position of photographs in relation to the alignment of type.

Elements should be arranged so there is a visual *flow, a movement*, from one element to another through the design, as in Figure 2-14. Visual flow is connected to the principle of rhythm. Rhythm, in part, is about a sense of movement from one element to another.

SCALE

In a design, **scale** is the size of a graphic element *seen in relation* to other graphic elements within the composition. Scale is based on proportional relationships between and among forms. Traditionally, architects show a person standing next to or in front of a model or illustration of a building to best give an idea about the size of the building. We understand the building in scale to the person. In general, we best understand the size of visual elements in relation to other visual elements. Scale can relate to our understanding of the relative size of real objects in our environment, such as the relative size of an apple compared to a tree. Through our experience of the natural world, we expect an apple to be much smaller than a tree. If a designer plays with our expectations, distorting scale compared to how we normally see things in nature, then the result is surreal or fantastic as in Figure 2-15.

Along with utilizing fundamental principles, one must control scale for the following reasons:

→ Manipulating scale can lend visual *variety* to a composition.

→ Scale adds contrast and dynamism among shapes and forms.

→ Manipulation of scale can create the illusion of three-dimensional space.

The foundation of a solid graphic design education begins with the study of two-dimensional design—the formal elements, the principles of design, and the manipulation of graphic space. Such a study provides the basic perceptual and conceptual skills necessary to learn graphic design.

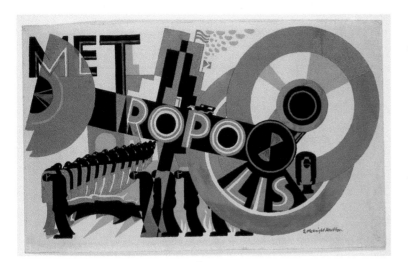

Fig. **2-14** /// POSTER: METROPOLIS

THE MUSEUM OF MODERN ART, GIVEN ANONYMOUSLY

- *Designer:* E. McNight Kauffer (1890–1954)
- *Kauffer, Edward McKnight (1890–1954) © Copyright. Metropolis. 1926. Gouache on paper, 29½ × 17" (74.9 × 43.2 cm). Given anonymously. (78.1961)*
- *The Museum of Modern Art, New York, NY, USA.*
- *Digital Image © The Museum of Modern Art/Licensed by SCALA/Art Resource, NY*

In this asymmetrical composition, top left are the letters "Met. . . ." The "T" extends downward leading the eye to the next part of this single word, ". . . ropo . . . ," which is itself a diagonal pointing down and to the right to the conclusion at the bottom, ". . . lis" and then we are pulled up, and the right-hand big red wheel balances the left side.

Fig. **2-15** /// POSTER

THE MUSEUM OF MODERN ART, NEW YORK, NY

- *Bayer, Herbert (1900-1985) © ARS, NY. Our Allies Need Eggs, Your Farm Can Help. Printer: NYC WPA War Services. c. 1942. Silkscreen, 20¼ × 30" (51.4 x 76.1 cm). Gift of the Rural Electrification Administration.*
- *The Museum of Modern Art, New York, NY, USA.*
- *Digital Image © The Museum of Modern Art / Licensed by SCALA /Art Resource, NY*
- *© 2012 Artists Rights Society (ARS), New York / VG Bild-Kunst, Bonn*

In this historic work by Bayer, monumentality is established by contrasting the size of the egg in the foreground with the burning buildings in the background. The contrast in scale, enhanced by the extreme light and dark lighting, results in dramatic communication.

Essay

Color Design Basics by Rose Gonnella

Equal to and perhaps surpassing the power of letterforms and the written word, color is a most powerful communication tool. Color can conjure intense emotions and create visual energy, or it can be mystical, musical, and exude a great sense of spiritual peacefulness. Color speaks on many levels. Each word used in our verbal and written language is constrained to a single or several variants of meaning and function. Yet, the emotions, associations, ideas, thoughts, and feelings contained by a color are fluid and boundless. Individual colors are the rich and dynamic "words" of a visual language—a language that takes time, patience, and experience in which to develop fluency.

When you begin to "speak" with color, remember that designing is not subjective. There is a far more important basis for choosing color for a design than just your personal taste. In fact, your personal taste should play only a small part in your design. Knowledge of the emotional, intellectual, and physical properties of color and understanding how these attributes and properties can contribute to solving the objectives of a design problem should be the primary guide for your creative choices. You can be creative and objective when you become versed in the language of color. For this brief study, let's try to simplify the monumental task of objectively designing with color: how do you pick a color for your design from the infinite possibilities?

ACTIVE, PASSIVE, HOT, AND COLD: FEELING THE COLORS

Don't be daunted. The process of learning always begins with the first step—an understanding of the fundamentals.

The pigment-based color wheel offers an excellent chart for a basic selection of color relationships. From an understanding of the basics, even the most complex and expressive designs can be created.

Each of the charted relationships on the color wheel can suggest an emotion, a feeling, and/or a physical state. The primary colors—from which all pigment-based hues are said to be mixed—seem to be innocent or wholesome due to their pureness. The secondaries are slightly more complex than the primaries, but still feel basic and simple. Analogous colors are harmonious because of their similarities, while complements that oppose each other on the color wheel feel tense. Red and accompanying analogous colors feel hot and loud at full saturation—their warmth seems to jump off the surface.

ROSE GONNELLA

Rose Gonnella is an educator, artist, designer, and writer. She is Executive Director of the Robert Busch School of Design at Kean University as well as the Kean Cre8tive Studio. A practicing artist and designer, Gonnella has exhibited her drawings internationally. Her published writing includes *Design to Touch: Engraving Process, Concepts, and Creativity*, and *Comp It Up*, both co-authored with Christopher Navetta, and a co-authored set with Robin Landa and Denise M. Anderson, *Creative Jolt*, and its companion, *Creative Jolt Inspirations*, and *Visual Workout: A Creativity Workbook*.

These warmer hues tend to create a very dynamic design. In contrast, blue and green hues feel cool and quiet and passive.

Expanding the physical properties of hue through saturation and value also affects the expressive character. Dark blues may be thought of as mysterious and brooding, or may simply suggest limitless spatial depth. Muted or low-saturation colors create a sense of stillness or sophistication. In pointed contrast, a muted color may also suggest something that is frayed and old. The meaning depends on the hue chosen and the degree of color saturation or value, as well as the association given to it by the viewer.

Each of the thousands of colors to choose from also carries a set of meanings and associations originating in many cultures. Individual colors may speak on several levels (emotional, intellectual, and physical), and each color may be interpreted in different ways by its viewers.

Imagine metallic bronze—flood your visual imagination with the color. Let yourself freely associate with it. Ask yourself these questions:

What associations do I have with the color? (Olympic medals? Ancient Greek statues? Skin color? Ancient tools?) How does metallic bronze physically feel (cold? warm? hot?); what does the color express (mystery? richness? tradition? achievement?); what other physical properties does it possess? (Is it dull? bright? hard?) Each color, selected from the thousands that exist, communicates an emotion and/or a state of being, and a physical feeling. Each color carries many associative meanings.

AN OBJECTIVE PICK

You may wonder how to control the communication of color when it can fluctuate in meaning and feeling so easily. The answer is: You can't. Instead of thinking that you can control color, you must remember that colors do not precisely define—they suggest.

Once you have developed a knowledge of the communicative power of the individual hues and hue relationships through reading, observation and practice, you will actually be able to suggest, with greater control, a complex range of emotions and ideas, and predict the reactions to your objective choices.

Do remember that color does not act alone; the many elements of your design (line, shape, type, pattern, space, format) must all work together with color to guide the viewer to the message you intended for a design solution. For a successful design solution, always pick your colors (and all the elements) objectively—using your base of knowledge, not your personal taste.

Exercises and Projects

Go to GDSOnline for more exercises and projects. 📲

Exercise 2-1

Exploring Lines

01. Divide a page into four units.

02. Draw a curving line from corner to corner in each square.

03. Draw different types of lines of varying direction and qualities in each square.

Project 2-1

Creating Illusion with Lines: A Warp

01. Using a black marker or the line tool in your software, draw horizontal lines of varying thickness completely across the page.

02. Vary the distance between the lines.

03. Do several small sketches (thumbnails) or versions before going to the final solution.

PRESENTATION

Create your solution on an 11" × 14" smooth board using a black marker, or mount a computer-generated printout on an 11" × 14" board or display on screen.

3 TYPOGRAPHY

Aspiring designers who view type as more than literal content, who embrace type as an integral component of visual communication, can best give striking form to their ideas.

ELEMENTS OF TYPE

A **typeface** is the design of a single set of characters unified by consistent visual properties. These stylistic visual properties create the essential character of a typeface, which remains recognizable even if the typeface is modified. Usually, a typeface includes letters, numbers, symbols, signs, punctuation marks, and accent or diacritical marks. Most type terminology is based on metal type terms, on a printing process where type was cast

in relief on a three-dimensional piece of metal (Diagram 3-1), which was then inked and printed. In the days of metal type, a font was a complete set of characters, numerals, symbols, and signs of a specific typeface in one size, weight, and style (to see The Typographic Font Chart, go to GDSOnline.) Today, a font is the digital file of a complete character set of a particular typeface *in all sizes*.

TYPE MEASUREMENT

In print, the traditional system of typographic measurement utilizes two basic units: the point and the pica (see Diagram 3-1). The height of type is measured in points. Point size is the height of the body of a letter in a typeface. The width of a letter or a line of type is measured in picas. The *set width* of a character describes the horizontal measure, how wide a character is.

→ 6 picas = 1 inch

→ 72 points = 1 inch

→ 1 point = $\frac{1}{72}$ inch

→ 12 points = 1 pica

For the screen, you can specify type measurement using points, pixels, percentages, or em units, which is a unit of measurement in typography. An em is defined as the width of the uppercase M in the parent face and point size; for example, in 14-point type, an em is a distance of 14 points. There are online resources that explain size conversion, such as pixel to em. See, for instance, http://www.pxtoem.com/

TYPE ANATOMY

A letter is a symbol, written (or in speech), representing a sound and constituting an individual letter of an alphabet (Diagram 3-2). Each letter of an alphabet has characteristics that must be preserved to retain the legibility of the symbol.

METAL TYPE TERMS

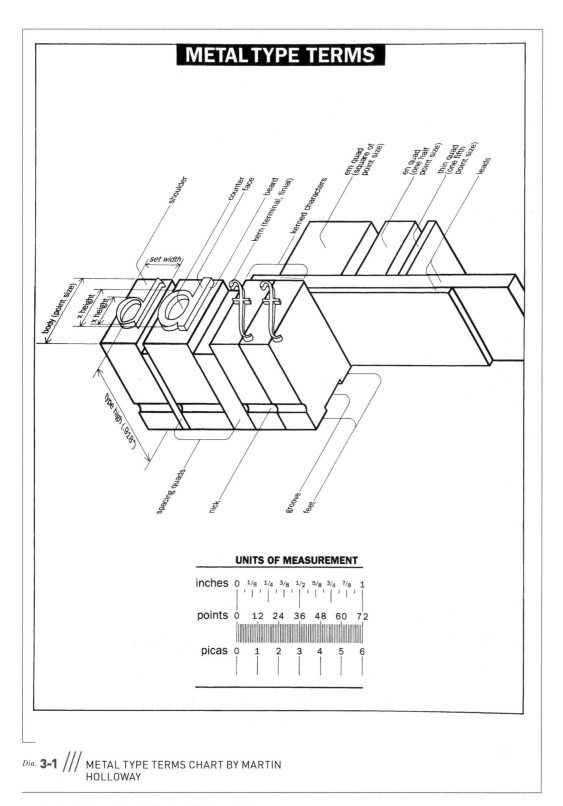

shoulder
counter
face
kern (terminal, finial)
kerned characters
em quad (square of point size)
en quad (one half point size)
thin quad (one fifth point size)
leads
set width
body (point size)
x height
x height
type high (.918")
spacing quads
nick
groove
feet

UNITS OF MEASUREMENT

inches 0 1/8 1/4 3/8 1/2 5/8 3/4 7/8 1

points 0 12 24 36 48 60 72

picas 0 1 2 3 4 5 6

Dia. **3-1** /// METAL TYPE TERMS CHART BY MARTIN
HOLLOWAY

Martin Holloway Graphic Design, Pittstown, NJ

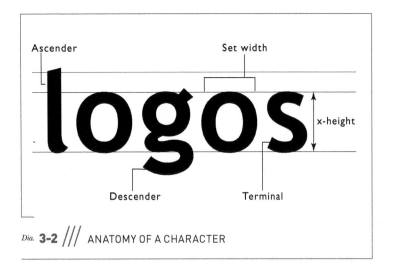

Ascender
Set width

x-height

Descender
Terminal

Dia. **3-2** /// ANATOMY OF A CHARACTER

→ *Arm:* a horizontal or diagonal stroke extending from a stem

→ *Ascender:* the part of lowercase letters (*b, d, f, h, k, l,* and *t*) that rises above the x-height

→ *Axis:* the oblique or angle of stress of the round part of a character or glyph

→ *Bar:* the horizontal stroke connecting two sides of a letterform, as in an *A, H,* or *e*; also called *crossbar*

→ **Baseline:** the bottom of capital and lowercase letters, excluding descenders

→ *Bowl:* a curved stroke that encloses a counter

→ *Cap height:* the height of a capital letter from the baseline to the top of the cap; also called *capline*

→ **Character:** a letterform, number, punctuation mark, or any single unit in a font

→ **Counter:** the space enclosed by the strokes of a letter

→ *Descender:* the part of lowercase characters (*g, j, p, q,* and *y*) that falls below the baseline

→ *Ear:* the projecting small stroke on the bowl of the *g*

→ *Foot:* the bottom portion of a character

→ *Hairline:* the thin stroke of a roman character

→ *Head:* the top portion of a letter

→ *Italics:* a specifically designed style variant of a typeface within a type family. Italics refer to typefaces that suggest a cursive origin, inspired by written forms, letters that slope to the right

→ *Leg:* a lower downward stroke of a letter, such as in a *K* and *R*

→ *Ligature:* two or more characters linked together

→ *Link:* the connecting stroke between a two-story lowercase *g*

→ *Loop:* the lower portion of the two-story lowercase *g*; also called *lobe*

→ *Oblique:* a slanting version of a face. Oblique is similar to italic but without the script quality of a true italic. Upright typefaces are usually referred to as roman

→ **Serif:** a small stroke added to the upper or lower end of the main stroke of a character

→ *Shoulder:* curved stroke of the lowercase *h, m,* or *n*

→ *Spine:* the main curved stroke of the *S*

→ *Spur:* a small projection of the main stroke

→ *Stem:* the main upright stroke of a character

→ *Stress:* the angle of the major axis of the stroke of a letter

→ *Stroke:* a line used to define a major structural portion of a character

→ *Swash:* a decorative extension on a letterform, usually a flourish replacing a terminal or serif

→ *Tail:* the descender of a *Q* when it descends below the baseline

→ *Terminal:* the end of a stroke not terminated with a serif

→ *Text Type:* narrative content, set smaller than titles, subtitles, headlines, or subheadlines; also called body text or body copy

→ *Thick/thin contrast:* the comparative thicknesses of the strokes in a typeface; that is, the amount of difference between the weight of thick and thin strokes

→ *Vertex:* the foot of a pointed letter

→ *Weight:* determined by the thickness of the stroke compared to the height—for example, light, medium, and bold weights

→ **x-height:** the height of a lowercase letter, excluding ascenders and descenders

→ *Type 1* is a standard format for digital type for every computer platform; it prints on almost every printer, either through a built-in PostScript language or through add-on utilities.

→ *TrueType* is a standard for digital type fonts built into both Windows and Mac OS.

→ *OpenType* fonts have cross-platform compatibility, can support more character sets, and access more features, such as small caps and ligatures, as well as support multiple languages—all in a single font.

TYPE CLASSIFICATION

Although there are numerous typefaces available today, there are some major classifications, by style and history, into which most fall (see Diagrams 3-3, 3-4, and 3-5). Please note these classifications vary among type historians.[1]

→ *Old Style or Humanist:* roman typefaces, introduced in the late fifteenth century, most directly descended in form from letters drawn with a broad-edged pen. Characterized by angled and bracketed serifs and biased stress, some examples are Caslon, Garamond, Hoefler Text, and Times New Roman.

→ *Transitional:* serif typefaces, originating in the eighteenth century, represent a transition from old style to modern, exhibiting design characteristics of both; examples are Baskerville, Century, and ITC Zapf International.

→ *Modern:* serif typefaces, developed in the late eighteenth and early nineteenth centuries; their form is more geometric in construction, as opposed to the old style typefaces, which stayed close to forms created by the chisel-edged pen. Characterized by greatest thick–thin stroke contrast and vertical stress, they are the most symmetrical of all roman typefaces; examples include Didot, Bodoni, and Walbaum.

→ *Slab Serif:* serif typefaces, characterized by heavy, slablike serifs, were introduced in the early nineteenth century; subcategories are Egyptian and Clarendon. Slab serif typefaces include American Typewriter, Memphis, ITC Lubalin Graph, Bookman, and Clarendon.

→ *Sans Serif:* these typefaces, characterized by the absence of serifs, were introduced in the early nineteenth century; examples are Futura, Helvetica, and Univers. Some letterforms without serifs have thick and thin strokes, such as Grotesque, Franklin Gothic, Universal, Futura, and Frutiger. Sans serif typeface subcategories include Grotesque, Humanist, Geometric, and others.

→ *Blackletter:* these typefaces are based upon the thirteenth- to fifteenth-century medieval manuscript letterforms; they are also called gothic. Blackletter characteristics include a heavy stroke weight and condensed letters with few curves. Gutenberg's Bible was printed in a Textura typeface, a blackletter style. Other examples include Rotunda, Schwabacher, and Fraktur.

→ *Script:* these typefaces most resemble handwriting. Letters usually slant and often are joined. Script types can emulate forms written with a chisel-edged pen, flexible pen, pointed pen, pencil, or brush; examples are Brush Script, Shelley Allegro Script, and Snell Roundhand Script.

→ *Display:* these typefaces are designed for use in larger sizes used primarily for headlines and titles and would be more difficult to read as text type; they often are more elaborate, decorated, handmade, and fall into any of the other classifications.

1. I am indebted to Professor Martin Holloway, designer and type history scholar, for information on type classifications and his brilliant type charts in this text.

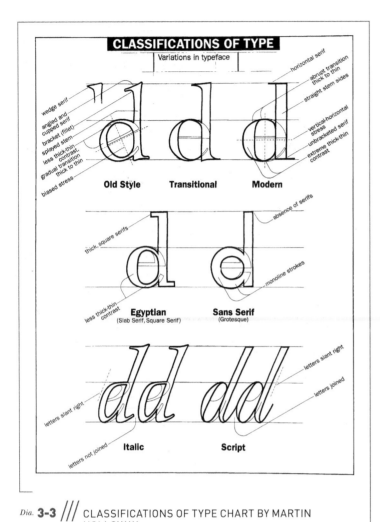

Variations in typeface

wedge serif
angled and cupped serif
bracket (fillet)
splayed stem
less thick-thin contrast
gradual transition thick to thin
biased stress

horizontal serif
abrupt transition thick to thin
straight stem sides
vertical-horizontal stress
unbracketed serif
extreme thick-thin contrast

Old Style **Transitional** **Modern**

thick, square serifs

absence of serifs

monoline strokes

less thick-thin contrast

Egyptian
(Slab Serif, Square Serif)

Sans Serif
(Grotesque)

letters slant right
letters slant right
letters joined
letters not joined

Italic **Script**

Dia. **3-3** /// CLASSIFICATIONS OF TYPE CHART BY MARTIN HOLLOWAY

Martin Holloway Graphic Design, Pittstown, NJ

Old Style/Garamond, Palatino
BAMO hamburgers
BAMO hamburgers

San Serif/Futura, Helvetica
BAMO hamburgers
BAMO hamburgers

Transitional/New Baskerville
BAMO hamburgers

Italic/Bodoni, Futura
BAMO hamburgers
BAMO hamburgers

Modern/Bodoni
BAMO hamburgers

Script/Palace Script
BAMO hamburgers

Egyptian/Clarendon, Egyptian
BAMO hamburgers
BAMO hamburgers

Dia. **3-4** /// TYPEFACE CLASSIFICATION EXAMPLES

SERIF SANS SERIF SLAB SERIF BLACKLETTER SCRIPT ITALIC DISPLAY

Dia. **3-5** /// TYPEFACE CLASSIFICATION/SINGLE LETTERFORMS

TYPE FAMILY

Variations of a typeface, which is called **type style**, offer variety while retaining the essential visual character of the face. These include variations in weight (light, medium, bold), width (condensed, regular, extended), and angle (roman or upright and italic), as well as elaborations on the basic form (outline, shaded, decorated).

A **type family** includes many *style* variations of a single typeface. Most type families include at least a light, medium, and bold weight, each with its own italic (to see The Typographic Family Chart, go to GDSOnline).

ITC Stone Informal Medium
ITC Stone Informal Medium Italic
ITC Stone Informal Semibold
ITC Stone Informal Semibold Italic
ITC Stone Informal Bold
ITC Stone Informal Bold Italic
ITC Stone Sans Medium
ITC Stone Sans Medium Italic
ITC Stone Sans Semibold
ITC Stone Sans Semibold Italic
ITC Stone Sans Bold
ITC Stone Sans Bold Italic
ITC Stone Serif Medium
ITC Stone Serif Medium Italic
ITC Stone Serif Semibold
ITC Stone Serif Semibold Italic
ITC Stone Serif Bold
ITC Stone Serif Bold Italic

Dia. **3-6** /// ITC STONE: EXAMPLE OF A TYPE SUPER FAMILY

→ *Extended Family:* contains more styles of a typeface than a traditional family, including, for example, hairline, extended, and condensed styles.

→ *Super Family:* a family that contains all styles, including serif and sans serif styles, and classifications that offer great versatility, such as ITC Stone (Diagram 3-6).

DESIGNING WITH TYPE

Type is form and should be evaluated based on aesthetic criteria of shape, proportion, and balance. Type communicates on a denotative (direct meaning) and connotative level (suggested or additional meaning). It must be thoughtfully integrated with visuals. Type should be readable. Margins present text type and need to be respected. Transitions between letters, words, and paragraphs are critical. Spacing can make or break communication.

TYPE AS SHAPES

Each letterform is made up of positive and negative shapes. The strokes of the letterform are the positive shapes (also called *forms*), and the spatial areas created and shaped by the letterform are the negative shapes (or counterforms). The term

Fig. **3-1** /// LOGO: CE SOFTWARE

MULLER BRESSLER BROWN, KANSAS CITY, MO

• *Client:* CE Software

Fig. **3-2** /// LOGO: CHANNEL 39

SIBLEY PETEET DESIGN, DALLAS

• *Client:* KXTX Channel 39

"This mark was selected from a group of about thirty alternatives presented. The mark's interest lies in the juxtaposition of a positive three with the negative shape of the nine, bleeding the common shapes of the two number forms."

—*Don Sibley, Principal, Sibley Peteet Design*

counterform includes counters, the shapes defined within the forms, as well as the negative shapes created *between* adjacent letterforms. The negative shapes are as important as the positive shapes, as demonstrated in the design of the logos in Figure 3-1 and Figure 3-2, where the *E* and *9* are formed by the negative shapes.

Garamond	Baskerville	Bodoni	Clarendon	Helvetica
Old Style	Transitional	Modern	Slab Serif/ Egyptian	Sans Serif
Little contrast	Greater contrast	Strong Contrast	Little contrast	Little contrast
Heavy bracketed serifs	Less heavily bracketed serifs	Abrupt serifs	Thick serifs	No serifs
Oblique stress and axis	Almost vertical axis	Vertical axis	Vertical axis	Very little stress
		Hairline thins	Large x-height	Large x-height

Dia. **3-7** /// COMPARISON OF LETTERFORMS IN VARIOUS TYPEFACES

Each letterform has distinguishing characteristics. Some letters are closed shapes, like the *O* and *B*, and some letters are open forms, like the *V* and *C*. The same letterform can vary in form depending on the typeface, like this lowercase *g* in Times and this lowercase **g** in Helvetica. Have you ever noticed the variations of the form of the letter *O* in the different typefaces? For example, the *O* in some typefaces is circular and in others it is oval. You may want to compare letterforms in a few classic typefaces such as Garamond (old style), Baskerville (transitional), Bodoni (modern), Clarendon (slab serif), and Helvetica (sans serif) (Diagram 3-7). In this case, classic means a typeface that has become a standard because of its grace, readability, and effectiveness. Familiarize yourself with classic typefaces in each classification to best understand their proportions and general form.

TYPE SELECTION

When there are thousands of typefaces available and more being designed each day, how do you select a typeface for a project? Jay Miller, principal, IMAGEHAUS, advises: "Before you choose a typeface, clearly define the audience, tone, personality and attitude of what you are trying to communicate and how you want to say it. This will help you strategically choose the right font to ensure successful communication."

TIPS ON SELECTING A TYPEFACE

→ Select based on appropriateness for audience, design concept, message, communication requirements, and context.

→ Is it display or text or both? Is it for print or screen? Most typefaces are suitable for display but not nearly as many for text type. Learn to recognize which typefaces are suitable for text type. Consider how the type will function and where it will be seen. *Caution*: Avoid selecting display typefaces for text type.

→ Will you be dealing with small, medium, or large amounts of text? For large amounts of text, you need a highly readable typeface.

→ To narrow down choices, select a typeface based on suitability for the purpose: editorial versus promotional versus branding.

→ Consider the voice of the typeface, the emotional tone, which is expressed by the particular characteristics of the letterforms and type classification. To help determine the voice, set different words in several typefaces that you are considering, words such as: "Mighty," "Fresh," "Confident," "Dignified," and "Festive." Examine how the typefaces express meaning.

→ Notice the x-height of a typeface. A substantial or large x-height aids readability, especially on screen.

→ Notice the counter shapes of a typeface to help judge the aesthetics of the forms. Take note of the counter of the uppercase O. Is it perfectly round? Oval? Do the counterforms of the typeface integrate well with the characteristics of accompanying imagery? Are type and image configurations similar?

→ Check legibility: set sample titles, headlines, subheadlines, and/or paragraphs in the typeface or review available text samples from online foundries and retailers. Some foundries and font vendors offer links to sites that use their fonts. Seeing the font in application is very useful for determining tone and readability. Try a type specimen at different sizes with actual content.

→ If selecting web type, use http://www.fontfonter.com/ to see web fonts on any website.

→ Check to see if the font is well spaced (font tracking).

→ Check readability. Try reading it and see how easy or hard it is to read on paper or different screen sizes.

→ Substrate or Screen: Check samples of the typeface on different weights of paper as well as on coated versus uncoated. Check how a typeface looks across browsers.

→ Make sure the font has a sufficient character set and can support your needs (multiple languages, bold, oblique, italics, glyphs, etc.).

→ See if the typeface is versatile.

→ Read reviews of the typeface and font.

→ For flexibility and unity, consider employing a type family. In a family, all the type maintains the same basic structure with variations, differentiated by slight individual characteristics. A well-conceived, well-designed family includes variation—variations in weight from ultra light to ultra black; variations in width from condensed to extended; multiple character sets, such as small capitals, titling capitals, swash capitals; and more. It's been said that a type family is like a variation on a theme. *Super families* offer more versatility, with serif and sans serif typefaces.

→ Ensure sufficient value contrast between the typeface and the background.

Fig. **3-3** /// POSTER: WERNER HERZOG RETROSPECTIVE

MENDEDESIGN, SAN FRANCISCO

- *Art Director:* Jeremy Mende
- *Designers:* Amadeo DeSouza, Steven Knodel, Jeremy Mende
- *Client:* San Francisco Museum of Modern Art

DESIGN CONCEPT

Often, beginning students (and almost all nondesigners) choose typefaces for their novelty appeal rather than select a suitable typeface to express the design concept. Beginners tend to be attracted to typefaces that are decorative. They may also have little understanding of what a typeface connotes, of its history and classification. For example, choosing a typeface associated with a time period or style, such as art deco, carries historical and aesthetic meaning, even if you aren't aware of it. Knowing type classifications and design history comes strongly into play when selecting a typeface. For example, would you use American nineteenth-century wood type for a magazine article about the history of East Asia?

Determine which typefaces would most aptly convey the design concept. For a retrospective of Werner Herzog films at San Francisco's Museum of Modern Art, Jeremy Mende, MendeDesign, wanted the poster to communicate the essence of selected Herzog films, about man's struggle against the universe, while also communicating something about Herzog himself. In *Step Inside Design* magazine, Mende said about Figure 3-3,

> "We chose the horizon to represent this vast, unyielding force and selected film stills that suggested the smallness of man against this backdrop." About this work, Romy Ashby writing in *Step Inside Design* explains, "Over those images, lists of adjectives were written—words such as conquistador, soldier, baron and mystic—meant to purposefully confuse descriptions of Herzog's main characters with descriptions of Herzog himself. At first glance the typography appears to be digitally generated, and most people will assume that it is. But up close, idiosyncrasies of hand-drawn letterforms become apparent, revealing an obsessive attempt to recreate 'the perfect' that Herzog likewise obsessively seeks to capture in his films."[2]

2. Romy Ashby. http://www.stepinsidedesign.com/STEP/Article/28854/0/page/7

For the book design of *Dugong, Manatee, Sea Cow* (Figure 3-4), Charles Nix comments, "The solution is born out of the language and content of the poem. The language is of a peculiar 19th-century style—turning back on itself, using clauses to modify clauses to modify clauses, and a vocabulary suited to Victorian descriptions. The typography alludes to the period: De Vinne and a host of other typefaces are from that period. The poem refers to the geographic locations of the dugong, manatee and sea cow throughout, and so the design steals aspects of late-19th-century maps—line numbers undulating like latitude lines, a cordoned text block tucked low and toward the spine like a legend, pages lettered in circles rather than numbered."

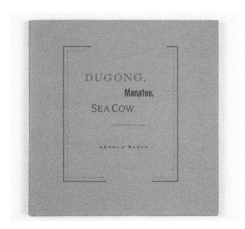

Fig. **3-4** /// **BOOK COVER AND INTERIOR PAGES:** *DUGONG, MANATEE, SEA COW* **BY ARNOLD KLEIN**

- *Art Director/Designer:* Charles Nix
- *Illustrator:* Stefano Arcella
- *Author:* Arnold Klein
- *Production Coordinator:* Charles Nix
- *Trim size:* 9 × 9¼ inches
- *Pages:* 32
- *Quantity printed:* 500
- *Compositor:* Charles Nix
- *Typefaces:* Caslon Open Face, Engravers Bold Face, Monotype Grotesque, Usherwood Book, Bitstream De Vinne

READABILITY AND LEGIBILITY

Ensuring *readability* means text is easy to read, thereby making reading enjoyable and free of frustration. How you design with a suitable typeface, with considerations of size, spacing, margins, color, and paper selection, contributes to readability. *Legibility* has to do with how easily a person can recognize the letters in a typeface—how the characteristics of each individual letterform are distinguished. Here are some pointers:

→ Typefaces that are too light or too heavy may be difficult to read, especially in smaller sizes. *Caution:* Thin strokes are very difficult to see on screen and should be avoided for text.

→ Typefaces with too much thick–thin contrast may be difficult to read if they are set very small—the thin strokes may seem to disappear.

→ Condensed or expanded letters are more difficult to read (especially in small sizes). They can appear to merge together when condensed and dissociate when expanded.

→ Text type set in all capitals is difficult to read. Opinions differ on whether all caps enhance or diminish readability for display type.

→ Greater *value contrast* between type and background increases readability.

→ Highly saturated colors may interfere with readability.

→ People tend to read darker colors first.

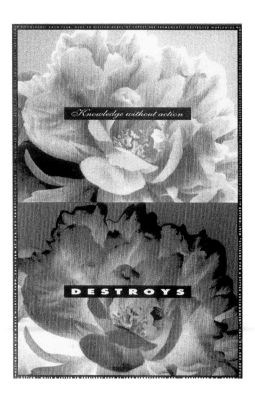

Knowledge without action

DESTROYS

Fig. **3-5** /// **POSTER: ENVIRONMENTAL AWARENESS, AIGA**

MORLA DESIGN, SAN FRANCISCO

- *Art Director:* Jennifer Morla
- *Designers:* Jennifer Morla, Jeanette Arambu
- *Client:* AIGA, San Francisco

The visualization of the type and image in the top half of this poster contrasts with the visualization of the negative visual and sans serif caps depicted in the bottom half. Together they communicate the need for environmental awareness.

A TYPEFACE IN CONTEXT

When selecting a typeface, consider the audience, design concept, and communication goals.

Think about a typeface in context:

Display Versus Text

Media: Print Versus Screen

Size of Screen (mobile, tablet, computer, or public screen)

Distance of the Viewer from the Screen

Indoor Versus Outdoor Display

AESTHETICS AND IMPACT

Creating or selecting a typeface for its aesthetic value and the impact it will have on screen or in print is as important as creating or selecting an image. Every characteristic of a typeface contributes to communication. Each typeface should be evaluated for its characteristics, aesthetics based on proportion, balance, visual weight, contrast in thick and thin, positive and negative shapes of each individual letter and counters, as well as shape relationships between and among letters.

Realizing how display type will be *seen in context*—up close, its impact from a distance, where it is seen, lighting conditions, and more—should be considered. How a typeface looks as display or text must be tested and evaluated. John Sayles suggests doing the following exercise:

→ "If there is a font I use more than others it is probably _____ because . . ."

→ "—Helvetica: simple, easy to read, portrays a clear message"

INTEGRATION WITH IMAGE

Each characteristic of a typeface should be considered for integration with the characteristics of the accompanying images, as in Figure 3-5. With thousands of typefaces available, selecting a typeface to pair with an image may seem daunting. Here is a set of questions that will help you select well.

→ Should the typeface *share* visual characteristics with the image?

→ Should the typeface *contrast* with the characteristics of the image?

→ Should the typeface be *neutral* (one that does not draw great attention to itself) and allow the image to drive the solution? In such a case, the typeface would contextualize the image.

→ Should the typeface dominate the solution? Should the typeface carry the main communication with the image subordinate to it?

→ Should the type and image operate collectively? (See Figure 3-7)

→ Would hand-drawn or handmade lettering or handwriting work best?

TYPEFACE PAIRINGS

Being creative involves experimentation. Having guidelines or grasping standards allows you to critique your experiments. Designers mix typefaces for conceptual, creative, and/or aesthetic reasons. There are general type rules for beginners and, perhaps, for any designer.

LIMIT MIXING AND SELECT FOR CONTRAST

Pair typefaces for *distinction between display type and text type.* The most common rule is to restrict designing to *utilizing no more than two typefaces*—one for display and one for text. For example, in print, mix a sans serif for display and a serif for readable text. The obvious point of mixing faces is to add contrast, for differentiation (for example, to make captions distinct from text) (Diagram 3-8). The equally obvious reason to avoid selecting similar typefaces is that the reader would not be able to tell them apart.

Select for contrast yet choose for similar proportions or configurations. Selecting for contrast means mixing typefaces based on differences in structural classifications—for example, mixing a sans serif face with a slab serif face. Do consider how well their proportions work to create harmony. Also consider typefaces from different classifications yet based on similar configurations. For example, designer/illustrator John Sposato recommends City

Bold (Slab Serif) with Eurostyle Condensed (Sans), which are both based on a square configuration. He also suggests Gill Display Compressed (Sans) with Bodoni Book (Serif), which are based on a similar oval. For harmony, Sposato also suggests pairing typefaces with rounded terminals, such as Helvetica or Arial Rounded (Sans) with American Typewriter Light (Serif).

Janet Slowik, senior art director, Pearson Professional & Career, advises:

> In editorial design the type and image should coexist harmoniously, and one should never overpower the other. They should complement each other. Novice designers often select elaborate display typefaces that conflict with the image. A good selection of a serif and sans serif typeface that contain a corresponding italic is all that is needed . . . a proficient designer helps.

Select for Contrast and Variation

→ Serif Versus Sans Serif

→ Light Versus Bold

→ Regular Versus Condensed

PAIR COMPLEMENTARY TYPEFACES

Select typefaces that have contrasting voices but similar x-heights—for example, pair a soft voice with a bombastic voice. Consider pairing a typeface with a linear quality with a typeface made from thick strokes. Consider pairing actual handwriting with an industrial typeface.

PAIR TYPEFACES WITH DIFFERENT TYPOGRAPHIC TEXTURES

The term **typographic texture**, also called **typographic color**, refers to the overall density or tonal quality of a mass of type on a field—page or screen—usually referring to the mass of text type. In graphic design projects that require blocks of text, the value of the mass of the type block, paragraph, or column takes

Design is a Way of Life
"Design is a way of life, a point of view. It involves the whole complex of visual communications: talent, creative ability, manual skill, and technical knowledge. Aesthetics and economics, technology and psychology are intrinsically related to the process." —Paul Rand

Garamond / Optima

Design is a Way of Life
"Design is a way of life, a point of view. It involves the whole complex of visual communications: talent, creative ability, manual skill, and technical knowledge. Aesthetics and economics, technology and psychology are intrinsically related to the process." —Paul Rand

Optima / Garamond

Design is a Way of Life
"Design is a way of life, a point of view. It involves the whole complex of visual communications: talent, creative ability, manual skill, and technical knowledge. Aesthetics and economics, technology and psychology are intrinsically related to the process." —Paul Rand

Century Schoolbook / Univers 45

Design is a Way of Life
"Design is a way of life, a point of view. It involves the whole complex of visual communications: talent, creative ability, manual skill, and technical knowledge. Aesthetics and economics, technology and psychology are intrinsically related to the process." —Paul Rand

Univers 45 / Century Schoolbook

Design is a Way of Life
"Design is a way of life, a point of view. It involves the whole complex of visual communications: talent, creative ability, manual skill, and technical knowledge. Aesthetics and economics, technology and psychology are intrinsically related to the process." —Paul Rand

Bauer Bodoni / News Gothic

Design is a Way of Life
"Design is a way of life, a point of view. It involves the whole complex of visual communications: talent, creative ability, manual skill, and technical knowledge. Aesthetics and economics, technology and psychology are intrinsically related to the process." —Paul Rand

News Gothic / Bauer Bodoni

Design is a Way of Life
"Design is a way of life, a point of view. It involves the whole complex of visual communications: talent, creative ability, manual skill, and technical knowledge. Aesthetics and economics, technology and psychology are intrinsically related to the process." —Paul Rand

Univers family / Serifa family

Design is a Way of Life
"Design is a way of life, a point of view. It involves the whole complex of visual communications: talent, creative ability, manual skill, and technical knowledge. Aesthetics and economics, technology and psychology are intrinsically related to the process." —Paul Rand

Serifa family / Univers family

Design is a Way of Life
"Design is a way of life, a point of view. It involves the whole complex of visual communications: talent, creative ability, manual skill, and technical knowledge. Aesthetics and economics, technology and psychology are intrinsically related to the process." —Paul Rand

Didot / Franklin Gothic Demi

Design is a Way of Life
"Design is a way of life, a point of view. It involves the whole complex of visual communications: talent, creative ability, manual skill, and technical knowledge. Aesthetics and economics, technology and psychology are intrinsically related to the process." —Paul Rand

Franklin Gothic Demi / Didot

Dia. **3-8** /// TYPEFACE PAIRINGS

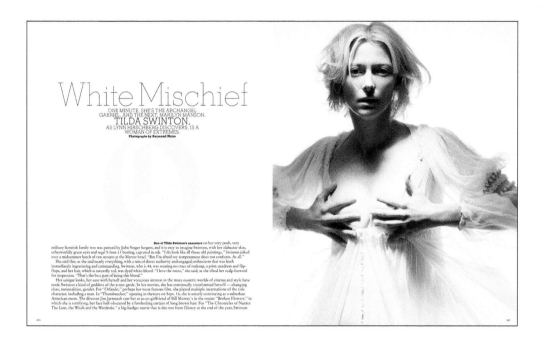

In the image: **White Mischief**

ONE MINUTE, SHE'S THE ARCHANGEL GABRIEL. AND THE NEXT, MARILYN MANSON. **TILDA SWINTON**, AS LYNN HIRSCHBERG DISCOVERS, IS A WOMAN OF EXTREMES.

Photographs by Raymond Meier

One of Tilda Swinton's ancestors on her very posh, very military Scottish family tree was painted by John Singer Sargent, and it is easy to imagine Swinton, with her alabaster skin, otherworldly green eyes and regal 5-foot-11 bearing, captured in oils. "I do look like all those old paintings," Swinton joked over a midsummer lunch of raw oysters at the Mercer hotel. "But I'm afraid my temperament does not conform. At all."

She said this, as she said nearly everything, with a mix of direct authority and engaged enthusiasm that was both immediately ingratiating and commanding. Swinton, who is 44, was wearing no trace of makeup, a print sundress and flip-flops, and her hair, which is naturally red, was dyed white-blond. "I love the roots," she said, as she tilted her scalp forward for inspection. "That's the best part of being this blond."

Her unique looks, her ease with herself and her voracious interest in the more esoteric worlds of cinema and style have made Swinton a kind of goddess of the avant-garde. In her movies, she has continually transformed herself — changing class, nationality, gender. For "Orlando," perhaps her most famous film, she played multiple incarnations of the title character, including a man. In "Thumbsucker," opening in theaters on Sept. 16, she is utterly convincing as a suburban American mom. The director Jim Jarmusch cast her as an ex-girlfriend of Bill Murray's in the recent "Broken Flowers," in which she is terrifying, her face half-obscured by a foreboding curtain of long brown hair. For "The Chronicles of Narnia: The Lion, the Witch and the Wardrobe," a big-budget movie that is due out from Disney at the end of the year, Swinton

Fig. **3-6** /// **THE NEW YORK TIMES MAGAZINE, "WHITE MISCHIEF"**

- *Creative Director:* Janet Froelich, *The New York Times Magazines*
- *Designer:* Janet Froelich
- *Photographer:* Raymond Meier

On this opening spread for an article, we see parallel shapes and forms on the facing pages, with each page having a central axis that parallels the other, contributing to balance and unity. The block of text type on the left page takes on typographic color and the subheading has typographic texture.

on a tonal quality, creating a block of gray tone (see Figure 3-6). Typographic texture is established through the spacing of letters, words, and lines; by the characteristics of the typeface; by the pattern created by the letterforms; by the contrast of roman to italic, bold to light; and/or by the variations in typefaces, column widths, and alignment. Consider the relationship among type sizes in the same composition. Different typographic textures create contrast and visual interest on page or screen. Here is a tip: Stand back and squint at typography to get a sense of its lightness or darkness, its tonal quality, or view it in a mirror.

TEST
Experiment by testing how the typefaces work in various combinations: heading plus paragraph; short and long paragraphs; headings, subheadings, captions; and so forth.

CHOOSE A TYPE FAMILY, EXTENDED FAMILY, OR SUPER FAMILY
Pair any from among a family, extended family, or super family.

USE DECORATIVE FACES WITH GREAT CAUTION
Decorative faces include outlines, in-lines, stencils, faceted, shaded, and shadowed letters. Some have endured, such as those based on copperplate engravings or wood type. Decorative faces tend to be highly ornamental. Because decorative faces tend to overwhelm a design (and designer), they should be left to sea-

soned designers. If you must use a decorative face, *use it for display type in very small quantities and mix with a timeless face for text.* Avoid using a decorative typeface for text type.

ALIGNMENT
Arranging text type is called **type alignment** (Diagram 3-9). The primary options are as follows:

→ *Left-aligned:* text aligned to the left margin and ragged or uneven on the right side; it is also called *left-justification* or *flush left/ragged right.*

→ *Right-aligned:* text aligned to the right margin and ragged or uneven on the left margin; it is also called *right-justification* or *flush right/ragged left.*

→ *Justified:* text aligned on both the left and right sides.

→ *Centered:* lines of type centered on an imaginary central vertical axis.

→ *Runaround:* type wraps around an image, photograph, or graphic element; it is also called *text wrap.*

→ *Asymmetrical:* lines composed for asymmetrical balance—not conforming to a set, repetitive arrangement.

SPACING

When setting type, whether it's a big, two-word headline or a big, two-hundred-page document, one of the most overlooked aspects is the space between the letters, the words, the sentences and the paragraphs. This is as important as which typeface you choose and at what size you use it. Everyone can look at type and design with it but it takes a real craftsperson to look at the negative space and define the true relationship within the typography. Whether it's loose or tight, it has to be consistent and pleasurable, and it's right there, you just have to shift your attention.

—Armin Vit
UnderConsideration LLC

Spatial intervals occur between letters, between words, and between two lines of type. Spacing should enhance reader comprehension or, at the very least, enrich the reader's experience (unless, of course, your concept and approach call for purposeful dissonance). If people have difficulty reading something, they probably will lose interest. *Spacing is about transitions*—from letter to letter, from word to word, from line to line, from paragraph to paragraph, from page to page, from screen to screen. Seventy percent of how you design with type depends on how well you craft transitions!

→ **Letterspacing** is the spatial interval between letters. Adjusting the letterspacing is called **kerning**.

→ **Word spacing** is the spatial interval between words.

→ **Line spacing** is the spatial interval between two lines of type measured vertically from baseline to baseline, which is traditionally called **leading**.

In metal type, strips of lead of varying thickness (measured in points) were used to increase the space between lines of type. Many people still use the term *leading* to mean line spacing.

When a character is produced digitally, the software automatically advances in numbers of units before generating the next character. When designing display type, do not rely on automatic spacing. You can control the letterspacing by adding or subtracting units between letters to improve readability.

Design matters

Design matters

Design matters

Dia. **3-10** /// SPACING ISSUES

Although there are preset calculations for each font, designers should consider the type as form, adjusting letter, word, and line spacing for balance and visual relationships (Diagram 3-10). Consider adjusting spacing between adjacent characters based on their shapes.

In metal type, letterspacing and word spacing are produced by the insertion of quads—metal blocks shorter than the type height—between pieces of metal type. Both traditionally and today, an *em* is used as a unit of measure. An em is the square of the point size of any type—a unit of type measurement based on the M character. One half of an em is called an *en*.

In digital typography, spacing is controlled using a unit system. A unit is a subdivision of the em, used in measuring and counting characters in photographic and digital typesetting systems.[3] The unit is a relative measurement determined by dividing the em into thin, equal, vertical measurements. When characters are digitally generated, each has a unit value including space on either side of the letter for the purpose of letterspacing, which can be adjusted by the designer.

3. Rob Carter, Ben Day, and Philip Meggs. *Typographic Design: Form and Communication*, 3rd ed. Hoboken, NJ: Wiley, 2002, p. 293.

You should always judge letterspacing optically. This fine-tuning of negative space is a hallmark of typographic excellence.

TEXT TYPE: SPACING, CHUNKING, PACING, AND MARGINS

Spacing. When designing text, check word spacing, line length, and the unevenness of a ragged edge. Also, check for awkward configurations, such as a widow, a very short line of text or word that appears at the end of a paragraph, and an orphan, a word or short line at the beginning or end of a column that is separated from the rest of the paragraph.

Consider the point size of the typeface in relation to the amount of spacing. For example, small point sizes set with a lot of leading will seem lost and hard to read. Generally, longer line lengths should take more leading to offer some spatial breathing room.

Too much interline and interword space may detract from readability. Conversely, too little interline and interword space may make reading difficult. As stated earlier, you must not trust automatic spacing. Always make optical adjustments. In display and text, uneven letterspacing and word spacing may cause unwanted pauses or interruptions that make something more difficult to read. John Sayles advises being aware of line breaks and suggests reading the copy as you lay it out, following the same process as the reader, to ensure a flow.

If the line length is too long or too short, it will detract from readability. Some designers say that if you have open letterspacing, the word and line spacing should be open. Conversely, if you have tight letterspacing, the word and line spacing should be tight as well. Much depends on the typeface or type family you are using and the point sizes, weights, and widths. Some typefaces seem to lend themselves to more open spacing because of their shapes, whereas others lend themselves to tight spacing. Study specimens of display and text type to develop a keen sensibility for typefaces, weights, and widths.

Chunking and pacing. When we read a novel, we see a page with one column of text. Paragraphs help break up the one-column page of a novel. In newspapers, reports, brochures, and even textbooks, content is most appealing when broken into modules, into chunks of text. For any screen-based communication, chunks of text are the best arrangement. When you modularize content, it is broken into manageable, digestible units. Many people scan written content for specific information, which is enabled by chunking along with other devices such as rules, subheadings, color, or other ways to create emphasis. On screen, readers find it easiest to take in information and absorb it in module doses.

How you arrange modules or chunks will create a reading pace. Depending on the background color, typeface and typeface color, each chunk will become a tonal unit and help or impede moving from one unit to another.

Pacing involves creating a visual sense of rhythm, syncopation—creating variation and allowing the reader's eyes a rest somewhere in the text.

Margins. Understanding margins as borders—as presenting text—aids in respectfully *framing* text, giving enough distance from the boundaries of a page, in print, or on screen to allow a reader to focus. Margins can be used creatively, but never ignored or violated without purpose.

BASIC TYPE SPECIFICATIONS FOR PARAGRAPHS

Type size and leading are indicated by placing one number over the other; for example: 10/11 indicates a type size of 10 points with 1 point leading; 8/11 indicates a type size of 8 with 3 points leading. The amount of leading you choose depends on several factors, such as the type size, the x-height, the line length, and the length of the ascenders and descenders. When a designer does not want additional space between lines, type is set *solid*; that is, there are no additional points between lines, such as 10/10 (Diagram 3-11).

The most important thing to keep in mind when designing with type is that its purpose is to communicate. It needs to be comprehended, usually quickly and easily.

Type is inherently verbal in nature. That's not to say that it doesn't have a visual component as well. Every typeface has characteristics that convey meaning, however subtle or overt. Consider blackletter, wood type, and script faces. Letterforms from these categories contain an abundance of culturally informed information.

But the visual aspects of type are meant to reinforce the verbal message. They provide context for the voice of the speaker, whether an individual or institution. As such, type choice is a critical aspect of effective communication.

In addition, type treatment provides subtle levels of meaning to the reader.

Violations of typographic norms can communicate in their own right, but they usually result from lack of care or skill on the part of the designer. Following these norms with respect to letterform proportion, letterspacing, wordspacing, leading, etc., results in messages that effectively convey the meaning of the speaker.

—Chris Herron
Chris Herron Design, Chicago

10/10 Gather material and inspiration from various sources and bring them together. Examine other cultures and draw inspiration from diverse styles, imagery, and compositional structures. Go to the movies, look at magazines, listen to comedians, read humorists's works, watch music videos, look at all graphic design, and observe human behavior.

10/11 Gather material and inspiration from various sources and bring them together. Examine other cultures and draw inspiration from diverse styles, imagery, and compositional structures. Go to the movies, look at magazines, listen to comedians, read humorists's works, watch music videos, look at all graphic design, and observe human behavior.

10/12 Gather material and inspiration from various sources and bring them together. Examine other cultures and draw inspiration from diverse styles, imagery, and compositional structures. Go to the movies, look at magazines, listen to comedians, read humorists's works, watch music videos, look at all graphic design, and observe human behavior.

Dia. **3-11** /// TYPE SIZE/LEADING CHART

Indication of type size and leading; the type size and the amount of leading you choose will enhance or detract from readability.

PAGE COMPOSITION: VOLUME OF TEXT VERSUS IMAGES

Communication goals and requirements, the kind of format and content—the volume of text and images—guide your type decisions about structuring a page(s).

TEXT HEAVY

If a project is text heavy, it should narrow your choices to typefaces that are eminently readable as well as a typeface from an extended type family, which offers many options while sustaining unity. *Running text* is text that continues from column to column, often filling a page in a history textbook, a newspaper, or a government website.

TEXT AND IMAGES

If a project has an almost equal volume of text and images, then you need to select a highly readable typeface based on your design concept, audience, and context (print or screen and environment). The typeface should integrate in an appropriate and aesthetic manner with the images. Also consider how the type will act as text, caption, and perhaps display type all in relation to the images.

IMAGE HEAVY

If a project primarily relies on images, mostly requiring display type (title or headline)—for example, a cover, poster, advertisement, social media ad, or web banner—then your typeface selection is governed by design concept and context. For display type, some people argue that a well-designed sans serif typeface is most legible—easiest to recognize. Others argue that serifs aid in distinguishing one letter from another. For display type, legibility is a concern because people tend to read titles and headlines very quickly. Judicious spacing and larger point sizes increase the readability of display type. A clear visual hierarchy encourages a reading sequence.

CAPTION HEAVY

If a project predominantly calls for captions or tables—for example, a catalog, map, art book, or photo-sharing website—then your selection should consider how readable the face is at a smaller point size and how well it integrates with the images.

FACILITATING THE READING OF TEXT TYPE

Socrates is attributed with extolling the desirable quality of moderation—"take everything in moderation; nothing in excess." If we apply this axiom to facilitating reading, then:

→ Long line lengths impede readability.

→ Very small point sizes and extreme column depths impede readability.

→ Very open spacing and very tight spacing impede readability.

→ Left-justification or justified text type alignments are most readable.

→ When composing text type, headings, and subheadings, break text into manageable chunks.

→ Larger x-heights enhance readability.

→ Avoid extreme raggedness, widows, and orphans.

◊ The irregular side of a left-justified or right-justified block of text type should not be extremely ragged. Any ragged edge should not impede reading. Major variation in line lengths will result in negative shapes that interrupt the flow of moving from one line to the next.

◊ Avoid a widow, a short line or single word at the end of a paragraph. Widows do *not* contribute to balance. The last line length of a paragraph should be long enough to act as a base or platform.

◊ Avoid starting a page with a word or short line at the beginning of a column that is separated from the rest of the paragraph on the previous page.

Variation and contrast in text type aid reading. Create variation in text type with

→ a pull quote

→ an image

→ an initial cap (large letter used at the beginning of a column) or drop initial (a display letterform set into the text)

→ a color

→ a rule(s)

→ a paragraph that starts with small caps or all caps

→ a graphic element

→ a simple graphic, or dingbat

→ anything that makes sense for your concept and adds some variation, some rest stop of visual interest, for the reader

ORCHESTRATING THE FLOW OF INFORMATION

There are several ways to achieve emphasis within an entire composition using typography:

→ emphasis by isolation

→ emphasis by placement

→ emphasis through scale (size relationships of title to subtitle to text as well as to images)

→ emphasis through contrast

→ emphasis through direction (see Figure 3-7)

→ emphasis through diagrammatic structures

There are also ways to achieve emphasis in text type:

→ size

→ color

→ boldface

→ italics or bold italics

→ typeface change

→ type style change—variations in weight (light, medium, bold), width (condensed, regular, extended), and angle (roman or upright and italic), as well as elaborations on the basic form (outline, shaded, decorated)

Fundamental organizational principles also apply to typographic design. When arranging typographic elements, besides visual hierarchy, you should consider rhythm and unity. You direct the reader from one typographic element to another by establishing a visual hierarchy and *rhythm* (a pattern created through position of components, intervals, repetition, and variation), by considering the space between elements, and by establishing a sense of movement from one element to another, as in Figure 3-8.

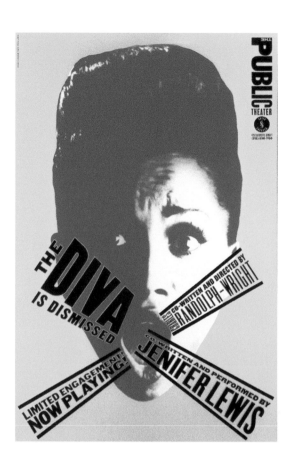

Fig. **3-7** /// POSTER: THE DIVA IS DISMISSED

PENTAGRAM, NEW YORK

- *Partner/Designer:* Paula Scher
- *Designers:* Ron Louie, Lisa Mazur, Jane Mella
- *Photographer:* Teresa Lizotte
- *Client:* Public Theater, New York

"When Joseph Papp was producer at the Public Theater, Paul Davis produced a memorable series of illustrated posters which set the standard for theater promotion for nearly a decade. In keeping with the expanded vision of new producer George C. Wolfe, an identity and promotional graphics program were developed to reflect street typography: active, unconventional, and graffiti-like. These posters are based on juxtapositions of photography and type.

"*The Diva Is Dismissed* was Jennifer Lewis's one-woman show."

—*Pentagram*

Fig. **3-8** /// POSTER: THE NEW YORK BOOK SHOW

- *Designer:* Ray Cruz, Oakland, NJ
- *Client:* The Bookbinders' Guild of New York

The viewer can easily flow from one piece of information to another due to placement and intervals in the composition as well a clear visual hierarchy.

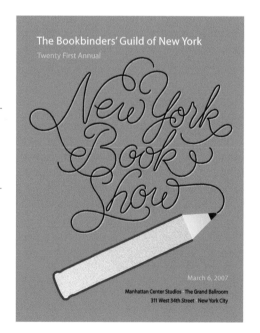

To establish *unity*, limit type alignments (for a novice, employ one alignment), consider employing a type family rather than mixing faces or mix two faces at most, intentionally integrate type and visuals using a sympathetic type/image relationship or contrast, use color to unify, and aim for correspondence among graphic elements.

In the logo design by Red Flannel, between the type and image, Jim Redzinak finds what is called an intuitive alignment, finding edges that seem to naturally align well together (Figure 3-9), where the word *Spirit* seems to "fit" naturally in the negative shape of the butterfly.

Spirit of a Child Foundation

Fig. **3-9** /// LOGO: **SPIRIT OF A CHILD FOUNDATION**

RED FLANNEL, FREEHOLD, NJ

• *CD/Designer/Illustrator:* Jim Redzinak

"This logo symbolizes the metamorphosis of the dysfunctional cycle of destructive parent-child relationships, transforming them into something more meaningful and rewarding through their experiences with nature. It represents a new beginning for the children and their parents."

—*Jim Redzinak*

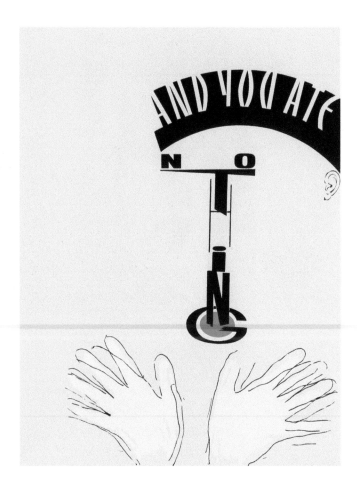

Fig. **3-10** /// POSTER: **AND YOU ATE NOTHING**

• *Ed Fella*

HANDMADE/HAND-DRAWN TYPE

Although most designers rely on selecting from among digital typefaces, others make use of handmade type. Try hand-drawn, collaged type or found type, which includes photographed type (for example, see neonmuseum.org). Some designers focus on hand-drawn typography, such as Ray Cruz (Figure 3-8), Ed Fella (Figure 3-10), and Mike Perry (Figure 3-11).

WEB TYPE BASICS

The basic rules about typography apply to print as well as to screen media. As in the design of the website for USC Law, web typography should be eminently legible and readable with a clear visual hierarchy of information (Figure 3-12).

LEGIBILITY

Select for

→ ample x-height

→ open counters

→ modest stroke contrast

→ sufficient stroke weight (avoid modern typefaces with thin strokes)

→ simple shapes, which are easier to read (on screen, sans serif typefaces tend to be more legible, especially for numbers)

And to guarantee legibility, set type slightly bigger for the screen than you would for print.

READABILITY

→ The greatest contrast between the color of the type and the background color offers the best reading experience—for example, black type on a white background or red type on a white background. Reverse type, white type on a black background, is often difficult to read in print but works better on screen.

URBAN URBAN
URBAN

Fig. **3-11** /// TYPOGRAPHY:
URBAN OUTFITTERS

• *Mike Perry*

 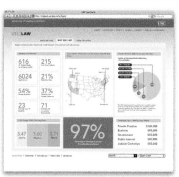

Fig. **3-12** /// WEBSITE: USC LAW

ADAMSMORIOKA, INC., BEVERLY HILLS, CA

• *Creative Directors:* Sean Adams, Noreen Morioka

• *Art Director:* Monica Schlaug

• *Designer:* Christopher Taillon

Fig. **3-13** /// EDITORIAL ILLUSTRATION: "SO FIVE MINUTES AGO"

THIRST/3ST.COM

- *Typography:* Rick Valicenti/Thirst/3st.com
- *3D Illustration:* Rick Valicenti/Thirst/3st.com and Matt Daly/Luxwork
- *Client: i4Design Magazine*, Chicago

"The typographic geometry is consciously rendered by Paul Rand's YALE logotype and by looking back to this master's iconic work, the continuum in which we practice design is acknowledged and respected."

—*Thirst/3st.com—a design collaborative*

→ Bright colors detract from readability. Specifying a larger pixel size adds readability to saturated colored type.

→ Keep line lengths a bit shorter for screen than for print. Keep text type line length to no longer than about twelve words.

→ Design the text type in chunks. A large text block is not inviting on screen. People prefer to read text in smaller chunks or short paragraphs.

→ More so than in print, a condensed type style and very tight spacing may diminish readability.

VOICE AND BRANDING

→ Make sure the typeface selection is appropriate for the brand or entity.

→ Typeface selection can help differentiate a brand. (*Caution:* Typefaces selected for a brand or group's identity may work in print but may not translate well to the screen—for example, a modern classification with very thin strokes.)

→ Any display typeface should support the logo, not fight with it for attention. Maintain enough area of isolation (margins of white space) around the logo.

→ The typeface's voice should enhance communication.

VARIETY

→ As in print, a type family, extended family, or super family offers a variety of weights and widths.

→ Select type styles for weight and width contrast.

SELECTING TYPEFACES FOR SCREENS

There are many typefaces for use on screen available for dynamic download from the cloud. You can purchase web fonts from reputable type foundries online. Many web font purchases include a font for print as well.

EXPRESSIVE TYPOGRAPHY

In addition to understanding the fundamentals of design and how they relate specifically to designing with type, it is essential to understand how type is used creatively and expressively. Furthermore, type can be the design solution. In Figure 3-13, an editorial illustration for *i4Design Magazine*, Rick Valicenti/Thirst/3st.com creates, ". . . a comment on architecture's ephemeral fashionable presence is rendered in polished stainless."

About Figure 3-14, a personal work made public for "5:12: China's Massive Earthquake: A Commemorative Exhibition" in Nanjing, Rick Valicenti/Thirst/3st.com comments:

Fig. **3-14** //// INFECTED

THIRST/3ST.COM, CHICAGO

- *Studio/Designer/Typography:* Rick Valicenti/ Thirst/3st.com
- *Client:* Personal work made public for "5.12: China's Massive Earthquake: A Commemorative Exhibition," RCM Art Museum, Nanjing

Fig. **3-15** //// POSTER: IF NOT NOW, WHEN?

MENDEDESIGN, SAN FRANCISCO

- *Art Director:* Jeremy Mende
- *Designers:* Jennifer Bagheri, Amadeo DeSouza, Jeremy Mende
- *Client:* AIA CALIFORNIA COUNCIL California Practice Conference

My entry was inspired by the calligraphy on display at the Chinese National Museum in Shanghai. I decided to enter my journal entries in large form and physical in expression. My marks were made with Sumi ink applied with either a syringe or a foam brush on 22 × 30" Rives BFK. Gravity's influence is also a central component within the temporal nature of this making process. Since the beginning of 2008, I have made over 500 entries.

In Figure 3-15, Jeremy Mende expresses a conference theme in unique typography. The Mesa Grill logo is a play on the word *mesa*, which means "flat-topped mountain" (Figure 3-16).

Type should always be an active contributor and can, in fact, express the entire message, as in Figure 3-17 where the *O* becomes an image. Providing equal access to the law is conveyed through the expressive typography in Figure 3-18, an annual report for Chicago Volunteer Legal Services, one of the largest law firms in the city.

About the type design for *The Fate of the Nation State* (Figure 3-19), David Drummond says: "This book deals with the future viability of nation-states in the context of globalization. I don't often do type-only covers but when I do I try to add a twist and have type interact in some way with the created environment."

For this sophisticated love story with a twist, the arrowheads perfectly replace letters to express the narrator's emotions (Figure 3-20). Some designers and design studios have different design expertise, including designing typefaces, such as Figure 3-21, display type design by Topos Graphics.

Fig. **3-16** /// LOGO: MESA GRILL

ALEXANDER ISLEY INC., REDDING, CT

- *Client:* Mesa Grill

P☀LARIS

Fig. **3-17** /// LOGO: POLARIS

REGINA RUBINO / IMAGE: GLOBAL VISION - SANTA MONICA, CA
AND HONG KONG, BEIJING, SHANGHAI, CHINA

- *Creative Directors:* Robert Louey, Regina
Rubino

Fig. **3-18** /// ANNUAL REPORT: CHICAGO VOLUNTEER
LEGAL SERVICES

LOWERCASE, INC., CHICAGO

- *Art Director/Designer/Illustrator:* Tim Bruce
- *Photographer:* Tony Armour
- *Client:* Chicago Volunteer Legal Services

"Chicago Volunteer Legal Services provides
legal assistance to roughly 17,000 people a year
in the Chicago area. They accept no government
funding, are lean and entrepreneurial. Our
books help them increase awareness for their
work, raise money and recruit talent. Each of the
books reflects this purpose and yet captures the
year and point of view uniquely."

—*Tim Bruce, LOWERCASE, INC.*

Fig. 3-19 /// BOOK COVER: *THE FATE OF THE NATION STATE* EDITED BY MICHEL SEYMOUR

SALAMANDER HILL DESIGN, QUEBEC

- *Designer:* David Drummond
- *Client:* McGill–Queen's University Press

EDITED BY MICHEL SEYMOUR

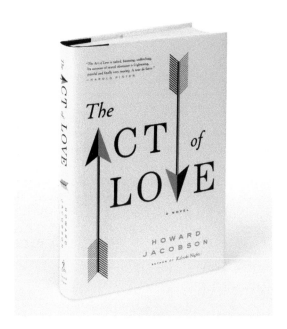

Fig. 3-20 /// BOOK COVER: *THE ACT OF LOVE: A NOVEL* BY HOWARD JACOBSON

- *Jacket Design:* Catherine Casalino
- *Creative Director:* Jackie Seow
- *Publisher:* Simon & Schuster

Fig. 3-21 /// DISPLAY TYPE: *GRUS*

TOPOS GRAPHICS, BROOKLYN, NY & MIAMI, FL

- *Art Direction and Design:* Seth Labenz and Roy Rub

"Inspired by the Japanese tradition of giving a Senbazuru—1,000 paper cranes held together by string—we designed *Grus*, a display typeface in three weights."

—Topos Graphics

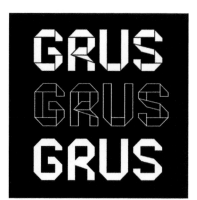

Case Study

Balthazar Restaurant Mucca Design

Keith McNally, the man behind Café Luxembourg, Odeon, Nell's, Lucky Strike, Pravda, Schiller's, and Pastis, is one of New York's most successful restaurateurs—a truly inspired and inspiring visionary and one of Mucca's favorite clients.

As with most of the projects we've undertaken with McNally, the process of creating Balthazar Restaurant was deeply involved and truly collaborative. It was immediately apparent to the Mucca team that the Balthazar identity had to communicate McNally's obsession with quality and detailed authenticity. From the logos and signage to menus and matchboxes to packaging and delivery vans, every part of the Balthazar brand was designed and orchestrated to give it the feel of a place that had evolved over generations to become the familiar institution that it is now.

MuccaTypo created the Decora Typeface (based on vintage Victorian examples) specifically for Balthazar packaging, and gathered dozens of other fonts and faces to support it. Elements of the brand identity are leveraged throughout the restaurant and have become widely recognizable symbols of quality and luxury.

With the overwhelming growth of Balthazar's popularity came several extensions of the brand, including Balthazar Bakery and its wholesale division, as well as its popular gift items and famous cookbook, all of them designed by the Mucca team. Though they share defining characteristics, each new division or extension of the central Balthazar brand was given an individual identity with its own color scheme and typographical system in order to clarify the unique brand proposition.

Balthazar is now one of New York's most popular restaurants. Widely recognized as an institutional landmark and credited with sparking the revitalization of several city blocks in lower Manhattan, the McNally flagship is also highly regarded as a singularly successful and multifaceted luxury brand.

—Mucca Design

BRANDING: BALTHAZAR

- *Mucca Design Corporation, New York*

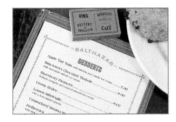 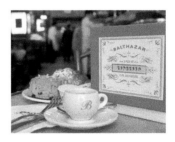

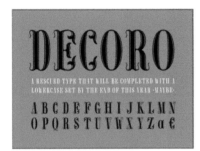

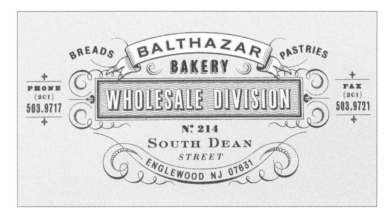

Exercises and Projects

Go to GDSOnline for more exercises and projects. ✈

Exercise 3-1

Design Your Name

01. With the notion that your handwriting is you, your identification, write your name. Determine if your signature has any features that might characterize your personality.

02. Write ten adjectives that describe your personality.

03. Find typefaces that express your personality.

04. Design your name in ten different typefaces that you believe are appropriate.

05. Now, hand make, hand draw, or hand letter the letterforms of your name retaining any quirks or imperfections that might characterize you.

06. Give careful consideration to the spacing between the letters and words.

Project 3-1

Design a Type-Driven Poster

Choice of subject: Healthier kids or flu prevention

STEP 1

01. Choose from: Healthier kids (http://www.letsmove.gov/) *or* flu prevention (http://www.cdc.gov/flu/). Research your subject.

02. In one sentence, write your objective. For example, motivate kids to move more and sit less. Or, motivate people to wash their hands more often to avoid spreading germs. Define the purpose and function of the poster, the audience, and the information to be communicated.

03. Find one interesting fact. Use this fact as the basis for writing a headline.

STEP 2

01. Find typefaces that express the spirit of the subject. Or use handmade or found type or a combination of handmade type and a typeface.

02. Design a poster that is type driven—that is, type mostly carries the message of the poster. If you use any image, it should play a secondary role to the type-driven composition.

03. Produce at least twenty sketches.

STEP 3

01. Choose two of your best sketches and refine them.

02. Establish emphasis through a visual hierarchy.

03. Carefully examine the spacing between letters, among words, and between lines of type.

STEP 4

01. Create a finished solution.

02. The poster should be no larger than 14" × 17" when held in portrait or landscape orientation.

PRESENTATION

Present your solution mounted with a 2" border all around or display on screen.

THE DESIGN PROCESS

THE GRAPHIC DESIGN PROCESS

FIVE PHASES OF THE DESIGN PROCESS

Orientation ▶ Analysis ▶ Conception ▶ Design ▶ Implementation

PHASE 1: ORIENTATION

Phase 1 is **orientation**—the process of becoming familiar with your assignment, the graphic design problem, and the client's business or organization, product, service, or group. Usually, junior designers and junior art directors or copywriters are not involved in strategic planning or in design brief formation. More often, juniors are challenged by a simple design brief that has been distilled for them by their design director or art director.

WHO CONDUCTS THE ORIENTATION?

During this initial phase, you and your team learn about the assignment. Since designers and art directors work in a variety of settings, who conducts the orientation and how it is conducted depends on the nature of your firm. Designers work in design studios (small, medium, and large), advertising agencies, publishing houses, in-house corporate and nonprofit organizations, educational institutions, and any setting where a designer's expertise may be required. Perhaps it is an in-house design department for a retail chain, a regional design studio, a global ad agency, or the design unit of a charitable organization. Therefore, a variety or combination of individuals might conduct an orientation: the client, the client's team, an account manager or team from your own studio or agency, your design director or creative director. Other possibilities are an editor, an in-house marketing executive, or any individual who is the liaison with a client in charge of the assignment.

OBJECTIVES

01 LEARN PHASE 1 OF THE DESIGN PROCESS: ORIENTATION

02 LEARN PHASE 2 OF THE DESIGN PROCESS: ANALYSIS

03 GAIN KNOWLEDGE OF A DESIGN BRIEF

04 LEARN PHASE 3 OF THE DESIGN PROCESS: CONCEPTION

05 UNDERSTAND THE STEPS OF CONCEPT GENERATION

06 LEARN PHASE 4 OF THE DESIGN PROCESS: DESIGN

07 LEARN PHASE 5 OF THE DESIGN PROCESS: IMPLEMENTATION

Ascertaining essential information happens during this phase. Before sketching, you need to gather and absorb a good deal of information. Although there are legendary stories of seasoned designers who, during the first client meeting, sketch their logo solutions right there and then, most designs are not generated that way. For instance, Paula Scher, a Pentagram partner, sketched the Citibank™ logo during the first client meeting. For Taco Bueno, a regional restaurant chain, former Pentagram partner Lowell Williams said about the development of the wordmark, "We did the original design, the conceptual part, on a napkin. Woody Pirtle was in [our office] at the time, and I asked him to draw out the idea." Woody Pirtle sketched his poster concept for the Art Directors Association of Iowa on a napkin; see Figure 4-1.

Fig. **4-1** /// POSTER: ART DIRECTORS ASSOCIATION OF IOWA

PENTAGRAM, NEW YORK

- *Designer/Illustrator:* Woody Pirtle, Pentagram
- *Client:* Art Directors Association of Iowa

"This design was developed from a sketch Woody Pirtle made with a fountain pen on a napkin."

—*Sarah Haun, former Communications Manager, Pentagram*

→ What are the functional benefits (useful assets) and the emotional benefits (assets based on feelings)?

→ How does the brand or group compare to the competition? Is the brand or group a category or industry leader? In second place? A newcomer?

→ Is the brand or group relevant to its target audience?

→ What is the five-year plan for this brand or group? Ten-year plan?

For information design, here are additional questions:

→ How should it function? What form should it take?

→ What are the audience's limitations?

→ How can we best display this type of information?

→ What is the context? Where and how will this format be seen?

For editorial design, here are additional questions:

→ Is it a new publication or an existing publication? Is it a supplemental publication?

→ What is its function?

→ What is the context? Where, when, and how will this publication be seen and in which media and on which platforms (mobile, tablet [orientation], computer screen)?

→ What is the subject of the editorial content? Who is the author or editor? When will I have access to the content (entire publication, summary, synopsis, proposal)?

→ What are the audience's limitations (vision, language, reading level)?

For environmental design, here are additional questions:

→ What is its function?

→ What type of space is it?

→ How will the design solution work with the interior design and architecture?

For most assignments, there are standard questions, and some will be revisited during the next phase of analysis.

→ What is the nature of the assignment? Is it an individual format or part of a broader project/strategy?

→ What does the assignment entail? What is its role in a broader scheme?

→ Who is the audience?

→ How is this project relevant to its audience?

→ Does a similar solution already exist?

→ What is the media plan? Budget? Deadline? Other parameters?

For a brand or group (nonprofit organization, educational institution, company, human services, any entity that is not a branded product or service), here are additional questions that will help obtain information:

→ Is the brand or group new, established, merging, or being rethought? A start-up? Known or unknown? Regional, national, or global?

→ What makes this brand or group (organization, company, any entity) unique?

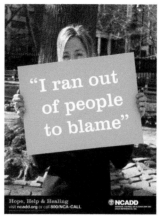
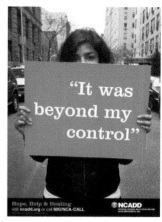

Fig. **4-2** /// POSTERS: HOPE, HELP & HEALING CAMPAIGN FOR THE NATIONAL COUNCIL ON ALCOHOL AND DRUG DEPENDENCY (NCADD)

- *Designer:* Lara McCormick
- *A Sappi Ideas That Matter Grant Recipient*
- *NCADD:* Description

"Founded in 1944, NCADD is the oldest advocacy organization addressing the disease of alcoholism and other drug addictions focusing on education, awareness, policy and advocacy."

- *Strategy*

"Each poster set targeted a different audience; young people (under 21), the general public, and family. Because of the anonymity factor associated with recovery, I did not want the campaign to use images of people that showed their identity. For the posters, I took photographs in which the faces of individuals could not be seen."

—*Lara McCormick*

→ Where will it exist?

→ What are the audience's limitations?

→ Will I be collaborating with an interior designer? Architect?

→ What is the context?

Orientation also involves reviewing and evaluating the current graphic design solutions, branding, and/or advertising program created for this product, service, or group. How well did those solutions fare? How does the client consider those solutions? How does the public or audience perceive and respond to the existing solutions? What are the analytics (data analysis)? What is the performance measurement, the return on investment (ROI)? This process is referred to as a marketing audit, a methodical examination and analysis of existing and past marketing for a brand or group. A competitive audit is an examination and analysis of the competition's branding efforts with the intention of best understanding how the competitors position themselves in the marketplace, their functional and emotional advantages and disadvantages, and who their audiences are.

THE AUDIENCE

Equally important during orientation is learning about the **audience**—the targeted, specified group of people at whom you are aiming your visual communication. The audience is the main *relevant* group who would purchase this brand or utilize this information, service, or product, or patronize this entity or who can influence others. Knowing about the audience is critical. For example, in Figure 4-2, *Hope, Help & Healing*, a campaign for the National Council on Alcohol and Drug Dependency (NCADD), "The audience is in recovery, the average age is 48, and only one fifth are 30 and below (Alcoholics Anonymous survey). *Hope, Help & Healing* targets addicts and alcoholics between the ages of 20–35, and their family and friends. The goal is to get people into recovery at an earlier age." Designer Lara McCormick's goal was to make the process of recovery inviting and easy to understand. The posters also encourage people to call the NCADD hopeline or visit their website to get more information about how to get themselves or someone they know into recovery.

For HBO (Figure 4-3), Visual Dialogue viewed the design problem this way: "How do you reach an urban, cutting-edge 12- to 35-year-old demographic if you're HBO?" Their solution: "Start a new online portal, of course. (This is an audience that is always online.) Give it a cool, evocative name like volume.com. And then hire Visual Dialogue to create a logo, which a 15-year-old marketing cynic wouldn't mind sticking on his skateboard," explains Fritz Klaetke, design director.

Fig. **4-3** /// **VOLUME.COM LOGOS FOR HBO**

VISUAL DIALOGUE, BOSTON

- *Design Director:* Fritz Klaetke
- *Designers:* Fritz Klaetke, Ian Varrassi

If we go deeply enough, or far enough, we nearly always find that between every product and some consumers there is an individuality of relationship, which may lead to an idea.

—James Webb Young

from *A Technique for Producing Ideas*

MATERIAL GATHERING: GETTING ALL THE INFORMATION

To design, first you must learn about the sector, the product, service, company, or organization, the company's history, core values and attributes, mission, and of course, the audience. If your assignment is to design a logo for a farm tractor manufacturer, you need to learn about farm tractors, a farm tractor's purpose and utility, who purchases and uses tractors, the marketplace for such equipment, as well as competing farm tractor brands. Unless you are an expert on farm tractors, you'd have to collect information. And even if you are an expert, you'd still need to learn about your client's farm tractors and that company's goals, objectives and mission, philosophy, points of distinction, and the competition. If your assignment is to design packaging for an energy beverage, even though you might be more generally familiar with that product category than with farm tractors, you still would have to gather materials and orient yourself to your client's product and needs. Every designer must be informed about his or her sector under assignment, the client's business, and the problem under assignment.

GATHERING INFORMATION THROUGH LISTENING

During this first phase of the design process, you get the lay of the land and obtain as much raw materials as you can. In most cases, the client or individual (executive, editor, creative director, other) in charge of the project provides a good deal of information. This person is the expert about his or her brand or group. That certainly does *not* qualify the client (or account executive or editor) to design, but it does mean that you should listen carefully to the information this particular expert can offer—to what the client says about the problem, audience, and marketplace—and thoughtfully examine the information provided by the client. (For more about this, please see Showcase: From Start to Finish by Dave Mason, SamataMason on page 94 of this chapter.) Often, an active listener can identify an insight, pluck it from all that is said, by carefully paying attention to what the client (or individual in charge) says about the brand or group and about the competition. Active listening entails concentrating, focusing on the content of the speaker's message, interpreting what the client says and means, and actively reflecting on what has been said.

In an interview in *HOW* magazine, designer Mark Oldach advised:

Listen. Listen to how clients speak about their business, the language they use, the concepts they focus on and the initiatives that define what they do. Everything that I've learned about business, process and strategic communications has been through and with my clients. Sure, I read books and journals and take courses, but the vast amount of learning has been by listening to clients.[1]

1. Interview by Bryn Mooth. Eureka! Column, *HOW,* June 2002. http://www.zoominfo.com/Search/PersonDetail.aspx?PersonID=200486704

INDUSTRIES AND SECTORS

Characteristically, designers tend to be curious. Many designers value learning about a variety of industries and organizations. They enjoy discovery and gathering raw materials.

Industries and sectors include:

- Agriculture
- Airlines
- Alcoholic Beverages: Beer, Wine, and Spirits
- Animal Services
- Arts Organizations
- Automotive and Transportation
- Beverages
- Business Services
- Charity Organizations
- Childcare Organizations
- Churches and Religious Organizations
- Communications
- Consumer Products
- Education
- Energy and Utilities
- Entertainment
- Environmental Groups and Organizations
- Fashion
- Financial Services
- Food
- Government
- Healthcare
- Hotel and Hospitality
- Human Services
- Industrial Institutions
- Insurance Corporations or Organizations
- Music
- Nonprofits
- Political Groups or Organizations
- Private Foundations
- Public Foundations
- Real Estate
- Restaurants
- Retail

MATERIAL GATHERING

This involves:

- Becoming thoroughly acquainted with the brand or group: background, the entity's orientation/culture, core values, core attributes, information, data analysis, subject matter, history, industry or sector
- Understanding the client's goals and objectives, current and imminent hurdles, and listening carefully to the client about the assignment, brand or group
- Identifying how the immediate assignment relates to the entity's broader brand strategy and solutions (past, present, and future)
- Knowing the audience
- Making initial discoveries

Usually, the client provides most of the information. At times, the provided information, in part, comes from an outside market research firm. Other materials might need to be gathered, found, or researched by you or your design firm or advertising agency. Develop an understanding of conducting research. Learn where to look for and gather information. For Internet research basics, go to GDSOnline. ✈

Too many students skip material gathering with the naïve belief that it is not important. Perhaps many skip or rush this step because they find it not as engaging as the great adventure of designing. Not only does gathering information about the client's business help you solve the assignment, but it also enriches your general wealth of knowledge. With each client and assignment, you have the potential to become more informed about many subjects and industry sectors. Taking in more information, processing it, assimilating data, and putting it in its proper place contribute to original thinking.[2]

To best solve any visual communication problem, you need to complete this phase. For students working on class assignments without actual clients, your instructor becomes your client. You still need to gather materials, familiarize yourself with the brand or group under assignment, and actively listen to the instructor's orientation.

2. Sara Reistad-Long. "Older Brain Really May Be a Wiser Brain," *The New York Times*, May 20, 2008, p. F5. http://www.nytimes.com/2008/08/05/health/research/05mind.html

PHASE 2: ANALYSIS

In this phase, you are examining, assessing, discovering, and planning. You are *not* conceptualizing or designing during this phase of the design process.

ANALYSIS

Once Phase 1 is completed, the next phase is **analysis**—examining all you have unearthed to best understand, assess, and strategize to move forward with the assignment. After reflective thinking, you develop the direction your solution(s) will take. When you analyze, you

→ Examine each part of the problem

→ Concisely and accurately define constituent elements

→ Organize the information so it is broken down into parts that are easily analyzable

→ Draw conclusions based on your analysis that will allow you to move forward to the next step

DISCOVERY AND STRATEGY

Strategy is the core tactical underpinning of any visual communication. It unifies all planning for all design and copy within a strategic program or campaign. Essentially, the strategy is how you are conceiving, creating, and positioning your brand or group and aiming your graphic design in the marketplace to achieve differentiation, relevance, and resonance. A clearly defined strategy directs all strategic and creative expressions, and keeps the client and creative professionals on the same page.

Strategic questions include:

→ What's the message? What do you need to communicate?

→ Who is the audience?

→ Who is the competition? How have they addressed similar problems?

→ What is the marketplace like right now?

→ What is the client's actual problem versus what he or she perceives it to be?

→ What are the impediments to getting the message out and opportunities to communicate the message?

→ What is the call to action? Donate? Purchase? Go online? Make a phone call? Subscribe? Become aware? Take medication properly? Get tested?

→ Articulate the audience's incentive. What would propel people to take action?

THE DESIGN BRIEF

A **design brief** is a *strategic* plan that both the client and design firm or advertising agency agree upon, a written document outlining and strategizing a design project; it is also called a **creative brief**, brief, or creative work plan. (Strategy can be determined outside a design brief, as well.) Most important for designers and the creative team, strategy is a springboard for conceptual development.

Most design briefs are made up of questions and answers—a format used in an attempt to fully understand the assignment, the objectives of the project, the design context, and the audience. The answers to questions delineated in a design brief are usually based on predesign (preliminary) market research and information gathered about the product, service or group, and audience. Answers are predicated on the budget. Finally, the design brief becomes the strategic plan for implementing objectives. It is a written standard against which creative solutions can be measured. The client and creative professionals can go back to the brief for guidance, or designers can use it to support their concepts and/or solutions. A thoughtful, clear brief can foster creative concept generation.

Who Constructs the Design Brief?

Newer models of strategic planning include designers and art directors in design brief construction. From the project outset, integrated teams (client, strategists, planners, marketing or account managers, designers, copywriters, editors, tech professionals, architects, interior designers, industrial designers, among others) are more progressive. Integrated teams lead to broader strategic thinking, multiple perspectives, and foster greater collaboration. An integrated team considers multiple media channels of delivery simultaneously. *With screen media, an integrated team is critical to strategic planning.*

In small studios and agencies, junior designers might have the opportunity to work on writing a brief. In midsize and larger graphic design studios and agencies, junior designers are not likely to be part of design brief development. Everyone on the team, both marketing and creative professionals, should intimately understand the assignment, brand or group, and audience.

Each type of creative studio—design studio, agency, publisher, in-house studio—handles a brief differently. A brief can be written collaboratively between client and design firm or ad agency, or the client can give one to the design firm or ad agency. The design brief can be initiated by the client's marketing team or by the design firm or ad agency's strategic planner or creative director (CD) or design director. The brief may include input from the creative team, strategic planners, research or media department in the design firm or agency, or any related media unit.

Design briefs may take different forms.

→ In a design studio, the brief might be written by the design director or by the client's team.

→ In an advertising agency, most often, the strategic planner gives the creative brief to the creative team.

→ In publishing, instead of a brief, a synopsis or a manuscript will be provided to the book designer.

VISUAL BRIEF COLLAGE BOARD

A visual brief collage board is a visual way of determining strategy, an alternative to using written strategy. For example, Duffy & Partners first developed visual positioning collages for a brand revitalization for Fresca™ with the goal of designing a "new visual brand language" to communicate the intrinsic characteristics of Fresca. After focus group research for Fresca, Duffy reported, "Two design directions clearly rose to the top and were fused to form one visual brief for the brand" (http://www.duffypov.com/).

The advantage of visual briefs is their use as a tool with clients and focus groups (in market research, small groups of people are brought together to focus on a brand or design or advertising solution). Directions for color palettes, kinds of imagery, photography styles, and other graphic approaches can be narrowed down to distill a strategic goal. Client involvement at this phase almost guarantees client satisfaction because the client becomes part of the process early on.

SAMPLE DETAILED DESIGN BRIEF USED FOR BRANDING, VISUAL IDENTITY, PROMOTIONAL DESIGN, AND ADVERTISING

Question 1: What Is Our Challenge?

Every project has a goal and desired outcome. The project could be anything from the design of a comprehensive visual identity program to a single project such as the design of a brochure or poster. It could be for a new or established brand or group or for a merger. Succinct answers to these questions will aid concept generation. Remember that a team works together to answer these questions.

Fig. **4-4** /// **PACKAGE DESIGN:
SUPERDRUG STORES PLC,
LITTLE MONSTERS**

**TURNER DUCKWORTH, LONDON AND SAN
FRANCISCO**

- *Creative Directors:* David
 Turner, Bruce Duckworth
- *Designer:* Sam Lachlan
- *Illustrator:* Nathan Jurevicius
- *Typographer:* Sam Lachlan
- *Client:* Superdrug Stores Plc

"For Little Monsters—
everywhere."

Question 2: Who Is the Core Audience?

Identifying the people who comprise the core audience is essential in formulating relevant ideas. Many factors and criteria are evaluated when defining the core audience. The final answer is usually in the form of a demographic, psychographic, or behavioral profile. The term **demographic** means selected population characteristics. Some common variables include age, sex/gender, income, education, home ownership, marital status, race, and religion. *Psychographic* profiles are any type of attributes relating to personality, attitudes, interests, values, or lifestyles. *Behavioral* variables refer to things such as brand loyalty or the frequency of a product's use. They can also include activities that these people perform either individually or as a group, such as blogging, dancing, or playing soccer. In digital media and social media, we can effectively narrowcast (target small, relevant audiences) to audiences who have microrelevance.

Question 3: What Is the Audience's Perception of the Brand or Group?

Assess what the core audience thinks and feels about the brand or group to better understand and appreciate the audience's needs and desires. Keep in mind that people's perceptions of a brand, group, or entity fluctuate. People can be fickle.

Question 4: What Would You Like the Core Audience to Think and Feel?

Determine one clear reaction you want the audience to have. The designer needs to develop a concept to engage the core audience. This question reflects the goals of the assignment and relates to Question 3.

For Figure 4-4, Superdrug asked Turner Duckworth "to create a new kid's hair care range of shampoos, conditioners, and detanglers that would bring a sense of fun to a sometime stressful experience for both parent and child."

With tongue firmly in cheek we created a range of fruity little monsters, which hint at the fragrance of each product. Other monsters that illustrate the product type are a dripping three-eyed monster for the "After Swim 3 in 1 Conditioning Shampoo and Body Wash" and a two headed monster for the "2 in 1 Conditioning Shampoo," for example.

Kids love the illustrations and the name connects on a personal level with mums. Fun continues on back of pack with copy talking directly to the little monster in every household with a "helpful" checklist of what you should and shouldn't do when washing your own hair. Bath time transformed.

Question 5: What Specific Information and Thoughts Will Assist in This Change?

Provide facts and information that will enable people to alter their beliefs and opinions. Make a short list of the relevant information to support the message. Rank information by importance to further focus the creative development.

Question 6: What Is at the Core of the Brand Personality?

Each brand or group should have a well-defined essence, a core brand personality. This allows for positioning which will help define the entity against the competition in the minds of the target audience.

Examples of well-known brand cores are:

→ Volvo: Safety

→ Orbit gum: Clean

→ BMW: German engineering

→ Apple: Creativity

→ Doctors Without Borders/Médecins Sans Frontières (MSF): Humanitarianism

Fig. **4-5** /// **AD**

LEO BURNETT

- *Client:* Fiat Auto China, Shanghai

Question 7: What Is the Key Emotion That Will Build a Relationship with the Core Audience?

Identify one emotion that people ought to feel most about the brand or group. Establishing the right emotional connection with people creates deep relationships, builds brand communities, and fosters loyalty. Determining how to connect to a targeted audience also means understanding their culture or community. What might connect to an audience in China might not connect to an audience in Ireland (Figure 4-5).

Question 8: What Media Will Best Facilitate Our Goal?

Where do the people you want to reach spend the most time? Consider media in connected ways. For example, if people prefer screen media, would an outdoor poster campaign help drive people to a website or social media platform?

Budget affects media selection. For example, a television commercial or website design requires a substantial budget.

Question 9: What Are the Most Critical Executional Elements and What Is the Budget?

Determine the visual and text elements required for each project. Elements can include requisite images, color palette, typeface(s), logo, tagline (catchphrase), main text or copy, features, and rules or regulations. They can also include promotions, values, expiration dates, 800 numbers, website addresses, social media icons, and games. Again, budget will affect many of your decisions, including media, paper selection or substrates for print, and colors for print. The number of required elements will vary depending on the nature and scope of the project. For example, a logo and web address may be the only elements required for an outdoor billboard. For a website, there will be a longer list of required components.

Question 10: What Is the Single Most Important Takeaway?

Establish the single most important message to convey in the form of a single thought. What do you want the audience to remember, to take away with them? Some people prefer to answer this question first as a general guide. By making it the penultimate question, the answers from the other nine questions might provide an insight by which to answer this question.

Question 11: What Do We Want the Audience to Do?

Define the call to action—what you want the viewer or visitor to do. These include buy, subscribe, donate, visit a place or website, call a number, click through, complete a survey, get a medical exam or test, share information, save a choking victim, and more.

Figure 4-6 is a sample creative brief from The Richards Group, Dallas.

CLIENT REVIEW DURING PHASE 2

During certain phases of the design process, the client reviews and approves the direction and efforts up until that point. Asking a client to review and sign off on what has been discussed and determined can help avoid misunderstandings down the road.

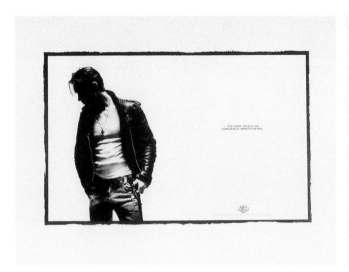

Fig. **4-6** /// **PRINT AD CAMPAIGN: HARLEY-DAVIDSON OF DALLAS**

THE RICHARDS GROUP, DALLAS

- *Creative Director/Writer:* Todd Tilford
- *Art Director:* Bryan Burlison
- *Photographer:* Richard Reens
- *Client:* Harley-Davidson of Dallas

"Warning: People don't like ads. People don't trust ads. People don't remember ads. How do we make sure this one will be different?

Why are we advertising?
To announce the introduction of a clothing line to the Harley-Davidson store in Dallas.

Who are we talking to?
Weekend rebels. Middle-class men who are not hard-core bikers (they may not even own motorcycles), but want a piece of the mystique.

What do they currently think?
Harley-Davidson has a badass image that appeals to me.

What would we like them to think?
Harley-Davidson now makes clothing that reflects that wild, rebellious image.

What is the single most persuasive idea we can convey?
Harley-Davidson clothing reflects the rebellious personality of the Harley-Davidson biker.

Why should they believe it?
Harley-Davidson bikers shop for their clothes at Harley-Davidson.

Are there any creative guidelines?
Real and honest. Should be viewed favorably by hard-core Harley-Davidson bikers."

—*The Richards Group*

PHASE 3: CONCEPTION

A foundational concept drives the design. A **design concept** is the creative reasoning underpinning a design. It is the guiding idea that determines how you design—how you create or why you select imagery and typefaces or lettering and the reasoning for color palette selection. The design concept sets the framework for all your design decisions. It is the primary broad abstract idea driving the hows and whys of your design decisions. For example, in Figure 4-7, Matsumoto Incorporated explains how the design expresses their concept:

> The square format is used because Poul Kjaerholm based many of his furniture designs on the square. The use of Futura type reinforces the mid-century look of the furniture. The photographs used throughout the book were taken by Keld Helmer-Petersen, Kjaerholm's friend and sometime collaborator. The all black-and-white catalog reinforces the spareness and elegance of Kjaerholm's designs.

A design concept is visually expressed through the creation, selection, combination, manipulation, and arrangement of visual and type elements. For Opus™, a new carpet brand (see Figure 4-8), Tricycle, Inc. wanted to communicate that the company is a bold and hip "brand in a dinosaur industry. A visual trick is played with the same letterform used for the p and s to represent a roll of carpet."

For many students and novices, generating concepts is the most challenging stage in the design process. It is not enough to simply arrange graphic elements into a pleasing form. It is necessary to expressively and clearly communicate an idea and/or message to an audience through the visual design. Formulating a concept necessitates analysis, interpretation, inference, and reflective thinking.

For any assignment, a design studio or agency must generate several viable concepts to present to their client, as in Figure

Fig. **4-7** /// **CATALOG RAISONNÉ: THE FURNITURE OF POUL KJAERHOLM**

MATSUMOTO INCORPORATED, NEW YORK

- *Author:* Michael Sheridan
- *Creative Director:* Takaaki Matsumoto
- *Designers:* Takaaki Matsumoto, Hisami Aoki
- *Photographer:* Keld Helmer-Petersen
- *Editor:* Amy Wilkins
- *Printer:* Nissha Printing Co., Kyoto

This catalog raisonné documents the complete work of mid-twentieth century Danish furniture designer Poul Kjaerholm.

Fig. **4-8** /// **LOGO, OPUS**

TRICYCLE, INC., CHATTANOOGA, TN

- *Creative Director:* R. Michael Hendrix
- *Designer:* Ben Horner
- *Client:* Opus

"The Opus logo is a bold, hip mark for a new carpet brand in a mature industry. A visual trick is played with the same truncated letterform used for the 'p' and 's' to represent a roll of carpet. Repeating the logo implies abstract patterns found in modern carpet design."

—*Tricycle, Inc.*

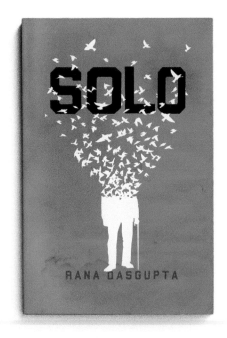
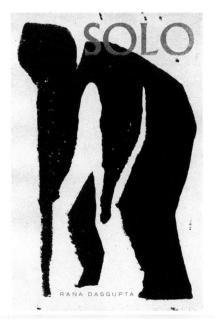
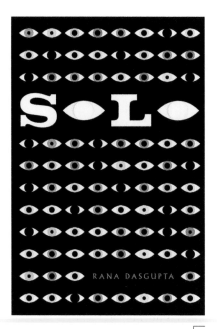

Fig. **4-9** /// **BOOK COVER: *SOLO* BY RANA DASGUPTA**

THE HEADS OF STATE, PHILADELPHIA

- *Art Director:* Martha Kennedy
- *Designer:* Dustin Summers/Jason Kernevich
- *Client:* Houghton Mifflin

Shown here is the final cover (far left) plus two alternative covers.

4-9, where you see two alternative cover designs plus the chosen cover for *Solo*. Being able to generate several, or in fact many, concepts to solve any given problem is a design skill.

CONCEPT-GENERATION PROCESS

The generally accepted protocol for graphic design conception is based on the four-stage model outlined in *The Art of Thought* by Graham Wallas, English political scientist and psychologist, in 1926:

Preparation ▸ Incubation ▸ Illumination ▸ Verification

In 1965, James Webb Young, a renowned copywriter at J. Walter Thompson, wrote an indispensable book, *A Technique for Producing Ideas*, where he colorfully and articulately explains his process based on Wallas's model.

STEP 1: PREPARATION

A. Thoroughly examine your materials for insights.

B. Examine for connections among thoughts and/or facts. Then correlate to find an insight or idea platform.

C. Write any idea or insight on an index card, in a notebook, or in a digital file.

Software can aid in organizing the materials you've gathered, allowing you to save queries, save views, sort topics, select topics for modification, and more. Social bookmarking websites, such as http://del.icio.us, allow you to store your bookmarks online and add bookmarks from any computer. Such sites can keep track of source materials and commentary you find online.

Developing your ability to see relationships among elements, facts, information, places, or objects will help you generate concepts. Any of your first thoughts or (partially formed) ideas may lead to a workable design concept. Make sure you examine the materials with the clearly defined assignment and communication goals in mind.

STEP 2: INCUBATION PERIOD

Once you have examined all the materials, allow the information to incubate in your mind. Taking a break from working on an assignment turns the concept generation over to your subconscious mind. By allowing the problem to incubate in the back of your mind, your subconscious may do the job for you. Often, to take a break, designers turn to experiencing other arts, which might engage their conscious minds, stimulate emotional responses, and encourage the subconscious. Examples include reading award-winning fiction; seeing an art house film; attending a music or dance concert, theater performance, or fine art exhibit; or creating fine art (painting, sculpting, drawing, photography, or ceramic arts). Some designers find semiconscious behaviors prompt a constructive response, behaviors such as doodling, daydreaming, or folding

ing paper into odd shapes, or any kind of constructive self-entertainment. Psychologists say this is especially useful if the mind is turning over a problem.[3]

STEP 3: ILLUMINATION/CONCEPTION

For many, a concept pops up as if out of a magic lamp. When we are relaxed and not directly working at concept generation, while driving, cooking, exercising, showering, or dancing, an idea comes to us. However, if incubation has not worked for you, refer to Chapter 5, Creativity and Concept Generation. Here are other avenues to pursue.

More Avenues to Prompt Concept Generation

→ *Words:* Legendary graphic designer and adman George Lois advises using words to generate concepts. Lois asserts visual artists can think equally well in words as in visuals. Try making word lists, word associations, word maps, word mergers, or any method that will work for you.

→ *Theme:* A theme is a distinct conceptual or pictorial topic-based approach, which can be based on a thought, an emotion, society, nature, politics, religion, among other subject areas such as war and peace or democracy. Variations on a theme also can work as a platform for ideation.

→ *Symbol:* Employ an object or image to represent or stand for another thing, thought, idea, or feeling.

→ *Literary and rhetorical devices:* Use a metaphor, simile, onomatopoeia, personification, pleonasm, or metonymy.

→ *Merge:* Combine two related or unrelated objects or images together to form a unique new construction or relationship.

→ *Synthesis:* Combine/synthesize more than two separate elements that form a new, more complex whole.

→ *Juxtaposition:* Place two images side by side for contrast or comparison.

STEP 4: VERIFICATION: CRYSTALLIZING THE DESIGN CONCEPT

Once you generate a concept, you need to evaluate it, testing for both functionality and creativity. Most concepts require refinement to strengthen them and to ensure they will work in practice. This is the point in the process to keenly critique your own concepts. Verification involves evaluating/assessing and logically supporting your viewpoint.

Those who are able to generate concepts quickly or immediately are either seasoned designers or well informed about the subject and assignment. Experienced imaginative thinkers rely on creative thinking tools in their repertoire, just as a seasoned winning football coach relies on personal experience, a range of techniques, skills, and instincts.

Several steps are involved in concept generation:

→ Defining the design problem

→ Preparing: gathering and examining materials

→ Incubating

→ Generating and selecting ideas

→ Assessing ideas

PHASE 4: DESIGN

Finally, it's time to design. Now your design concept takes articulate visual form. For many, this is a nonlinear process, where the steps vary markedly as a result of creative thinking and designing. Individual factors or circumstances cause designers to follow different paths with deviations from those paths. For instance, many designers create thumbnail sketches throughout the process to develop concepts, to visualize, and to compose (see Case Study: Seed Media Group by Sagmeister Inc.

3. Benedict Carey. "You're Bored, but Your Brain Is Tuned In," *The New York Times*, August 5, 2008, p. F5.

on page 92 in this chapter and Case Study: Travel Series Posters & Sketches by The Heads of State, on page 140 in Chapter 6). Some designers start with visual collages. Others start with words. The following steps are a good point of departure. Soon you will find your own way of working that best suits you.

STEP 1: THUMBNAIL SKETCHES

Thumbnail sketches are preliminary, small, quick, unrefined drawings of your ideas in black and white or color. Best practice dictates that you use traditional image-making techniques—sketch by hand using a drawing tool, such as a pencil, marker, or pen, or digital pen and tablet. Sketching with a hand tool fosters exploring, problem finding, visual thinking, and discovering. (One caution: when starting with digital media tools other than a digital pen and tablet, many students do not sketch. Instead, they surf for images from stock houses to jump-start conceptualization.) Using conventional drawing tools or a digital pen also prevents you from refining visual concepts too quickly, which happens to almost every novice when using a mouse or trackpad to sketch.

When you sketch with a conventional or digital pen, the actual process of sketching allows you to think visually, to explore and make discoveries, and to stay open to possibilities during the art-making process. At first, generating many sketches may be frustrating. It gets easier with experience. Generate as many different visual concepts as possible. (Unfortunately, beginners are often happy with their first sketches, stopping after only a few.) José Mollá, founder and creative director of La Comunidad in Miami, advises: "The difference between bad and good creatives is that they both come up with the same pedestrian solutions, but the bad creative stops there and the good creative keeps working toward a more unique and interesting solution."

Tip: When you show your thumbnail sketches to your instructor or design director, it's helpful to number them for reference, especially if you are e-mailing them.

STEP 2: ROUGHS

Roughs are larger and more refined than thumbnail sketches. The purpose of this stage is to flesh out a few of your best ideas, to work on each design concept and how it can best be expressed through the creation, selection, and manipulation of type and visuals in a composition more fully, before going to a final stage. Even though a rough may look final, it is not finished at this point. Roughs should be done to scale (in correct aspect ratio of the final format, whether it is a website, outdoor billboard, or business card).

If a design concept does not work as a rough, it certainly will not work as a final solution. If it's not working, rethink, go back over your thumbnail sketches, or generate more concepts. It is important to generate several workable design concepts at the outset so that you have backup. Most clients prefer to select from among at least three entirely different design concepts and executions, *not variations on one concept*.

Depending on how you work, you will have begun or be in the midst of visualization. (See Chapter 6 on visualization.) Roughs are also used to explore possible creative approaches to image making—collage, photomontage, printmaking, drawing, or any handmade technique that can be used to best express your design concept.

Tip: It is a good idea to wait a day or so between creating roughs and creating comps, which is the next step. Time in between will give you a fresh perspective on your work. That means you have to budget your time accordingly.

STEP 3: COMPREHENSIVES

A **comprehensive**, referred to as a **comp**, is a detailed representation of a design concept thoughtfully visualized and composed. Comps usually look like a printed or finished piece, though they have not yet been produced. **Mock-up** or **dummy** describes a three-dimensional comp.

When a client sees a comp, he or she will see a very close representation of how the piece will look when produced. A comp fully represents your solution to the design problem before it goes public, before it is printed or viewed on screen or in an environment. (Color comps generated on an office or home ink-jet printer will vary a good deal from color printed by a professional printer using printing inks.)

Type, illustrations, photographs, and composition are rendered closely enough to the desired finished design to convey an accurate impression of the final piece. Every line of type should be adjusted, all the letterspacing, word spacing, and leading considered. Depending on your design director or creative director at work, he or she may wish to see each visual stage—from thumbnails through comps for input or approval. A client sees a well-crafted final comp.

CLIENT REVIEW DURING PHASE 4

Rarely do clients through up their arms in wild approval and say, "That's great! Let's produce this." More often than not, clients request changes and refinements. During this phase, the designer evaluates, refines, and secures approval from the client.

Very often, the comp is used as a visual agreement of the design solution between the designer and client and as a guide or "blueprint" for the printer. If you are designing for print, it is important to remind the client that the paper stock will most likely change the appearance of the printed piece. Comps viewed on screen will look different from comps printed on laser or fine paper.

PHASE 5: IMPLEMENTATION

For a graphic design student, execution means either printing one's solution on a home printer or displaying it on screen to one's instructor or crafting a mock-up, such as a package design. In a professional setting, implementing one's design solution takes a variety of forms depending on the kind of format and whether the format is print, screen-based, or environmental. Very often, designers go on press to assure accuracy and may work closely with the printer.

In Figure 4-10, you see some of the steps involved in producing and printing. Brainforest comments that their goal for pro bono client Gilda's Club Chicago was

... to spread the news about this special place where the focus is on living with cancer. We applied for, and won, a prestigious Sappi Ideas That Matter grant that allowed Brainforest to develop, print, and distribute 5000 *Living With Cancer Workbooks* on behalf of the Club. This piece won several design industry awards and has been used as a model for Gilda's Clubs and other cancer support foundations on the national level.

Production, also called **digital prepress**, includes preparing the digital files utilizing industry-standard software, collecting all needed photographs and/or illustrations and having them scanned, preparing font folders and image folders, proofreading (with or without the client), and following through by working with the printer or the web designer. Entry-level graphic designers often prepare digital files for the printer and prepare digital files for upload to the web. The designer must create meticulous digital files and give explicit instructions to the printer, select paper, check laser proofs and other prepress proofs, and deliver the job to the client.

The technical skills one needs for creating a comp are somewhat different from the ones needed to prepare a file for the printer. Many students and designers work in imaging or drawing software to create comps. For the printer, almost all files should be prepared in layout programs, Adobe InDesign®, or in Adobe Acrobat™. (For a fee, most printers can correct your files.) You must learn to prepare and label files correctly. Take courses in digital prepress and web development. Tutorials are available online, as well.

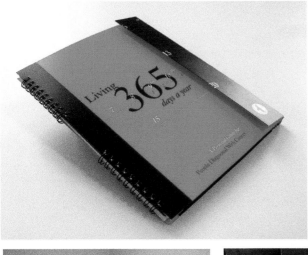

Fig. **4-10** /// GILDA'S CLUB CHICAGO LIVING WITH CANCER WORKBOOK

BRAINFOREST, CHICAGO

• *Sappi Grant Recipient*

CRAFTSMANSHIP

Craftsmanship refers to the level of skill, proficiency, and dexterity of the execution. It includes the use of papers, inks, varnishes, cutting and pasting, and software programs. Well-crafted work enhances good design concepts. Many students display their portfolios on websites, on mobile or other digital devices, or in PDFs. Some employers still prefer to see hard copies—comprehensives and mock-ups in portfolios. Many design directors respond to the visceral impact of work they can touch. Design solutions should be neat, clean, accurate, functional, and ecologically mindful.

You should familiarize yourself with as many materials, tools, and processes as possible: papers, boards, inks, adhesives, cutting tools, drawing tools (markers, pens, pencils, brushes), software programs, digital drawing tools, and graphic aids. Familiarize yourself with a variety of visual techniques, software, web development, and more. Learn about materials by visiting art supply stores and printing shops. Attend paper

shows where you can examine paper samples and ask questions of sales representatives. Learning about paper is crucial. When you obtain paper samples, notice how each paper takes ink. (Many designers are seduced by the tactile aspect of a paper and forget to check how it will take ink.) Visit a printer and see how things are done. Start conversations with printers. Learn about the different types of inks, finishes, and printing techniques. In addition to the basic materials listed, there is a wealth of presentation materials available. Learning to cut, glue, mount, and mat are essential hand skills for a design student. Read *Comp It Up* by Rose Gonnella and Christopher Navetta for lots of useful step-by-step information.

Presentation—the manner in which comps are presented to a client or the way work is presented in your portfolio—is important. A great presentation can truly enhance your chances of selling your solution to a client.

SUGGESTIONS

→ Make it accurate. Try to closely capture the colors, textures, type, and images to best visualize your design concept.

→ Make it neat. You want people to notice your design, not how poorly something is cut or pasted.

→ Present it professionally. A good and thoughtful presentation can enhance your design solution, and a poor presentation can seriously detract from it.

DEBRIEFING

After a design assignment has ended, some clients and designers find debriefing useful. This involves reviewing the solution and its consequences—examining your finished assignment to determine what went right and what went wrong.

PAPER TIPS

→ Consider recycled paper or tree-free papers.

→ Consider all paper attributes: finish, weight, and color.

→ Understand which weights of paper are best suited for various projects, for example brochures versus business cards.

Here are some tips from Sandy Alexander, Inc. of Clifton, New Jersey:

→ Ask, "How will this paper hold up for binding, laminating, foil stamping, spot varnish, die cut, or embossing?"

→ For a small quantity, the cost is insignificant for a higher grade paper.

→ When choosing paper, look at printed pieces, not just swatches.

→ Go to paper shows and get paper promotionals. They will allow you to see how paper takes ink and special printing techniques. Also, there is often an explanation of how it was printed on the back of the promo.

→ Paper choice usually represents fifty percent of the cost of the entire printing job.

→ Never skimp on paper! Stock will determine how the paper handles the finishing process.

→ Coated and uncoated papers take color very differently.

→ Think of paper choice and color results together.

→ Choice of paper will affect how the color is reproduced.

→ Each paper type has its own limitations.

The materials you use, whether for a comprehensive or a printed graphic design solution, are critical to the execution of the design and contribute to effective communication, expression, and impact. The skill with which you craft your solution and present it can enhance or detract from it.

Case Study

New Leaf Paper: Taking Green Mainstream

OPPORTUNITY

New Leaf Paper, a business-to-business brand featuring 100% post-consumer waste recycled paper, saw an opportunity to take their product direct to the consumer. What makes New Leaf different? New Leaf is polished, professional papers that are environmentally responsible. We set out to create products that could change consumer perceptions. There is nothing granola, unpolished or greenwashed about paper carrying the New Leaf Paper brand.

WILLOUGHBY PROCESS

New Leaf entered the consumer market with a line of student notebooks. Our first reaction was to plaster the covers with big, urban, 100% recycled graphics. Scream out to the world: "I love the earth!" Fortunately, our process always begins with consumer research, which kept us from falling into the same trap as so many other "green" products out in the world. We identified two key target audiences. Pre-teenage girls, ages 8–12, wanted "pretty" notebooks. High school and college students wanted notebooks that were easy to identify by color for different class uses. Neither group wanted to be a walking billboard for a recycled product. Consumers love that the paper is recycled and that is a reason to buy, but, even more importantly, the paper needs to function in the same way or better than their non-recycled choices.

RESULTS

New Leaf has expanded their market presence as a brand and is now licensing their products. Despite initial concern by retailers, stores carrying the New Leaf product actually added a new consumer set spanning across all age groups with the addition of these paper products. In turn, New Leaf and Willoughby went on to develop more than 150 additional SKUs [Stock Keeping Units] across all paper products including social stationery, résumé paper and office paper. Our partnership continues today.

PAPER PRODUCT DESIGN: NEW LEAF PAPER

WILLOUGHBY DESIGN, KANSAS CITY, MO

- *Principal, Brand Experience:* Zack Shubkagel
- *Client:* New Leaf

Case Study

Seed Media Group Sagmeister, Inc.

Seed Media Group is a scientific publisher of magazines, books and films.

As we worked on the identity it became clear that the end result should constitute a visualization of science and media.

Science is culture, it surrounds us, it is part of everything we do. We were looking for something open ended and flexible, a vessel we could fill with new meanings as they developed.

Formally the identity is based on phyllotaxis, an arrangement of form found everywhere from seashells to Greek architecture, from pineapples to the Sydney Opera House, horns of gazelles to the optimum curve a highway turns. It plays a role in biology, zoology, botany, medicine, physics, geometry and math. It's in the golden ratio and golden curve.

Looking at the world through this scientific lens of the phyllotaxis, we developed an identity like a chameleon, it always takes on the form of the medium it is put on. On the business cards it shows a version of the portrait of the bearer, the letterhead— iridescently reflects the room, etc.

—Sagmeister

SKETCHES

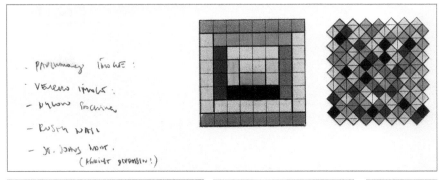

SAGMEISTER INC., NEW YORK

- *Creative Director:* Stefan Sagmeister
- *Designer:* Matthias Ernstberger
- *Client:* Seed Media Group

PRESENTATIONS

FINISHED IDENTITY

seed media group.

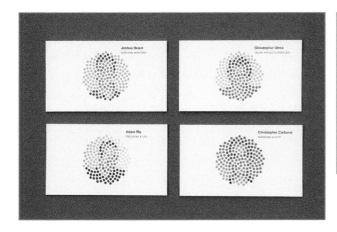

From Start to Finish

Dave Mason SamataMason

DAVE MASON

SAMATAMASON, WEST DUNDEE, IL

After twelve years of specializing in corporate communication design, Dave Mason and cofounders Greg and Pat Samata formed SamataMason Inc. in 1995. Dave Mason's work has been honored in numerous national and international competitions and publications, including The Mead Annual Report Show, The AR100 Annual Report Show, The American Center for Design 100 Show, *Communication Arts*, *Graphis Annual Reports*, and *Print* and *HOW* magazines.

I've been asked to write a brief article about the process designers use to move an idea from thought to execution. Since design is the result of both left and right brain activity in varying proportions, it's subject to the individual nuances of individual brains; it's highly unlikely that any two designers would solve the same problems in exactly the same way. So although there are probably universal checkpoints in the design process, the only designer I can actually speak for is me. A lot of this may be just common sense and a lot happens between and around these points, but here's my attempt to systemize an incredibly complex, nonlinear process.

1. Have a problem. There is no more difficult design project than one which does not involve solving a problem. All of the work I consider my most successful has been built around a problem (or two). Want something to just look good? Big problem!

2. Have an audience. If I don't know who my client wants to be talking to, how can I determine which language to use?

3. Get the information. Design is about solving someone else's problem with someone else's money, so it has to start with someone else's information. I'm an "expert" in very few areas, but I get asked to help communicate for people who do incredibly diverse things, and they usually know their stuff. So I sell my ignorance. I ask as many dumb/smart questions as necessary to try to get to the essence of any problem.

4. Read between the lines. I pay attention to what I'm hearing but also to what I'm not hearing. Sometimes there are incredible ideas hiding in there.

5. Get the words right. A picture may paint a thousand words, but a few of the right words can help me visualize a design solution. I think in words. I design around words. There are usually lots of good ones flying around in the meetings I have with my clients. And clients say the darnedest things!

6. Bring yourself to the problem. Design is the product of human interpretation. I believe if a client has hired me to help solve their problem, I have to approach it in a way that makes sense to me. If I try to solve a problem the way I think someone else would, what value have I added?

7. Recognize the solution when you see it. Buckminster Fuller summed it up perfectly: "When I am working on a problem, I never think about beauty. I only think about how to solve the problem. But when I have finished, if the solution is not beautiful, I know it is wrong."

8. Don't sell design. When I present a design recommendation, I'm not selling "design"—I'm selling a solution to my client's problems. Colors, images, typefaces, technologies, papers—whatever. No one cares but you and your peers. Your client just wants to: insert client problem here.

ANNUAL REPORT: SWISS ARMY BRANDS

SAMATAMASON, WEST DUNDEE, IL

- *Art Director:* Dave Mason
- *Designers:* Dave Mason, Pamela Lee
- *Copywriters:* Swiss Army Brands personnel, Dave Mason
- *Photographers:* Victor John Penner, James LaBounty
- *Client:* Swiss Army Brands

9. Make sure your clients can see themselves in the solution. If I've done my homework and my interpretation is correct, my clients should recognize themselves—either as they are or as they want to be—in what I design. If they don't, I missed the mark. If you don't believe in listening to your clients, try putting your money where your mouth is: give your hair stylist $500 and let him do whatever he wants to your head.

10. Make sure you can build what you've designed. Everyone has a budget, and everyone needs/wants more for that budget than they can get. Never present anything unless you know it delivers on that. The best solution isn't a solution at all if your client can't afford it.

11. Keep the ball in your client's court. Once a project is into development and production, never get into a situation where you are the one holding things up. Move it or lose it.

12. See it through. How a design project is printed/programmed/fabricated/finished is critical, and attention to detail makes all the difference. I remember seeing a sign in an aircraft factory: "Build it as if you are going to fly it." When the finished design project is in your client's hands, your reputation is too.

Exercises and Projects

Go to GDSOnline for more exercises and projects. 🡕

Exercise 4-1

What's In Your Paper?

01. Most paper is made from virgin-fiber pulp. Some are made from recycled materials. Some papers are nonwood and tree free.

02. Conduct research about what is in your paper and how it is produced.

03. Visit http://environmentalpaper.org/

04. Identify four sources of tree-free paper.

Exercise 4-2

Visual Brief for Your Personal Visual Identity

01. Using found materials create a visual brief. A visual brief collage board is a visual way of determining strategy, an alternative to using written strategy.

02. Select and compose a palette of colors, imagery, photograph styles, illustration styles, and graphic approaches that strategically communicate your identity as a designer.

03. Based on the visual brief, can you determine a strategy about your own visual identity to utilize for your website or *résumé*?

Project 4-1

Illuminating Ideas About Energy

01. The classic four-stage model for the graphic design process is

◊ Preparation ▶ Incubation ▶ Illumination ▶ Verification

◊ During the illumination phase, trying a variety of paths for ideation can spark concepts.

02. Design a poster to promote saving energy aimed at college students. Concentrate on one action a person can take, such as when to turn off your personal computer for energy savings.

03. Prepare by researching how to save energy. Visit http://www.energysavers.gov.

04. Let your research incubate. Then try these avenues for developing a concept:

◊ Words: Try making word lists, word associations, word mergers, or any method that will work for you

◊ Symbol: Employ an object or image to represent or stand for another thing, thought, idea, or feeling

◊ Literary device: Use a metaphor

◊ Merge: Combine two related or unrelated objects or images together to form a unique new construction or relationship

◊ Juxtaposition: Place two images side by side for contrast or comparison

05. With your concept as the driving force, make thumbnail sketches of different possible compositions. Form a composition through experimentation.

06. Choose one or two sketches and turn them into roughs.

07. Refine one rough and turn it into a final comp.

PRESENTATION

This can be done on paper or online. If printed, print on good-quality, matte photo paper; use double-sided printing paper (so no paper company trademarks are on the back). Print full size; do not include any borders or additional graphics, as these would interfere with the composition of the presented work. Arrange the design solution on the page either at life size or as large as possible.

5 CREATIVITY AND CONCEPT GENERATION

CREATIVE THINKING

Creativity is the power to connect the seemingly unconnected.

—William Plomer

Of all the competencies necessary to be a graphic designer, creativity is the most elusive. Developing your creativity will enhance everything you do—from graphic design to how you live your life.

Synthetic creative thinking is the skill to construct original ideas and novel relationships, to be innovative, and to be flexible in one's thinking. Imaginative designers learn to think differently and are able to generate relevant creative design solutions. For example, Catherine Casalino's inspiration for the *Procession of the Dead* book cover was based on a scene with shadow puppets (Figure 5-1).

Fig. **5-1** /// BOOK JACKET, *PROCESSION OF THE DEAD*

- *Design and Photography:* Catherine Casalino
- *Publisher:* Grand Central Publishing

"The inspiration for the cover was a scene in the book with shadow puppets. The shadow letters were created by placing metal letters on wooden skewers behind a sheet. The whole set up was then lit from behind and photographed (see process photo)."

—*Catherine Casalino*

Facets of creative thinking are:

→ associative thinking (recognizing commonalities, common attributes)

→ metaphorical thinking (identifying similarities between seemingly unrelated things)

→ elaboration and modification (working out details and proposing alterations)

→ imaginative thinking (forming images in one's mind and imagining unlikely objects or events)

CHARACTERISTICS OF CREATIVE THINKERS

Certain characteristics are markers of creative thinking:

→ Courage: Fear quashes creative risk taking and supports playing it safe. Courage coupled with intellectual curiosity fuels creativity.

→ Receptiveness: Being open to different ways of thinking as well as constructive criticism allows you to embrace possibilities and new ideas.

→ Curiosity: The desire to know and to explore allows one to grow intellectually, artistically, and technically.

→ Flexibility: Not only do an agile mind and flexible personality allow you to keep up with the times, but these characteristics also allow you to bend with the path of a budding idea or let go of a path that is not fruitful.

→ Being Sharp-Eyed: Paying attention to what you see every day (shadows, juxtapositions, color combinations, textures, found compositions, peeling posters, etc.) allows you to see inherent creative possibilities in any given environment; you notice what others miss or do not think noteworthy.

→ Seeking and Recognizing Connections: Creative people have the skills to bring two related or unrelated things together to form a new combination or relationship. They arrange associative hierarchies in ways that allow them to make connections that might elude others.

TOOLS THAT STIMULATE CREATIVE THINKING

There are tools that aid creative thinking. Besides using these creativity techniques for concept generation, some designers and students use them as visualization and spontaneous compositional tools (see Chapter 6, Visualization, and Chapter 7, Composition).

BRAINSTORMING (GROUP OR INDIVIDUAL TOOL)

In *Your Creative Power*, published in 1945, Alex Osborn, an advertising partner at BBDO in New York, presented a technique he had been using for years at BBDO: brainstorming. The objective of Osborn's technique was to generate ideas that could be solutions to advertising problems. Traditional brainstorming is conducted with a group of people so that one contributor's thought builds on or triggers another's, although it may even work better when modified for individual use, since there is no holding back when one is alone. An uninhibited atmosphere cultivates the flow of creative thinking.

OSBORN'S CHECKLIST (INDIVIDUAL TOOL)

In the mid-1960s, American artist Richard Serra began experimenting with nontraditional materials, including fiberglass, neon, vulcanized rubber, and lead. He combined his examination of these materials and their properties with an interest in

HOW TO BRAINSTORM IN A GROUP

- Clearly and succinctly define the problem. Determine criteria.
- Appoint two people: (1) a good note taker and (2) an effective facilitator responsible for running the brainstorming session. (An oversized note pad, a marker board, or an interactive whiteboard screen is useful. Or record the session. Notes should be evaluated at the conclusion.)
- Including participants with different expertise is optimum.
- Participants should openly contribute.
- Stay focused on the problem under discussion.
- During the brainstorming session, do not judge any contributed ideas. Creativity should not be stifled, no matter how harebrained the idea offered.
- A second round of brainstorming builds onto ideas suggested in round one.

Average time: 30- to 45-minute session.

At the conclusion of the session, evaluate ideas. According to creativity expert Edward de Bono, ideas should be evaluated for usefulness, for whether they merit further exploration, and for originality.

The advantages of brainstorming include:

- Effective idea-generation tool
- Encourages creative thinking
- Provides an opportunity for collaboration and cross-pollination

the physical process of making sculpture. The result was a list of action verbs Serra compiled—"to roll, to crease, to curve"—listed on paper and then enacted with the materials he had collected in his studio. *To Lift* by Serra, "made from discarded rubber recovered from a warehouse in lower Manhattan, is a result of the rubber's unique response to the artist's enacting of the action verb 'to lift.'" [1]

> It struck me that instead of thinking what a sculpture is going to be and how you're going to do it compositionally, what if you just enacted those verbs in relation to a material, and didn't worry about the results?

—Richard Serra

Before Serra's sculptural experiments, Alex Osborn, who developed brainstorming, created an inspired checklist technique as a tool to transform an existent idea or object. Arguably, this could be the only tool you ever need to foster creative thinking. In short, Osborn's checklist is composed of action verbs:

→ Adapt

→ Modify

→ Magnify

→ Minimize

→ Substitute

→ Rearrange

→ Reverse

MAPPING (INDIVIDUAL TOOL)

A **mind map** is a visual representation or diagram of the various ways words, themes, images, thoughts, or ideas can be related to one another. Mapping is a brainstorming and visual diagramming tool that is used to develop an idea or lead to an idea; it is also called word mapping, idea mapping, mind

1. *To Lift*, 1967, Vulcanized Rubber. http://www.moma.org/

mapping™, word clustering, and spider diagramming. It can be used to visualize, structure, and classify ideas and as an aid in study, organization, problem solving, and decision making. A resulting visual map is a diagram that represents thoughts, words, information, tasks, or images in a specific diagrammatic arrangement. There is a central key word or thought, and all other words, thoughts, or visuals stem from and are linked to the central idea in a radius around that central focal point.

TYPES OF MIND MAPS

Mapping is a useful tool for the writing process, design process, brainstorming process, exploring relationships, or simply for thinking something through. You can approach mapping in two basic ways:

→ Automatic mapping relies heavily on the surrealist strategy of spontaneous free association, trying to avoid conscious choices and allowing associations to flow freely.

→ Deliberate mapping relies more on the natural growth of associations, revealing the way your mind instinctively organizes or makes associations.

A mind map is a tangible representation of associations that may reveal an insight or lead to an idea. You can rearrange items to create a new beginning (central word or image), reordering subtopics (secondary items), sub-subtopics (tertiary items), and so on. You can remap based on a deeper understanding derived from the first go-round or based on something that occurred to you while mapping. You can articulate a section of connections or see links among items on the map.

HOW TO CREATE A MIND MAP

Mapping software is available that offers templates, shuffling, notes, labels, cross-linking, and more. However, since the nature of the drawing process maximizes spontaneous mapping, doing it by hand offers superior outcomes. Drawing

your own map assures personalization and a natural flow of thoughts.

→ Position an extra large sheet of paper in landscape position.

→ At the center of the page, your starting point, draw a key visual or write a key word, topic, or theme.

→ Starting with the central word or image, draw branches (using lines, arrows, any type of branch) out in all directions making as many associations as possible. Don't be judgmental; just write or draw freely.

Each subtopic should branch out from the major central topic. Then, each sub-subtopic or image should branch out from the subtopic and continue branching out on and on. Seek relationships and generate branches among as many items as possible. Feel free to repeat items and/or cross-link.

Spontaneous mapping draws upon the unconscious. Write or draw as quickly as possible without deliberating or editing. This type of mapping promotes nonlinear thinking. Interestingly, it can be the most unforeseen item or possibility that becomes a key to idea generation. Deliberate mapping utilizes long and careful thinking. As a complement, you could consider note taking—writing down some explanatory notes near the items or branches so that later, when you reexamine the map, you can more easily recall exactly what you were thinking. The ad campaign in Robert Skwiat's senior portfolio was based on a mind map (Figure 5-2).

ORAL PRESENTATION TOOL: PRESENT THE PROBLEM TO SOMEONE ELSE

Writing or sketching can lead to an idea. Talking about the design problem can lead to ideas and insights as well.

This tool is based on two premises: (1) talking about your design problem may reveal insights (analogous to speaking to a therapist, so you can hear yourself), and (2) presenting or

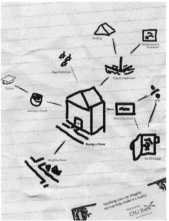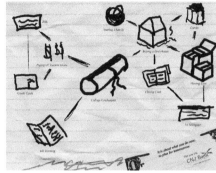

Fig. **5-2** /// DESIGN: ROBERT SKWIAT

- http://robertskwiat.com/

explaining the design problem to someone unfamiliar with it will force you to organize and articulate your thoughts, which might lead to a better understanding of the problem and ultimately to an insight or idea.

ORAL PRESENTATION TOOL TECHNIQUE

1. Solicit a friendly listener. This person should not attempt to help you solve the problem or make any comments. If no one is available, use a tape recorder. You will need to actively listen to what you say for a possible key insight.

2. Give an overview of the design problem. Then explain it in more detail. The listener should focus on you, nod to encourage you to keep speaking, but not comment so as not to interrupt your stream of thoughts.

3. If this process has not yet stimulated an insight from which you can develop an idea, then go to Step 4.

4. Once you finish speaking, the listener is then free to ask questions—questions to clarify points or questions that pop into that person's head based on what you have presented. If the person has been attentive, then he or she may have some pointed questions that can aid in focusing your thinking. Or ask the person to take notes, which you could use as jump-starts.

CREATIVITY THROUGH PROBLEM FINDING

In *The Mystery of Picasso* (a 1956 documentary film by director Henri-Georges Clouzot and cinematographer Claude Renoir), the artist is painting. As we watch Picasso paint, we realize his process is spontaneous. Each form he paints brings him to another, and nothing was preconceived. His free-form association continues. Five hours later, Picasso declares that he will have to discard the canvas, "Now that I begin to see where I'm going with it, I'll take a new canvas and start again." Picasso

used the process of painting to find inspiration and direction while painting; he didn't plan it before he began painting.[2]

Like Picasso, designers can employ **problem finding**, where the process of sketching or making marks allows visual thinking, discovery, and staying open to possibilities during the visual-making process; this is also called **problem seeking**.

PROBLEM FINDING BY IMAGE MAKING (INDIVIDUAL TOOL)

The act of creating art—drawing, painting, sculpture, ceramics, collage, photography, and any traditional or nontraditional art—activates many parts of the brain. It sharpens thinking, provokes the mind's associative network, and increases focus to a point where creative thinking can occur. When creating art for a solid period of time, you enter a meditative zone of active experimentation. Creating fine art frees the subconscious mind from the design problem and may lead to ideas.

PROBLEM FINDING THROUGH ART IMPROVISATION (INDIVIDUAL TOOL)

One of the premises of spontaneous art is that it allows access to your subconscious and liberates you from inhibitions. You create images without concerns regarding conventions, aesthetics, composition, and intention. There are no concerns about content, and you are not governed by the constraints of a design assignment. In *The Creative Vision: A Longitudinal Study of Problem Finding in Art*, a study of art students, Jacob W. Getzels and Mihaly Csikszentmihalyi found the more creative students were more adroit at staying open to possibilities during the art-making process.[3]

2. R. Keith Sawyer. "Improvisation and the Creative Process: Dewey, Collingwood, and the Aesthetics of Spontaneity," *The Journal of Aesthetics and Art Criticism*, Vol. 58, No. 2, *Improvisation in the Arts* (Spring 2000). Boston: Blackwell Publishing, p. 149. http://www.jstor.org/pss/432094
3. Jacob W. Getzels and Mihaly Csikszentmihalyi. *The Creative Vision: A Longitudinal Study of Problem Finding in Art*. New York: Wiley, 1976, p. 126.

Enjoy the process without concern about an end product or finishing anything. Choose any preferred art medium—traditional or nontraditional, nonrepresentational, abstract, or representational.

→ Start making art

→ Keep working

→ Move from surface to surface or medium to medium, as you like it.

If you're not sure which subject matter or techniques to explore, choose one of the following:

→ Everyday experiences

→ Environments: cities, landscapes, oceanscapes

→ Emotions

→ Nonrepresentational patterns or textures

→ Frottage, or rubbing (the technique of obtaining an impression of a surface texture by placing paper over the surface and rubbing it with a soft pencil or crayon)

→ Collage

→ Photomontage

HAPPY ACCIDENTS

If we think about how Picasso painted on one canvas for five hours, only to discard the canvas and declare he had now found direction, then we have an insight into many visual artists's artistic process. According to an evolutionary model of creativity,[4] we need two processes:

1. a process to generate things that we can't or don't plan and

2. another process to assess what we have generated for merit

Knowledge and experience enable a practitioner to distinguish between what has merit and what does not. As Professor Robert D. Austin, Technology and Operations Management unit at Harvard Business School, stated, the key point is to be "a bit skeptical of preset intentions and plans that commit you too firmly to the endpoints you can envision in advance."[5]

Professor Austin believes,

Artists think they develop a talent for causing good accidents. Equally or perhaps even more important, they believe they cultivate an ability to notice the value in interesting accidents. This is a non-trivial capability. Pasteur called it the "prepared mind." . . . Knowing too clearly where you are going, focusing too hard on a predefined objective, can cause you to miss value that might lie in a different direction.[6]

EXQUISITE CORPSE (GROUP TOOL)

Believing in artistic collaboration while pursuing the enigma of accidental art, the surrealists played a collective word game called Exquisite Corpse (*cadavre exquis*). Each player contributes one word to a collective sentence without seeing what the other players have written. Adapted to using collective images, each player is assigned a different section of the human body, though the original players did not adhere to any conventional sense of human form. (See Case Study: Kobo Abe Book Cover Series on page 110 of this chapter for an example of using the Exquisite Corpse tool.)

An interactive interpretation of the Surrealist idea of exquisite corpse, Big Spaceship "made Corpsify as a playful drawing game that lets users craft unique collaborations by completing either the head, torso, or legs of a 'corpse.' The design of the game allows artists to connect lines from another artist's section, which ultimately form a cohesive picture when finished." Big Spaceship "designed the experience so that artists are only exposed to a tiny portion of the previous section—they can continue the drawing, but without getting a sense of the whole picture. Once the three sections have been completed, the final product is revealed—resulting in some wacky (and weirdly remarkable) masterpieces," comments Big Spaceship about Figure 5-3.

4. Sarah Jane Gilbert. "The Accidental Innovator: Q&A with Robert A. Austin," *Harvard Business School Working Knowledge*, July 5, 2006. http://hbswk.hbs.edu/item/5441.html

5. Gilbert, "The Accidental Innovator."

6. Gilbert, "The Accidental Innovator."

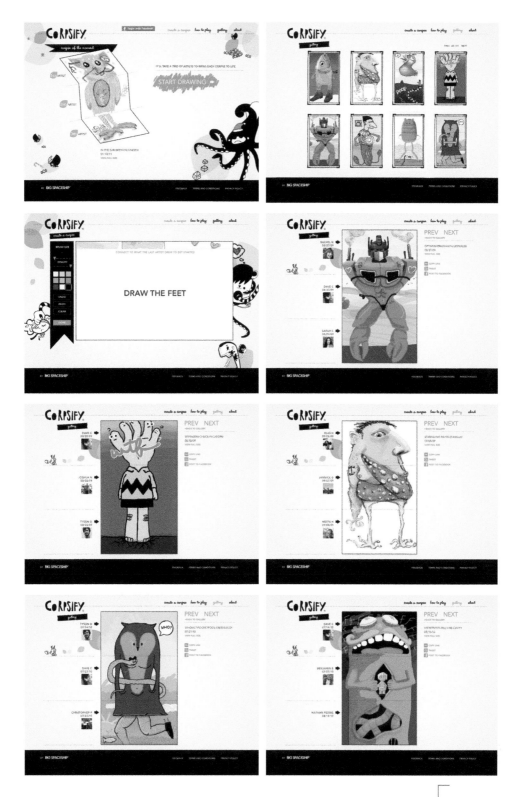

Fig. 5-3 /// WEBSITE: BIG SPACESHIP/CORPSIFY.COM

- *Client:* Big Spaceship, Brooklyn

Corpsify is a playful social drawing game where users collectively conspire with other users to create drawings—without knowing what other users have drawn. Corpsify.com is an interactive interpretation of Exquisite Corpse, an invention of the Surrealists, reimagined by the crew of Big Spaceship.

Fig. 5-4 /// POSTER: EXQUISITE CORPSE

- *Art Director/Designer:* Steven Brower
- *Participants:* Steven Brower, Milton Glaser, Mirko Ilić, Luba Lukova
- *Clients:* Art Directors Club of New Jersey and Kean University

Steven Brower designed this poster for the inaugural creativity conference at Kean University. Attendees waited patiently in line to have Brower and Luba Lukova (one of the poster's illustrators/participants) autograph their posters, which have now, undoubtedly, become prized objects of contemplation.

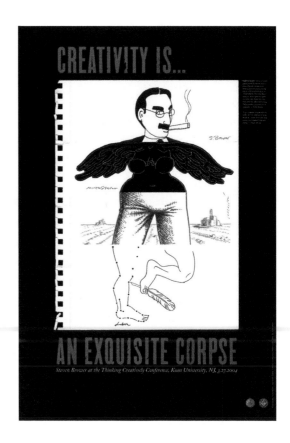

Steven Brower comments about Figure 5-4:

While researching my talk for the Kean University Thinking Creatively conference, I began to think about what it truly means to be creative in what is essentially a collaborative field. I recalled a game I used to play with my father, wherein one person draws the beginning of a figure, folds the paper, and the next one continues the drawing without seeing what came before. When I invited Milton Glaser to participate, he informed me that the "game" was actually an "Exquisite Corpse," invented by the Dadaists and Surrealists. I also asked Mirko Ilić and Luba Lukova to participate.

Steven Brower further elaborates his process as discussed in the following section.

HOW TO PLAY EXQUISITE CORPSE: COLLECTIVE IMAGES

1. Fold a piece of paper into four parts. (Fold the paper in half from top to bottom. Fold it again from top to bottom.)

2. On the first fold, the first player draws a head. That player extends the lines of the neck slightly below the fold and then folds the paper over so the second player cannot see what has been drawn.

3. The second player creates the neck, shoulders, top half of the torso with arms, extending the waist below the fold so that the third player cannot see what has been drawn.

4. The third player creates the bottom half of the torso. The upper thighs extend below the fold so that the fourth player cannot see what has been drawn.

5. The fourth player continues until the figure is drawn.

6. The group unfolds the paper and discusses the resulting figure.

ATTRIBUTE LISTING

By focusing on the attributes of an object, person, place, character, topic or theme, product, or service, you can find an attribute that might lead to an idea. **Attribute listing**, an approach developed by Robert Platt Crawford in *Techniques of Creative Thinking*, is a method for analyzing and separating data through observing and identifying various qualities that might have otherwise been overlooked. Attribute listing is a diagrammed list of attributes, working deconstructively, breaking down information into smaller parts that are then examined individually.

Break the object down into constituent parts. Then examine the attributes of each part. For example, if the item under examination is a laptop computer, break it down into the screen, keyboard, and motherboard. Or if the topic in question is a tax preparation service, break it down into the online operation, the brick-and-mortar storefront, the name, the staff, the environment, their proprietary preparation process, and so on.

THE PROCESS OF ATTRIBUTE LISTING

→ Select an object, person, place, character, topic or theme, product, or service for examination.

→ List the physical or functional attributes (parts, characteristics, properties, qualities, or design elements) of the object under examination.

→ List as many attributes as you possibly can.

→ Separately list unique or unusual attributes.

→ List the psychological or emotional attributes, if applicable.

→ Think about the value of each attribute. Ask: "What is the purpose? Benefit?" Consider the positive versus negative values of each attribute. (For example, a heavy glass laptop screen might prevent breakage but adds overall weight to the laptop.)

→ Examine ways attributes can be modified to increase positive values or create new values.

→ Examine for potential leads to a design concept (the main reasoning for your design).

USING ATTRIBUTE LISTING FOR CREATIVITY ENHANCEMENT

→ Choose a place or thing.

→ List its attributes.

→ Then choose one attribute and focus on it.

→ Think of ways (from conventional to outlandish) to change that attribute.

VISUAL METAPHORS

An idea can hinge on a visual metaphor, suggesting a similarity between two nonidentical things (see Figure 2-10, Visual Metaphors poster by Luba Lukova). Additionally, a visual metaphor, a nonliteral use of an image, results in a "partial mapping of one term, image, object, concept or process onto another to reveal unsuspected similarities."[7] A visual metaphor makes connections between two worlds of meaning, revealing an insight.

THE VISUAL METAPHORS EXERCISE

1. At the top of a page, write a topic.

7. In *Making Truths: Metaphors in Science*, Professor Theodore L. Brown explains a conceptual metaphor as any nonliteral use of language that results in a partial mapping of one term, image, object, concept, or process onto another to reveal unsuspected similarities.

2. Sketch or write as many objects having similarities to your topic. If you're having difficulty, use attribute listing to help you. Or treat this as a kind of a Rorschach inkblot test, where you simply sketch the first thing that comes to mind when asking yourself, "What might this remind me of or be similar to?"

KEEPING A SKETCHBOOK OR JOURNAL

Keeping a sketchbook or journal is a wonderful way to practice creative thinking and visualization on a daily basis. Carry a sketchbook with you for sketching, doodling (automatic drawing), and jotting down ideas. Pep Carrió, a graphic designer/illustrator from Madrid, created an image every day in these visual diaries (Figure 5-5). About this self-initiated project, Carrió explains that his journals are "a portable laboratory, where I can work with different ideas and found images."

Frank Viva, graphic designer, illustrator, and author, keeps two kinds of sketchbooks—one kind is for children's books and editorial illustration, and the other is for design projects (Figure 5-6).

Keep another book as a collage sourcebook, adhering inspiring images and typography to pages of the book. Add interesting articles or phrases. Keep an image file, which you can use to draw from or upon. Some people freeze in the face of a blank sketchbook or journal. Prompts, cuing people to respond to whatever creative action the prompt calls for—sketch, design, conceive, write—can help kick-start creativity exercises and sketching, as in these pages from *Take a Line for a Walk: A Creativity Journal* (Figure 5-7). Unlike a blank journal, *Take a Line for a Walk* is a unique creativity journal—comprised of varied prompts, cueing people to respond to whatever creative action the prompt calls for—sketch, design, conceive, write. Esteemed designers (Michael Bierut, Stefan Sagmeister, Rick Valicenti, and more), artists, scientists, architects, and experts in a variety of disciplines contributed prompts to this journal, which address numerous ways of thinking and creating.

Fig. **5-5** /// **VISUAL JOURNAL PAGES**

- *Graphic Designer/Illustrator:* Pep Carrió, Madrid

Fig. **5-6** /// **JOURNAL PAGES**

FRANK VIVA, CREATIVE DIRECTOR, VIVA & CO., TORONTO

Combine two elements that do not normally belong together to create a surprising outcome and new meaning. —Earl Gee

ℙ:98

Steal a technique from someone you admire. I did—from director Steven Soderbergh. When his writing does not get anywhere, he goes to the busiest cafe in L.A., without anybody to meet and nothing to read, just bringing pencil and paper. Being all alone in the bustling café, Soderbergh looks stupid and shames himself into writing. Works brilliantly for design, too. —Stefan Sagmeister

ℙ:1

Fig. **5-7** /// **BOOK COVER AND INTERIOR PAGES: *TAKE A LINE FOR A WALK: A CREATIVITY JOURNAL* BY ROBIN LANDA AND FRIENDS**

- *Art Director:* Cate Rickard Barr, Wadsworth
- *Design:* Modern Dog Design Co., Seattle
- *Client:* Wadsworth Publishing

Unlike a completely blank journal, this one cues you in the same way acting and creative writing coaches use prompts. The more you conceive and sketch, the more your thinking evolves, and thus, so do the images and ideas you conceive and realize.

CREATIVE PROMPTS

→ Change any measurement of time. Abolish seconds, minutes, and hours, A.M. and P.M. What new system would you use? What would the new clock look like? What time would you wake up?—Suzanne Bousquet, Ph.D. in cognitive psychology, Dean, College of Humanities and Social Sciences, Kean University

→ Rip an old letter or magazine article into bits. Move the bits around to form a new shape.—Hayley Gruenspan, aspiring novelist

→ Find badly set text in a magazine. Find the "rivers" in the text. Draw boats in the rivers.

→ Experience free association. Write down everything that comes to mind until you fill up the page.—Brandie Knox, knox design strategy, Creative Director

→ The subjects of many online videos are surprises and pranks. Visualize a stunt or gotcha.

CONCEPTUAL THINKING

Concept generation—the ability to come up with an idea, cogently state the idea, and then evaluate it—demands creativity and critical thinking skills. According to Dr. John Chaffee, professor of philosophy at the City University of New York, "Logic and critical thinking seek to establish rules of correct reasoning, clear understanding, and valid arguments. In addition, they identify fallacies—chronic ways in which people use illogical reasoning to reach conclusions."[8] Critical thinking also entails appraising concepts, issues, statements, and points of view. Among the many thinking skills of a critical thinker, the ones that are most applicable to designing are the ability to

→ Analyze

→ Ask penetrating questions

→ Identify and address key issues

→ Identify patterns or connections

→ Conceive concepts

→ Conceive a conceptual framework

→ Communicate effectively

→ Support one's viewpoint with reasons and evidence

8. John Chaffee. *The Philosopher's Way, Teaching and Learning.* Classroom Edition: *Thinking Critically About Profound Ideas.* Englewood Cliffs, NJ: Prentice Hall, 2004, p. 35.

Fig. 5-8 /// **LOGO: AETHER**

CARBONE SMOLAN AGENCY, NEW YORK
- *Creative Director:* Ken Carbone
- *Designers:* Nina Masuda, David Goldstein
- *Project Manager:* Rachel Crawford
- *Client:* Aether Apparel

Solving graphic design or advertising assignments involves gathering or generating content, problem solving, elaboration (adding details to a main idea), working within (or possibly setting) parameters of an assignment, and forecasting—which all depend on critical thinking skills.

Any good graphic design solution is based on a design concept—the designer's primary reasoning. The design concept sets the framework for all your design decisions—for how you are creating, selecting, and arranging imagery, writing copy for the imagery, the colors you select, for cropping an image or choosing a particular typeface. Reasoning does not exclude any designer's intuitive choices. For the most part, graphic designers use the term *design concept* and advertising professionals use the term *idea* or the *big idea* to mean the same thing. Design is not about decoration—creative thinkers conceptualize and communicate their ideas visually, as in Figure 5-8. "Aether Apparel, a new line of adventure sportswear inspired by a life spent outdoors, aims to appeal to the outdoor enthusiast who needs the function of performance garments, but who desires a more sophisticated form. CSA designed the brand's logo, which evokes infinity and clouds circling a mountain peak, to appeal to this demographic and to reference the word itself, Aether, meaning 'the heavens.'"

GENERATING DESIGN CONCEPTS

Coming up with a design concept is a form of creative problem solving—the process of understanding a communication goal, brainstorming for original ideas, and evaluating ideas for merit. In graphic design, a design concept is realized when it is visually expressed in a creative way.

SIX ESSENTIAL QUESTIONS: THE KIPLING QUESTIONS

Becoming a good problem solver involves cultivating investigative thinking. Rudyard Kipling immortalized the following questions, referring to them as "six honest serving men" that taught him all he knew, in a short poem embedded in "The Elephant's Child." This set of six questions can help solve problems and trigger ideas:

→ Who?
→ What?
→ Where?
→ When?
→ Why?
→ How?

You can tailor the six questions into the form of a design brief, as in this example:

→ Who is the audience?
→ What is the problem?
→ Where does this problem exist?
→ When does this happen?
→ Why is it happening?
→ How can we overcome this problem?

LEARNING TO GENERATE DESIGN CONCEPTS

In Chapter 4, we examined the graphic design process and the four steps of the concept-generation process, which are preparation, incubation, illumination, and verification. The design concept sets the framework for all your design decisions—from selecting a typeface, to a color palette, to how you visualize imagery.

Fig. **5-9** /// **BOOK COVER:** *POETRY AFTER 9/11*

- *Designer:* Christopher King
- *Cover Photograph:* Eric Ryan Anderson
- *Publisher:* Melville House

Some element of the content will prompt an idea. For example, the theme of a book itself can lead to a design concept for the cover, as in Figure 5-9. Designer Christopher King comments, "A simple, conceptual photograph paired with a stark design created a strong emotional response among readers to this book, which commemorates the tenth anniversary of the terrorist attacks."

As discussed earlier in this chapter, different creative exercises can help you formulate a concept. After executing exercises, such as mind mapping or spontaneous art, among others, it is a good idea to take a break and relax. When you're doing something unrelated to the design assignment, assuming you've prepared, ideas may pop into your head. All of us are stuck at one time or another for a variety of reasons.

Beyond the creativity exercises already mentioned, here are some ways to kick-start formulating ideas for various graphic design projects:

→ Start with visual brief collage boards (see Chapter 4).

→ Lead with a word list.

→ Join words with an image to form a cooperative message (neither should repeat the other but they should complement one another).

→ Start by selecting a typeface that is appropriate in form and voice.

→ Set up a symbolic color palette.

→ Try a "chance collage" by tearing found papers and materials, dropping them onto a larger sheet of paper, then gluing the pieces down wherever they happen to fall. (Artist Jean (Hans) Arp created collages by chance.)

→ Make a list of the all the "wrong" design concepts for this assignment.

→ Begin with a simple image that relates to your topic. Then alter it in a startling way to see it anew.

→ Using ink and brush or a digital pen and tablet, spontaneously draw type and an image so that they are inseparable; they should be intertwined and emblematic.

→ What story do you need to tell? Every design tells a story, whether it is a logo or a website.

→ Identify intriguing scenes in a book or article that embody the editorial essence (see Figure 5-1).

→ Define the meaning of the logo's name (see Figure 5-8).

→ Visualize the theme or plot line (see Figure 5-9).

→ Rewrite the goal of the communication.

→ Identify one emotional connection you want the audience to make with the design.

→ Write one takeaway from the visual communication.

→ How can you engage people with the brand or entity or message?

→ How can you make the brand or group social, make it work/live in a social media space?

Case Study

Kobo Abe Book Cover Series John Gall and Ned Drew

If the computer and the Internet allow us to connect with distant communities, then creative methods that take advantage of this power must be created. One such way is the following book covers conceived by John Gall and myself. Taking advantage of my ability to send images across the Internet, I re-conceptualized the surrealist game Exquisite Corpse. Asking design colleagues to respond to images sent to them became the basis for these collaborations. A piece of art was sent back and forth—with each designer adding something to the collage—until they reached a mutual agreed-upon finishing point.

John Gall, Creative Director at Abrams Books and former Vice President and Art Director for Vintage and Anchor Books, an imprint of Alfred A. Knopf, was one of the collaborators that I had engaged in this creative process. John realized that the eclectic nature of these electronic collages might work well with a series of books that were going to be reissued for the author Kobo Abe, who is known for his surreal narratives. This collaborative method became a natural fit. The electronic collaboration allows for an "open" design process in which unexpected and oddly juxtaposed images could be created to parallel the often bizarre and dreamlike worlds created by Abe's books. There is a sophisticated and subtle use of common elements that create a visual cohesiveness to the series. Muted, golden yellow-toned paper textures become a foundation upon which the images are built. A distinctive bold frame on each cover helps create a unity to the typographic system, while retaining its own individual characteristic within the composition. The typographic system mimics the juxtaposition of elements in their contrasting typographic style. Roman vs. Italic, Bold vs. Light, Serif vs. Sans Serif, All Caps vs. Lower Case.

Intuition, chance, and play can serve a valuable role in the problem-solving process. Collage, as a game of chance, embraces this idea and can help develop new discoveries. This methodology, when established with ample time for experimentation, often leads to innovative solutions. Challenging our perceptions about the role of the computer in the process can safeguard against our solutions becoming predictable and/or formulaic. Switching back and forth between the computer and drawing board keeps the process balanced and fresh. We need to use the tools we have to advance and explore creative ways of working, collaborating, researching, and discovering.

—Ned Drew

KOBO ABE BOOK COVER SERIES

- *Art Director:* John Gall
- *Designers/Illustrators:* John Gall, Ned Drew
- *Client:* Vintage/Anchor Books

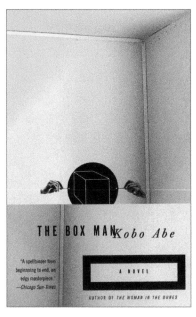

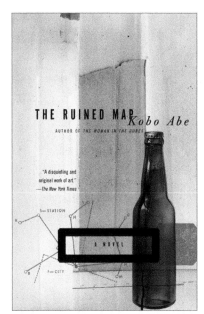

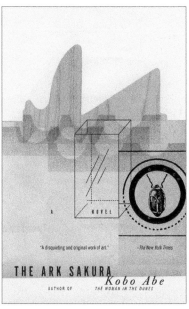

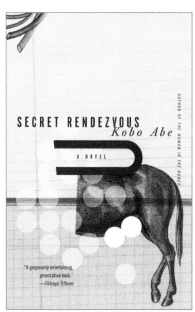

Exercises and Projects

Go to GDSOnline for more exercises and projects. ⬈

Exercise 5-1

Brainstorming: Movie Poster

Select an independent film or classic film you've recently seen. If you have never seen an independent film or classic film, then rent one or view one online (http://www.ifc.com offers web series films online; http://www.hulu.com).

My recommendations: *Metropolis* directed by Fritz Lang; *Infamous* directed by Douglas McGrath; *Some Like It Hot* directed by Billy Wilder; *Rashomon* directed by Akira Kurosawa; *Midnight in Paris* directed by Woody Allen; *Lost in Translation* directed by Sofia Coppola; *Hugo* directed by Martin Scorsese.

Write a summary (a few paragraphs) about the film.

01. Sketch four images that relate to the film. Assign emotions to each image. Creatively name each image.

02. Now pair each of your sketches with a (logical or absurd) related image (found or handmade). Using the creative tool of synthesis, merge or juxtapose the images. If you merge the two images, you bring two graphic elements together to form a new combination.

Exercise 5-2

Brainstorming: Rethinking a Brand

Select a brand or organization you believe has been superseded by a more vital or efficient brand or organization.

01. Write the brand's or organization's epitaph.

02. Rethink the group based on what's wrong with it. Reconceive it and write its birth announcement.

03. Use attribute listing for the brand or group, a method for analyzing and separating data through observing and identifying various qualities that might have otherwise been overlooked. It is a diagrammed list of attributes.

Project 5-1

Action Verbs + Visual

01. Choose an existing photograph of yourself or take a photo of an object or person.

02. Using a variety of methods to alter the image, by digital means and by hand, take the following actions:

→ Change drastically

→ Modify

→ Magnify

→ Minimize

→ Substitute

→ Rearrange

→ Reverse

Project 5-2

Book Cover: Exquisite Corpse

01. Choose one of the following authors and titles (or any title that would be appropriate for a Surrealist image):

→ *The Magnetic Fields* by Andre Breton and Philippe Soupault

→ *Hitchhiker's Guide to the Galaxy* by Douglas Adams

→ *The Secret Life of Salvador Dali* by Salvador Dali

→ *A Book of Surrealist Games* by Alastair Brotchie

02. Play the Exquisite Corpse game with a friend or two.

03. Use the resulting image for a book cover design.

04. Select a Swiss International Style (somewhat neutral) typeface such as Akzidenz Grotesk, Helvetica, or Univers.

05. Compose the cover. The resulting image should dominate the composition.

6 VISUALIZATION AND COLOR

Designers learn by doing. They can learn faster when someone gives them a way to do it. When they learn how, they can understand it.

—Paula Scher

Visualization and composition, major components in the design process, are driven by a design concept and communication goals. As Alice E. Drueding, Professor, Graphic and Interactive Design and Area Head of the BFA Program at Tyler School of Art, Temple University, points out, steps in the design process may not progress in an orderly fashion: "The order I emphasize with students is (1) concept, (2) general visualization (content, medium, style) and

(3) organization (composition, grid, golden section, etc.)—with the caveat that things don't always work in such a linear manner."

Steps in the process of conceptualization, visualization, and composition can happen simultaneously or with great overlap, with back and forth, modifying a concept as you make discoveries while visualizing. You can use visualizing for concept generation or whichever method best allows you to visually express your concept. During the course of visualization, you will find your preliminary decisions are subject to change. You may find your initial impulse overridden by intuition during the process, by a critique, by practical matters related to image quality, time, budget, by a happy accident that altered your thinking, or by any number of factors.

IMAGE CLASSIFICATIONS AND DEPICTIONS

Graphic designers work with two main components: type and images. As discussed in Chapter 3, type can be created in a variety of ways—computer generated, hand drawn, handmade, found, or photographed. **Images** is a broad term encompassing a great variety of representational, abstract, or nonobjective images—photographs, illustrations, drawings, paintings, prints, pictographs, signs, symbols, maps, diagrams, optical illusions, patterns, and graphic elements and marks; images are also called **visuals**.

In *Type and Image: The Language of Graphic Design*, Philip B. Meggs explains, with great clarity, how we classify images from the rudimentary to the complex.[1] Classifying images helps you understand the range and how to depict them to meet your communication goals (see Diagram 6-1).

→ **Notation**: a linear, reductive visual that captures the essence of its subject, characterized by its minimalism.

1. Philip B. Meggs. *Type and Image: The Language of Graphic Design.* Hoboken, NJ: Wiley, 1992, p. 18.

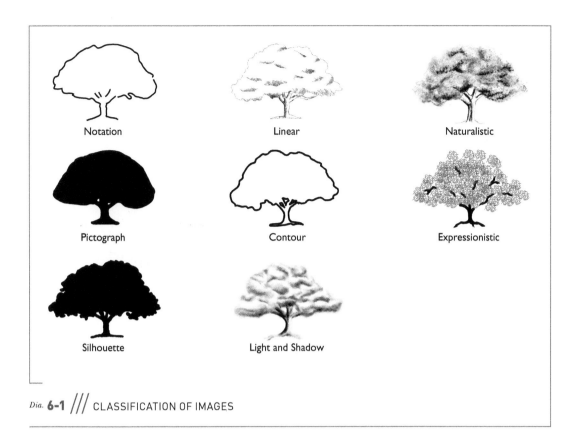

Dia. **6-1** /// CLASSIFICATION OF IMAGES

→ **Pictograph**: an elemental, universal picture *denoting* an object, activity, place, or person captured through shape—for example, the images denoting gender on restroom doors.

→ **Silhouette**: the articulated shape of an object or subject taking its specificity into account (as opposed to the more elemental form of a pictograph).

→ **Linear**: a shape or form described predominantly by use of line.

→ *Contour*: a shape or form depicted through the linear outline of an object's or subject's boundaries.

→ **Light and Shadow**: using light and shadow to describe form and the illusion of three-dimensional space. This most closely simulates how we perceive forms in nature. Also, a logical flow of light, as it touches and describes forms, can help unify a composition. An extreme use of light and shadow is called *chiaroscuro* (also called *claire-obscure*).

→ **Naturalistic**: a visual appearance or style created by full color or tone using light and shadow that attempts to replicate an object or subject as it is perceived in nature; also called *realistic*. (Please note, in modern and contemporary *fine art* theory and criticism, the terms *naturalism*

and *realism* are defined differently and represent different schools of thought.)

→ **Expressionistic**: a style of visualization characterized by a highly stylized or subjective interpretation, with an emphasis on the psychological or spiritual meaning. There is no strict adherence to things as they appear in nature, as opposed to naturalism.

There are three basic classifications of depiction as they directly refer to and then move away from what we see in nature (see Diagram 6-2):

→ *Representational*: a rendering that attempts to replicate actual objects as seen in nature. The viewer recognizes the image; also called *pictorial* or *figurative*.

→ **Abstraction**: a simple or complex rearrangement, alteration, or distortion of the representation of natural appearance, used for stylistic distinction and/or communication purposes.

→ **Nonobjective**: a purely invented visual that is not derived from anything visually perceived. It does not relate to any object in nature and does not literally represent a person, place, or thing; also called *nonrepresentational*.

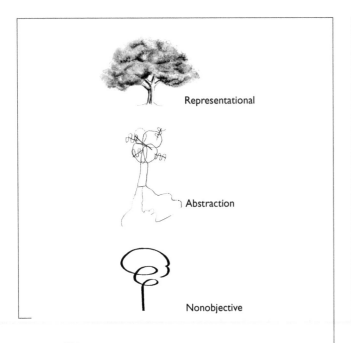
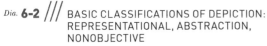

Dia. **6-2** /// BASIC CLASSIFICATIONS OF DEPICTION: REPRESENTATIONAL, ABSTRACTION, NONOBJECTIVE

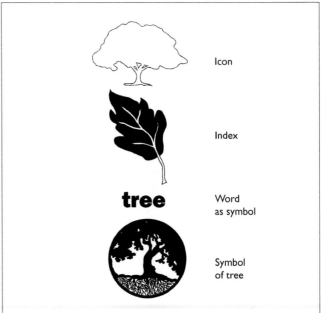

Dia. **6-3** /// SIGNS AND SYMBOLS

ABOUT SIGNS AND SYMBOLS

Graphic design signifies. Graphic design represents. Graphic design communicates. From the theory of semiotics, the study of signs and symbols, we have a classification of signs—what they mean and how they are used in graphic design.[2] (Please see Diagram 6-3.)

→ **Sign**: a visual mark or a part of language that *denotes* another thing. For example, the word *dog* and a pictograph of a dog are both signs used to represent "dog"; the $ denotes money; the written letter *H* is a sign for a spoken sound.

→ **Icon**: a visual (pictorial image or symbol) to represent objects, actions, and concepts. An icon resembles the thing it represents or, at a minimum, shares a quality with it. It can be a photograph, a pictorial representation, an elemental visual (think magnifying glass desktop icon), arbitrary (think radioactive sign), or symbolic (think lightning bolt to represent electricity).

→ **Index**: a sign that signifies through a direct relationship between the sign and the object, without describing or resembling the thing signified. There are a variety of ways

this happens: whether as a cue that makes the viewer think of the reference (for example, a pacifier is an indexical sign for an infant), by its proximity to it (for example, a diver down flag means someone is under water and you must steer clear of the area), by actually pointing to the thing signified (an arrow at an intersection on a roadside), or by being physical evidence of it (for example, a photogram of a hand or a hoof print on the ground).

→ **Symbol**: a visual that has an arbitrary or conventional relationship between the signifier and the thing signified. We decode meaning through learned associations (for example, a dove has become accepted as a symbol of peace). Spoken or written words are symbols as well.

→ Some symbols take on greater meaning than most other symbols due to their context and roles in religion, culture, history, or society. Examples include the cross in Christianity, the phoenix for eternal life, the ankh for life associated with ancient Egypt, the Star of David in Judaism, and the yin–yang, which is the Chinese symbol of the interplay of forces in the universe. It is hard to think of antiwar protest posters without thinking of the nuclear disarmament symbol designed by Gerald Holton in 1956. This graphic, a circle with a few lines in it, stands for something as profound as the idea of peace (Diagram 6-4).

2. Meggs. *Type and Image,* p. 8.

Dia. **6-4** /// PEACE SYMBOL

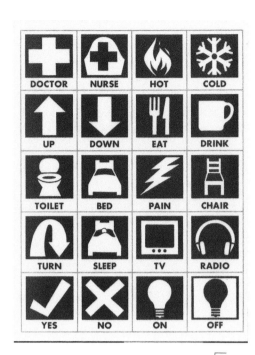

Fig. **6-1** /// **THE TALK CHART**

THE DESIGN CENTER AT KEAN UNIVERSITY

- *Description of Work:* A communication device utilizing icons
- *Creative Director:* Alan Robbins, The Design Center, Robert Busch School of Design at Kean University
- *Designers:* Various dedicated students
- *Client:* Self-initiated

The Talk Chart was created and designed by university students in The Design Studio at Kean University under the direction of Professor Alan Robbins and is donated to local hospitals. Thanks to a generous grant from Sappi Paper, The Talk Chart is currently used in 2,000 hospitals throughout the United States.

USE OF SIGNS AND SYMBOLS

Signs and symbols—reductive images—serve many functions in graphic design. They can be stand-alone images, such as a pictograph of a woman on a restroom door, a desktop or mobile icon, or most often, components of a broader design solution, such as a sign system that is part of a visual identity program. They serve as icons for mobile web and apps. Icons are also referred to as *symbol signs*.

So much information must be universally understood crossing language and cultural barriers. Signs or icons in the form of pictographs—visual, nonverbal communication—are characterized by elemental forms. These graphics depict universal, immediately recognizable objects, places, human gestures, and actions, which are easily deciphered by all; they are also called *pictograms*.

ISOTYPE, the International System Of Typographic Picture Education was developed in the twentieth-century by the Viennese social scientist and philosopher Otto Neurath as a method for visual statistics. Gerd Arntz was the designer tasked with making Isotype's pictograms and visual signs. Arntz designed around 4000 such signs, which symbolized key data from industry, demographics, politics, and economy. The pictograms designed by Arntz were systematically employed in combination with stylized maps and diagrams. Neurath and Arntz made extensive collections of visual statistics in this manner, and their system

became a world-wide emulated example of what we now term: infographics.[3]

—http://www.gerdarntz.org/content/gerd-arntz

Otto Neurath's goals were to aid people by directly illustrating information about the world for those who were illiterate, or could just barely read, as well as by designing information that could be universally understood, overcoming barriers of language and culture.

Information graphics in the form of icons are also used to help people navigate spaces or life issues. **Wayfinding systems**, used internationally, assist and guide visitors and tourists to

3. Gerd Arntz Web Archive. http://www.gerdarntz.org

Fig. **6-2** /// DISABILITY ACCESS SYMBOLS PROJECT

X2 DESIGN, NEW YORK

> The Disability Access Symbols were produced
> by the Graphic Artists Guild Foundation with
> support and technical assistance from the Office
> for Special Constituencies, National Endowment
> for the Arts. Special thanks to the National
> Endowment for the Arts. Graphic design assis-
> tance by the Society of Environmental Graphic
> Design. Consultant: Jacqueline Ann Clipsham.
>
> —*Graphic Artists Guild Foundation*

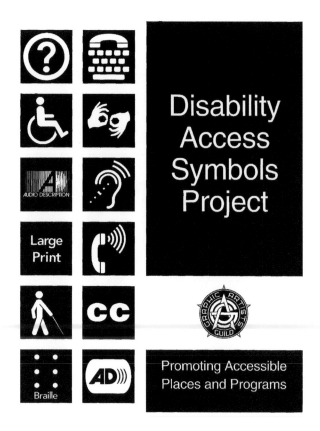

find what they are looking for in museums, airports, zoos, and city centers. The Talk Chart, a communication device, is an example of information design (Figure 6-1). Using the 8½" × 11" laminated pointing chart, people in healthcare facilities who cannot speak due to stroke, aphasia, or other physical challenges can now make their needs known to family and staff by pointing to the graphic symbols or letters of the alphabet that appear on the chart.

The primary objective of the Disability Access Symbols Project is for organizations to use these to better serve their audiences with disabilities (Figure 6-2). The Graphic Artists Guild Foundation explains:

"**The project was extremely challenging in terms of design because the client insisted on having organizations representing people with various disabilities review and comment on the proposed symbols. With the help of a disability consultant, we were able to reach consensus among all these groups and still achieve the primary objective—for organizations to use these symbols to better serve their audiences with disabilities.**

"**Several existing symbols did not meet the standards we established and needed redesign. For example, the old symbol for Assistive Listening Systems focused on the disability (an ear with a diagonal bar through it). The new symbol focuses on the accommodation to the disability, i.e., a device that amplifies sound for people who have difficulty hearing. Other upgraded symbols include Sign Language Interpreted, Access (Other than Print or Braille) for Individuals Who Are Blind or Have Low Vision, and the International Symbol of Accessibility. A new symbol for Audio Description for TV, Video and Film was developed which, through design, proved less likely to degenerate when subjected to frequent photocopying.**"

ICON DESIGN

Icons and icon systems are used for print, environmental graphics, or screen. They have become more ubiquitous due

to the proliferation of screen media and their significant roles in websites, mobile apps and more. Across media, you have many of the same considerations:

→ Who is the *audience*?

→ At what size will the icons be seen?

→ What is the context and where will the icons be seen—on screen, close-up, lighted, from a distance, in print? At which perspective or angle?

→ What are the communication goals? What do the icons represent—actions, figures, places, objects, creatures?

→ How reductive or elemental do they need to be to work? Totally no-frills?

→ Are the icons part of a system?

→ Which style will work across the system and is appropriate for the entire design project?

When icons function as part of a larger design solution, such as a mobile app, a desktop application, a wayfinding program, or a website, their design is considered in relation to the broader context and project, ensuring they function as stand-alone solutions, achieving communication goals, and within the broader context.

Mobile media make great use of icons, as in this series of icons for Textons, a company that distributes mobile coupons through texting on mobile phone devices (Figure 6-3). Each icon reflects a business sector that would potentially offer mobile discounted coupons. "The style of the icons was meant to be casual, fun and simple—making it easier for the user to select types of businesses they like," clarifies designer Travis N. Tom.

This is a set of eleven icons (and preliminary sketches) for the human resources department for Georgia-Pacific Corporation (Figure 6-4) also by Travis N. Tom, an icon specialist, who explains his process, "Two to three pen and ink concepts per icon were presented to the project manager as jpgs for selection and approval. The icons were then digitally rendered in Adobe Illustrator and two rounds of revisions were offered before finalizing the look and feel of the icons. Some direction was offered—for example, they liked a color fill in some or all of the space that didn't quite fill the outlines. The client also provided a screen shot of the site for the color scheme. Final color was explored and the icons were delivered

Fig. **6-3** //// **TEXTONS ICON DESIGNS FOR A WEBSITE**

TNTOMDESIGN.COM

- *Designer, Illustrator, Icon Specialist:* Travis N. Tom, Augusta, GA

- *Client:* Textons, Las Vegas, NV

"The icons were drawn directly in Adobe Illustrator without preliminary sketches. Final icons were delivered in jpg, png and eps formats to the client. An app icon, also, was requested by the client. With the presence of social networking and texting, advertising on mobile phone devices has made a huge impact on marketing for businesses."

—*Travis N. Tom*

Fig. **6-4** /// ICONS AND PRELIMINARY SKETCHES

TNTOMDESIGN.COM

- *Designer, Illustrator, Icon Specialist:* Travis N. Tom, Augusta, GA
- *Client:* Georgia-Pacific Corporation

Personal Info

HR Policies & Programs

Safety & Security

Time Away From Work

Benefits

Career & Development

Life Events

Pay & Performance

Retirement

Travel

HR Dept & Contacts

as jpgs and an eps file. The icons were rendered on my laptop in Adobe Illustrator while traveling."

Designing a system requires a clear design concept and a consistent use of scale, perspective, shapes, and formal elements, such as line, color, and texture. The signs or icons in a system must look as if they belong to the same family. At times, more than one designer in a design studio will work to produce a system. It is imperative to establish a firm design concept, style, and vocabulary of shapes for the system to look like it was created by one hand and mind, as in the complete set of fifty passenger and pedestrian symbols developed by the AIGA (American Institute of Graphic Arts).

Icon Design Tips

→ *Accurately depict the shape of the object* to allow users to recognize and decipher the icon at a glance.

→ *Aim for elemental form.* Economy of form trumps intricacy or complexity. Details and any excess information may confuse the user, especially on smaller screens.

→ *Represent an image from its most characteristic angle.*

→ *Select commonly recognizable images* that people around the world will be able to understand.

→ *Select color and/or values for impact, legibility, meaning, brand storytelling, and context* (for example, icons inside toolbar buttons are not in color).

→ *Treat all icons in a system consistently* in terms of style of visualization, perspective, and near and far. For example, as a general rule, if one icon is cropped, they should all be cropped. If one icon is seen in full view from straight on, all should be depicted similarly.

→ *Use a consistent single light source on all icon objects,* if using light and shadow to depict form.

→ *Icons should work well on both white and black backgrounds.*

→ *Scale the icon for different sizes* (1,024 × 1,024 pixels; 512 × 512 pixels; 256 × 256 pixels; 128 × 128 pixels; 32 × 32 pixels; 16 × 16 pixels).

Fig. **6-5** /// POSTER: AVILA/WEEKS DANCE

LUBA LUKOVA STUDIO, NEW YORK

- *Designer/Illustrator:* Luba Lukova
- *Client:* Pace Downtown Theater

(Figure 5-6), Lanny Sommese (Figure 7-10), among many others, also illustrate. Professional illustrators work in a variety of media and most often have uniquely identifiable styles. The AIGA notes, "Each illustrator brings a different perspective, vision and idea to play that, when married with great design, becomes an original art form." When you are working professionally and need to hire an illustrator, you can find one through their representatives (agents) or in annuals, in sourcebooks, and through professional organizations. (On a historical note, prior to the invention of photography, and also when photography was in its infancy and the equipment cumbersome, illustration was the most popular form of imagery in visual communication.)

→ **Photography**: a visual created using a camera to capture or record an image. Commercial photographers specialize in various genres, such as still life, portraiture, sports, outdoor imagery, fashion, journalist, aerial, landscape, urban, moving image, events, food, and others. When you are working professionally and need to hire a photographer, you can find one in annuals, sourcebooks, on the Internet, or through their agents. Fine art photography and journalistic photography are also utilized in graphic design. (Today, photography is probably the most popular form of image in visual communication.)

→ **Graphic interpretation**: an elemental visualization of an object or subject, almost resembling a sign, pictograph, or symbol in its reductive representation. Although a graphic interpretation employs economy (stripping down visuals to fundamental forms), what differentiates a graphic interpretation from a sign or pictograph is its expressive quality; it is often more descriptive. *With the same skill set used to design logos or pictographs, graphic designers can capably create graphic interpretations.*

→ **Collage**: a visual created by cutting and pasting bits or pieces of paper, photographs, cloth, or any material to a two-dimensional surface, which can be combined with handmade visuals and colors. A conventional collage

MEDIA, METHODS, AND VISUALIZATION

After you generate a design concept or several concepts for an assignment, you consider the content, which is the required text and image components. Then you make *preliminary* decisions about:

→ *Media and Methods*: How the graphic components will be created, visualized, and displayed on screen or in print. Some media and methods include illustration, drawing and painting, photography, graphic illustration, collage, photomontage, layering, and type as an image.

→ *Mode of Visualization and/or Style*: This is how you will render and execute the visuals and type for a project, including decisions about the characteristics of the form.

You can create imagery using a multitude of tools and media. The following list explains broad categories of producing and creating images.

→ **Illustration**: a handmade unique image that accompanies or complements printed, digital, or spoken text, which clarifies, enhances, illuminates, or demonstrates the message of the text. Some designers, such as Luba Lukova (Figure 6-5), Robynne Raye (Figure 6-6), Frank Viva

technique can be simulated and rethought for digital media using computer software (and its tools and capabilities) and hardware, a digital camera, a digital pen and tablet, and/or a scanner.

→ **Photomontage**: a composite visual made up of a number of photographs or parts of photographs to form a unique image.

→ **Mixed media**: a visual resulting from the use of different media—for example, photography combined with illustration.

→ **Motion graphics**: time-based visual communication that integrates visuals, typography, and audio; it is created using film, video, and computer software, including animation, television commercials, film titles, and promotional and informational applications for broadcast media and screen media.

→ **Diagram**: a graphic representation of information, statistical data, a structure, environment, or process—the workings of something. A **chart** is a specific type of diagrammatic representation of facts or data. A **graph** is a specific type of diagram used to indicate relationships between two (or more) variables, often represented on axes. A **map** is a specific type of diagrammatic representation used to depict a route or geographic area—to show location.

CREATING, SELECTING, AND MANIPULATING IMAGES

Imagery is either *created* by the designer, *commissioned* from an illustrator or photographer, *selected* by the designer from among obtainable stock imagery or the client's archives, or *found* by the designer.

When a budget does not allow for commissioning an illustrator or photographer, you can turn to available archives of preexisting illustrations or photographs, referred to as *stock*, which can be licensed for a project from stock houses (a creative resource for graphic design, advertising, and media professionals that provides illustration, photography, footage, and rights services). Broad collections of imagery, footage (a shot or sequence of shots on videotape or film), and music are available online from stock houses. Stock and image collections can be rights-managed (licensed, some with exclusive rights) or royalty-free (unlimited-use license). Always read the agreement from each stock vendor.

When you create your own image, you are in control. You decide what goes into the image or scene (point of view, colors, textures, people, pictorial space, clothing, setting, etc.). As a practicing designer or art director, when you commission an image from a professional illustrator or photographer, you also have input over the art direction of the image.

When you *select* a stock image, you either accept the image as is—as someone else conceived, visualized, and composed it—or alter it, *assuming the stock image provides rights for such alterations.* When you utilize a stock photograph, for example, you decide if everything in that photograph will enhance the communication. You may need to delete extraneous elements in the photograph if they detract from focus or meaning. Or you may need to alter (color or tonality, crop, silhouette, posterize, texturize, paint, etc.) the photograph.

The difference between creating an image and selecting an image is one of control. Every component of an image contributes to communication. For example, legendary American cartoonist Henry Martin explains his process:

I get the idea first and then think how the idea would look. What props would I need? Who are the people? What are their clothes? Where are they? In a room? On a boat? In America? Then I imagine the setting and the people and then start to draw. I usually do a rough drawing and then a finished drawing.

Some designers employ *found* imagery, utilizing openly available imagery or objects in environments, public domain, or copyright-free images (woodcuts, linocuts, etchings, patterns, rules, and more). There are historical images, ephemera, old postcards, old letters, old maps, family photos, old photos, old playing cards, old stamps, and old greeting cards. These and images such as old wrapping paper, old cigar box labels, other old labels, old signs, and so forth all include securing necessary rights if any are required.

Image making also involves manipulation. A common decision a designer must make is whether to use a visual *as is* or change it—manipulate it. Image manipulation includes:

→ *Alteration*: a modification or change to the appearance of an image

→ *Combination*: merging two or more different or related images into a unique whole

→ *Cropping*: cut part of a photograph

→ *Deliberated camera angle and viewpoint*: the perspective from which you position your camera (still or moving)

→ *Economy*: a reductive visualization

→ *Exaggeration*: a modification that embellishes, amplifies, or overstates

→ *Silhouette*: removing the background of an image leaving only the outline of an object or figure

IMAGERY, IMAGE APPROPRIATION, AND INTELLECTUAL PROPERTY

Many students start the visualization process by searching through stock image websites. This route stunts thinking and visualization. Also, the ease of finding high-resolution visuals on the Internet has led to some significant issues concerning image appropriation and violating intellectual property rights. Other than copyright-free images that are in the public domain, most photographs, illustrations, and graphic representations found on the Internet or in print publications are intellectual property (original creative work that is legally protected) belonging to other visual artists. In a professional setting, a designer or art director would have to commission images from a photographer or illustrator for a design project and/or license stock images from an archive or a stock house.

Many design directors and creative directors prefer to see original visuals created by students themselves in their portfolio projects. Original work demonstrates a student's creativity, skills, individuality, range, and initiative. With the advantage of digital cameras, students can take their own photography and work in Adobe Photoshop™. Scanners allow students to scan in their own handmade images and illustrations or illustrate using computer software. Digital drawing tools and tablets facilitate making images. Some use of stock imagery in your portfolio allows creative directors to see that a beginner can choose stock appropriately and well. Choosing appropriately and well entails understanding images—their denotative and connotative meaning, classification, style, shape, orientation, lighting, point of view/angle, color palette, and composition. It's best to focus on original work and include occasional stock images in projects to demonstrate your skills in both areas.

Certainly, you are free to change or manipulate your own illustrations or photographs. However, original artwork created by other illustrators or photographers *cannot* be changed without the creator's approval or the specific rights in the license with the stock vendor.

Fig. **6-6** /// **POSTER: THE PRETENDERS**

MODERN DOG DESIGN CO., SEATTLE

- _Designer:_ Robynne Raye
- _Client:_ House of Blues

The pixelated image of Chrissie Hynde corresponds with the treatment of the type to make an imaginative and unified visual statement.

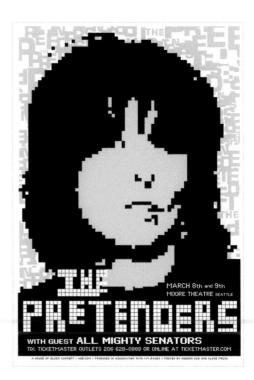

BASICS OF VISUALIZING FORM

Study ways to describe forms as well as approaches to imagery to broaden your vocabulary for visualization.

SHARPNESS VERSUS DIFFUSION

Sharpness is characterized by clarity of form, detail, clean and clear edges and boundaries, saturated color, readable and legible typography, hyperrealism, photorealism, closed compositions, and limited type alignment. **Diffusion** is characterized by blurred forms and boundaries, transparencies, muted color palettes, layering, open compositions, and painterliness.

ACCURACY VERSUS DISTORTION

Viewers believe an object or subject to be _accurately_ depicted when it conforms with what they know or to common knowledge of that form. When an object or subject is twisted, stretched, bent, warped, buckled, or significantly altered from its normal appearance, it is _distorted_. In the poster promoting a concert by The Pretenders, the image of Chrissie Hynde and the typography are pixelated, expressively distorting them (Figure 6-6).

ECONOMY VERSUS INTRICACY

Economy refers to stripping down visuals to fundamental forms, reducing them, using as little description and as few details as possible for denotation. It is employed for icons, pictographs, and symbols, for instance. **Intricacy** is based on complexity, on the use of many component parts and/or details to describe and visually communicate.

SUBTLE VERSUS BOLD

Using a subtle visualizing treatment is about restraint. _Subtlety_ can be created through low contrast, muted color palettes or tints, static compositions, transparencies, layering, limiting typefaces and alignment, and atmospheric perspective. _Boldness_ can be conveyed with big, brassy, aggressive movements and compositions, saturated color palettes, thick lines, high contrast, cropping, or images that are near. Related to this is _understatement versus exaggeration_. An understated visual is less dramatic, subtle, and restrained, whereas an exaggerated depiction uses visual hyperbole and might be bigger, grander, more prominent, more dramatic, embellished, or amplified.

PREDICTABLE VERSUS SPONTANEOUS

Pattern, symmetry, absolute consistency of elements and their treatment, stable compositions, even weights, among other things would be considered _predictable_. Sketchiness, abrupt movements, asymmetry, changes in pace, staccato lines, open forms, changes in case, or blurring of edges could communicate _spontaneity_. In Figure 6-7, the spontaneous quality in Ed Fella's Low and Behold poster is conveyed through whimsical changes in the sizes of letters, hand-drawn letters, and forms. You can see why in _Graphis_, Stuart Frolick titled his article about Fella "Design Doodler."

OPAQUE VERSUS TRANSPARENT

Opaque elements are dense, seemingly solid, and not seen through. Elements, type, and visuals can be **transparent**, which means see-through from one image to another, from one letterform to another, or from one color to another, as in the free-form shapes constituting the visuals in Figure

Fig. **6-7** /// **POSTER: LOW AND BEHOLD**

ED FELLA

6-8. Seeing through could imply space to various degrees of graphic depth. *Digital transparency* involves altering the opacity of any graphic element or image in print or motion. The contrast of an element is lowered so that it appears transparent in relation to its original opaque form. You also can juxtapose transparent and opaque elements for contrast or another expressive purpose.

Patterns often employ *graphic transparency* where layers of lines, shapes, textures, forms, letterforms, or fields or bands of color overlap. Related to graphic transparency, *linear transparency* refers to transparent layering of linear forms or lines or outline type.

LINEAR VERSUS PAINTERLY MODES

A linear mode is characterized by a predominant use of lines to describe forms or shapes within a composition. In graphic design, painterly modes are characterized by the use of color and value to describe shapes and forms, relying on visible, broad, or a sketchy description of form rather than the specificity of lines. Utilizing a linear or painterly mode can also contribute to unifying a composition.

In his seminal work *Principles of Art History: The Problem of the Development of Style in Later Art*, Swiss art historian Heinrich Wölfflin describes linear versus painterly modes of

One of a series of Digipak CD sets for Lesley Spencer. This one is *Authentic Flavors* with t-shirts. **AUTHENTIC FLAVORS** LESLEY SPENCER® AND THE LATIN CHAMBER POP ENSEMBLE

Fig. **6-8** /// **CD COVER:** *AUTHENTIC FLAVORS*

SEGURA INC., CHICAGO

- *Designer:* Carlos Segura

Segura utilizes related visual elements (unity with variety) on the CD cover and the CD itself, as well as on promotional items such as T-shirts.

representation in fine art, which help us understand how form and style communicate meaning and how they are shaped by culture, time period, and context.

HARD EDGE VERSUS BRUSHY

In painting, hard-edge visualization is almost diametrically opposed to works in a brushy, painterly style. For the unique "Day Without Art" symbol, by contrasting a brushstroke X with the hard-edge delineation of the square representing a picture frame, meaning is enhanced (Figure 6-9).

PROXIMATE VISION VERSUS DISTANT VISION: MODES OF REPRESENTATION

In this must-read essay "On Point of View in the Arts," philosopher José Ortega y Gasset offers "proximate vision" and "distant vision" modes, accounting for the difference in how visual artists describe forms that they see. He explains the point of view of artists in relation to what is seen, representative of changes during eras reflecting the culture, religious beliefs, and philosophy of their time periods.

All images are rendered in focus and in detail in *proximate vision* regardless of whether they are near or far in space. There is no evidence of the effect of the atmosphere on what is seen. We see every form and shape with clarity and in detail no matter how far from us it is.

In *distant vision*, the effect of the atmosphere between the artist's (and viewer's) vision and the thing seen is in evidence. There is one point of focus (in any given moment, we can only focus on one thing at a time) with surrounding elements somewhat obscured. Distant vision is usually partnered with a painterly mode.

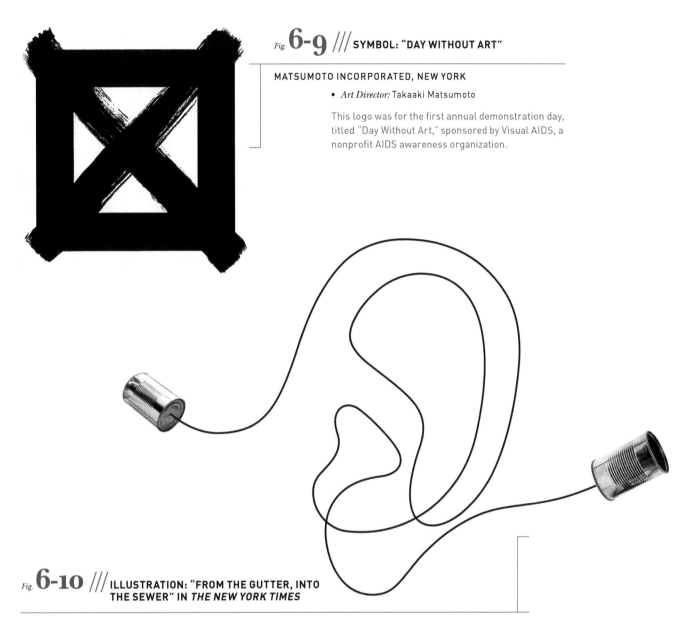

Fig. **6-9** /// SYMBOL: "DAY WITHOUT ART"

MATSUMOTO INCORPORATED, NEW YORK

- *Art Director:* Takaaki Matsumoto

This logo was for the first annual demonstration day, titled "Day Without Art," sponsored by Visual AIDS, a nonprofit AIDS awareness organization.

Fig. **6-10** /// ILLUSTRATION: "FROM THE GUTTER, INTO THE SEWER" IN *THE NEW YORK TIMES*

TOPOS GRAPHICS, BROOKLYN

- *Art Directors/Designers:* Seth Labenz, Roy Rub
- *Client:* The New York Times

This image complemented an article by A. C. Grayling about a phone hacking scandal in Britain.

SINGULARITY VERSUS JUXTAPOSITION

Whether you look at any religious icon—for example, any saint depicted during the Middle Ages—or at a contemporary poster using a single visual, you can see how a singular image can be employed to communicate a message or to symbolize or represent an idea. You can juxtapose two or more images for contrast or in a synergistic way.

DRAWING FOR DESIGNERS AND GRAPHIC INTERPRETATIONS

Drawing as visualizing for graphic design, in which communication is primary, is different from drawing as a fine art discipline, in which form and personal expression are primary, although similar competencies are necessary. Designers utilize a variety of visualizing techniques (Diagram 6-5). They also use visualizing as a creative process of visual thinking and during concept development and design development. Creative visualization gives expressive form to an idea, as in Figure 6-10.

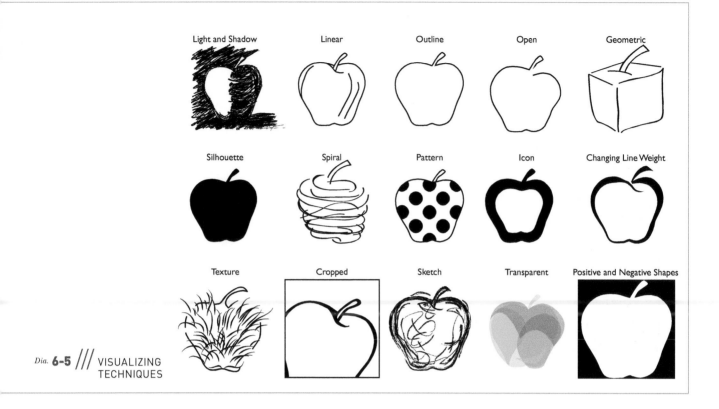

Light and Shadow · Linear · Outline · Open · Geometric

Silhouette · Spiral · Pattern · Icon · Changing Line Weight

Texture · Cropped · Sketch · Transparent · Positive and Negative Shapes

Dia. **6-5** /// VISUALIZING TECHNIQUES

Visualizing techniques include:

→ *Line Drawing*: An image created with line, using a tool such as a stylus or pencil, with no solid areas or shading effects other than cross-hatching; it is also called *line art*. Lines can stay on a surface or extend into an environmental space. Line can be created by unconventional materials and tools as well.

→ *Contour Drawing*: Emphasis is given to the outline of an object or figure, to its specific contour, to render mass and form.

→ *Elemental Flat Shape*: Basic shape rendering of a form using flat colors or neutrals.

→ *Tonal Drawing*: A form is depicted through varying tonal values, through shading, rather than through line.

→ *Sketches*: A rapid visualization technique; a quick, rough drawing method used to communicate concepts and to present layouts and plans.

→ *Rendering*: Drawing to define three-dimensional spaces or objects.

→ *Cartoon Drawing*: Simple rendering of figures and situations.

→ *Caricaturing*: Drawing that captures particular expressions and features.

PRESENTATION: MARGINS, RULES, BORDERS, CROPPING, AND BLEEDS

How you present an image affects communication. How will you use the visual as an independent entity? Will you crop it? Bleed it? Isolate it? Combine it? Juxtapose it? Frame it? Silhouette it? You also need to plan how you will utilize it within the format's entire visual field. How will the visual be composed on the page? Considerations include:

→ *Margins*: the blank space surrounding a visual on the left, right, top, or bottom edge of a page can frame a visual, almost presenting it in a formal manner. Margins also afford space for page numbers, running heads in publications, notations, captions, headings, titles, and credits.

→ *Rules*: thin stripe(s) or line(s) used for borders or for separating text, columns of text, or visuals. Most often, rules function best when used to separate, as *dividers*, attracting little notice.

→ *Borders*: a graphic band that runs along the edge of an image, acting to separate the image from the background, like a frame, by something as simple as a thin rule or as ornate as a Baroque frame. Borders can also act to emphasize the boundaries of an image. *A border should never overwhelm or distract from what it frames.*

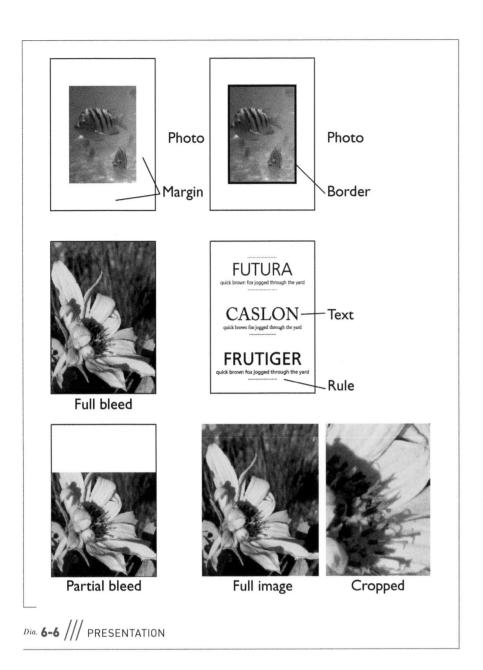

Photo

Margin

Photo

Border

FUTURA
quick brown fox jogged through the yard

CASLON — Text
quick brown fox jogged through the yard

FRUTIGER
quick brown fox jogged through the yard

Rule

Full bleed

Partial bleed

Full image

Cropped

Dia. **6-6** /// PRESENTATION

→ *Cropping*: the act of cutting an image, a photograph, or an illustration to use only part of it, not using it in its entirety. Crop an image to edit it, to improve it, or to delete visual information that might distract the viewer from the communication. You can crop for effect. Cropping alters the original visual. It alters its outer shape, its internal scale, how the inner content is framed, and can change its focus.

→ *Bleed or full bleed*: type or a visual that extends off the edges of the page, filling the page with an image. A *partial bleed* can run off one, two, or three sides (see Diagram 6-6).

USING COLOR

Responses to color vary depending on culture, region, gender, and personal preferences. Color is elusive; its meaning is tied to specific experiential contexts. It has optical properties that change. Color is physical and also lives in the digital realm.

Some designers have an affinity for using color. They create unique color palettes and understand the potential of color to communicate on a symbolic, brand, and visceral level. Others have to study color. Although we design for print and screen,

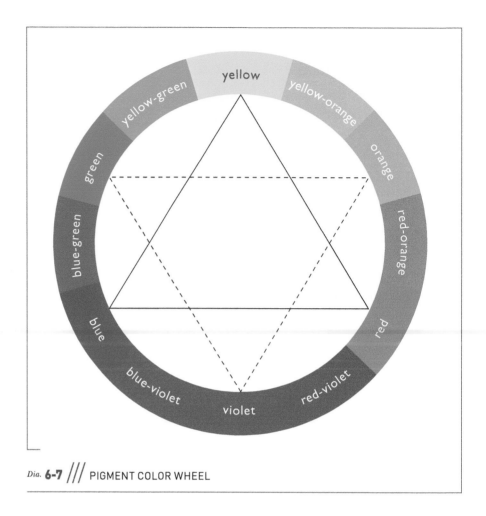

Dia. **6-7** /// PIGMENT COLOR WHEEL

RELATIONSHIPS ON THE PIGMENT COLOR WHEEL

a good place to learn about color is with the pigment color wheel as a point of departure.

Essential color relationships start with the *pigment* color wheel, which diagrams basic color harmonies. The three primary colors (red, blue, and yellow) on the color wheel are connected by an inscribed equilateral triangle, which indicates a basic color group and relationship (Diagram 6-7). When used together as a *color palette*, a planned combination of colors created by a designer for a specific project, brand, or entity, this basic group of pigment primaries is bold and elemental or expresses nostalgia or childlike innocence. The secondary colors in pigment (orange, green, and violet) are mixtures of the primaries. They have less hue contrast among themselves than the primary group because they are mixtures; they yield a less bold relationship.

Mixtures of the pigment primaries and secondaries yield interval colors between the two: blue (primary) + green (secondary) = blue-green (interval). These three sets of color groups (primary, secondary, and interval) comprise the basic pigment color wheel, which we use as a guide for mixing and for harmonious color combinations (Diagram 6-8).

The role of neutrals (white, black, and gray) in color relationships varies depending on amounts, position, and the hues they accompany; they are also called *achromatic* colors. Within a group of saturated hues, white, black, and gray might act as areas of visual rest or chromatic neutrality. Depending on amounts, black may darken (as well as deepen) a design, and white may lighten (as well as open up, enlarge) a design. Black-and-white relationships may also be used for contrast, differentiation, or drama. Surrounding a saturated hue with grays can turn the high-intensity hue into a focal point (see Diagram 6-9).

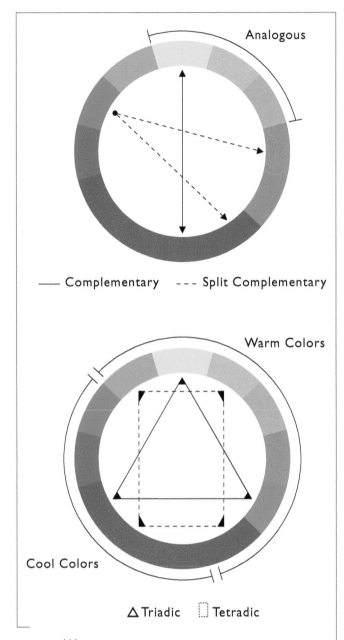

— Complementary - - - Split Complementary

△ Triadic ▢ Tetradic

Dia. **6-8** //// FUNDAMENTAL COLOR RELATIONSHIPS ON THE PIGMENT COLOR WHEEL

Analogous colors are any three adjacent hues.

Complementary colors are opposing hues.

Split complementary colors are two near hues in opposition to one hue.

Triadic are three hues at equal distance from each other.

Tetradic are two sets of complements.

Cool and warm colors are blue, green, and violet hues versus yellow, orange, and red hues.

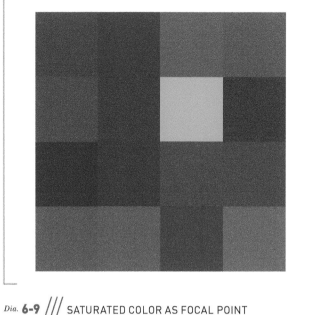

Dia. **6-9** //// SATURATED COLOR AS FOCAL POINT

COLOR TEMPERATURE

A hue may be warm or cool in temperature (Diagram 6-10), which refers to whether the color looks hot or cold (for more information, please see Chapter 2). The temperature of a color is not absolute but can fluctuate depending on the strength of the dominant hue of a color. For example, a red may contain blue, making it look cooler than a warm red-orange. Saturation and value also affect temperature. In print, color temperature is affected by the color of the paper that any ink is printed on. Although it is more difficult to read the temperature of a dark or dull color, these colors do appear warm or cool. Grays mixed from colors, not neutrals, may appear cool or warm as well.

For student designers, when mixing colors, it is best practice to use a color palette that is either cool or warm, especially for representational imagery. When used in the same design solution, cool and warm colors may visually separate or appear disparate. For example, if you are depicting a blue box, it is best to describe all the surfaces with cool values of blue, blue-grays, or a palette of cool tones. If you depict the darker side of the blue box with a warm brown or warm gray, the warmer tone will tend to visually separate from the cooler sides and not enhance a three-dimensional appearance.

Cool and warm colors in opposition on the color wheel seem to create visual tension or spatial "push-and-pull" effects when composed together. When placed next to one another, a warm

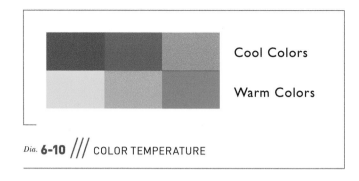

Dia. **6-10** /// COLOR TEMPERATURE

Cool Colors

Warm Colors

color may seem to move forward and a cool color recedes, but this is all relative to the specific composition, amount of color, weight, saturation, value, and position in the composition.

In nonobjective imagery or typography, color temperature can be used for contrast. However, again, be aware that cool and warm colors do tend to appear inconsonant. Color temperature contributes to expression, to feelings of heat, warmth, placidness, or coolness, and so on. The human brain and eyes perceive color in a relational manner. Any color is seen in relation to other colors that surround it or that are near it. A color's visual appearance may by altered by surrounding colors.

COLOR SCHEMES

The following color schemes, harmonious color combinations, are based on hues at full saturation and of middle value range (see Diagram 6-11). When designing with color, always consider hue, value, and saturation. Changing the value or saturation of a color will affect how it works and communicates. Also consider how colors will appear and interact on screen or in print (see Chapter 2 for information about digital color). On screen, colors are more luminous. In print, the inert properties of ink applied to a paper substrate will look differently from when designing them on screen. Combining the following color schemes with black, white, and gray also affects how they behave and communicate and could be altered by changes in value and saturation and the addition of neutrals.

Monochromatic color schemes employ only one hue. These schemes establish a dominant hue identity while allowing for (a variety of) contrasts in value and saturation. A monochromatic palette can contribute to a visualization and composition's unity and balance. It can appear restrained, simple, and act as an alternative to black for a one-color project. (When used on a white screen or paper, a monochromatic scheme based on a hue that is naturally light in value, such as yellow, would not provide enough contrast on its own unless a neutral such as black is added.)

Analogous color schemes employ three adjacent hues. Due to their proximity on the color wheel, analogous colors tend to be a harmonious or congruent color palette. The harmony is created because of the colors's similarity to each another. An analogous color scheme aids establishing unity and calm, like a monochromatic scheme, but it is more diverse. In an analogous scheme, one color can dominate, and the other two colors play supporting roles.

Complementary color schemes are based on a relationship between any two opposing hues on the pigment color wheel. These opposing hues tend to visually vibrate and can express tension or excitement through their strong contrast. Used in small amounts placed close together, complementary colors may mix optically to form grays or to shimmer, which is called *mélange optique* (optical mixture). (In painting, Divisionism described the separation of color through small individual strokes of paint. Pointillism described the application of small dots of paint positioned closely together. Both create optical mixtures.)

Split complementary color schemes include three hues: one color plus the two colors adjacent to its complement on the color wheel. A split complement's vibratory nature is high contrast but somewhat more diffused than a complement and is less dramatic than a complementary color scheme but still visually intense.

Triadic color schemes include three colors that are at equal distance from each other on the color wheel. Basic triadic groups are the primaries and secondaries. An example of another triadic relationship is red-orange/blue-violet/yellow-green. The inherent equilibrium of a triadic group is visually diverse with good hue contrast yet harmonious.

Tetradic color schemes are composed of four colors in two sets of complements (a double complementary). Tetradic palettes offer great hue diversity and contrast. For student designers, this palette may be difficult to harmonize unless one hue becomes dominant with the others as supporting players.

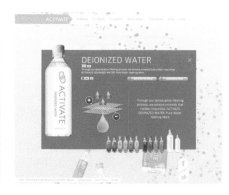

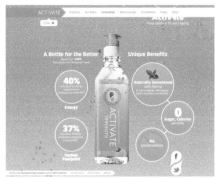

Fig. **6-11** /// WEB: ACTIVATE DRINKS:
HTTP://WWW.ACTIVATEDRINKS.COM

Cool colors are the blue, green, and violet hues located approximately on the left half of the pigment color wheel. When a composition is based on a cool color palette, it feels synchronized and congruent. Often, the resulting effect is calm or serene. Cool colors are easier to balance than warm colors or combined warm/cool palettes.

Warm colors are the red, orange, and yellow hues located approximately on the right half of the color wheel. When used together, warm colors look harmonious and are easier to balance than combined warm/cool palettes. The conventional associations with warm colors is the feeling or sensation of heat (fire, the sun), spiciness, or intensity.

Color palettes reach well beyond the pigment color wheel. Color groupings can be found in nature (earth tones, minerals, sea, etc.), seasons and climates (autumn, tropical, etc.), fine art (Fauves, Pointillism, Divisionism, Mannerism, etc.), periods of design history (Psychedelic, New Wave, etc.), fashion across centuries and countries, textiles (batik, Scot plaids), ceramics (ancient Chinese ceramics, Greek red vase period, etc.), and in global cultures. Always research color symbolism for meaning in relation to the audience, culture, region, and country because each has its own set of associations and meanings.

Beyond color schemes, designers use color to denote, connote, symbolize, distinguish, differentiate, cue, as themes, to demarcate spatial zones or define a website section, and

DIGITAL AGENCY: BIG SPACESHIP, BROOKLYN

- *Client:* ACTIVATE Drinks/The Rising Beverage Co. LLC

"Putting a new twist on vitamin-enhanced water, ACTIVATE has built their brand through innovative product design and the promise of 'a turn for the better'—fresh vitamins released into the bottle with a simple twist of the cap. We began our ongoing relationship with the brand by crafting a digital foundation that mirrors their innovative personality, while visually showcasing the power of fresh vitamins. To that end, we crafted an immersive site that tells the unique story of vitamins and water interacting within every ACTIVATE bottle."

—© *Big Spaceship*

more. For example, Big Spaceship used color in a strategic way for their design of the ACTIVATE website (Figure 6-11). When asked what makes their website design better or different, Big Spaceship responded, "Being a new brand, we wanted to help ACTIVATE make a bold statement. Upon landing at ACTIVATEdrinks.com, users are prompted to 'twist the cap,' activating a rich vertical animation experience that guides you through each section with a flow of vitamins and water. As users scroll down the page, a custom parallax effect gives depth

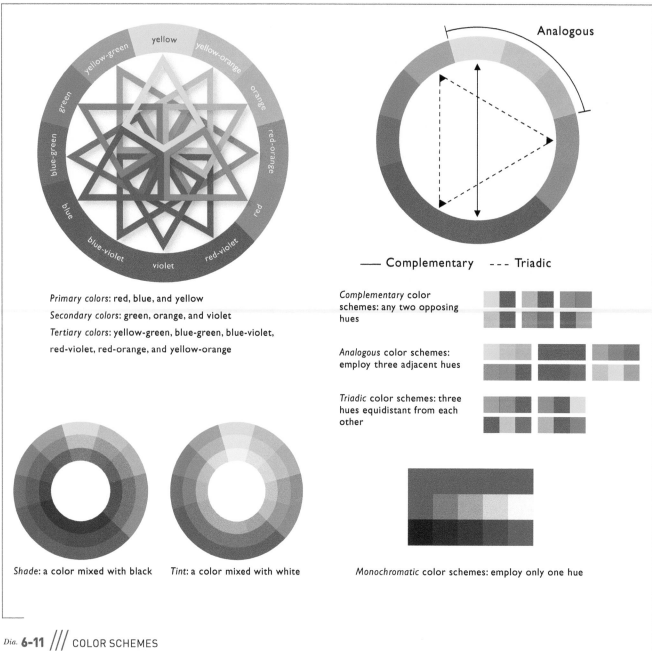

Primary colors: red, blue, and yellow

Secondary colors: green, orange, and violet

Tertiary colors: yellow-green, blue-green, blue-violet, red-violet, red-orange, and yellow-orange

Complementary color schemes: any two opposing hues

Analogous color schemes: employ three adjacent hues

Triadic color schemes: three hues equidistant from each other

Shade: a color mixed with black

Tint: a color mixed with white

Monochromatic color schemes: employ only one hue

Dia. **6-11** /// COLOR SCHEMES

to the layers of content, oversized fonts and flowing water that change color as you explore. Each site section is defined by the color themes of a given flavor, allowing the product to be front and center at all times. Ultimately, ACTIVATE's new digital presence showcases the brand's unique personality and affinity for innovation—and the possibilities that come with a turn for the better."

A FINAL WORD ON VISUALIZATION: STORYTELLING

How can an image tell a story? How can combining text and image tell a story more fully?

COLOR: BEST PRACTICE

- Color always must be appropriate for a brand, group, or organization as well as for the audience.
- Color is perceived depending on audience and context and colors that surround it.
- Color is perceived in relation to the hues, values, and neutrals that surround it.
- Color can be used to create a focal point.
- Color can differentiate a graphic element from others in a composition.
- Using color is the easiest way to establish connections among graphic elements in a single composition or across multiple pages.
- Color can be thematic.
- Color can define a section of a website or publication.

Every image tells a story through its subject, visualization, and composition. And every aspect of that image—color, light and shadow, details, angle/point of view, value contrast—all contribute to the nature of the story: what you leave in an image, what you edit out—how you frame it, whether you crop it, and so on.

A still image is an artificial construct. It is a deliberately constructed visual held in time for us to contemplate, to help inform us, to help us make sense of the world. Motion— moving images whether created by a filmmaker or motion designer—is also an artificial construct that is deliberate and deliberated. All images tell stories—the story the visual artist, director, or writer intends—and the story the viewer gleans from it and brings to it.

If you doubt that a single image can convey meaning, then look at the work of great photographers, illustrators, and painters. If you look at stills from great filmmakers, you will also see how each shot tells a story on its own, yet contributes to the greater story.

Writer and director Doug McGrath noted:

In my film *INFAMOUS*, which was about the making and undoing of Truman Capote, a key scene is his arrival in Kansas. He has come with his childhood friend, Nelle Harper Lee, who lived, as he did, in New York City. Capote lives his life in that city in a glittering way: nightclubs, private clubs, events that were often underwritten by his friends whom he chose carefully from the famous and wealthy. He himself was not yet famous to a wider public; he was only known among the rarified social circles in Manhattan and to a slightly wider literary audience. But it was not his way to tiptoe in to someplace new on little cat's paws. He always announced himself.

I wanted to cover his arrival in one shot: not several angles, just one, and with no dialogue because in this case, I felt the image would say more than words would. I preceded his arrival in Kansas with an opening of several minutes set in Manhattan, in crowded noisy restaurants, smoky nightclubs, glamorous penthouses. But then we cut to the shot of him and Nelle, just off a dusty red train, deposited on the platform in Holcomb, Kansas.

The train fills the shot, top to bottom, side to side. At the start of the shot, a conductor signals the driver that the passengers from New York—Truman and Nelle—are off. The train slowly pulls out and, in so doing, appears to wipe the screen clean: as it leaves to the left of screen, to the right it begins to reveal the vast emptiness of the Kansas plains, until finally there is nothing in the shot but the high sky, the endless horizon, the empty fields, and the two New Yorkers, one of whom has his very pretty luggage stacked high beside him.

It is a quiet shot. There is some music, but gently played, so that the audience is aware of how noiseless the new world is. I held the shot for a long time, without moving the camera, to let the audience feel the change in mood. Up till then everything had been merry and bustling, bursting and jolly. It also allows the audience to notice how Truman was dressed which, without getting into it too much, was not typical for the Kansas man of 1959. By keeping it as a single shot, without close-ups, and letting it sit there for a minute, I allow the audience to discover all the things it needs to on its own, which is always more flattering and pleasing to the viewer because it says that you trust them—and you trust the image, with all its information.

—Doug McGrath, Writer/Director

For Figure 6-12,

Whether a logo, a shot in a film, or an icon, a story can be told in a single image. Nike asked HUSH to come up with a single, definitive image that evokes the idea surrounding the NIKEiD service. NIKEiD is Nike's online service that allows anyone to customize the look of their own shoe (a "blank") by choosing colors and material types.

HUSH presented several different design concepts and Nike immediately gravitated towards the idea of the "Splash." HUSH created "Splash"—a dynamic single frame in which a blank, gray shoe is transformed instantaneously by color and style . . . like jumping in a puddle. This image speaks directly to Nike customers where they have the ability to rapidly transform a blank shoe into the vastly more colorful, personal and unique vision in their minds.

This image was commissioned, for display in Nike Town retail stores, the unique NIKEiD Studio in New York's Nolita neighborhood, as well as used for various other NIKEiD collateral.[4]

"We needed to tell the story in a single image," says HUSH cofounder and creative partner David Schwarz. "Working in motion-based media, we literally have time on our side—which allows for a story to develop. Creating a single image meant we had to be smart in our approach and figure out how to embed a lot of thinking into one frame."

4. Neil Bennett. "Hush Makes a Splash with Nike Art." *Digital Arts*, May 14, 2008. http://www.digitalartsonline.co.uk/features/index .cfm?featureid=1716&pn=2

Fig. **6-12** /// ENVIRONMENTAL GRAPHIC: "SPLASH"

HUSH, NEW YORK

- *Design/Production:* HUSH
- *Creative Directors:* David Schwarz, Erik Karasyk
- *Art Director:* Heather Amuny
- *Design Directors:* Manny Bernardez, Scott Denton-Cardew
- *Designers/Illustrators:* Laura Alejo, Doug Lee, Jonathan Cannon, David Schwarz, Erik Karasyk
- *Producers:* Jess Pierik, Lori Severson
- *Client:* Nike, Inc.

HUSH created two 10-foot-wide images intended as wall coverings for NIKEiD and Nike Town stores to represent the NIKEiD service, which allows people to customize their Nike footwear.

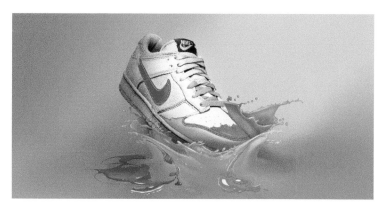

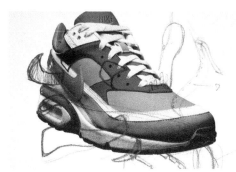

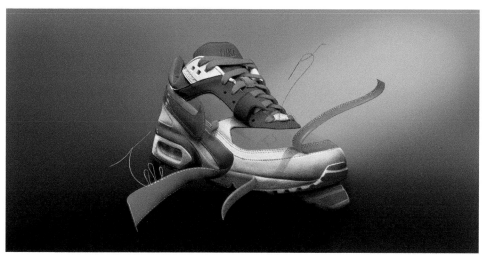

Case Study

Glasgow 2014 Commonwealth Games Pictograms Tangent Graphic

Pictograms are an integral part of the Games identity, enabling the immediate recognition of all sports by athletes, officials, spectators, regardless of language. They will be a huge part of the look of the city at Games-time, helping people find their way to venues and showcasing the seventeen sports on offer at the XX Commonwealth Games.

TIME, DATA, AND MEASUREMENT

In competitive sport, measurement, timing and results are everything. Of course there are the personalities, the emotion, the thrill, the elation and the disappointment. But when it comes to those medals it's a matter of who jumps the highest, throws the farthest, runs the fastest, scores the most goals, wins the most points, lifts the heaviest weight, swims the fastest. During every event and at the end of every event, there is always time, data and measurement.

"Time, Data, and Measurement" are the inspiration for the creative expression of the Glasgow 2014 brand, and remain the inspiration for the Pictograms.

THE DEFINING MOMENT

In every sport, there are key decisive moments. This is the moment that time, data or measurement is captured, the moment that defines winners. Years of training and preparation culminating in a split second, it is the most dramatic and climactic moment of the event.

This is the moment we are capturing for the Pictograms.

—Tangent Graphic

GLASGOW 2014 COMMONWEALTH GAMES PICTOGRAMS

- *Design and Art Direction:* Tangent Graphic, Glasgow
- *http://*www.tangentgraphic.co.uk
- © *Glasgow 2014*

Pictogram Construction
The Glasgow 2014 logo has been created from a set of geometric, concentric rings.

Pictogram Construction
The Pictograms are constructed on a foundation of concentric rings. Identical line thickness and spacing as the logo to create a visual link between them.

Pictogram Construction
This dynamic foundation gives the Pictogram both energy and motion.

Aquatics
Data capture: Fastest time
Defining moment: The last critical stroke; streamlined with arm extended at full stretch; the final touch on the wall determines the winner.

Athletics
Data capture: Fastest time
Defining moment: With speed, power and dramatic momentum; cross the finish line in full flight to stop the clock and be fastest.

Badminton
Data capture: Winning point
Defining moment: Anticipating the flight of the shuttle; jump high in the air to strike the match winning smash.

Boxing
Data capture: Winning blow
Defining moment: Across three 3-minute rounds; use discipline to dominate your opponent and strike a series of decisive blows to score maximum points or knockout for victory.

Cycling
Data capture: Fastest time
Defining moment: Racing against the clock; with muscles burning, that final lunge for the line decides victory.

Gymnastics
Data capture: Most points
Defining moment: Degree of difficulty; execute each move with strength, flexibility and poise to score maximum points.

Hockey
Data capture: Winning goal
Defining moment: The game on the line; across comes the ball and with accuracy and power, strike the winning goal.

Judo
Data capture: Winning point
Defining moment: With strength and guile; dominate your opponent by executing a decisive throw to the mat to score point and victory.

Lawn Bowls
Data capture: Winning point
Defining moment: With the jack in sight; use concentration and precision to roll out the final and decisive bowl.

Netball
Data capture: Winning goal
Defining moment: With time running out; the pass comes in, arms fully extended to release the ball and score the winning goal.

Rugby Sevens
Data capture: Winning try
Defining moment: Fast and furious; break clear of a tackle, see the line and dive forward to score the winning try.

Shooting
Data capture: Winning shot
Defining moment: Locked and loaded; poise, concentration and precision results in the accuracy required to fire the winning shot.

Squash
Data capture: Winning point
Defining moment: Moving into position, lunging to the ball and with precise placement, find the unplayable nick of the wall to secure the match winning point.

Table Tennis
Data capture: Winning point
Defining moment: Match point; the ball is in play across the table and with agility and skill, rising up to hit the winning shot and achieve victory.

Triathlon
Data capture: Fastest time
Defining moment: From swim to cycle to run; with the last ounce of energy, crossing the finishing line in front.

Weightlifting
Data capture: Winning lift
Defining moment: With the bar fully loaded, in the zone and pumped up; arms fully extended with a technically clean lift of the medal winning heaviest weight.

Wrestling
Data capture: Winning point
Defining moment: Skillfully executing a clean, high-point scoring takedown with ease; looking to complete a throw that results in a straight pin and instant victory.

Case Study

Travel Series Heads of State

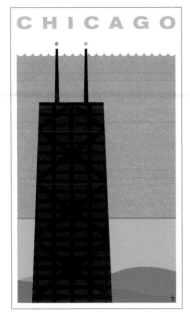

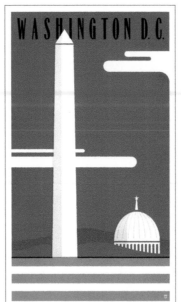

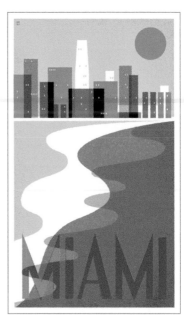

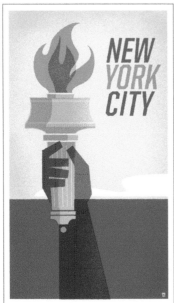

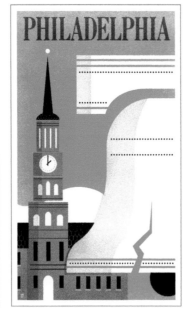

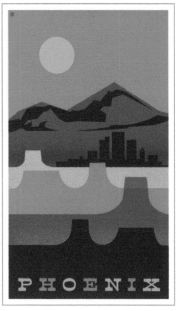

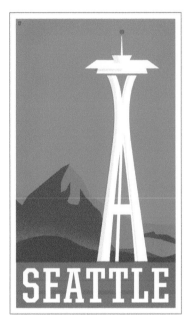

POSTERS: TRAVEL SERIES & SKETCHES

HEADS OF STATE, PHILADELPHIA

- *Art Directors/Designers:* Dustin Summers, Jason Kernevich

Exercises and Projects

Go to GDSOnline for more exercises and projects. ⬈

Exercise 6-1

Drawing for Designers

01. Choose one image, such as a tree, bird, house, or flower.

02. Sketch or draw the chosen image twenty different times, trying different sketching styles. Experiment with drawing or sketching tools.

Project 6-1

Image Classifications and Depictions

01. Choose one image, such as a tree, bird, house, or flower.

02. Depict the chosen image as a notation, pictograph, and silhouette.

03. Depict the same image in the following modes: linear, light and shadow, naturalistic, and expressionistic. (Research fine art examples of these modes.)

04. Create ten thumbnail sketches for each depiction.

05. Choose the best of each and refine into comps.

PRESENTATION

Present all the depictions in black and white only.

7 COMPOSITION

FUNDAMENTALS OF COMPOSITION

When you look at a poster, you might think: "Do I find this interesting?" and "Do I get the message?" Creating visual interest and clarity of communication are two main goals of composition. For certain types of graphic design disciplines, such as information design (think of a poster illustrating the Heimlich maneuver or a subway map), clarity is essential and perhaps enough. For other disciplines of design with greater promotional intent (think mobile advertisement or book cover), catching people's attention is critical because someone has to be attracted enough by the design's form to take the time to interpret the message. A formulaic design might be clear, but if it's boring, no one is going to bother to look at it or spend time with it. Often, viewers will spend more time trying to make sense of a message if the form of a graphic design solution interests them. To create interesting and comprehensible solutions, you need to develop keen compositional skills.

Composition is the form, the *whole spatial property and structure* resulting from the visualization and arrangement of graphic elements—type and images—in relation to one another and to the format, created with the intention to visually communicate, to be compelling, and to be expressive. *Composing* is about how all the parts of your design work together—the visual organization of type and images in a graphic spatial arrangement.

MARGINS

Defining boundaries starts with **margins**—the blank space on the left, right, top, or bottom edge of any printed or digital page (Diagram 7-1). Basically, margins function as frames around images and typographic content, concurrently defining active or live areas of the page or screen real estate as well as its boundaries.

Considerations for determining the margins include:

→ How the margins (width and proportions) can best present the content

→ White space in the form of margins increases readability

→ Control the proportions of the margins to produce harmony, balance, and stability

→ Consider function and aesthetics of symmetrical versus asymmetrical margins

THE FORMAT: STATIC VERSUS ACTIVE COMPOSITION

Almost all formats (books, billboards, business cards, website page, brochures, etc.) across media (print, smart phone, tablet, computer screen, outdoor screen) are rectangular. Screen

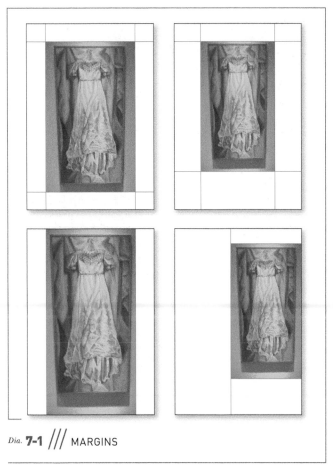

Dia. **7-1** /// MARGINS

Art: Ashley Bargende

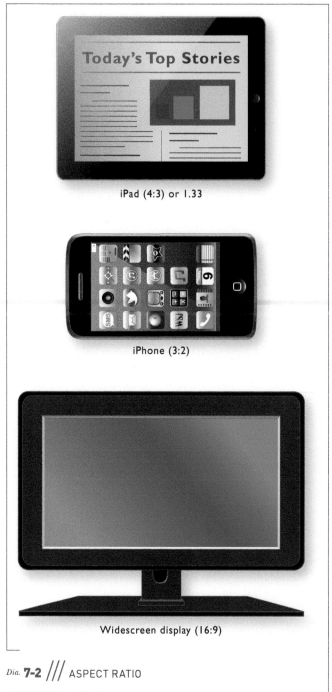

iPad (4:3) or 1.33

iPhone (3:2)

Widescreen display (16:9)

Dia. **7-2** /// ASPECT RATIO

media are all rectangular with different aspect ratios, the screen image width–height ratio (Diagram 7-2).

The following concepts about composition apply to all media. Vertical and horizontal elements and movements parallel the edges of a rectangular or square format. In static compositions, vertical and horizontal movements are emphasized. In active compositions, diagonal or curved movements—directions that contradict or are in counterpoint to the edges of the format— are emphasized. Generally, compositions with dominating parallel movements are deemed more placid. Compositions with counterpointing movements are more active or tense; for example, in Figure 7-1, the angles of the guitar, edges of the boom box, and figure's gesture all move at angles to the format. Please note: you can manipulate vertical and horizontal lines or movements to generate an active composition.

If the shape of a single surface format is extended in one direction, for example, an extended landscape-shaped rectangle (elongated poster, outdoor billboard, web banner), parallel movements, in this case horizontal movements, will take on more force than those in a more conventional rectangular format (standard magazine format, tablet). Consult Diagram 7-3 for static versus active graphic elements within a format.

RESPONDING TO THE EDGES OF THE FORMAT

All visual elements must respond to (though not necessarily touch) the edges of the page. Not merely the end of the graphic space, a format's boundaries fully participate in the compositional structure, as in Figure 7-2, where the numbers and arrows relate to the edges of the cover.

Fig. **7-1** /// **POSTER: THE B'Z**

MODERN DOG DESIGN CO., SEATTLE

- *Designer:* Junichi Tsuneoka
- *Client:* House of Blues
- © *Modern Dog Design Co.*

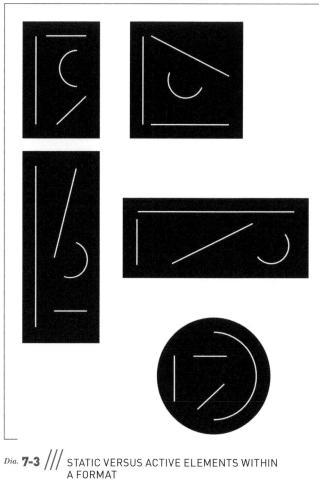

Dia. **7-3** /// STATIC VERSUS ACTIVE ELEMENTS WITHIN A FORMAT

Fig. **7-2** /// **BOOK COVER:** *DECODING THE UNIVERSE* **BY CHARLES SEIFE**

THINK DESIGN, NEW YORK

- *Design:* John Clifford, Herb Thornby

"This is a visual representation of the concept of information theory."

—John Clifford

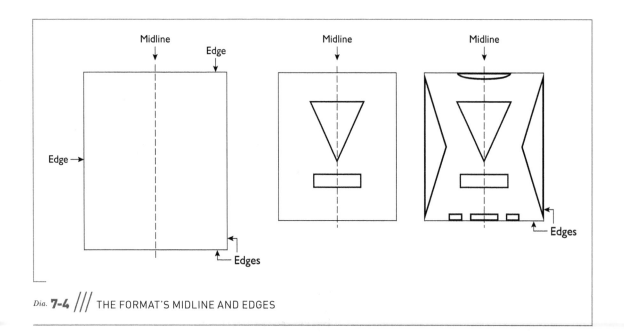

Midline

Edge

Midline

Midline

Edge →

Edges

Edges

Edges

Dia. **7-4** /// THE FORMAT'S MIDLINE AND EDGES

ACKNOWLEDGING THE MIDLINE

Envision an imaginary vertical line down the center of a page (Diagram 7-4). As you position graphic elements, analyze how each interacts with that midline. Do graphic elements cross the midline? Approach the midline? How do the graphic elements interrelate in the central space of the composition? Notice how Figure 7-3 makes use of a prominent midline.

Fig. **7-3** /// BOOK COVER: *SAYONARA HOME RUN! THE ART OF THE JAPANESE BASEBALL CARD* BY JOHN GALL AND GARY ENGEL

- *Art Director:* John Gall
- *Design/Illustration:* John Gall, Chin Yee Lai
- *Photographer:* Simon Lee
- *Client:* Chronicle Books

The vertical red rule, the midline dividing the baseball card images, becomes an important structural device. Notice how the baseball is directly under the red line and how the words "Sayonara" and "Home Run!" are angled in relation to the red midline rule and the baseball to create movement.

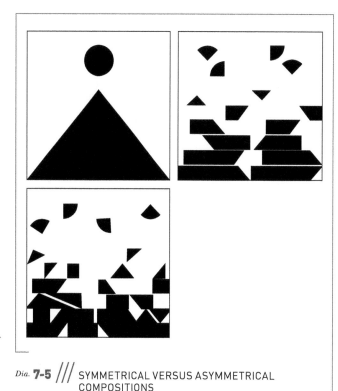

Dia. **7-5** /// SYMMETRICAL VERSUS ASYMMETRICAL COMPOSITIONS

THE FORMAT: CLOSED VERSUS OPEN COMPOSITION

The terms *closed* and *open* refer to the way the graphic elements of a composition relate to the edges of a format. Basically, if the internal elements's directions and orientations echo the format's edges to a great extent *and* the viewer's focus is kept tightly within the format, that composition is considered **closed** (think artist Raphael Sanzio's *School of Athens*, found at http://mv.vatican.va). If the major directions and orientations within the composition oppose the edges (think diagonals) or direct our eyes past the boundaries of the format (think artist Jackson Pollock's *Number 1, 1950 (Lavender Mist)* found at http://www.nga.gov), that composition is considered **open**.

SYMMETRICAL VERSUS ASYMMETRICAL COMPOSITIONS

Whether in print or on screen, each static, single format has a vertical axis. Imagine a line down the center of the format. The equal distribution of visual weight on either side of the vertical axis is the key to establishing balance (Diagram 7-5).

In a *symmetrical composition*, corresponding (mirrored) forms are arranged on either side of the vertical axis. In general, balance achieved through symmetry yields stable and often static (as opposed to active) results. This is not a qualitative critique of symmetry but a consideration for how to use this compositional approach. (Some hold the notion that viewers respond with less interest to symmetrical compositions than to the variations inherent in an asymmetrical composition. There are too many variables in any compositional arrangement to hold such a generalized opinion about the potential for visual interest and expressive communication. Visual results always depend on the specific composition. There are many uninteresting asymmetrical compositions and very interesting symmetrical compositions.)

In an *asymmetrical composition*, arranging a balanced composition does not rely on symmetry. Forms are arranged to coun-

terbalance each other without mirrored opposite visual weight and positioning. To achieve a balanced asymmetrical composition, you consider the position and visual weight (size, texture, color, value) of each graphic element in relation to the other and to the format. Asymmetry is not a formulaic approach to composition. Asymmetry often is more active due to its inherent variations, but it does not necessarily have more impact than symmetry.

In asymmetrical compositions where complementary graphic elements are positioned in counterpoint, visual weight deliberations are strategic, not formulaic. To understand balancing a composition through counterpoint, think of every visual weight you position in a composition requiring a contrasting counterbalancing force strategically placed in the composition. In music, the most rudimentary way to think of counterpoint is "note against note." In design, counterpoint is the use of contrast or the *interplay* of graphic elements in a work simultaneously providing unity and variety. In any balanced composition, if you move one graphic element, you will need to reconsider the balance of the entire composition. (See Chapter 2 for more information on visual weight.)

Try this little experiment. Figure 7-4 is a spread from an edition of *Aesop's Fables* designed by Milton Glaser. Cover the graphic element (artwork) in the lower right corner. You'll notice that the composition is no longer balanced. This demonstrates just how important the arrangement of every element is to establish asymmetrical balance.

Fundamentals of Composition / p.147

Fig. **7-4** /// BOOK SPREAD: *AESOP'S FABLES*, NEW EDITION OF ARTWORK CREATED IN 1947

MILTON GLASER

- *Artwork:* John Hedjuk, architect
- *Publisher:* Rizzoli International Publications, Inc.

The Four Oxen and the Lion

A LION used to prowl about a field in which four Oxen used to dwell. Many a time he tried to attack them; but whenever he came near, they turned their tails to one another, so that whichever way he approached, he was met by the horns of one of them.

At last, however, the Oxen fell a-quarreling among themselves, and each went off to pasture alone in a separate corner of the field. Then the Lion attacked them one by one and soon made an end of all four.

United we stand, divided we fall.

BALANCING FORCES

Every graphic element positioned on a page contributes to a potentially balanced action, similar to how opposing physical movements operate in sports, dance, and yoga. Think of these comple-mentary balancing forces as simultaneous actions building stability, balance, and harmony (Diagram 7-6).

- *In and Out.* Pulling forces inward, toward the vertical midline of the page, and forces expanding outward, toward the edges of the page (see Figure 7-5).
- *Afferent and Efferent.* Inward contraction from the outer edges to the core, moving from the edges *to the focal point* (the point of emphasis in a composition) and then back from focal point to the boundaries. (Not to be confused with actual radial composition where the composition radiates outward from a central point.)
- *Up and Down.* Grounding (rooting) the elements down while simultaneously lifting them up; that is, consider-ing how the composition flows from top to bottom and bottom to top and considering all the transi-tions in between.

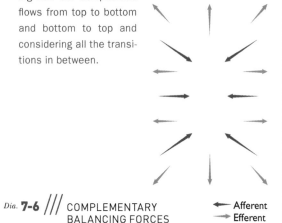

Dia. **7-6** /// COMPLEMENTARY BALANCING FORCES

← Afferent
→ Efferent

Fig. **7-5** /// POSTER: NEW MUSIC AMERICA

ALEXANDER ISLEY INC., REDDING, CT

- *Art Director:* Alexander Isley
- *Designer:* Alexander Knowlton
- *Client:* Brooklyn Academy of Music, New Music America Festival

Fig. 7-6 /// TOMMY BAHAMA ECOMMERCE WEBSITE (FLASH DESIGNED)

HORNALL ANDERSON, SEATTLE

- *Creative Director:* Jamie Monberg
- *Designers:* Nate Young, Joseph King
- *Photography:* Client provided
- *Programmers:* Gordon Mueller, Matt Frickelton
- *Senior Producer:* Erica Goldsmith
- *Client:* Tommy Bahama
- http://www.tommybahama.com

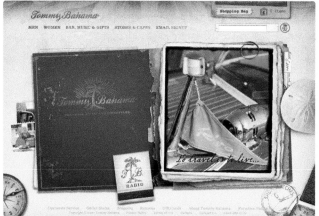

ILLUSION OF SPATIAL DEPTH

A plane is a flat surface, and the **picture plane** is the blank, flat surface plane of a print or digital single, static page. When you set out to compose on a two-dimensional surface, like a screen or a piece of paper, you begin with the picture plane. As soon as you make one mark (draw a line, place a letterform, or any graphic element) on the surface, that mark interacts with the picture plane *and* perimeter of the format. The marks you make and composition you create can maintain the flat picture plane or can create the illusion of spatial depth. The **illusion of spatial depth** means the appearance of three-dimensional space, where some things appear closer to the viewer and some things appear farther away—just as in actual space. The illusion of spatial depth can be shallow or deep, recessive or projected. One diagonal line can evoke the illusion of depth (see Diagram 7-7).

It is possible to create such impressive illusions that the viewer, at first sight, doubts whether the thing depicted is real or a representation. This effect is called **trompe l'oeil.** The use of shadows and overlapping shapes can create effects fooling the viewer into thinking the elements are actually adhered to the surface rather than an illusion, which appeals to our tactile sense.

Hornall Anderson's solution to evolving the Tommy Bahama online shopping process involved the objective of "Bringing the in-store experience online." In Figure 7-6, you can see how the trompe l'oeil illusion would make the online shopping experience more tactile and rich. Note how the map that is the background is the picture plane, and all the objects and images move in front of the picture plane. "Through a new, richer web presence, visitors are offered a true digital 'experience' that mirrors the Tommy Bahama signature brand offerings. This site redesign marries the extension of their products, retail look & feel, and customer service to the creation of a new ecommerce platform with intuitive buy-flow, all designed to seamlessly launch their products online," explains Hornall Anderson.

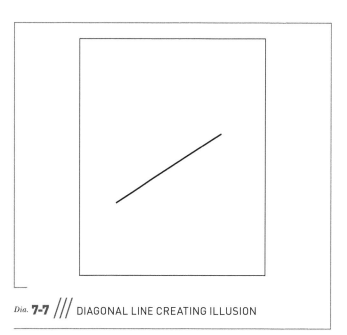

Dia. 7-7 /// DIAGONAL LINE CREATING ILLUSION

Fig. **7-7** /// BOOK COVER: *I NEVER HAD IT MADE* BY JACKIE ROBINSON

- *Art Director:* Roberto de Vicq de Cumptich
- *Designer:* Will Staehle
- *Client:* Ecco Publishers

We see the winning image of Jackie Robinson from behind his baseball card, which establishes the picture plane.

In "regular" or "Classical" compositions (Classical here refers to the Italian Renaissance; think Raphael [Raffaello Sanzio] and Leonardo da Vinci), none of the major forms appear to move in front of the picture plane. This can be called a "picture window" arrangement, where, like a window pane, all that we see recedes behind the front plane and does not move in front of the picture plane into the viewer's space (Figure 7-7).

In contrast, in an "irregular" or Baroque pictorial space (referring to Flemish Baroque painting; think Peter Paul Rubens, or a comic book superhero's fist punching in front of the picture plane), diagonal elements and planes move in front of as well as behind the picture plane creating the illusion of depth and action, suggesting an aggressive spatial property (Figure 7-8).

FOREGROUND, MIDDLE GROUND, BACKGROUND

In pictorial space, the picture plane can be manipulated into the illusion of spatial planes (Diagram 7-8). There are three main planes with many others in between: the *foreground* (the part of a composition that appears nearest the viewer), the

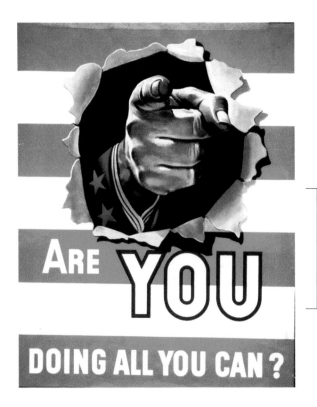

Fig. **7-8** /// POSTER: ARE YOU DOING ALL YOU CAN? 1942

NATIONAL MUSEUM OF AMERICAN HISTORY, SMITHSONIAN INSTITUTION

GIFT OF GENERAL CABLE CORPORATION

- *Designer:* Unidentified Poster Maker
- *Photographer:* Terry McCrea
- *Producer:* General Cable Corporation
- *Photomechanical lithograph, 71.1 × 55.9 cm (28 × 22 in.)*

In this historical poster, the hand busts through the picture plane to confront the viewer, coming into the viewer's space for dramatic impact. The red and white stripes define the picture plane.

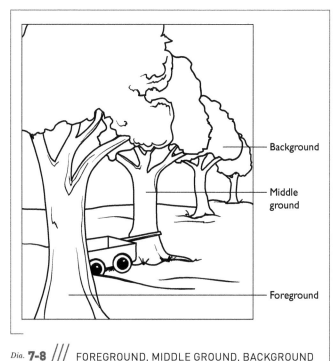

Dia. **7-8** /// FOREGROUND, MIDDLE GROUND, BACKGROUND

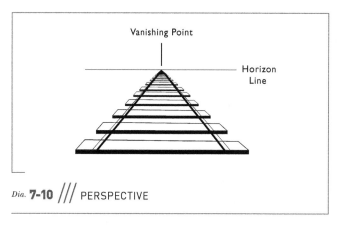

Dia. **7-9** /// TILTED PLANE

The position of any graphic element in the pictorial space would be understood in relation to the titled plane—an element would be in front of the plane, behind the plane, or ambiguously positioned. A recessional space formed by a titled plane moving back in perspective can create a heightened illusion of three-dimensional space.

Dia. **7-10** /// PERSPECTIVE

middle ground (an intermediate position between the foreground and the background), and the *background* (the part of a composition that appears in the distance or behind the most important part). To create the illusion of three-dimensional space, graphic elements positioned in the foreground are bigger, rendered in great detail, are brighter, and have more contrast than those in the middle ground and background. This (conventional Western) pictorial illusion of space on a two-dimensional surface imitates the way we perceive forms in the real world; forms appear to become smaller and grayer as they move away from us and recede into the distance.

TILTED PLANE/IMITATING THE RECESSION OF SPACE

If you draw a tilted plane on a surface, you create the illusion of three-dimensional space (Diagram 7-9). The viewer understands the longer side of the plane to be closer in space and perceives the plane as receding. You could suggest a floor plane in a room space with a tilted plane.

Perspective is based on the idea that diagonals moving toward a point on the horizon, called the *vanishing point*, will imitate the recession of space into the distance and create the illusion of spatial depth. Perspective is a *schematic* way of translating three-dimensional space onto a two-dimensional surface (Diagram 7-10). Italian Renaissance artist, architect, and engineer Filippo Brunelleschi, who had reproduced a three-dimen-

sional object in two dimensions, is credited with inventing perspective. Once learning formal mathematical perspective, most designers create the illusion of spatial depth with less formal methods by "eyeballing" what they see or imagine rather than using formal perspectival drawing methods.

OVERLAPPING

When an *opaque* flat plane or form is placed in front of another, that overlap creates the illusion of spatial depth. Successive overlaps create the illusion of a recessive space, which can be

Fig. **7-9** /// **POSTER: TØÜRISTÁ**

MENDEDESIGN, SAN FRANCISCO

- *Art Director:* Jeremy Mende
- *Designers:* Amadeo Desouza, Steven Knodel, Jeremy Mende
- *Client:* Tourism Studies Working Group, University of California, Berkeley

Layering conveys movement, thought, and the passage of time.

manipulated to appear shallow or deep. When you position one form or shape in front of another, that overlap suggests that one form is closer to the viewer than another. If the form in the background is smaller in size than the form(s) in the foreground, the illusion is heightened. We understand smaller size elements to be farther away from us in pictorial space. If the elements in the background are grayer or lighter in value, then the illusion is heightened as well.

Overlaps can function to display a familial relationship among related information or visuals; they denote associations. Overlapping can aid emphasis, utilized with such structures as nest structures and stair structures (see Diagram 2-16). Overlapping also can be used to create **fractured space**, as in the Cubist style of fine art, where multiple viewpoints are seen simultaneously.

LAYERING AND TRANSPARENCY

By overlapping parts of an image simultaneously or in a sequence, the illusion of space is created by layering. Layers can be opaque or transparent, aligned or purposely misaligned, typographic layers, layers of information on maps or layers of data on charts, layers of images in motion graphics, or subtitles on film and in motion graphics. Layers can imitate actual textures found in environments (think peeling layers of outdoor boards or layers of scrapbook elements on pages). Layering can convey movement, thought, or the passage of time. Using **transparency**—making graphic elements transparent (see-through) and layering them or positioning a graphic element over or under another or between similar elements—can create the illusion of ambiguous spatial relationships, which tends to appear as shallow space. In motion-based media, transparency is utilized to create transitions.

In Figure 7-9 by MendeDesign, the layers and transparencies beckon us to travel throughout the poster to enjoy and absorb the images. When interviewed by Sean Adams for *Step Inside Design* magazine, Jeremy Mende said:

"Good work, whatever the medium, is driven partly from an authentic idea and partly from a unique way of expressing it. [A concept] has to result from something more than just the idea or the expressive method. Otherwise the result is at best clever but never really satisfying. This notion of a personalized and whole gesture—one that can't be broken down into 'parts'—is what I find compelling. In this sense, the concept is really how idea and expression are fused."

—http://www.stepinsidedesign.com/STEPMagazine/Article/28865

VOLUME

Volume on a two-dimensional surface can be defined as the illusion of a form with mass or weight, a shape with a back as well as a front (Diagram 7-11). A curving line can suggest volume. A modulated line, a line changing in thickness, can suggest volume. Volumetric shapes, such as cubes, cones, and cylinders, create the illusion of depth. Many volumes together can create the illusion of a recessional space, a Baroque space, or an ambiguous space (think artist Al Held's work *Solar Wind III*, found at http://www.brooklynmuseum.org/).

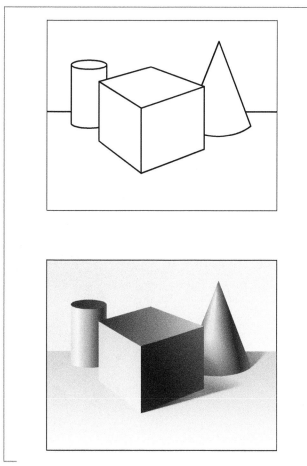

Dia. **7-11** /// DIAGRAM OF VOLUME AND MODULATED FORM

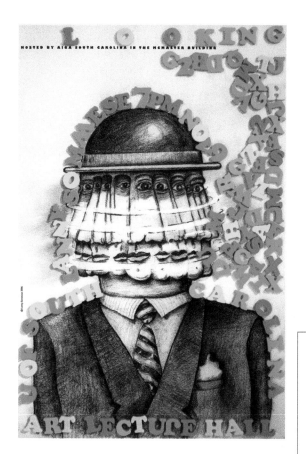

Fig. **7-10** /// **POSTER: LOOKING**

SOMMESE DESIGN, PORT MATILDA, PA

- *Art Director/Designer/Illustrator:* Lanny Sommese
- *Digital Expert:* Ryan Russell
- *Client:* University of South Carolina

"Surprised, the angst-ridden face frantically watches the menacing letterforms as they move about to form words announcing my lecture. I used the colorful magnetic plastic letters not only because they added to the playfulness but also to enhance the meaning; they are often stuck on refrigerator doors to remind family members of upcoming events (like my lecture)."

—Lanny Sommese

VALUE MODULATION AND ATMOSPHERIC PERSPECTIVE

A gradual or progressive change from one color to another or a progressive shift in tone or value, from dark to light or light to dark, can contribute to the illusion of spatial depth or motion. If you observe a landscape receding from you, you'll note its hues and tones change due to the effects of the atmosphere. Hence, the atmosphere affects how we perceive hues and tones seen in the distance. The interposition of the atmosphere between the thing seen and us changes how we perceive form and color. Pictorially, this effect is called *atmospheric perspective*, an illusion that approximates and simulates the effect the atmosphere has on color, shape, form, texture, and detail seen from a distance; it is also called *aerial perspective.* Many artists studied this phenomenon, including a thorough written study by Leonardo da Vinci.

MOVEMENT

In print and on any static digital page, motion is an illusion created through skillful manipulation. A composition can look still, suggest motion, or even suggest intervals of stillness and movement. The illusion of movement can be suggested through active relationships such as diagonal counterpoints, acute shifts in scale, extreme value contrasts, and more. In Figure 7-10, motion is implied in the face and letters.

In time-based media, such as motion graphics and animation, motion occurs from frame to frame over time.

Fig. **7-11** /// **POSTER: SUISSE (FOR THE SWISS TOURIST BOARD, DESIGNED BY HERBERT MATTER, C. 1932)**

THE HERBERT MATTER COLLECTION. DEPARTMENT OF SPECIAL COLLECTIONS, STANFORD UNIVERSITY LIBRARY.

• *Designer:* Herbert Matter

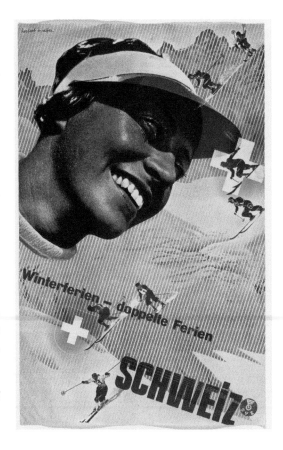

CONTRAST

"Contrast is your friend," Bob Aufuldish of Aufuldish & Warinner tells his students. We comprehend *concave* juxtaposed to *convex*. *Straight* looks straighter compared to *crooked*. In music, we understand *loud* in contrast to *soft*.

There are two overarching purposes for differentiating graphic elements:

1. To create visual variety and interest, and

2. To compare the dissimilarity of elements by contrast.

To differentiate between graphic elements in a design, you must establish a difference between two or more. You must make distinctions. For example, if you intend to mix typefaces, it would be logical to mix two typefaces that are *not* too similar (for example, a serif with a sans serif) so that people can distinguish them. One purpose of using more than one typeface is to create visual variety. Another purpose is to differentiate parts of the text—for example, headings from the main body of the text. Through variation and contrast, you establish visual interest.

Johannes Itten, artist, professor, author, and color and design theoretician, held to a theory of structural compositional oppositions, which he referred to as "polar contrasts":

→ big/small

→ long/short

→ straight/curved

→ pointed/blunt

→ much/little

→ light/heavy

→ hard/soft

Itten's polar contrasts have the potential for visual drama, enabling the viewer to better understand each graphic element through comparison, as in Figure 7-11, where we understand big in relation to small. We understand a bright color compared to dull colors. We understand a rough texture in contrast to smooth and so on. Imagine if an actor delivered all his or her lines in a monotone voice—without any variation; that would be like a design without contrast. Some variation adds visual interest. When one or more elements differ in visual characteristics (color, shape, form, texture, value, size) or in treatment or in position (isolated versus grouping), then variation is established.

We could add other extremes to Itten's list:

→ compress/stretch

→ bright color/dull color

→ colorful/gray

→ light/dark

→ dense/sparse

→ twisted/straight

→ irregular/regular

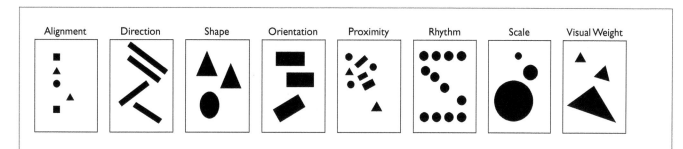

Alignment Direction Shape Orientation Proximity Rhythm Scale Visual Weight

Dia. **7-12** /// DIFFERENTIATION

→ bold/subtle

→ dynamic/static

→ disharmonious/harmonious

→ disorderly/orderly

→ sharp/dull

→ night/day

→ organic/geometric

→ understated/exaggerated

→ whole/fragment

→ transparent/opaque

→ flat/deep

DIFFERENTIATION THROUGH GROUPING

In the 1920s, a group of German psychologists proposed theories to explain how people perceive and organization visual information. The Gestalt principles of perception—similarity, proximity, continuity, and closure—explain how people tend to understand what they see by grouping, by visually assembling images and how they relate to one another into groups. *Grouping* is a fundamental Gestalt concept, proposing that when graphic elements appear similar—share characteristics, are arranged close together, are connected, or are enclosed in a common spatial area—people perceive them as belonging together. Groups can be formed in a variety of ways.

If you understand how grouping functions, you can more easily create visual emphasis in a composition through differentiation. One graphic element can be emphasized, become the focal point, by *differentiating* it from the other graphic elements through contrast in size (scale), weight, color, rhythm, orientation, and more (Diagram 7-12).

COMPOSITIONAL PROCESS

Composing is a process where one achieves a desired result by repeating a sequence of steps and successively getting closer to that result. If the result is "Point B," there are lots of ways to reach Point B. You can get there by spontaneous means, by using proportional systems or compositional structures. The compositional method you use depends on the project's specifications and your own method of composing and visualizing. Composing is an iterative process. Iterations or revising (major and minor changes) usually happen at the same time as creating and producing. This means you are rethinking, revising as you work, which is part of the creative process of composing.

Spontaneous methods for composing (and visualization) include but are certainly not limited to:

→ *Spontaneous composing*: mostly unplanned visualization and structuring, with the *design concept driving* the visualizing and composing. In the process of creating, shaping, moving, improvising, and experimenting with graphic elements, while utilizing the principles of composition as well as relying on your intuition and insights into the creative process, you form a composition. This type of composing is usually for a single surface and therefore does not utilize formal structural devices or systems, such as a grid, which is necessary and utilized for multiple pages or screens. Spontaneous composing does rely on creative as well as critical thinking, creative impulses that result from a working knowledge of design principles and ardent experimentation. Many designers use creativity exercises to start the process, such as problem finding, free drawing/ sketching, prompted sketching, unconventional methods, or any of the creativity exercises in this book. The best way is to start sketching, to think with a pencil, marker, or stylus in your hand. *Sketching is thinking*.

PLEASURE, NEW YORK

- *Creative Director:* Kevin Brainard
- *Designer:* Christopher Brand

If spontaneous composing is too open ended as a starting point, you can try sketching or experimenting using one of the following as preliminary creativity exercises:

→ *Play with form*: Use contrast. Create the illusion of three-dimensional space, movement, or sound. Exaggerate scale. Exaggerate near and far relationships. Manipulate images through synthesis or create a visual merge. Form unexpected juxtapositions. Use abstraction.

→ *Play with media*: collage, photograms, photomontage, experimental materials, mixed media, painting, sculpture, 3D illustrations, photography, sewing/stitching, weavings, rubbings/blottings, monotypes, printmaking, among many others.

→ *Play with historical styles*: Vienna Secession, Psychedelic, New Wave, among many others.

→ *Sketch in the style of* Alberto Giacometti, Honoré Daumier, Georges Seurat, Luca Cambiaso, Käthe Kollwitz, Willem de Kooning, Julie Mehretu, among many other fine artists.

COMPOSING FOR A SINGLE STATIC SURFACE FORMAT

When composing for a single surface format such as a poster, book or magazine cover, mobile ad, or website landing page or ad (as opposed to multipage formats, such as book interiors or websites), consider the roles and interrelationships of type and images as a whole.

TYPE-DRIVEN, IMAGE-DRIVEN, AND VISUAL-VERBAL SYNERGY

Consider one of the following ways to drive the communication:

→ *Type-driven*: emphasis on type and de-emphasis on images, where type is the dominant force with images as secondary, as in Figure 7-12. Type can be the only component of such a solution.

→ *Image-driven*: emphasis on image and de-emphasis on type, where image is the "hero" and type is subordinate to the image, as in Figure 7-13. An image-driven composition can have no text. In advertising, an image-driven ad with no text is referred to as a *no-copy* solution.

→ *Visual-verbal synergy*: a synergistic relationship between verbal message (the title or headline) and the primary image. This mode is a fundamental means for advertising design and for book jacket design and posters, as in Figure 7-14.

THE DIARY OF
ANNE FRANK
BY FRANCES GOODRICH AND ALBERT HACKETT
ADAPTED BY WENDY KESSELMAN

SEPT 28–OCT 16
FOR TICKETS CALL 203-227-4177
WWW.WESTPORTPLAYHOUSE.ORG

Fig. **7-13** /// WESTPORT THEATRE POSTER,
THE DIARY OF ANNE FRANK

PLEASURE, NEW YORK

- *Creative Director/Designer:* Kevin Brainard

Fig. **7-14** /// WESTPORT THEATRE POSTER, *HAPPY DAYS* BY SAMUEL BECKETT

PLEASURE, NEW YORK

- *Creative Director:* Kevin Brainard
- *Designers:* Kevin Brainard, Jamus Marquette
- *Photographer:* Darren Cox

ARRANGING TYPE AND IMAGE

When you compose type and image (the two main graphic components), you arrange them to respond to one another and to the shape and edges of the format. Will type and image be fused? Will they appear next to one another not touching? Will they touch? Will type run across the image(s)? You can think of these juxtapositions in several broad categories (Diagram 7-13).

→ *Type and image are fused*: type is inseparable from the image, often positioned inside the primary image, creating a conjoined relationship. When type and image are fused, there is an automatic relationship. When they are fused in an organic, almost seamless, relationship, they appear and operate as a single entity.

→ *Type runs across image*: type runs across the image(s). The viewer reads the type while seeing the image behind it, as if the type were on a pane of glass over the image. "Seeing" both type and image simultaneously enhances the message; the type/image relationship is constructed this way for the purpose of communicating in unison.

→ *Type is positioned outside the image or adjacent to the image*: type is not placed inside the main image, does not run over the main image, but is placed outside the image within the remaining pictorial space of the format. The type may also be adjacent to the image.

When type runs across an image, the relationship is evident through touching one another. When type and image are not fused or do not touch, their relationship must be arranged through alignment and flow. Consider how one leads to the other. Consider size relationships; consider which element is dominant and which is subordinate. Which is the focal point of the composition? Do you want the viewer to see the type or image first?

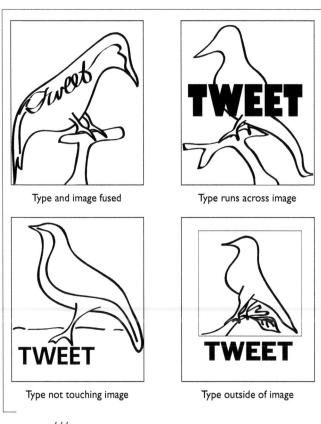

Type and image fused

Type runs across image

Type not touching image

Type outside of image

Dia. **7-13** /// POSITIONING STRATEGIES

Designers who compose spontaneously optically seek naturally inherent ways to align type and images. They find movements within the graphic elements that can be paralleled or echoed and prospect for occasions of sympathetic relationships among the forms where alignments could occur. Several basic alignments—flush left, flush right, centered, justified—help establish flow and unity. There are wraparound or edge or internal alignments as well (Diagram 7-14).

INTEGRATING TYPE AND IMAGE

A line will take us hours maybe; Yet if it does not seem a moment's thought,
Our stitching and unstitching has been naught.
—from *O Do Not Love Too Long* by William Butler Yeats

A graphic design problem can be solved typographically or with images alone. But when type and images interact, then you have to determine *how they will interact*.

→ Will the form of type and images share characteristics?

→ Will the type and images work in opposition, be contrasted in style of visualization and/or form?

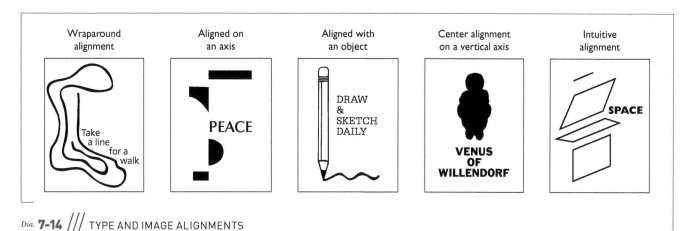

Dia. **7-14** /// TYPE AND IMAGE ALIGNMENTS

→ Will the type drive the composition? Will the image drive the composition?

→ Will the type and images be organically intertwined?

→ Will they touch, overlap, be juxtaposed, fuse? Will they be words that incorporate images or be images that incorporate words?

→ Will one be the star and the other the supporting player?

To best explain type and image integration, let's break it into three categories.

SUPPORTING PARTNER TYPE AND IMAGE RELATIONSHIP

In the *supporting partner* relationship, a classic "neutral" typeface works cooperatively with the image, which has the starring role. (Designers, by far, employ this category most commonly.)

For the sake of clarity and visual interest, the tendency is to allow either type *or* image(s) to be the star, hero, or heavy lifter, with the other component acting in a more neutral fashion, like a supporting actor. As an analogy, when reviewing a revival of David Mamet's play *Speed the Plow*, Ben Brantley, chief theater critic of *The New York Times*, described Scott Pask's "tasteful, sterile sets" for a character's office and house as "blank slates; words are what furnish these rooms."[1] Similarly, in a design, type might be the well-chosen, sterile, blank slate, and the visual "furnishes the room." If both type and image attract our attention due to equal prominence, then focus is diffused or lost. Here type is *purposely understated* in contrast to a strong visual statement, where, perhaps, the visual is the "big idea." This doesn't mean the type, or text for that matter, is given a diminutive role. Rather, it means the type simultaneously contextualizes the image and by its understatement bestows celebrity status to the image while being noble itself.

1. Ben Brantley, "Do You Speak Hollywood?" *The New York Times*, October 24, 2008.

Fig. **7-15** /// BOOK COVER: *SOUTH OF THE BORDER, WEST OF THE SUN* BY HARUKI MURAKAMI

- *Art Director/Designer:* John Gall
- *Publisher:* Vintage Books

For Haruki Murakami's *South of the Border, West of the Sun*, John Gall creates an image as visually rich and mysterious as the novel (Figure 7-15), with the type designed for clarity to complement the image.

 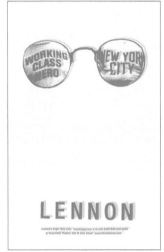 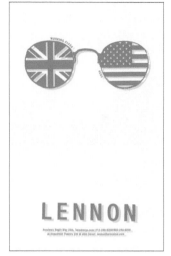 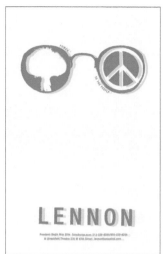

Fig. **7-16** /// **POSTERS, LENNON SERIES**

PLEASURE (FOR SPOTCO, NEW YORK)

- *Creative Director:* Gail Anderson (SpotCo)
- *Art Director/Designer:* Kevin Brainard, Darren Cox

SYMPATHETIC TYPE AND IMAGE RELATIONSHIP

Type and images possess shared or similar characteristics, which produce harmony. The agreement in form enhances meaning. Type and image share apparent character and purpose. (This is the next most often employed category.)

Congruence relies on agreement in shape, form, proportions, weights, widths, thin/thick strokes, lines, textures, positive and negative shapes, and time period. For example, in Figure 7-16, type and image share characteristics.

CONTRASTING TYPE AND IMAGE RELATIONSHIP

Type and images possess apparent differences, contrasting points of differentiation, contrasting or opposing qualities and characteristics. The contrast between type and image characteristics is purposeful and synergistic, producing a unique communication. (This is the least utilized category because it is the most difficult to work out.)

There are two basic ways type and images work in contrast: complementary relationship or a formal ironic relationship.

Complementary relationship. Typeface or hand-drawn type is chosen to work *in opposition to or in juxtaposition to images, relying on contrasts* in shape, form, proportions, weights, widths, thin/thick strokes, lines, textures, positive and negative shapes—for example, geometric versus organic, elegant versus rough, refined versus sloppy, detailed versus loosely rendered (such as a detailed linear illustration contrasted with sloppy huge type). In Figure 7-17, a logo for Ground, a landscape architecture firm, hard-edged, geometric type contrasts with the organic plant imagery. Mixing styles and historical periods can also create contrast.

Formal ironic relationship. Typeface and image(s) are selected for incongruity, for an ironic effect—for example, the typeface chosen for Figure 7-18, Catch of the Day, by Scorsone and Drueding or the irony of choosing a subway map typeface to write "Lost" in Figure 7-19.

ARRANGEMENT

In all two-dimensional design compositions—graphic design, illustration, painting, or drawing—the viewer seeks a point of entry into the graphic space, just as a visitor seeks a point of entry into an architectural space. The designer needs to construct visual cues about where to enter. Most people look at foreground elements first and try to find a way to enter the graphic space.

This *entry point* can be the *focal point* (the largest or brightest or key positioned element, or component with the greatest visual weight, etc.), it can be a *visual path* created by white space, or any number of other kinds of entry points. You must structure space to facilitate the viewer's comprehension (visual reading) of the composition, his or her passage through the compositional space. In Figure 7-20, we enter the composition along the tilted floor plane, along the book's title and author's name. As we enter, we realize we are about to be crushed by a huge shoed foot.

ground ground
ground ground
ground
ground

Fig. **7-17** /// **LOGO: GROUND**

VISUAL DIALOGUE, BOSTON

- *Design Director:* Fritz Klaetke
- *Designers:* Fritz Klaetke, Jesse Hart
- *Client:* Ground

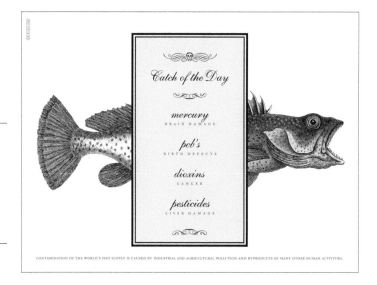

Fig. **7-18** /// **POSTER: CATCH OF THE DAY**

- *Design:* Joe Scorsone, Alice Drueding, Jenkintown, PA

Fig. **7-19** /// **ILLUSTRATION: OP-ED LETTERS PAGE, *THE NEW YORK TIMES***

STEVEN BROWER DESIGN, MATAWAN, NJ

- *Illustrator/Designer:* Steven Brower
- *Client: The New York Times*
- © *Steven Brower*

Fig. **7-20** /// **BOOK COVER:** *KOCKROACH:*
A NOVEL **BY TYLER KNOX**

- *Art Director:* Richard Aquan
- *Designer:* Will Staehle, lonewolfblacksheep
- *Illustrator:* Collage by Will Staehle
- *Client:* William Morrow

a design. Often, the transition is white space or a subordinate element (see Figure 7-21).

Consider each and every interstice and every transition from shape to shape, letter to letter, and visual component to type component. If you focus on the interstices, spaces that intervene between shapes and forms and type, then the entire composition will be appear organically related and taut. (If you imagine choreography composed of individual dance moves with awkward or unconsidered transitions, you'll realize the importance of efficient transitions to smooth visual moves.)

To create visual passageways, employ negative space to direct the viewer's eyes. If you think of negative space as a dramatic pause in the same way a pause is used between musical notes or dance movements, then you can consider a "white" space as a purposeful break between positive shapes.

CONTINUITY

You can help the viewer navigate through a composition with *continuity*—one element directing your eyes to the next element. Goals of composition are to create a visual flow from one graphic element to another, to create continuity (visual paths) as well as unity. There are arrangement strategies for producing continuity, composing the visual path and/or alignments within a group of graphic elements to direct the viewer's eyes to the point of emphasis.

To produce *agreement*, keep in mind these factors:

→ Position and orientation of the graphic elements can promote (or inhibit) visual flow.

→ An articulate visual hierarchy with an apparent focal point will provide a point of entry; for example, a dominant title or headline or a dominant visual provides a point of entry.

→ All directions must be considered: right, left, up, and down.

Eye-tracking studies (a method used to determine how people's eyes move, scan, and rest on a page) reveal how visitors observe print, web banners, and websites. Besides the composition, there are many variables involved with how an individual views and scans a single surface, including associative meaning, time exposed to the design, personal attention span, and distractions, among others.

GUIDING THE VIEWER

TRANSITIONS

Preferred points of entry can be the focal point, the key graphic element established through visual hierarchy, or a dominant image (people tend to prefer images over text). In addition to the point of entry, *transitions* are the key to creating a smooth visual flow from one graphic element to another throughout the composition. A transition is the passage or progression connecting one graphic element or movement to another in

Fig. **7-21** /// BOOK COVER AND DIAGRAM: *SATCHMO: THE WONDERFUL WORLD AND ART OF LOUIS ARMSTRONG* BY STEVEN BROWER

- *Art Director:* Michelle Ishay
- *Design:* Steven Brower
- *Art:* Louis Armstrong
- *Client:* Harry N. Abrams

Each transition in this composition is considered.

→ Viewers tend to be drawn to the figure as opposed to the ground.

→ Unity and balance contribute to visual flow.

→ Repetition, parallel movements, and counterpointing movements contribute to guiding the viewer.

→ *Agreement throughout a website or app*: A clear sense of place or geography created by consistent position of menus and graphic elements helps guide the viewer (Figure 7-22).

→ *Agreement across a spread*: Determine the most advantageous way to bridge the gap of the **gutter** (the blank space formed by the inner margins of two facing pages in a publication).

→ *Agreement in a series*: When designing for a series of individual but related units (for example, a series of brochures, a series of covers, related package designs), establish parameters to define a typographic system (palette and usage). Also develop a common visualization language, compositional structure, and color palette to ensure continuity across the individual units and to ensure that viewers see the individual units as belonging to a series. Plan for some variation among the individual units within the series for purposes of identification of each as a unique unit and to create visual interest and differentiation within the series (think differentiation of caffeinated and decaffeinated beverages through color palette). Figure 7-23, a redesign of Superdrug's everyday wipes range, is an example.

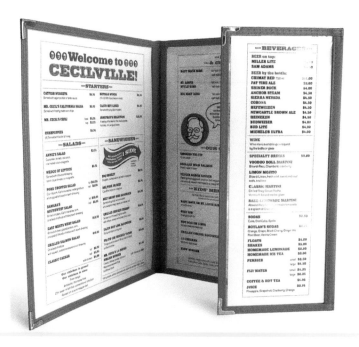

Fig. **7-22** /// WEBSITE: MR. CECIL'S MENU AND WEBSITE

ADAMSMORIOKA INC., BEVERLY HILLS, CA

- *Creative Directors:* Sean Adams, Noreen Morioka
- *Designer:* Monica Schlaug

"Mr. Cecil's California Ribs is a longstanding client of AdamsMorioka. After revamping the menu, the site was also reformatted to fit the updated look and feel. Its simple color palette and 'placemat' containing shape are a bold and simple foundation for information about the restaurant. But of course, small details throughout the site allow the Mr. Cecil's personality to shine through."

—AdamsMorioka Inc.

Fig. **7-23** /// PACKAGE DESIGN:
SUPERDRUG STORES
PLC., HANDY WIPES

TURNER DUCKWORTH, LONDON AND SAN FRANCISCO

- *Creative Directors:* David Turner, Bruce Duckworth
- *Designers:* Sam Lachlan, Christian Eager
- *Photographer:* Andy Grimshaw
- *Image Retouching:* Peter Ruane
- *Client:* Superdrug Handy Wipes

Turner Duckworth explains about Figure 7-23:

"The objective of the redesign was to remind Superdrug shoppers of the myriad occasions on which they might need a wipe or two!

"Each pack has a different visual prompt of accidents waiting to happen, perfectly illustrating the point that it is not only parents with small children who should have a pack of wipes on hand.

"The designs show a bitten doughnut about to drip gloopy jam, an ice lolly starting to melt and create a sticky mess, a banana skin for the antiseptic wipes to sooth and clean impending cuts and grazes, and tomato ketchup because those condiment sachets are impossible to open without a mess following shortly after!"

→ Discrepancies interrupt visual flow (think road barrier). However, a divergent graphic element could also establish an anomaly (think interesting focal point), which might be desirable depending on your intention.

→ Any movement that pulls the viewer's eye from the preferred path or from important information is counterproductive; that is *disagreement*.

For text-heavy formats, such as publications (print and on screen), newsletters, government websites, and editorial websites, some designers rely on the Gutenberg Diagram (or Gutenberg Rule) to help guide the viewer. The Gutenberg Dia-

gram describes a general pattern of reading a single page or screen of equally distributed information. It breaks the page into four quadrants: the top left is the *primary optical area*, the bottom right is the *terminal area*, the top right is the *strong fallow area*, and, the bottom left is the *weak fallow area*. By habit Western readers naturally begin at the top left of a page making that quadrant the primary optical area. Newspaper designer and educator Edmund Arnold is credited with this theory. The Z pattern of processing posits that Western readers follow a Z pattern of scanning a page, starting with the upper left corner, followed by the middle, and then to bottom right.

BUILDING COMPOSITIONS

You can build a composition around one dominant visual (using size, shape, color, pattern, or value contrast), where all other graphic elements form relationships with that dominant visual (see Figure 7-5). A dominant composition can be based on one major movement, gesture, or compositional thrust, with all other movements minor ones *built in relation to it through optical decisions and adjustments*.

Or you can build a composition where there is no one overtly dominant visual. Here relationships are built through sequence, pattern, grid, modular structure, repetition, stair structures, axis alignment, edge alignment, positioning and

Guiding the Viewer / p.165

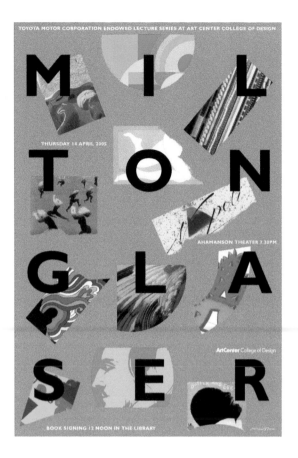

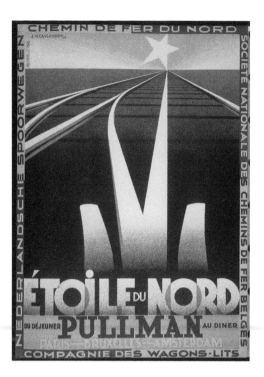

flow, or some unifying principle. No graphic element dominates (Figure 7-24). This structuring concept applies to single surfaces, multiple surfaces, and motion graphics.

You can build a static composition or one that suggests motion or movement. A static composition represents a fixed position. It neither moves nor does it imply motion. The illusion of movement can be created by a variety of means—for example, through receding diagonals (Figure 7-25) or through a kinetic-looking figure, by capturing an archetypal movement (think Myron's *Discus Thrower,* a copy found at http://www.britishmuseum.org), or by an angle, point of view, or large shifts in scale.

A visual sequence is a number of items, graphic elements, or events in an order that might *imply the passage of time, interval, or motion over a period of time (duration).* A sequence can be established on a single surface, on sequential pages, or in motion

graphics. For example, a storyboard or comic graphic format can visualize a sequence. Or when a reader turns a page, that kinetic experience can be utilized to represent a sequence of events over a short period of time. Certainly, motion graphics and film are natural media for depicting sequence. Also, you could say that "before-and-after" images imply duration.

Sequential arrangements have a discernible specific order or form a particular sequence. One graphic element or frame can seem to be the consequence or result of the previous element or frame. Sequential elements can also denote the illusion of motion through visual multiplication. Multiple positions (think a comic book rendering of a dog with many legs to denote running), blurred boundaries or edges, repetition, shifts, or layers contribute to the illusion of motion (see Figure 7-10 for an example of multiple positions).

HAVE YOU MENT IT?

To ensure your arrangement is deliberate and each graphic component (images and type) is thoughtfully and deliberately positioned, consider employing these four reminders, which will aid awareness of how you position graphic elements in relation to the format. Here the word relate *means "having some bearing to"; it doesn't mean graphic elements need to literally touch the midline or edges.*

1. M = midline
 Consider all graphic components in relation to the format's midline.
2. E = edges
 Consider all graphic elements in response to the format's edges.
3. N = negative shapes/space
 Consider all negative space.
4. T = transitions
 Consider all transitions among graphic elements.

BASIC COMPOSITIONAL CHECKLIST

- Have you ordered the visual hierarchy for clarity?
- Is the composition balanced?
- Have you used alignment and correspondence to promote unity?
- Have you arranged the composition to guide the viewer through the graphic space?
- Have you employed contrast?
- Have you created visual interest?
- Does your arrangement seem stable?
- Have you MENT it?
- Does your composition facilitate communication?

AVOID AMBIGUITY

In visual perception, theoretically, a viewer associates psychological tension with the position of a visual element in a composition. Accordingly, viewers feel confused if the position of a visual element is ambiguous, if the positioning seems *tentative*. People prefer positioning that produces stability and certainty. (This is not to be confused with figure/ground shapes that are intentionally equivocal.) For example, if you position a dark circle slightly off center as if it had migrated from the center and should be returned to it, it might be disconcerting for the viewer. Therefore, if you position an element off center, make sure it looks off center, not out of kilter. If you want a line quality to be scratchy, make it really scratchy. If you want it to feel tall, make sure it is very tall. Rule of thumb: avoid tentativeness and make your intention clear.

Showcase

Jennifer Sterling Sterling Design

JENNIFER STERLING

JENNIFER STERLING
DESIGN

Jennifer Sterling, a graphic designer, typographer, illustrator, and educator, is principal of and designer at Sterling Design.

Her work is included in the permanent collections of The San Francisco Museum of Modern Art (where she has had numerous exhibits), The Cooper-Hewitt National Design Museum, The Library of Congress, The Bibliothèque Nationale de France, and The Museum für Kunst und Gewerbe, Hamburg.

Numerous groups including the New York Art Directors Club, American Center for Design, *Communication Arts*, *Graphis*, The Type Directors Club, The Society of Illustrators, *I.D.* magazine, AIGA, *Print* magazine, *HOW* magazine, and *ADWeek* have recognized her work for a wide range of clients in both the business and art worlds.

Sterling's work has been featured in more than 180 magazine and book articles around the world, including a feature in *Graphis* magazine, which named her one of the top ten designers in the world, and a front page article in the *Graphic Design* USA, naming her one of "Twelve Designers to Change Design into the Millennium."

Jennifer has served on the board of the SFMOMA's Architecture and Design Accession Committee and was inducted into AGI and "Who's Who in America" in the year 2000.

"WHAT THE FONT"

- *Illustration/Typography/Design:*
Jennifer Sterling

OPENSIGHT (LAUNCH FOR OPENSIGHT MUSIC)

- *Illustration/Typography/Design:* Jennifer Sterling

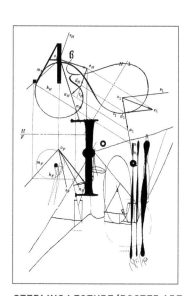

**STERLING LECTURE (POSTER ART
FOR LECTURE)**

- *Illustration/Typography/
Design:* Jennifer Sterling

"BUILD YOUR WORLD"

- *Illustration/Typography/Design:*
Jennifer Sterling

STERLING LECTURE POSTER

- *Illustration/Typography/
Design:* Jennifer
Sterling

Exercises and Projects

Go to GDSOnline for more exercises and projects. ⊿

Exercise 7-1

Graphic Space: Closed Versus Open

01. Drawing either a landscape or room space, you will create two sketches. Hold the page in a landscape format.

02. First sketch: Draw the landscape or room by emphasizing the horizontal movements, allowing images to continue off the sides of the page so that the viewer understands the space to be *open*—to go on and on.

03. Second sketch: Draw the landscape or room by emphasizing vertical movements that echo the vertical edges of the page. Here your goal is to make the space seem "closed," as if the entire space is all contained within the format and does not reach beyond the boundaries of the page.

04. Compare the pictorial space in both drawings.

Project 7-1

Spontaneous Composition

01. Design a promotional poster that drives people to a magazine website. Choose a magazine with online presence, such as *National Geographic*. The topic of this promotional poster should illuminate a special topic that might be covered in the magazine; for example, animal conservation might be covered in *National Geographic*.

02. Develop a design concept for the poster focusing on the specific topic.

03. Determine a method of visualization, such as collage, photomontage, drawing, or any media.

04. With your concept as the driving force, make thumbnail sketches of different possible compositions. Form a composition through experimentation. Do not use any formal structuring devices such as a grid or golden section.

05. Choose one or two sketches and turn them into roughs.

06. Refine one rough and turn it into a final comp.

PRESENTATION

This can be done on paper or online. If printed, print on good-quality, matte photo paper; use double-sided printing paper (so no paper company trademarks are on the back). Print full size; do not include any borders or additional graphics, as these would interfere with the composition of the presented work. Arrange the design solution on the page either at life size or as large as possible.

8 PROPORTIONAL SYSTEMS AND THE GRID

MATHEMATICAL RATIOS AND PROPORTIONAL SYSTEMS

Since the time of ancient Greece, artists, architects, and musicians have been interested in ideal proportions. Some looked to math for a system of creating ideal proportions that could be applied to the visual arts, music, and architecture.

Most designers prefer to rely on their learned and innate sense of proportion. Others employ graphic devices that can aid in establishing harmony, such as Fibonacci numbers or the golden section, among other proportional systems.

PROPORTION

Proportion is the comparative size relationships of parts to one another and to the whole. Elements or parts are compared to the whole in terms of magnitude, measure, and/or quantity. For example, the size relationship of an average-height person's head to his or her body is a proportional relationship. The viewer *expects* there to be one head and expects the head to be in a particular proportion to the average body. Also, if the head is *not* in a logical proportion to the body, then the viewer would expect that other elements or parts might be out of proportion as well. That expectation implies a standard relationship among elements, such that if one varies from the norm or standard, then another element-to-whole relationship should vary in the same manner. When the viewer's expectations are challenged, the designer creates a visual surprise, possibly a surreal solution, or a disjunctive appearance.

For designers, there is an additional implied meaning to proportion. It is an aesthetic arrangement—a harmonious or agreeable relationship of parts or elements within a whole. Considered proportions are one main key to creating pleasing form. In design, **harmony** is agreement within a composition, where elements are constructed, arranged, and function in relation to one another to a congruent effect. Art critic John

Ruskin said, "In all perfectly beautiful objects there is found the opposition of one part to another and a reciprocal balance." Although Ruskin's view bestows value on aesthetics and beauty, a designer can deliberately play with expected proportion in a composition with the goal of creating graphic impact that is not even remotely about beauty, yet still establish a balanced reciprocity among the graphic elements.

FIBONACCI NUMBERS

Fibonacci numbers are a numerical sequence used as a model for constructing proportion, named after medieval Italian mathematician Leonardo of Pisa, also known as Fibonacci. They constitute a numerical sequence where each subsequent number in the sequence is the sum of the two preceding numbers, for example, $1 + 1 = 2$, $1 + 2 = 3$, $2 + 3 = 5$, $3 + 5 = 8$, etc., yielding the series 1, 1, 2, 3, 5, 8, 13, 21, and so on.

Fibonacci squares (Diagram 8-1) have sides with lengths that correspond to the numbers in the Fibonacci sequence. Placing two squares with sides of 1 next to each other constructs a 1×2 (or 2×1) rectangle. That is, the short side of the rectangle is 1 unit in length and the long side is 2 units. Placing a square with a side of 2 next to the long side of the 1×2 rectangle creates a new 2×3 rectangle. Likewise, adding a square with a side of 3 to the long side of that rectangle yields a new rectangle with sides of 3 and 5. The addition of a square with a side of 5 then yields a 5×8 rectangle, a square of 8 yields an

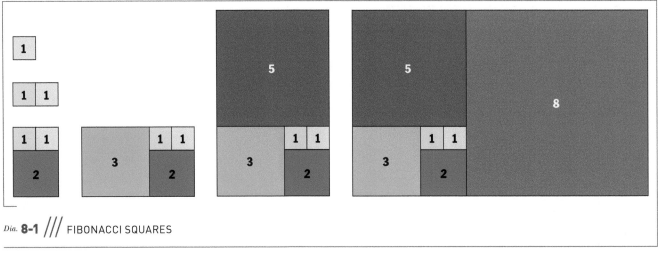

Dia. **8-1** /// FIBONACCI SQUARES

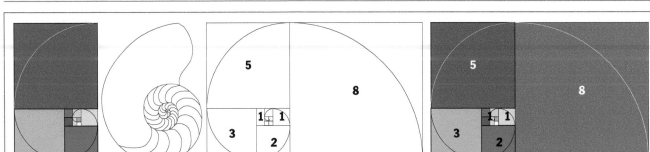

Dia. **8-2** /// FIBONACCI SPIRAL

8 × 13 rectangle, and so on. (The ratio of the long to the short side of each rectangle constructed in this way from Fibonacci squares approximates the golden ratio, discussed later.)

By drawing quarter circles through a set of Fibonacci squares, you can create a Fibonacci spiral (Diagram 8-2). Connecting the opposite corners of the squares yields a spiral that resembles many found in plants, seashells, and other forms in nature.

The ratio between adjacent numbers in the Fibonacci sequence approximates 1.6. That is, 5/3, 8/5, 13/8, and 21/13 all approximate 1.6, a value that in turn approximates the *golden ratio*, a mathematical constant, which is approximately 1.618.

THE GOLDEN RATIO

The golden ratio, commonly denoted by the Greek letter phi (ϕ), refers to a geometric relationship in which a longer length *a* is to a shorter length *b* as the sum of the lengths $(a + b)$ is to *a*. Mathematically, the golden ratio can be expressed as $(a + b)/a = a/b = 1.618$.

Conversely, $a/(a + b) = b/a = 0.618$. The golden ratio also is referred to as the golden mean, golden number, or divine proportion. A rectangle whose ratio of length to width is the golden ratio is a *golden rectangle*.

A *golden section* is a line segment sectioned into two unequal parts, *a* and *b*, such that the total length $(a + b)$ is to the longer section *a* as *a* is to the shorter section *b*.

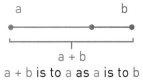

a + b is to a as a is to b

Again, stated algebraically,
$(a + b)/a = a/b$

In Western art, shapes or structures defined by or based on the golden section have been considered aesthetically pleasing by many artists, designers, and architects. For example, architect Le Corbusier used the golden ratio as the basis of his modular architectural system. The golden ratio is still used today in

Dia. **8-3** /// A GOLDEN SECTION SEEN IN THE FORMAT OF AN
8½" × 11" PAGE

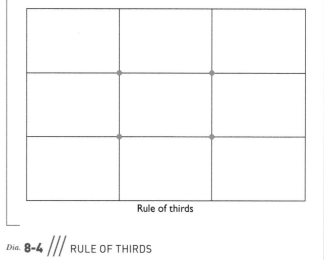

Rule of thirds

Dia. **8-4** /// RULE OF THIRDS

graphic design, fine art, and architecture. Graphic designers utilize the golden section for grid systems and page formats. Although the U.S. standard size page (8.5 × 11 in) and the European standard size page (210 × 297 mm) are not golden section proportions, a golden section can be inscribed in each (Diagram 8-3). Likewise, a website's aspect ratio is not golden-section based; however, a golden section can be inscribed in it.

RULE OF THIRDS

The rule of thirds is an asymmetrical compositional technique often used by painters, photographers, and designers to create visual interest and balance. It involves overlaying the format with a grid and positioning or aligning the focal point or primary graphic elements of the composition along these grid lines or especially on the intersections of the grid lines. To employ the rule, the focal point is placed at one intersection, for example, and a counterbalancing secondary graphic element or accent placed at an opposing intersection. In a landscape, this often translates into placing the horizon line along one of the horizontal grid lines. This rule is also sometimes called the golden grid rule because the modules created by the grid roughly relate to the ratio of the golden section (rule of thirds: ⅔ = 0.666; the golden section = 0.618; see Diagram 8-4). In practice, the aim of the rule is to prevent the placement of the subject of an image at the center of a composition or to discourage placements that divide the image in half.

Although the intersections provide guidelines for the placement of primary elements, when working with asymmetry, you still need to make judgments involving balance and counterpoint. Inflexible adherence to any compositional rule is deemed undesirable, and you should be able to relax such adherence after working with the rule as a guideline for a while.

MODULARITY

In graphic design, **modularity** is a structural principle employed to subdivide a format into manageable smaller parts—that is, to handle content using modules (see Diagram 8-5). A **module** is a self-contained, fixed unit that is combined with others to form a larger foundational structure composed of regular units. A *module* is also defined as any single fixed element within a bigger system or structure. For example, a unit on graph paper is a module, a pixel in a digital image is a module, a rectangular unit in a grid system is a module, and a fixed encapsulated chunk of a composition is a module.

Modularity in the form of grids helps manage content as well as complexity (think of all the content on a government website). Modularity has three main advantages: (1) the underlying structure produces unity and continuity across a multipage application, (2) the content within each module can easily be replaced or interchanged, and (3) modules can be rearranged to create different zones or forms yet still remain unified.

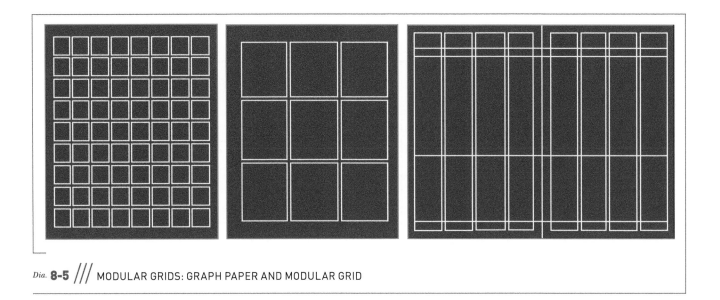

Dia. **8-5** /// MODULAR GRIDS: GRAPH PAPER AND MODULAR GRID

Modularity is also used to create modular alphabets, hand-lettering (as in Figure 8-1), typographic treatments, signage systems, symbol systems, pixel effects, or any modular-based imagery (for example, a transformation or sequence developed in modular units; figures composed of units).

CHUNKING

Chunking is a technique related to modularity in graphic design, where content is split or information is grouped into chunks (Diagram 8-6). The aim of chunking is to break content into digestible amounts to make reading easier, as exemplified in the website for OpenIDEO (see the figure in the Case Study: OpenIDEO by IDEO on page 182 of this chapter). (Chunking is utilized to facilitate memory in musical composition.)

THE GRID

Open up a magazine. How many columns do you see? How are the visual elements organized? All the elements, display and text type, and visuals (illustrations, graphics, and photographs) on the pages of a print or digital magazine, book, or newspaper are almost always organized on a grid. A **grid** is a guide—a compositional structure made up of verticals and horizontals that divide a format into columns and margins. Grids underlie the structure of books, magazines, brochures, desktop websites, mobile websites, and more. As far back in history as 3000 B.C., we can see the use of a column structure in cuneiform writing in Mesopotamia as well as similar structures in hieroglyphics writing in Egypt. In the 1950s, Swiss designers adopted the grid as a structural design device. Their enthusiasm propelled the grid into popular use.

Fig. **8-1** /// **LOGO: COUNTRY THINGS**

MARTIN HOLLOWAY GRAPHIC DESIGN, PITTSTOWN, NJ

• *Lettering/Designer:* Martin Holloway

Grids organize type and images. They help you build pages, print or digital. If you have to organize the enormous amount of content in any given newspaper, textbook, or corporate, government, museum, or editorial website (Figure 8-2), you would want some type of structure to ensure that readers would be able to easily access and read an abundance of information. Imagine designing your daily newspaper using a spontaneous composition method. You would have to intuitively design every page and then make sure each page had some resemblance to all the others while ensuring a sense of congruence across all the pages. Certainly, you could compose spontane-

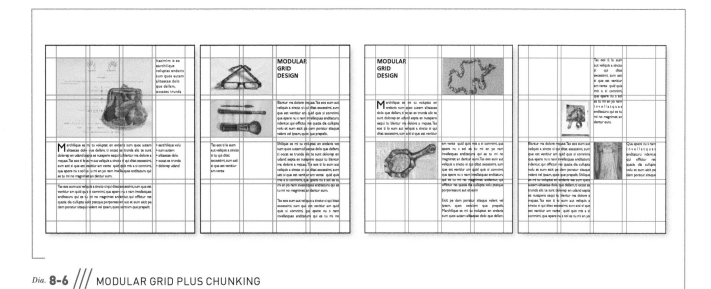

Dia. **8-6** /// MODULAR GRID PLUS CHUNKING

Art: Ashley Bargende

ously, but you would not meet a daily deadline. Not only does a grid spare you the time of having to spontaneously compose every page, but it also affords a skeletal structure that provides continuity, congruence, unity, and visual flow across many print or digital pages.

SINGLE-COLUMN GRID

If you think about the page of a contemporary novel or a page from Gutenberg's Bible—a single column of text surrounded by margins—that is a single-column grid, the most basic page structure; it is also called a *manuscript grid*. This structure is defined by a single column or block of text surrounded by *margins*, the blank space on the left, right, top, or bottom edge of any printed or digital page. Margins function as the proportional frame structure around visual and typographic content. Whether for a printed poster or a mobile screen, margins aid the designer in determining how closely images and text should approach the edges of the format. Unless you are cropping an image or letterform intentionally, margins ensure that content stays safely within the format or viewport.

DESIGNING MARGINS

When you design the width of the single column, you are designing the proportions of the margins (see Diagram 8-7). Not only do margins function as white space to present the content, but they can also function as a spatial field to accommodate marginalia—information, such as notes, folios, running heads and running feet, and figure numbers and captions.

Base the design of the margins on functional and aesthetic considerations. Functional considerations include the preferred shape of the single-column text, accommodating marginalia or notations, and determining where the readers's thumbs will hold the page or tablet. As an aesthetic consideration, determine whether symmetrical or asymmetrical margins and wide or narrow margins would best present the content.

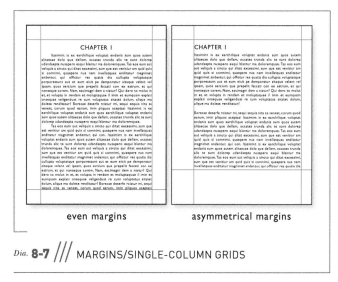

even margins asymmetrical margins

Dia. **8-7** /// MARGINS/SINGLE-COLUMN GRIDS

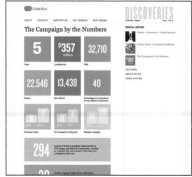

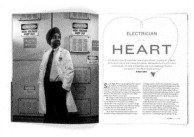
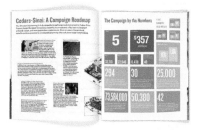

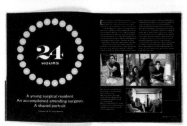

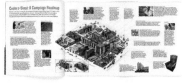

Fig. **8-2** /// PUBLICATIONS: *DISCOVERIES* MAGAZINE: ONLINE AND PRINT

ADAMSMORIOKA INC., BEVERLY HILLS, CA

- *Creative Director:* Sean Adams
- *Art Director:* Monica Schlaug
- *Designer:* Nathan Stock
- *Client:* Cedars-Sinai

Cedars-Sinai *Discoveries* is a semiannual magazine produced by the Community Relations and Development Department of Cedars-Sinai Medical Center.

"*Discoveries* magazine is a collaboration between AdamsMorioka and Cedars-Sinai's editorial team. Our first issue of *Discoveries* was such a success that Cedars-Sinai approached us to bring the content to life in an online form as well. We developed a Wordpress-based site that is easy to update, and worked all of the print version's features into the web space, along with bonus videos for readers."

—AdamsMorioka Inc.

ONE-COLUMN GRID: *PRINT* MAGAZINE

- *Designer:* Steven Brower

TWO-COLUMN GRID: *PRINT* MAGAZINE

- *Designer:* Steven Brower

Although we associate single-column grids with books, a single-column grid structure tends to work well on the smaller size of mobile screens. (See the Gastrodamus image in this chapter's Showcase feature on page 186.) When designing a site for both desktop and mobile screen, some designers draft the grid structures simultaneously so that they offer similar experiences. When designing for several screens—desktop, tablet, and mobile—some say best practice is to design the desktop website first. Others say to design the mobile grid structure first because it needs to have the simplest structure due to its diminutive screen. "Mobile devices require software development teams to focus on only the most important data and actions in an application," advises Luke Wroblewski (http://www.lukew.com).

A single-column grid can be divided into more columns, both symmetrical and asymmetrical—for example, half and then in half again as shown in the three sample grids that had been designed for *Print* magazine (Figure 8-3).

MULTICOLUMN GRIDS

A grid maintains alignment. If you think of the pool lanes in a swim meet and how they efficiently keep the swimmers where they are supposed to be, then one goal of using a grid structure becomes clear. Compare the orderly swim meet in Figure 8-4 to the frenzied sea of bodies in a triathlon open ocean swim in Figure 8-5. A grid defines boundaries and keeps content in order.

Fig. **8-3** /// FOUR-COLUMN GRID: *PRINT* MAGAZINE

- *Designer:* Steven Brower

A grid establishes an underlying structure to maintain structural clarity, balance, and unity for a multipage format, establishing a flow or sense of visual consistency from one page to another.

Fig. **8-4** /// **POOL LANES IN A SWIM MEET**

• *Kohjiro Kinno/Newsport/Corbis*

Fig. **8-5** /// **TRIATHLON OPEN OCEAN SWIM**

• *Rick Doyle/Corbis*

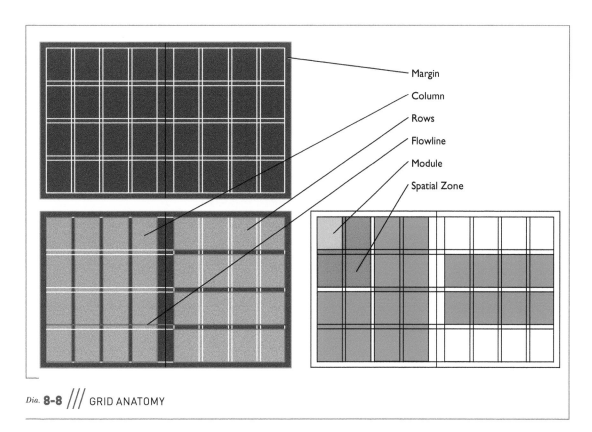

Dia. **8-8** /// GRID ANATOMY

Depending on the size and proportions of the format, determine the number of columns and whether columns can be combined to accommodate headings and large visuals or divided to accommodate captions and smaller visuals. A column grid can also be designed with dedicated columns for text and large visuals. Columns can be even or uneven depending on content and function.

COLUMNS AND COLUMN INTERVALS

Columns act similarly to the lanes of a swim meet. **Columns** are vertical alignments or arrangements used to accommodate text and images. In any grid, the number of columns depends on several factors, mainly the concept, purpose, and how the designer wants to present the content. When using more than one column, columns can be the same width or vary in width. One or more columns can be dedicated to only text or only images or a combination thereof. The spaces between columns are called **column intervals**. Diagram 8-8 illustrates grid anatomy.

A grid's proportions and spaces provide a consistent visual appearance for a multipage format in print or on screen. A grid is a structural system that supplies an underlying unifying skeletal structure (see Diagram 8-9). *It provides alignment.*

Multicolumn grids are used for desktop, tablet, and mobile screens measured and designed in pixels. Nathan Smith created the 960 Grid System (http://960.gs/), a web grid that is 960 pixels wide, which works well on a majority of screens. A twelve-column grid has 60 pixel-wide columns, which yield

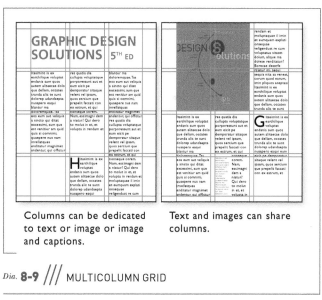

Columns can be dedicated to text or image or image and captions.

Text and images can share columns.

Dia. **8-9** /// MULTICOLUMN GRID

column widths of 60, 140, 220, 300, 380, 460, 540, 620, 700, 780, 860, and 940. A sixteen-column grid has 40 pixel-wide columns, which yield column widths of 40, 100, 160, 220, 280, 340, 400, 460, 520, 580, 640, 700, 760, 820, 880, and 940. Each column has 10-pixel margins on left and right, which yield 20 pixel-wide column intervals between columns (see http://www.thegridsystem.org/).

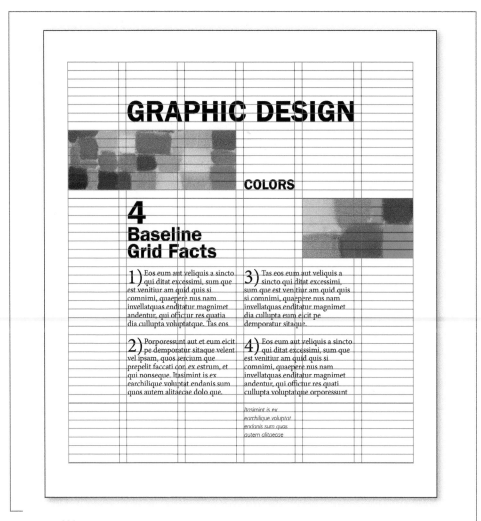

The grid system is an aid, not a guarantee. It permits a number of possible uses and each designer can look for a solution appropriate to his personal style. But one must learn how to use the grid; it is an art that requires practice.

—Josef Müller-Brockmann

FLOWLINES

Flowlines establish horizontal alignments in a grid and can aid visual flow. When flowlines are established at regular intervals, a regular set of spatial units called modules is created. Flowlines can be drawn at regular or irregular intervals.

GRID MODULES

Grid modules are the individual units created by the intersection of the vertical column and horizontal flowlines. A text block or image is placed in a grid module. When employing a modular grid, a text block or image can be positioned on one or more modules.

SPATIAL ZONES

A **spatial zone** is a distinct field formed by grouping several grid modules together used to organize the placement of various graphic elements. Spatial zones can be dedicated to text, to image, or either. When establishing spatial zones, keep proportional relationships, the Gutenberg Rule, and visual weight in mind.

Devise a grid's proportions based on the content, the nature of the publication or website, the audience, and the medium or platform. You can plan for any number of columns—two, three, four, five, six, eight, or more—depending on the amount of text and images and the page size or screen size. Some large publications or websites utilize a double grid (or more) to accommodate different content and to add visual variety.

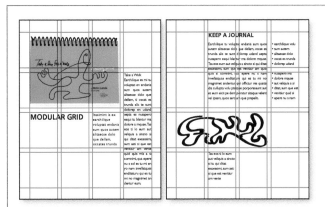

A text block or image can occupy one module or more.
Information can be chunked into one module or into a zone.

Dia. **8-11** /// MODULAR GRID

Fig. **8-6** /// **UNIGRID**

"In order to achieve better identification and
financial savings through standardization of
every aspect of the publications program, we
designed a modular system that determined
everything from the paper size to graphics to
cartography and illustration."

—Vignelli.com

A designer can strictly adhere to a grid or break a grid. For the
sake of visual drama or surprise, you can occasionally break
the grid. If you break the grid too often, however, the arma-
ture it provides will be lost.

A baseline is the invisible line upon which type sits, defining
the bottom of capital and lowercase letters excluding descend-
ers. A *baseline grid* is a visual guide created by planning a set of
baselines for the primary text, which run from the top margin
to the bottom margin. These horizontal divisions are guide-
lines for text and image alignment from column to column
(Diagram 8-10). A baseline grid should accommodate the larg-
est size type of the body text. This grid allows for adding line
spacing between paragraphs to create chunks of text so that
the visitor can easily scan or read the copy.

MODULAR GRIDS

A modular grid is composed of modules, individual units created
by the intersection of columns and flowlines (Diagram 8-11).
Text and images can occupy one or more modules. A functional
benefit of a modular grid is how information can be chunked
into individual modules or grouped together into zones.

The zones should be designed to produce a clear visual hier-
archy. When designing heavily illustrated content, a modular
grid offers the most flexibility. When designing moderately
illustrated content, a modular grid can accommodate one
column for running text (body of writing). Many designers
believe a modular grid is the most flexible, allowing for greater
variety. A leading practitioner and pioneer of the International
Typographic Style, Swiss Style, Josef Müller-Brockmann was a
major proponent of the modular grid.

How do you know which grid option to choose? Base your
decision on communication goals, purpose, the amount of
images and text, and audience. An award-winning (Presiden-
tial Awards for Design Excellence) example of a modular grid
is the Unigrid designed by Massimo Vignelli for the United
States National Park Service, Washington, DC, Publications
Program (Figure 8-6). Since 1977, all United States National
Park Service brochures have been designed based on the Uni-
grid System format, a modular grid system for layout of text
and graphics. The design includes black bands at the top and
bottom of the brochures, a standardized typeface, and stan-
dard map formats; all establish a uniform identity for National
Park Service brochures (http://www.nps.gov).

Case Study

OpenIDEO IDEO

As champions of using design thinking to solve complex problems, IDEO designers are constantly on the lookout for emerging technologies and methods that will complement its existing tools and approach. In 2009, a London-based team observed that online collaboration and consumer activism were trending up—more than 2 billion people worldwide now engage in Web-based interactions—and sought ways to harness that tremendous human resource to do social good.

The team set out to establish a global network of creative, conscientious thinkers who could help IDEO and its partners address social issues. Our designers considered more than 100 different ways of engaging people in design challenges, but couldn't find a platform that met IDEO's fundamental needs. So, we created OpenIDEO.com.

The website provides an open platform for innovation where designers and other creative thinkers can create better, together. Its goal is to leverage IDEO's ability to attract talent worldwide, to encourage collaboration and a visual approach, and to provide clear feedback—all in order to overcome diverse challenges. What's in it for users? Inspiration, knowledge, and recognition, to say the least. All contributions will be used to help address some of the toughest problems faced by modern society.

Here's how OpenIDEO works: IDEO posts a design problem, which moves through three phases of development toward a solution. These phases are Inspiration, Concepting, and Evaluation. Users participate and provide feedback every step of the way, receiving points (known as their Design Quotient, or 'DQ') for their contributions. Like in any good brainstorming session, both quality and quantity are valued. At the end of the process, which takes about ten weeks, a final design is chosen. The winning design may be produced by whoever chooses to do so—all concepts are generated under a Creative Commons license and are thus shareable, remixable, and reusable. Because the problems presented all seek a solution for social good, everybody wins!

The site's first challenge was getting more people involved in British chef Jamie Oliver's "Food Revolution" online. "Join me at OpenIDEO.com and share your inspiration and ideas for how we can help educate kids about eating healthy food," Oliver requested. "This is open to everyone and is an easy way for all of us to help solve this massive problem. Let's give kids the knowledge they need to eat healthy food and make a difference once and for all." In hosting this challenge, OpenIDEO supported Oliver in fulfilling his 2010 TED prize wish list.

Since then, the OpenIDEO.com has helped nonprofit Grey Matters Capital generate a catalogue of potential low-cost educational tools and services for the developing world. The platform has also been used to build a separate online community for Sony and the World Wildlife Fund, which relies on the same technology and shares the community. OpenPlanetIdeas.com marks the first time that Sony has opened up some of its technologies for environmental causes, the nature of which will be decided by users.

—IDEO

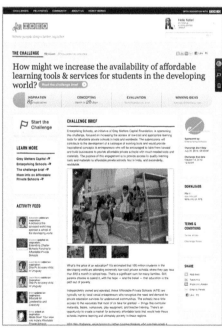

Showcase

Interview Rick Webb, Tumblr

RICK WEBB

INTERIM VP REVENUE AND
MARKETING, TUMBLR

Rick Webb cofounded The Barbarian Group and served as its COO for the first ten years. The Barbarian Group is an award-winning digital marketing services company. Since the company's founding, Rick had been instrumental in building the organization from a few nerds working out of partner Benjamin Palmer's apartment to a multicity, internationally recognized full-service digital marketing services firm. In addition to being one of the creative shepherds of the company, Rick had primarily been responsible for developing the celebrated "secret sauce" of The Barbarian Group: its consistent ability to deliver uncompromising creative work and undisputedly brilliant interactive marketing, over and over, even as the company grew. As COO, Rick oversaw the integration of the client service, production, operations, and marketing of the company. Additionally, as a cofounder, he acted as a new business and client service executive for several clients.

Rick has more than fifteen years of experience in design, advertising, and the Internet. Prior to cofounding The Barbarian Group, he served at Arnold Worldwide during their celebrated Volkswagen days, working with fellow cofounder partner Keith Butters on a variety of award-winning campaigns. Rick has also worked at Philip Johnson Associates, a Cambridge-based technology-focused advertising agency, and at Ernst & Young LLP, where he worked when the web was born. Rick has a degree in international economics and art history from Boston University; he was born and raised in Fairbanks, Alaska.

Rick Webb is an investor and writer, and owns a record label called The Archenemy Record Company.

Q: If you were going to teach a speed seminar about creating undisputedly brilliant interactive marketing, what five things would you stress?

A: First, learn the business of advertising.

Second, learn about your clients—you can have a great idea, but you gotta sell it. This is so massively understated these days it's ridiculous.

Third, the team—having the right team means the difference between a good idea that goes nowhere and a great execution.

Fourth, measurement and goals—lay them out beforehand. It's a mess right now, but with some advance planning, healthy collaboration, and honesty, you can nail these with your client, and it will be vital along the way.

Fifth, a creative habits class—how to nurture and harness the good ideas you have throughout the day and your life and make them into something actionable for clients.

Q: Please explain some of the many capabilities of The Barbarian Group.

A: The Barbarian Group endeavors to be able to provide all services for a client that needs to accomplish something in the digital space. This means the obvious axis of creative, tech, and user experience (UX) at the core, of course. It also means content strategy, social media, brand planning, media planning, web implementation consulting, content, and revenue/business consulting. In tech, creative, and UX, the Barbarian Group tries to be platform agnostic—know all of the languages and be able to build sites, games, apps, and mobile platforms, radically committed to an integrated approach for better quality.

Q: What are the immutable laws of what you do?

A: I believe strongly in the good/quick/cheap trifecta—you can have two, pick which. I also believe that your work is your PR, and we strenuously, constantly endeavor to only put out high-quality work. I also believe in a strong company culture and a healthy work-life balance, but not a separation. These are the beliefs I've kept since the beginning and haven't budged on.

Q: What aesthetic criteria did you employ at The Barbarian Group?

A: It's all in the service of the client and project. The Barbarian Group doesn't have a "house style." I like the diversity of the visual styles we've employed through the years, from DIY, to hypey-designed, to elegant. I think a poke through the company's portfolio reflects this, and it's something The Barbarian Group consciously aspires to.

Q: What are the best practices for social media?

A: I think the key to social media is to have something awesome to share. A piece of news. A viewpoint. A cool app. A cool gift to the public. So many people gloss over this one, simple, fact and just talk about nothing. There are times when a company has something to say—a new product, for example. And there are times when they don't. Yet social media requires a constant conversation. So when you don't have something you *have* to say, you gotta make something interesting to talk about. You see this executed really well with The Barbarian Group's Tweetwrap project and the GE show (http://www .barbariangroup.com/).

Q: Aesthetically and strategically, should one design differently for mobile media than for a website?

A: Definitely, on both counts. Aesthetically it's more minimalist, with every button mattering. It's a lot like web design in the old, bandwidth-constrained late nineties. Strategically, of course, the features people want while out in the world in front of their phone are often different from the ones they want at home. Amazon, for example, doesn't need to put the entire "order history export" functionality into the mobile site, but it's nice on the website.

SOFTWARE: GASTRODAMUS

HTTP://WWW.BARBARIANGROUP
.COM/SOFTWARE/GASTRODAMUS

THE BARBARIAN GROUP

- *Client:* The
 Barbarian Group

Q: Once you lay the foundation for your brand's or organization's website, then how should mobile web, apps, social media, and even games or location-based media work/ coordinate with the website's look and feel?

A: There's a step between building a brand bible and building a digital brand bible that some companies are doing at the outset of a new brand guide, but often you need to do that for your client—translate the visual style to all aspects of the web. I think you sort of answered your own question—the important part is to do it, up front, and be aware that you need to translate a brand bible into the digital realm, and get it done at the outset so the teams developing all of the different digital offerings have something to refer to. Often, at TBG, this is done in a fluid manner—the designers are aware of this, and the client-based creative director keeps an eye on it all. Sometimes, however, TBG actually builds a digital brand bible at the outset, especially for a large client just beginning to tackle digital.

Exercises and Projects

Go to GDSOnline for more exercises and projects. ⬈

Exercise 8-1

Single-column Grid for an App

01. Design a single-column grid for a mobile weather app.

02. Determine the margins.

Project 8-1

Modular Grid: A Historical Portrayal

01. Find photographs that commemorate or represent important moments in your own life or in the life of an individual in the news. Scan the photographs.

02. Write text that contextualizes or complements the images.

03. Design a basic modular grid. First, design a simple two- or three-column grid. Add horizontal flowlines to create grid modules. Grid modules are the individual units created by the intersection of the vertical column and horizontal flowlines. Grids organize content.

04. Place type or image in a grid module. Text and images can occupy one or more modules. As a point of departure to learn about the purpose and aesthetics of utilizing a modular grid, do not break the grid modules.

05. Use the grid to create a three-page story of the moments in the life of the person you selected.

PRESENTATION

Print on good-quality, matte photo paper; use double-sided printing paper (so no trademarks are on the back). Print full size or as large as possible. Do not include any borders or additional graphics, as these would interfere with the composition of the presented work. The objective is to present the work clearly. Bind the three pages.

GLOSSARY

abstraction: a simple or complex rearrangement, alteration, or distortion of the representation of natural appearance, used for stylistic distinction and/or communication purposes.

additive colors: digital colors seen in screen-based media; also known as mixtures of light.

advertising: the generation and creation of specific visual and verbal messages constructed to inform, persuade, promote, provoke, or motivate people on behalf of a brand or group.

alignment: the positioning of visual elements relative to one another so that their edges or axes line up.

analysis phase in the design process: examining all information unearthed in the orientation phase to best understand, assess, strategize, and move forward with the assignment.

asymmetry: an equal distribution of visual weights achieved through weight and counterweight, by balancing one element with the weight of a counterpointing element, *without mirroring* elements on either side of a central axis.

attribute listing: a method for analyzing and separating data through observing and identifying various qualities that might have otherwise been overlooked; it is a diagrammed list of attributes.

audience: any individual or group on the receiving end of a graphic design or advertising solution; the target audience is a specific targeted group of people.

balance: stability or equilibrium created by an even distribution of visual weight on each side of a central axis, as well as by an even distribution of weight among all the elements of the composition.

baseline: defines the bottom of capital letters and of lowercase letters, excluding descenders.

bleed: a printing term referring to type or a visual that extends off the edges of the page.

body copy: narrative text that further explains, supplements, and supports the main advertising concept and message; type that is 14 points and less is used for setting text, also called **text type**.

borders: a graphic band that runs along the edge of an image, acting to separate the image from the background, like a frame, by something as simple as a thin rule or as ornate as a Baroque frame.

brand: the sum total of all characteristics and assets that differentiates it from the competition.

character: a letterform, number, punctuation mark, or any single unit in a font.

chart: a specific type of diagrammatic representation of facts or data.

chunking: related to modularity in graphic design, content is split or information is grouped into chunks by combining units or capsules of content or information into a limited number of units or chunks.

closed: a composition where the internal elements echo a page's edges to a great extent *and* the viewer's focus is kept tightly within the format.

collage: a visual created by cutting and pasting bits or pieces of paper, photographs, cloth, or any material to a two-dimensional surface, which can be combined with handmade visuals and colors.

column intervals: spaces between columns.

columns: vertical alignments or arrangements used to accommodate text and images.

comp *or* **comprehensive:** a detailed representation of a design concept thoughtfully visualized and composed.

composition: the form, the *whole spatial property and structure* resulting from the intentional visualization and arrangement of graphic elements—type and visuals—in relation to one another and to the format, meant to visually communicate and to be compelling and expressive.

corporate communication design: involves any visual communication formats used to communicate internally with employees, materials for a sales force or other employees, as well as formats used by a corporation or organization to communicate externally with other businesses, the public, stockholders, and customers.

correspondence: a visual connection established when an element, such as color, direction, value, shape or texture, is repeated, or when style is utilized as a method of connecting visual elements, for example, a linear style.

counter: the space enclosed by the strokes of a letter.

craftsmanship: the level of skill, proficiency, and/or dexterity of the execution.

creative brief: a written document outlining and strategizing a design project; also called a **design brief**.

cropping: the act of cutting a visual, a photograph, or illustration in order to use only part of it.

demographic: selected population characteristics.

design brief: a written document outlining and strategizing a design project; also called a **creative brief**.

design concept: the creative thinking underpinning the design solution. The concept is expressed through the integration and manipulation of visual and verbal elements.

diagram: a graphic representation of information, statistical data, a structure, environment, or process (the workings of something).

diffusion: characterized by blurred forms and boundaries, transparencies, muted color palettes, layering, open compositions, and painterliness.

display type: type that is used primarily for headlines and titles and more difficult to read as text type.

economy: stripping down visuals to fundamental forms, using as little description and few details as possible for denotation.

editorial design: involves the design of editorial content for print or screen; also called *publication design*.

emphasis: the arrangement of visual elements according to importance, stressing some elements over others, making some superordinate (dominant) elements and subordinating other elements.

environmental design: promotion, information, or identity design in constructed or natural environments, defining and marking interior and exterior commercial, cultural, residential, and natural environments.

equivocal space: when interchangeable shapes (such as a checkerboard pattern) or an ambiguous figure/ground relationship is created making the background and foreground difficult to distinguish; similar to figure/ground reversal.

expressionistic: a visualization characterized by a highly stylized or subjective interpretation, with an emphasis on the psychological or spiritual meaning; there is no strict adherence to things as they appear in nature, as opposed to naturalism.

figure/ground: a basic principle of visual perception that refers to the relationship of shapes, of figure to ground, on a two-dimensional surface: also called **positive and negative** space.

flowlines: horizontal alignments in a grid that aid visual flow.

focal point: the part of a design that is most emphasized.

format: the defined perimeter as well as the field it encloses—the outer edges or boundaries of a design; in actuality, it is the field or substrate (piece of paper, mobile phone screen, outdoor board, etc.) for the graphic design. In addition, designers often use the term format to describe the type of project—that is, a poster, a CD cover, a mobile ad, and so on.

fractured space: multiple viewpoints seen simultaneously, as in Cubism.

graph: a specific type of diagram used to indicate relationships between two (or more) variables, often represented on vertical and horizontal axes.

graphic design: a form of visual communication used to convey a message or information to an audience; a visual representation of an idea relying on the creation, selection, and organization of visual elements.

graphic interpretation: an elemental visualization of an object or subject, almost resembling a sign, pictogram, or symbol in its reductive representation.

graphic standards manual: guidelines for how the logo (and/or visual identity) is to be applied to numerous applications, from business cards to point-of-purchase materials to vehicles to websites; also called an **identity standards manual**.

grid: a guide—a modular compositional structure made up of verticals and horizontals that divide a format into columns and margins. It may be used for single-page formats or multipage formats.

ground: shapes or areas created between and among figures; also called *negative space*.

grouping: perceiving visual units by location, orientation, likeness, shape, and color.

gutter: the blank space formed by the inner margins of two facing pages in a publication.

harmony: agreement within a composition, where elements are constructed, arranged, and function in relation to one another to an agreeable effect.

high contrast: a wide range of values.

hue: the name of a color; that is, red or green, blue or yellow.

icon: a generally accepted (pictorial or symbolic) visual to represent objects, actions, and concepts; an icon resembles the thing it represents or at minimum shares a quality with it—it can be a photograph, a pictorial representation, an elemental visual (think magnifying glass desktop icon), or arbitrary (think radioactive sign), or symbolic (think lightning bolt to represent electricity).

identity design: involves the creation of a systematic visual and verbal program intended to establish a consistent visual appearance and personality—a coordinated overarching identity—for a brand or group.

illusion of spatial depth: the appearance of three-dimensional space on a two-dimensional surface.

illustration: a visual rendering that accompanies or complements printed, digital, or spoken text to clarify, enhance, illuminate, or demonstrate the message of the text.

image: a broad term encompassing a great variety of representational, abstract, or nonobjective images—photographs, illustrations, drawings, paintings, prints, pictographs, signs, symbols, maps, diagrams, optical illusions, patterns, and graphic elements and marks; images are also called *visuals*.

index: a sign that signifies through a direct relationship between the sign and the object, without describing or resembling the thing signified.

information design: a highly specialized area of design that involves making large amounts of complex information clear and accessible to audiences of one to several hundred thousand.

interactive: graphic design and advertising for screen-based media; also called *experience design*.

intricacy: based on complexity, on the use of many component parts and/or details to describe and visually communicate.

kerning: adjustment of the letterspacing.

leading: in metal type, strips of lead of varying thickness (measured in points) used to increase the space between lines of type; also known as **line spacing**.

lettering: the drawing of letterforms by hand (as opposed to type generated on a computer).

letterspacing: spatial interval between letters.

light and shadow: employed to describe form; most closely simulates how we perceive forms in nature.

line: an elongated point, considered the path of a moving point; it also is a mark made by a visualizing tool as it is drawn across a surface.

line spacing or leading: spatial interval between two lines of type.

linear: line as the predominant element used to unify a composition or to describe shapes or forms in a design.

link: on a web page, a connection from one location to another location, or from one website to another website; also called *hyperlink*.

low contrast: a narrow range of values.

lowercase: the smaller set of letters. The name is derived from the days of metal typesetting when these letters were stored in the lower case.

map: a specific type of diagrammatical representation used to depict a route or geographical area—to show location.

margins: the blank space on the left, right, top, or bottom edge of any printed or digital page.

mind map: a visual representation, diagram, or presentation of the various ways words, terms, images, thoughts, or ideas can be related to one another.

mixed media: a visual resulting from the use of different media, for example, photography combined with illustration.

mock-up: a facsimile of a printed three-dimensional design piece; also called a *dummy*.

Modern typeface: serif typeface, developed in the late eighteenth and early nineteenth centuries, whose form is more geometric in construction, as opposed to the Old Style typefaces, which stayed close to forms created by the chisel-edged pen.

modularity: a structural principle used to manage content using modules.

module: any single fixed element within a bigger system or structure, for example, a unit on graph paper, a pixel in a digital image, a rectangular unit in a grid system, or a fixed encapsulated chunk of a composition.

motion graphics: time-based visual communication that integrates images, typography, and audio; created using film, video, and computer software; including animation, television commercials, film titles, promotional, and informational format for broadcast media and screen media.

naturalistic: a visual appearance or style created by full color or tone using light and shadow that attempts to replicate an object or subject as it is perceived in nature; also called *realistic*.

nonobjective: a purely invented visual, not derived from anything visually perceived; it does not relate to any object in nature and does not literally represent a person, place, or thing; also called *nonrepresentational*.

notation: a linear, reductive visual that captures the essence of its subject, characterized by its minimalism.

Old Style: Roman typeface, introduced in the late fifteenth century, most directly descended in form from letters drawn with a broad-edged pen.

opaque: dense, solid seeming, not see-through.

open: a composition where the major movements within the composition oppose the edges (think diagonals) or direct our eyes past the boundaries of the format.

orientation phase in the design process: the process of becoming familiar with an assignment, the graphic design problem, and the client's business or organization, product, service, or group.

package design: the complete strategic planning and designing of the form, structure, and appearance of a product's package, which functions as casing, promotes a brand, presents information, and becomes a brand experience.

pattern: a consistent repetition of a single visual unit or element within a given area.

perspective: a schematic way of translating three-dimensional space onto the two-dimensional surface. This is based on the idea that diagonals moving toward a point on the horizon, called the vanishing point, will imitate the recession of space into the distance and create the **illusion of spatial depth**.

photography: a visual created using a camera to capture or record an image.

photomontage: a composite visual made up of a number of photographs or parts of photographs to form a unique image.

pictograph: an elemental, universal picture denoting an object, activity, place, or person, captured through shape; for example, the images denoting gender on bathroom doors.

picture plane: the blank, flat surface of a page.

point: the smallest unit of a line and one that is usually recognized as being circular; also called a *dot*.

positive and negative: a basic principle of visual perception and refers to the relationship of shapes, of figure to ground, on a two-dimensional surface; also called **figure/ground**.

presentation: the manner in which comps are presented to a client or the way work is presented in a portfolio.

problem-finding: the process of sketching or making marks that allows visual thinking, allows for discovery, for staying open to possibilities during the visual-making process; also called *problem-seeking*.

production: includes preparing the digital files utilizing industry-standard software, collecting all needed photographs and/or illustrations and having themscanned, preparing font folders and image folders, proofreading (with or without the client), and following through by working with the printer or the web designer; also called *digital prepress*.

promotional design: involves generating and creating specific visual and verbal messages constructed to inform, persuade, promote, provoke, or motivate people on behalf of a brand or group.

proportion: the comparative size relationships of parts to one another and to the whole.

reflected color: colors that can be seen on the surfaces or objects in the environment; also known as *reflected light*.

repetition: occurs when one or a few visual elements are repeated a number times or with great or total consistency.

rhythm: a visual pulse and flow from one graphic element to another.

roughs: sketches that are larger and more refined than thumbnail sketches.

rules: thin stripe(s) or line(s) used for borders or for separating text, columns of text, or visuals.

sans serif: typefaces characterized by the absence of serifs.

saturation: the brightness or dullness of a color; also called *intensity* or *chroma*.

scale: the size of one shape or object in relation to another.

script: typeface that most resembles handwriting. Letters usually slant and often are joined.

serif: a small stroke added to the upper or lower end of the main stroke of a character.

shape: the general outline of something.

sharpness: characterized by clarity of form, detail, clean and clear edges and boundaries, saturated color, readable and legible typography, proximate vision, hyperrealism, photorealism, closed compositions, and limited type alignment.

sign: a visual mark or a part of language that denotes another thing.

silhouette: the articulated shape of an object or subject taking its specificity into account (as opposed to the universal visual language of a pictograph).

slab serif: serif typeface characterized by heavy, slab-like serifs.

spatial zones: formed by grouping several grid modules, in order to organize the placement of various graphic components.

strategy: the core tactical underpinning of any visual communication, unifying all planning for every visual and verbal application within a program of applications.

symbol: a visual having an arbitrary or conventional relationship between the signifier and the thing signified.

symmetry: an equal distribution of visual weights, a mirroring of equivalent elements on either side of a central axis; also called *reflection symmetry*.

tactile texture: a quality that can be physically touched and felt; also called *actual texture*.

temperature: the perception of a hue as warm or cool.

texture: the tactile quality of a surface or the representation of such a surface quality.

thumbnail sketches: preliminary, small, quick, unrefined drawings of ideas, in black and white or color.

Transitional: a serif typeface, originating in the eighteenth century, that represents a transition from Old Style to Modern, exhibiting design characteristics of both.

trompe l'oeil: literally, "to fool the eye"; a visual effect on a two-dimensional surface where the viewer is in doubt as to whether the object depicted is real or a representation.

type alignment: the arrangement of text type.

type family: includes many *style* variations of a single typeface.

type style: variations of a typeface, which include variations in weight (light, medium, bold), width (condensed, regular, extended), and angle (roman or upright, and italic), as well as elaborations on the basic form (outline, shaded, decorated).

typeface: the design of a single set of characters unified by consistent visual properties. These properties create the essential character, which remains recognizable even if the face is modified.

typographic color: the overall density or tonal quality of a mass of type on a field—page or screen— usually referring to the mass of text type; also called *typographic texture*.

typographic design: a highly specialized area of graphic design focusing on the creation and design of letterforms, typefaces, and type treatments.

unity: one of the primary goals of composition— composing an *integrated whole*, not unrelated component parts.

value: refers to the level of luminosity—lightness or darkness—of a color.

variation: established by a break or modification in the pattern or by changing elements, such as the color, size, shape, spacing, position, and visual weight.

visual hierarchy: arranging all graphic elements according to emphasis.

visual texture: the illusion of a real texture created by hand, scanned from an actual texture (such as lace) or photographed.

visual weight: the illusion of physical weight on a two-dimensional surface.

volume: the representation of mass on a two-dimensional surface.

wayfinding system: visual system that incorporates signs, pictograms, and symbols to assist and guide visitors and tourists to find what they are looking for in museums, airports, zoos, and city centers.

word spacing: the space between words.

x-height: the height of a lowercase letter, excluding ascenders and descenders.

BIBLIOGRAPHY

ADVERTISING

Aitchison, Jim. *Cutting Edge Advertising, 3ʳᵈ ed.* Singapore: Pearson, 2007.

Griffin, W. Glen, and Deborah Morrison. *The Creative Process Illustrated: How Advertising's Big Ideas Are Born*, Cincinnati: HOW, 2010.

Landa, Robin. *Advertising by Design: Generating and Designing Creative Ideas Across Media, 2ⁿᵈ ed.* Hoboken: John Wiley & Sons, 2010.

McDonough, John, and Karen Egolf, eds. *The Advertising Age Encyclopedia of Advertising.* 3 vols. New York: Fitzroy Dearborn, 2003.

Ogilvy, David. *Ogilvy on Advertising.* New York: Vintage, 1985.

Pincas, Stéphane, and Marc Loiseau. *A History of Advertising.* Köln: Taschen, 2008.

Sullivan, Luke, and Sam Bennett. *Hey Whipple, Squeeze This,* 4ᵗʰ ed. Hoboken: John Wiley & Sons, 2012.

Tag, Nancy. *Ad Critique: How to Deconstruct Ads In Order To Build Better Advertising.* New York: Sage Publications, 2011.

Young, James. *A Technique for Producing Ideas.* Advertising Age Classics Library. New York: McGraw Hill, 2003.

BRANDING

Chen, Joshua, and Margaret Hartwell. *Archetypes in Branding: A Toolkit for Creatives and Strategists.* Cincinnati: HOW Books, 2012.

Fisher, Jeff. *Identity Crisis: 50 Redesigns That Transformed Stale Identities into Successful Brands.* Cincinnati: HOW Books, 2007.

Gobé, Marc. *Emotional Branding: The New Paradigm for Connecting Brands to People.* New York: Allworth Press, 2009.

Landa, Robin. *BYOB: Build Your Own Brand.* Cincinnati: HOW Books, 2013.

———. *Designing Brand Experiences.* Clifton Park: Cengage Learning, 2006.

Millman, Debbie. *Brand Thinking and Other Noble Pursuits.* New York: Allworth Press, 2011.

Neumeier, Marty. *The Brand Gap: How to Bridge the Distance Between Business Strategy and Design, 2ⁿᵈ ed.* Berkeley: New Riders, 2005.

Roberts, Kevin. *Lovemarks: The Future Beyond Brands.* New York: PowerHouse Books, 2005.

Wheeler, Alina. *Designing Brand Identity: An Essential Guide for the Whole Branding Team.* 3rd ed. Hoboken: John Wiley & Sons, 2009.

Wheeler, Alina, and Joel Katz. *Brand Atlas.* Hoboken: John Wiley & Sons, 2011.

BUSINESS OF GRAPHIC DESIGN

Graphic Artists Guild. *Graphic Artists Guild Handbook: Pricing & Ethical Guidelines.* 12th ed. New York: Graphic Artists Guild, 2010.

Heller, Steven, and Teresa Fernandes. *Becoming a Graphic Designer: A Guide to Careers in Design.* Hoboken: John Wiley & Sons, 2010.

COLOR

Albers, Josef, and Nicolas Fox Weber. *Interaction of Color: Revised and Expanded Edition.* New Haven: Yale University Press, 2006.

Birren, Faber. *Principles of Color: A Review of Past Traditions and Modern Theories of Color Harmony.* Rev. ed. Atglen, PA: Schiffer Publishing, 1987.

Chevreul, M. E., and Faber Birren. *The Principles of Harmony and Contrast of Colors and Their Applications to the Arts.* Rev. ed. Atglen, PA: Schiffer Publishing, 1987.

Itten, Johannes. *The Art of Color: The Subjective Experience and Objective Rationale of Color.* New York: Van Nostrand Reinhold, 1974.

Munsell, Albert. *A Color Notation: An Illustrated System Defining All Colors and Their Relations 1941.* 9th ed. Whitefish, MT: Kessinger Publishing, 2004.

COMPOSITION AND DESIGN PRINCIPLES

Arnheim, Rudolf. *Art and Visual Perception: A Psychology of the Creative Eye.* Berkeley: University of California Press, 2004.

Dondis, Donis A. *Primer of Visual Literacy.* Cambridge: MIT Press, 1973.

Elam, Kimberly. *Grid Systems: Principles of Organizing Type.* New York: Princeton Architectural Press, 2004.

Hofmann, Armin. *Graphic Design Manual: Principles and Practice/Methodik Der Form—Und Bildgestaltung: Aufbau Synthese Anwendung/ Manuel de Création Graphique: Forme Synthèse Application.* Sulgen, Switzerland: Arthur Niggli, 1965.

Hurlburt, Allen. *The Grid: A Modular System for the Design and Production of Newspapers, Magazines, and Books.* New York: Van Nostrand Reinhold, 1978.

Kandinsky, Wassily. *Point, Line, and Plane.* 2nd ed. New York: Museum of Non-Objective Painting, 1947.

Kepes, Gyorgy. *Language of Vision.* Chicago: Paul Theobald, 1961.

Landa, Robin, Rose Gonnella, and Steven Brower. *2D: Visual Basics for Designers.* Clifton Park, New York: Cengage Learning, 2007.

Lidwell, William, Kritina Holden, and Jill Butler. *Universal Principles of Design.* Beverly, MA: Rockport Publishers, 2003.

Müller-Brockmann, Josef. *Grid Systems in Graphic Design.* 3rd ed. Stuttgart: Verlag Gerd Hatje, 1988.

———. *A History of Graphic Communication.* Sulgen, Switzerland: Arthur Niggli, 1971.

Roberts, Lucienne, and Julia Shrift. *The Designer and the Grid.* East Sussex, UK: RotoVision, 2002.

Samara, Timothy. *Making and Breaking the Grid: A Graphic Design Layout Workshop.* Gloucester, MA: Rockport Publishers, 2002.

Vinh, Khoi. *Ordering Disorder: Grid Princples for Web Design.* New York: New Riders Press, 2010.

Wong, Wucius. *Principles of Form and Design.* Hoboken: John Wiley & Sons, 1993.

HISTORY

Drucker, Johanna, and Emily McVarish. *Graphic Design History: A Critical Guide*. Englewood Cliffs, NJ: Prentice Hall, 2008.

Eskilson, Stephen J. *Graphic Design: A New History*. New Haven: Yale University Press, 2007.

Fiell, Charlotte, and Peter Fiell. *Graphic Design for the 21st Century*. Köln: Taschen, 2003.

"Graphic Design and Advertising Timeline." *Communication Arts* 41, no. 1 (1999): 80–95.

Heller, Steven, and Seymour Chwast. *Graphic Style: From Victorian to Digital*. New York: Harry N. Abrams, 2001.

———. *Illustration: A Visual History*. New York: Harry N. Abrams, 2008.

Heller, Steven, and Mirko Ilić. *Icons of Graphic Design*. 2nd ed. London: Thames & Hudson, 2008.

Heller, Steven, and Elinor Pettit. *Graphic Design Time Line: A Century of Design Milestones*. New York: Allworth Press, 2000.

Hollis, Richard. *Graphic Design: A Concise History*. London: Thames & Hudson, 2001.

———. *Swiss Graphic Design: The Origins and Growth of an International Style, 1920–1965*. New Haven: Yale University Press, 2006.

Johnson, J. Stewart. *The Modern American Poster*. New York: The National Museum of Modern Art, Kyoto, and The Museum of Modern Art, New York, 1983.

Meggs, Philip B., and Alston W. Purvis. *Meggs' History of Graphic Design*. 5th ed. Hoboken: John Wiley & Sons, 2011.

Müller-Brockmann, Josef, and Shizuko Müller-Brockmann. *History of the Poster*. London: Phaidon Press, 2004.

Poynor, Rick. *No More Rules: Graphic Design and Postmodernism*. New Haven: Yale University Press, 2003.

Remington, Roger, and Barbara J. Hodik. *Nine Pioneers in American Graphic Design*. Cambridge: MIT Press, 1989.

Vit, Armin, and Bryony Gomez-Palacio. *Women of Design: Influence and Inspiration from the Original Trailblazers to the New Groundbreakers*. Cincinnati: HOW Books, 2008.

———. *Graphic Design, Referenced: A Visual Guide to the Language, Applications, and History of Graphic Design*. Beverly, MA: Rockport Publishers, 2009.

THEORY, CRITICISM, CREATIVITY, AND INDIVIDUAL POINTS OF VIEW

Bierut, Michael. *79 Short Essays on Design*. New York: Princeton Architectural Press, 2007.

Bierut, Michael, William Drenttel, and Steven Heller, eds. *Looking Closer 5: Critical Writings on Graphic Design*. New York: Allworth Press, 2007.

Coles, Alex. *Design and Art*. Cambridge: MIT Press, 2007.

Csikszentmihalyi, Mihaly. *Creativity: Flow and the Psychology of Discovery and Invention*. 4th ed. New York: Harper Perennial, 1997.

Curtis, Hillman. *MTIV: Process, Inspiration, and Practice for the New Media Designer*. New York: New Riders Press, 2002.

Erlhoff, Michael, and Timothy Marshall, eds. *Design Dictionary: Perspectives on Design Terminology*. Board of International Research in Design. Basel: Birkhäuser Basel, 2008.

Glaser, Milton. *Art Is Work*. New York: Overlook Press: 2008.

———. *Drawing Is Thinking*. New York: Overlook Press, 2008.

———. *In Search of the Miraculous*. New York: Overlook Press, 2012.

Glaser, Milton, and Mirko Ilić, *The Design of Dissent: Socially and Politically Driven Graphics*. Beverly, MA: Rockport Publishers, 2006.

Heller, Steven, and Mirko Ilić. *The Anatomy of Design: Uncovering the Influences and Inspirations in Modern Graphic Design*. Beverly, MA: Rockport Publishers, 2007.

Heller, Steven, and Veronique Vienne. *Citizen Designer: Perspectives on Design Responsibility*. New York: Allworth Press, 2003.

Klee, Paul. *Pedagogical Sketchbook*. England: Faber and Faber, 1953.

Landa, Robin. *Take A Line For A Walk: A Creativity Journal*. Boston: Wadsworth, 2011.

Lupton, Ellen. *Design Writing Research*. New York: Phaidon Press, 1999.

Lupton, Ellen, and Miller Abbott. *The ABCs of the Bauhaus and Design Theory from Preschool to Post-Modernism*. New York: Princeton Architectural Press, 1993.

Maeda, John. *The Laws of Simplicity (Simplicity: Design, Technology, Business, Life)*. Cambridge: MIT Press, 2006.

Margolin, Victor. *Design Discourse: History, Theory, Criticism*. Chicago: University of Chicago Press, 1989.

Moholy-Nagy, Lazlo. *Vision in Motion*. Chicago: Paul Theobald, 1947.

Müller-Brockmann, Josef. *The Graphic Artist and His Design Problems*. Sulgen, Switzerland: Arthur Niggli, 1961.

Poynor, Rick. *Obey the Giant: Life in the Image World*. 2nd ed. Basel: Birkhäuser Basel, 2007.

Rand, Paul. *Conversations with Students*. New York: Princeton Architectural Press, 2008.

———. *Design, Form, and Chaos*. New Haven: Yale University Press, 1993.

———. *Thoughts on Design*. New York: Van Nostrand Reinhold, 1970.

Smoke, Trudy, and Alan Robbins. *World of the Image*. White Plains, NY: Longman, 2006.

Tufte, Edward R. *The Cognitive Style of PowerPoint*. Cheshire, CT: Graphics Press, 2003.

———. *Envisioning Information*. Cheshire, CT: Graphics Press, 1990.

TYPOGRAPHY

Bringhurst, Robert. *The Elements of Typographic Style*. Version 3.2. Point Roberts, WA: Hartley & Marks Publishers, 2008.

Burke, Christopher. *Active Literature: Jan Tschichold and New Typography*. London: Hyphen Press, 2008.

Carter, Rob. *American Typography Today*. New York: Van Nostrand Reinhold, 1989.

Carter, Rob, Ben Day, and Philip B. Meggs. *Typographic Design: Form and Communication*. 3rd ed. New York: Van Nostrand Reinhold, 2002.

Craig, James. *Basic Typography: A Design Manual*. New York: Watson-Guptill Publications, 1990.

————. *Designing with Type*. New York: Watson-Guptill Publications, 1992.

Dodd, Robin. *From Gutenberg to OpenType: An Illustrated History of Type from the Earliest Letterforms to the Latest Digital Fonts*. Dublin: Hartley and Marks Publishers, 2006.

Heller, Steven, and Lita Talarico. *Typography Sketchbooks*. Princeton: Princeton Architectural Press, 2011.

Kane, John. *A Type Primer*, 2nd ed., Englewood Cliffs, NJ: Prentice-Hall, 2011.

Lupton, Ellen. *Thinking with Type: A Critical Guide for Designers, Writers, Editors, and Students*. New York: Princeton Architectural Press, 2004.

Müller, Lars. *Helvetica: Homage to a Typeface*. Baden: Lars Müller, 2002.

Perry, Michael. *Hand Job: A Catalog of Type*. New York: Princeton Architectural Press, 2007.

Ruder, Emil. *Typography*. Sulgen, Switzerland: Arthur Niggli, and New York: Hastings House, 1981. First published in 1967.

Rüegg, Ruedi. *Basic Typography: Design with Letters*. New York: Van Nostrand Reinhold, 1989.

Solomon, Martin. *The Art of Typography: An Introduction to Typo.Icon.Ography*. New York: Watson-Guptill, 1986.

Spencer, Herbert. *Pioneers of Modern Typography*. Rev. ed. Cambridge: MIT Press, 2004.

Spencer, Herbert, ed. *The Liberated Page: An Anthology of Major Typographic Experiments of This Century as Recorded in "Typographica" Magazine*. London: Lund Humphries, 1987.

Spiekermann, Erik, and E. M. Ginger. *Stop Stealing Sheep and Find Out How Type Works*. 2nd ed. Berkeley: Adobe Press, 2002.

Tschichold, Jan. *The New Typography: A Handbook for Modern Designers*. Translation by Ruari McLean. Berkeley: University of California Press, 1995.

Weingart, Wolfgang. *Wolfgang Weingart: My Way to Typography*. Baden: Lars Müller, 2000.

Zapf, Hermann. *Hermann Zapf and His Design Philosophy*. Chicago: Society of Typographic Arts Chicago, 1997.

VISUALIZATION

Chen Design Associates. *Fingerprint 2: The Art of Using Hand-Made Elements in Graphic Design*. Cincinnati: HOW Books, 2011.

Dougherty, Brian, and Celery Design Collaborative. *Green Graphic Design*. New York: Allworth Press, 2009.

Evans, Poppy, and Aaris Sherin. *Forms, Folds, and Sizes: All the Details Graphic Designers Need to Know But Can Never Find*. 2nd ed. Beverly, MA: Rockport Publishers, 2009.

Gonnella, Rose, and Christopher Navetta. *Comp It Up*. Clifton Park, NY: Delmar Cengage Learning, 2010.

Gonnella, Rose, and Erin Smith, with Christopher Navetta. *Design to Touch: Engraving History, Process, Concepts, and Creativity*. Nashville, TN: International Engraved Graphics Association (IEGA), 2012.

Krug, Steve. *Don't Make Me Think! A Common Sense Approach to Web Usability*. 2nd ed. Berkeley: New Riders, 2006.

Landa, Robin, and Rose Gonnella. *Visual Workout: A Creativity Workbook*. Clifton Park, NY: Delmar Cengage Learning, 2004.

Miller, Brian. *Above the Fold: Understanding the Principles of Successful Web Site Design*. Cinncinnati, OH: HOW Books, 2011.

Perry, Michael. *Over and Over: A Catalog of Hand-Drawn Patterns*. New York: Princeton Architectural Press, 2008.

Sherin, Aaris. *SustainAble: A Handbook of Materials and Applications for Graphic Designers and Their Clients*. Beverly, MA: Rockport, 2008.

Victionary. *Print Work: An Exploration of Printing Techniques*. Hong Kong: Victionary, 2008.

RECOMMENDED READING

Arnheim, Rudolf. *Visual Thinking*. Berkeley: University of California Press, 2004.

Frederick, Matthew. *101 Things I Learned in Architecture School*. Cambridge: MIT Press, 2007.

Gombrich, E. H. *Art and Illusion*. Princeton: Princeton University Press, 2000.

Kubler, George. *The Shape of Time: Remarks on the History of Things*. Rev. ed. New Haven: Yale University Press, 2008.

Lois, George. *George Lois: On Creating the Big Idea*. New York: Assouline, 2008.

Meggs, Philip B. *Type and Image: The Language of Graphic Design*. New York: Van Nostrand Reinhold, 1989.

Ortega y Gasset, José. *Dehumanization of Art and Other Essays on Art, Culture, and Literature*. Princeton: Princeton University Press, 1968.

Panofsky, Erwin. *Meaning in the Visual Arts*. Chicago: University of Chicago Press, 1983.

Rapaille, Clotaire. *The Culture Code: An Ingenious Way to Understand Why People Around the World Live and Buy as They Do*. New York: Broadway Books, 2007.

Wolfflin, Heinrich. *Principles of Art History*. New York: Dover Publications, 1950.

Woodbridge, Homer E. *Essentials of English Composition*. New York: Harcourt, Brace, and Howe, 1920.

ONLINE RESOURCES

PROFESSIONAL ORGANIZATIONS

The Advertising Council
www.adcouncil.org

AIGA | the professional association for design
www.aiga.org

Art Directors Club
www.adcglobal.org

D&AD
www.dandad.org

Icograda
www.icograda.org

International Typographic Organization
www.atypi.org

The One Club
www.oneclub.org

Society of Illustrators
www.societyillustrators.org

The Type Directors Club
www.tdc.org

PUBLICATIONS

The Advertising Century
www.adage.com/century

Adweek
www.adweek.com

Brandweek
www.brandweek.com

CMYK Magazine
www.cmykmag.com

Communication Arts
www.commarts.com

Creativity Magazine
www.creativity-online.com

Fast Company
www.fastcompany.com

HOW Magazine
www.howdesign.com

Lürzer's Archive
www.luerzersarchive.com

Print Magazine
www.printmag.com

AWARDS AND BLOGS

Brand New
www.underconsideration.com/brandnew/

Design Blog, Cooper-Hewitt
blog.cooperhewitt.org

Design Envy Blog, (AIGA)
http://designenvy.aiga.org/

Design Observer
www.designobserver.com

The FMA (Favorite Website Awards)
www.thefwa.com/

The Webby Awards
www.webbyawards.com

ARCHIVES AND MUSEUMS

Ad Museum
www.admuseum.org

AIGA Design Archives
http://designarchives.aiga.org/

Cooper-Hewitt, National Design Museum
www.cooperhewitt.org

Design Museum London
www.designmuseum.org

The Eisner American Museum
of Advertising and Design
www.eisnermuseum.org

Graphic Design Archive | RIT Libraries
http://library.rit.edu/collections/rit-special-collections/design-archives.html

The Herb Lubalin Center
http://Lubalincenter.cooper.edu

Museum for Modern International
Book Art, Typography and Calligraphy
www.klingspor-museum.de/EUeberdasMuseum.html

Museum of Modern Art
www.moma.org

Smithsonian Institution
www.si.edu

BEYOND THE ESSENTIALS:
Poster and Book Cover Composition Basics, Design Checklist, & Projects

Designing for a static single surface, such as a poster or book cover, is a sound route to learning basic conceptual, visualization, compositional, and creative principles. In this section, you will find applied composition basics, a design checklist, and a series of projects for poster and book cover design to foster learning basic principles and acquiring skills.

POSTER AND BOOK COVER COMPOSITION BASICS

01. *Grab attention.* A poster can persuade people to see a show, purchase a brand, donate blood, get a mammogram, protest censorship, or buy concert tickets. A book cover can interest and compel. However, a poster or a book cover can only do those things if it attracts someone's attention—if it pulls someone in. It also must be interesting enough to hold a person's attention to prompt action.

02. *Set it apart.* To attract attention, a poster or cover must be visually interesting as well as different from its surroundings. Just like packaging on a market shelf, a poster or cover needs to be differentiated from others competing with it. Why should someone choose to look at one rather than another? How you visualize and compose can and should create distinction—a unique look and feel, mood, or emotional level for the subject. Your selection or creation of display type, how you visualize the imagery, and how the image and type work together contribute greatly to distinction.

03. *Communicate key messages.* Visual hierarchy is paramount in how well your composition communicates the key messages. Orchestrate visual hierarchy through placement, contrast, focal point, size, shape, color, typography, texture, and so on. An element such as color can guide the viewer as well as establish visual connections among elements. Once a focal point ushers the viewer into the composition, the composition should guide the viewer on from each point of information to the next.

04. *Single surface, one unit.* The advantage of structuring a composition for a poster or cover is in dealing only with a single surface; you don't have to worry about establishing continuity over several pages, as in magazine or website design. Ensuring all component parts act in concert to form a cohesive entity is vital. For a novice, it helps to decide if the composition will be dominated by an image, by type, or by a visual/verbal amalgamation.

POSTER AND BOOK COVER DESIGN CHECKLIST

→ Attract the audience with skillful visualization and composition

→ Organize and compose information in a clear visual hierarchy

→ Express the essence of the subject matter

→ Type and image should work cooperatively

→ Differentiate—make it unique

→ Consider the proportions of the format when composing

→ Design with type for impact as well as readability

Project 1

Poster Design Variations

STEP 1

Theme: Select an event, for example, a World Music Festival sponsored by your home state's Department of Cultural Affairs and Special Events.

STEP 2

Design three posters to promote the event in three different ways:

01. Design a type-driven poster: emphasis on type/de-emphasis on images, where type is the dominant force and images are secondary.

02. Design an image-driven poster: emphasis on image/de-emphasis on type, where the image is the "hero" and type is subordinate to the image.

03. Design a poster with the type and image merged in an emblematic way. For example, the type is positioned inside the primary image creating an inseparable relationship. When type and image are fused, there is an automatic relationship. When they are fused in an organic, almost seamless relationship, they appear and operate as a single entity, as an amalgamation.

STEP 3

01. Produce about twenty sketches before creating several roughs.

02. Create two different roughs for each poster. Refine.

03. Then prepare a final comp for each.

Project 2

Poster Design for a Social or Political Cause

STEP 1

01. Select a social or political cause, such as the Get Out the Vote, an AIGA Design for Democracy (http://www.aiga.org/design-for-democracy/) initiative.

02. Gather information about it.

03. Define the purpose and objectives of the poster; determine the audience and the information to be communicated. (*Optional*: Write a design brief.)

04. Generate a few design concepts. Concentrate your conceptual thinking on finding a way to prompt people to think about the cause and/or call them to action. Select and refine one concept.

STEP 2

01. Determine whether the poster should be image driven or type driven.

02. Design two compositions: one symmetrical and one asymmetrical.

03. Determine at least three different ways your concept could be visualized. The poster should grab the attention of people walking by.

04. The poster should include the social cause's web address and phone number so that people can take action. Consider including social media icons as well.

05. Produce at least twenty sketches.

STEP 3

01. Produce at least two roughs before going to the final comp.

02. Be sure to establish visual hierarchy.

03. The poster should be in a vertical (portrait) format. *Optional*: Design a companion Facebook ad.

STEP 4

01. Refine the roughs. Create one final comp.

02. The poster's size should be dictated by your strategy, design concept, and where the poster will be seen (environment).

Project 3

Book Cover Design: Single Focal Point Versus Multiple Focal Points

STEP 1

01. Choose a respected work of nonfiction.

02. Ideally, read the book. If not, read synopses and gather information about the subject.

03. Decide upon one image that best communicates the book's content. Preferably, the image should work cooperatively with the book's title rather than repeat it.

04. Visualize and compose the cover design with the aforementioned image as the main focal point. All other elements (title, author, any other graphic element or information) should be subordinate to the main focal point.

STEP 2

01. Design a different cover for the same work of nonfiction.

02. The cover's design should include the same information but should not have a main focal point. Instead, the cover composition should be structured with more than one point of focus yet maintain a visual hierarchy. There should be a clear order of emphasis.

03. Produce at least twenty sketches.

Reminder: Design with any or all tools that are appropriate—software, collage, handmade stamps, pencils, markers—but do not lock yourself into using one tool for all projects.

STEP 3

Create two roughs for each cover.

STEP 4

01. Refine the roughs. Create one comp for each cover.

02. You may employ black and white or full color.

Project 4

Book Cover Design: Midline Versus Edges

STEP 1

01. Choose a respected work of nonfiction or fiction, one that most easily conjures images or prompts ideas.

02. Ideally, read the book. If not, read synopses and gather information about it.

03. Brainstorm for design concepts (see Chapter 5 on creativity and concept generation).

04. Visualize and compose the cover design in a portrait orientation, emphasizing the midline to structure the composition. The composition does not have to be symmetrical, but the midline does need to be strongly employed.

STEP 2

01. Visualize and compose a different cover design in a portrait orientation for the same work of nonfiction.

02. This time, the cover's design should include the same information but should *not* be structured with an emphasis on the midline. Instead, the cover composition should be structured with an emphasis on the format's edges. *Or* this cover can be structured by transversing the surface through an action like pulling from opposite corners.

03. Produce at least twenty sketches.

Reminder: See Chapters 2 and 7 for refreshers on composition.

STEP 3

Create two roughs for each cover.

STEP 4

01. Refine the roughs. Create one comp for each cover.

02. You may use black and white or full color.

Project 5

Theater Poster

STEP 1

01. Choose a modern or contemporary play. Read it. Research it. Examples of playwrights include David Henry Hwang, David Mamet, Terrence McNally, Eduardo Machado, John Patrick Shanley, Wendy Wasserstein, and August Wilson.

02. Find related images you could use as references.

03. Write an objectives statement. Define the purpose and function of the poster, the audience, and the information to be communicated. On an index card, write down three adjectives that describe the spirit of the play, one sentence about the play's theme or plot, and images that relate to the play. Keep this card in front of you while sketching.

STEP 2

01. The poster should include the following copy: title, credits (author, director, lead actors), theater, web address, social media icons, and a ticket service phone number.

02. Your solution should include type and images that complement one another and are *composed in a fused, amalgamated way*. The key to developing your design concept may be an image that is symbolic of the play's spirit, theme, or mood. Images should *not* be photographs of the cast or scenes from the play.

03. Produce at least twenty sketches.

STEP 3

01. Produce at least two roughs before going to the comp.

02. Be sure to establish a visual hierarchy.

03. The poster can be in a vertical or horizontal orientation.

STEP 4

01. Refine the roughs. Create one comp.

02. The poster's size, proportions, and orientation should be dictated by your design concept and where the poster will be seen (environment).

03. Full color or limited color palette is your choice. The design concept should drive your decisions.

Optional: Design a playbill.

PRESENTATION

Printed Design Solutions

→ Two-dimensional designs should be printed on good quality, double-sided, matte photo paper.

→ Print the image at the largest size possible to fit on the paper (size to coordinate with portfolio binder).

→ All images must be at high resolution. Do not include any borders or additional graphics, as these would interfere with the composition of the presented work.

→ If there are several parts to the design solution, do not clutter the page. Rather, print each on a separate page. Optionally, you can layer and attach two pages to unite parts of one design solution. Print each part of the project on its own page. The part that is visible on the top layer will have a one-inch folded flap. The flap is glued to the back of the lower page—the page that will appear below it.

Digital Design Solutions

→ The suggestions are the same as print, but the images should be PDFs or seventy-two dpi resolution for embedded images on websites.

→ Display of images on websites should load quickly and be easy to navigate through in a linear progression, forward and back.

INDEX

By Subject

INDEX

Agencies, Clients, Creative Professionals, Studios, and Names